FLYING HIGH

AFRICA
FLYING HIGH

WHITE STAR
PUBLISHERS

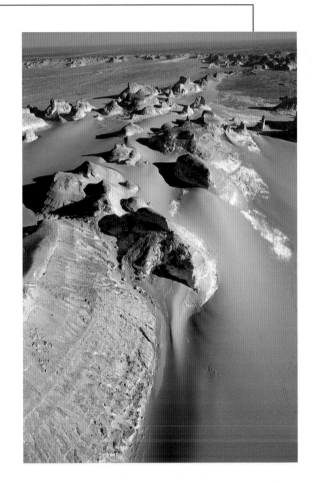

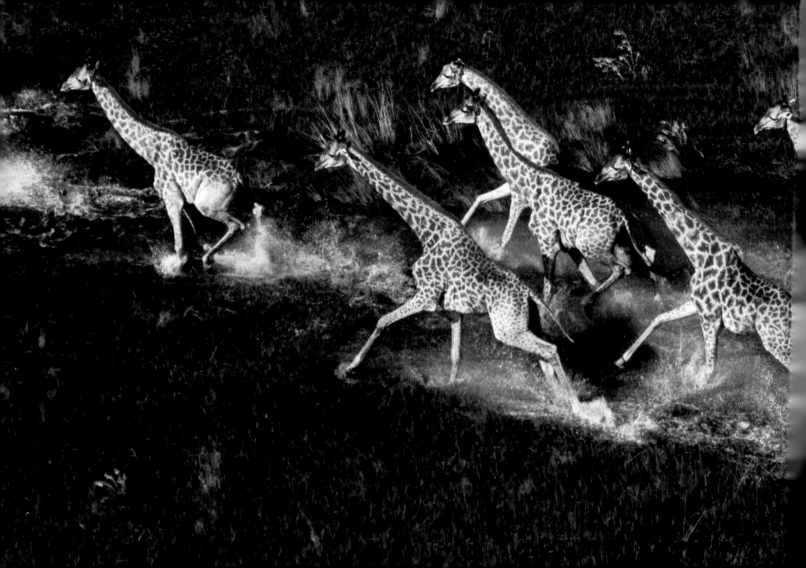

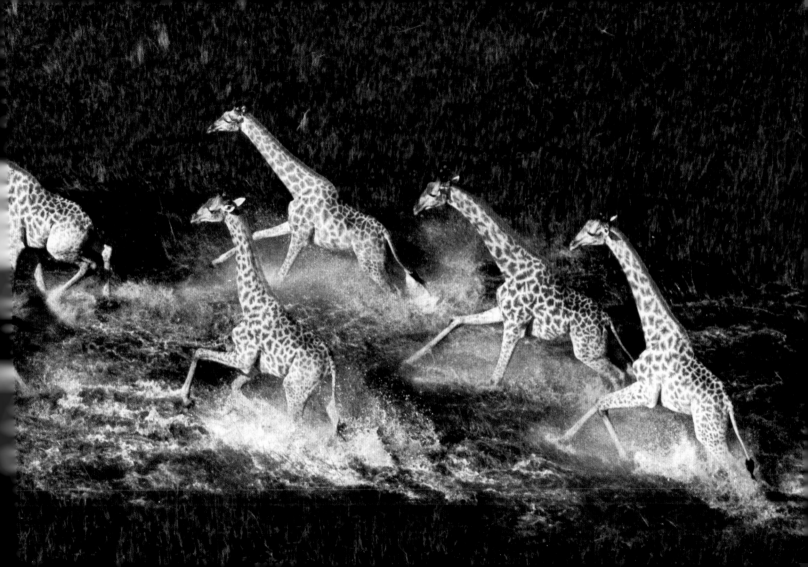

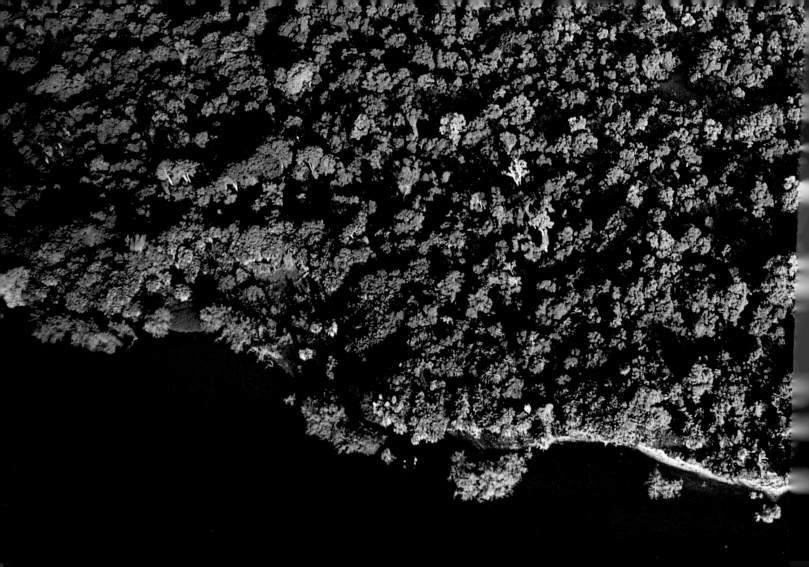

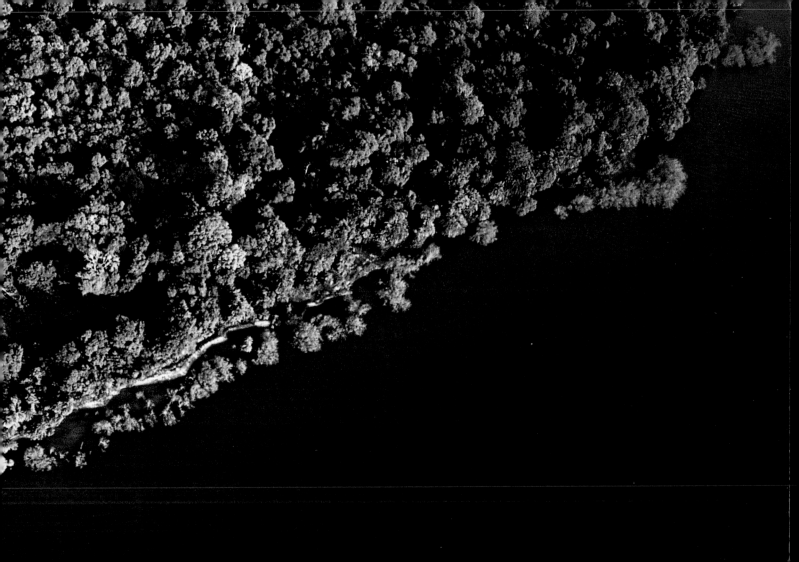

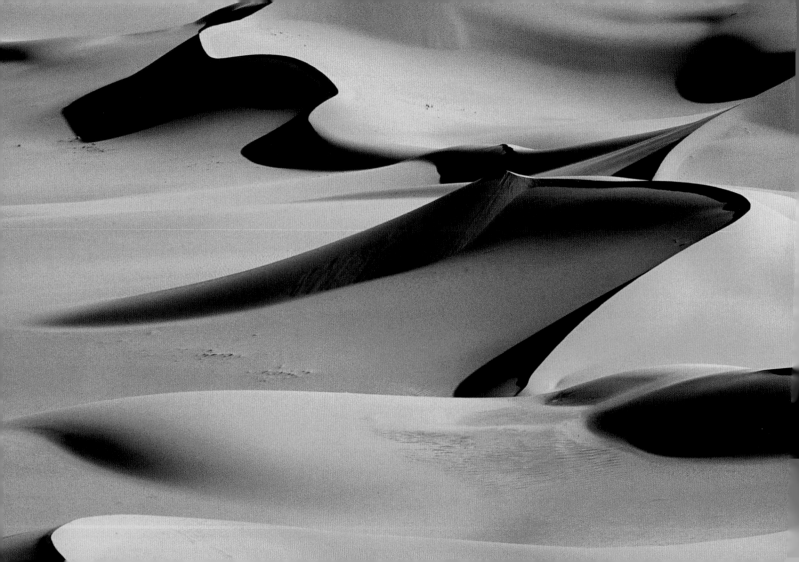

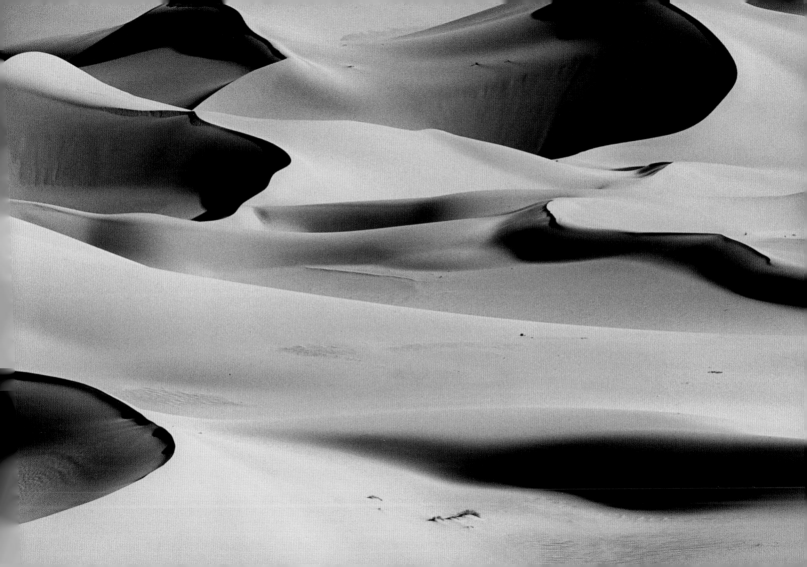

FLYING HIGH AFRICA

TEXT
Paolo Novaresio

PROJECT EDITOR
Valeria Manferto De Fabianis

EDITORIAL COORDINATION
Laura Accomazzo
Giada Francia
Marcello Libra
Novella Monti

GRAPHIC DESIGN
Paola Piacco

© 2006 WHITE STAR S.P.A.
Via Candido Sassone, 22-24
13100 Vercelli - Italy
WWW.WHITESTAR.IT

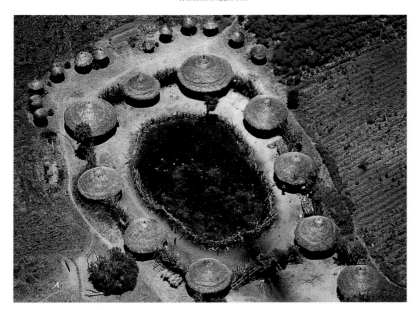

Translation: Maresa Moglia

ISBN 88-544-0107-2

Reprints: 1 2 3 4 5 6 10 09 08 07 06

Printed in China
Color separation: Chiaroscuro, Turin - Fotomec, Turin

1
The White Desert, Egypt.

2-3
A group of giraffes in the delta of
the Okawango River, Botswana.

4-5
Forests on the shores of Lake
Victoria, Tanzania.

Contents

6-7
Saharan dunes, Lybia.

8-9
Indian Ocean, Tanzania.

10
A Maasai with herd, Kenya.

11
A Maasai village, Tanzania.

12
Pink flamingos on the surface of a lake in Kenya.

13
A fight between elephants in the Amboseli National Park, Kenya.

14-15
Workers transport poles on a beach in Senegal.

16-17
The pyramids of Giza, Egypt.

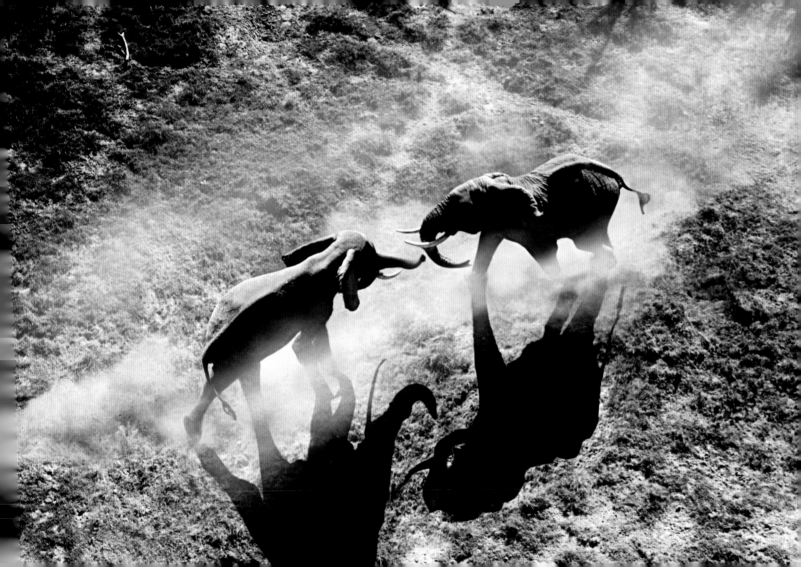

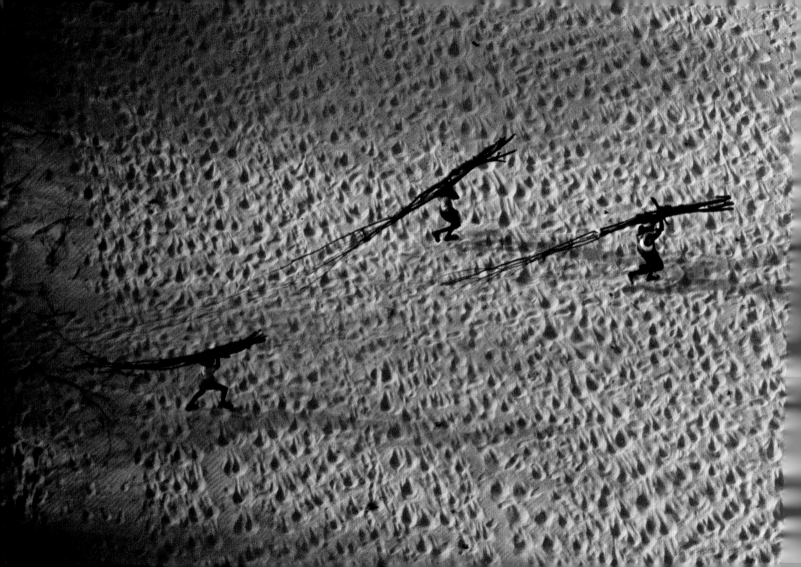

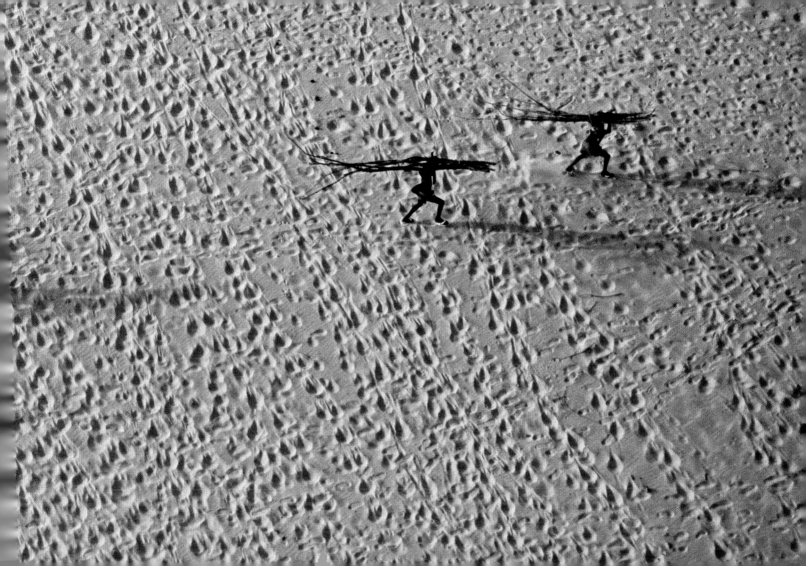

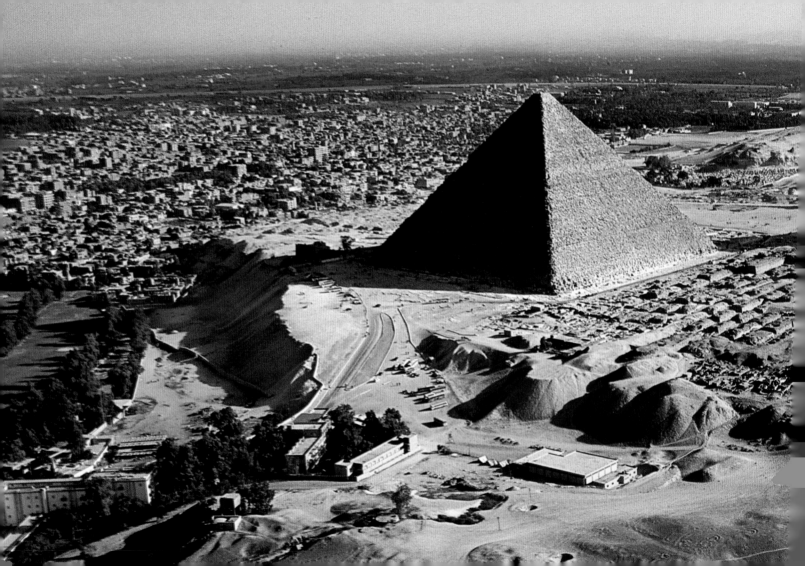

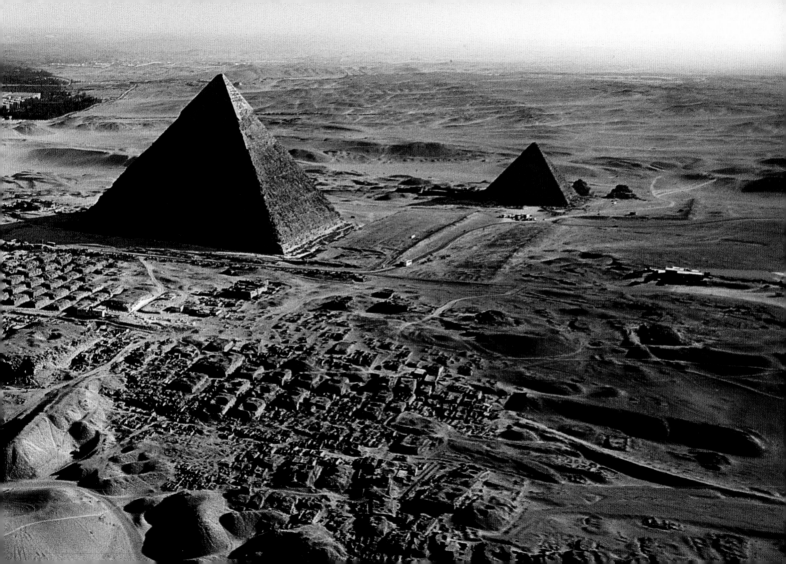

FLYING HIGH AFRICA

Introduction

"Stones, these are Africa's strength!" Courach hissed without turning around. His words reached me through the wind, a soft whisper through the hot, dense air that enveloped Kenya's northern plains like a shroud. Far off, on the edge of the horizon, Turkana Lake appeared like an unreal aquamarine line. The Cradle of Humanity is not a country of delights: endless stone quarries and 122° F in the shade, no trees in sight. It is pure horror to walk through. Still Courach, nomadic Rendille shepherd, baptized Joseph as a Christian, was capable of philosophizing and spitting out judgments. "You haven't seen anything yet!" he answered irritated. Blinded by my sweat and dying of thirst, I tried to imagine the great African rivers, coralline beaches on the In-

A caravan crosses the desert near Nouakchott, in Mauritania.

Introduction

dian Ocean, the infinite forests of the Congo or Camerun. No use: my mind only perceived Courach's damned stones, burning and razor sharp. Stones become pulverized into sand and blown into the undergrowth or hidden in the tufts of yellow grass, driven up to mountains or into lakebeds. Where the stones are invisible, they are hidden under a fine layer of soil: ask any African farmer and he will tell you. Now, after three decades of pilgrimage, from one corner to the other of this continent, I can confirm Courach-Joseph's statement: Africa is made of stone. That which is not stone is an exception, just as the oasis confirms the desert. Geologists support this theory: the main nucleus of the continent is constituted by a gigantic platform of ancient crystalline rock, a fragment of Gondwana that has remained practically intact. Bent, slashed, eroded by the wind and water, this foundation peeks through everywhere, giving the continent its unmistakable morphology. Africa is a succession of vast plains and plateaus from which

Introduction

occasional isolated volcanic masses emerge, like Kilimanjaro and Kenya. Except for the area near Cape Good Hope and along the Mediterranean coast, the countryside extends in obsessive monotony of desert, savanna, forest, to the Equator, then the opposite – forest, savanna, desert. Yet, Africa's charm is precisely in this infinite, cyclical repetition of landscape and environment. Africa is extreme, incommensurable in all of its manifestations. In Africa, the Sahara is king of deserts; the Nile flows, father of all rivers; the last great populations of wild animals on this planet reside. In a globalized and aseptic world, increasingly equal in all aspects, Africa remains a mystery, unexpected and carnal. At the risk of generalizing, over 6,000 different ethnic groups live on the continent; often, neighboring tribes have completely different languages, customs and world visions. Africa is the last stand of psychodiversity. In the Sahara, in Egypt, along the Nile and the Zambezi and on the shores of the seas and oceans that surround the

23
The Victoria waterfalls between Zambia and Zimbabwe.

24-25
The Okavango Delta, in Botswana.

continent, illustrious civilizations have bloomed. The pyramids of Giza and Meroe, the ruins of the Great Zimbabwe, the great medieval mosques in Mali's raw countryside and Kenya's and Tanzania's Swahili cities are the most noteworthy testimonials of a vast and profound culture. Africa is complicated, evasive and incomprehensible: it seems simple but is not at all. Our prejudice and ignorance often obstruct a true understanding of its essence and power. An ancient and immutable power is its stones. Courach was right, on that torrid afternoon many years ago, on the banks of Lake Turkana, our ancestors became, for the first time, man.

26-27
Antilopes, Okavango delta, in Botswana.

28-29
Pink flamingos, in South Africa.

30-31
Buffalos in Botswana.

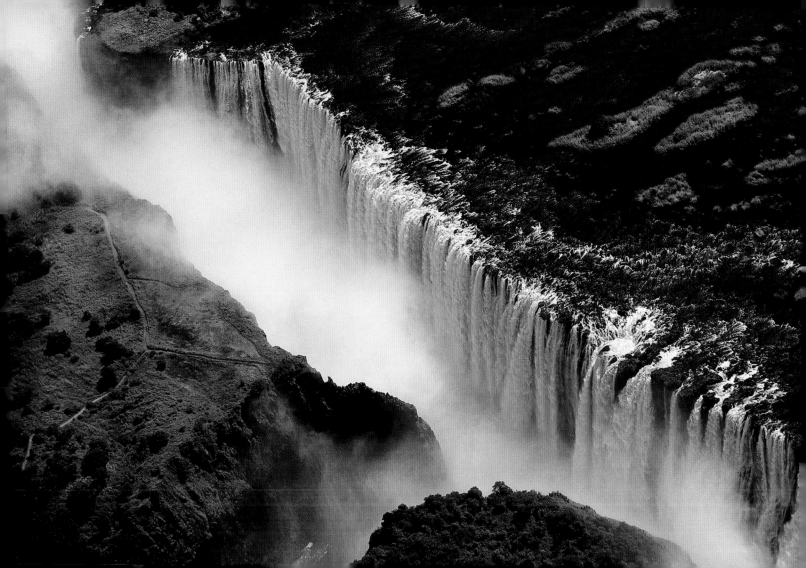

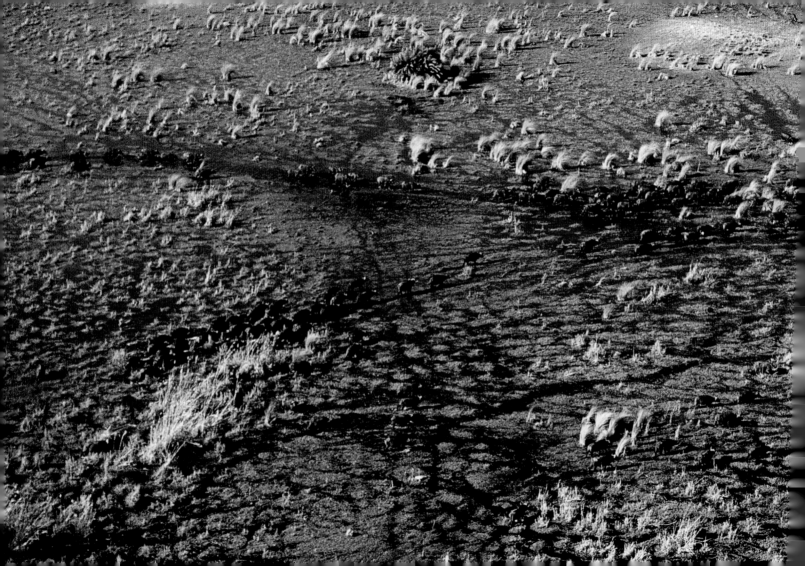

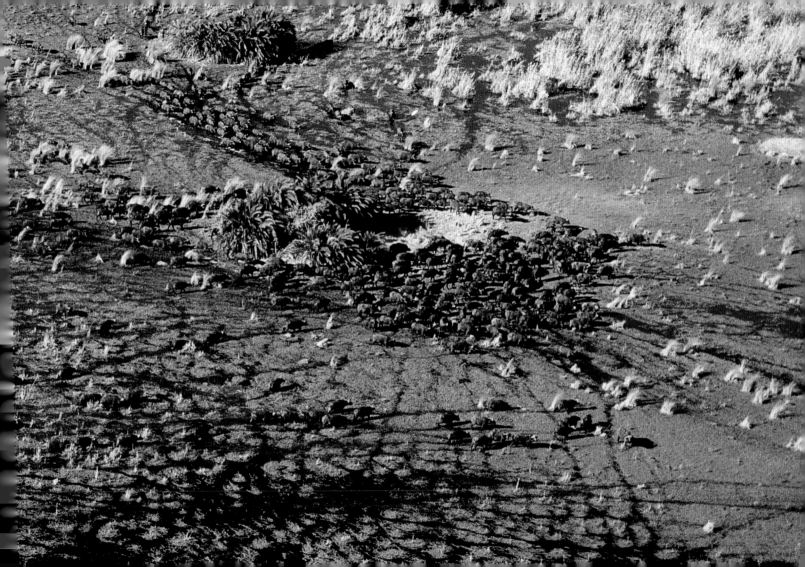

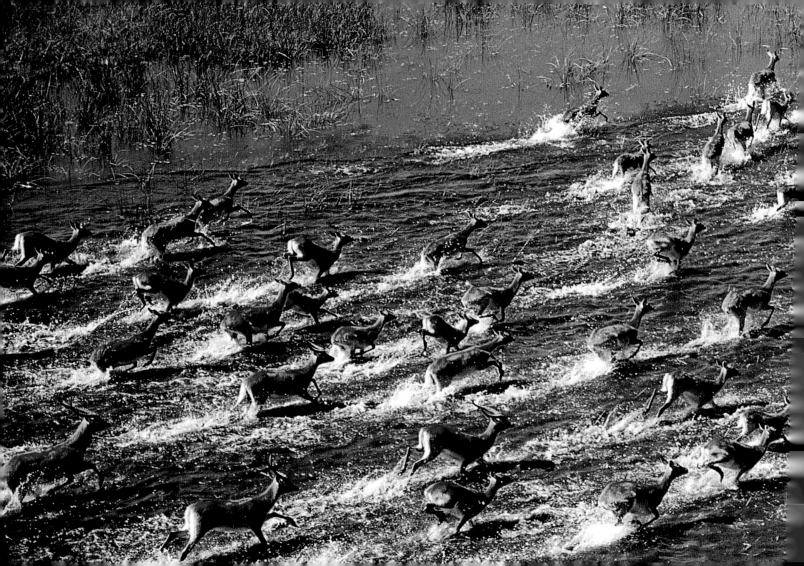

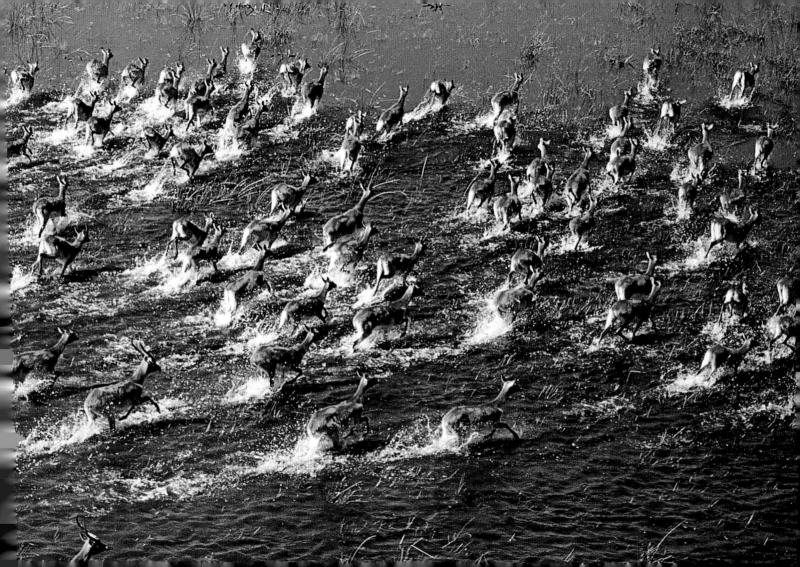

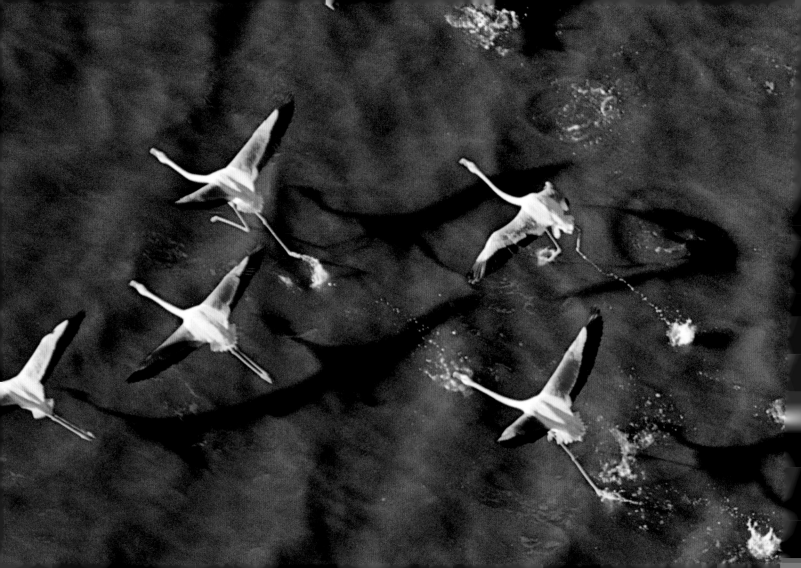

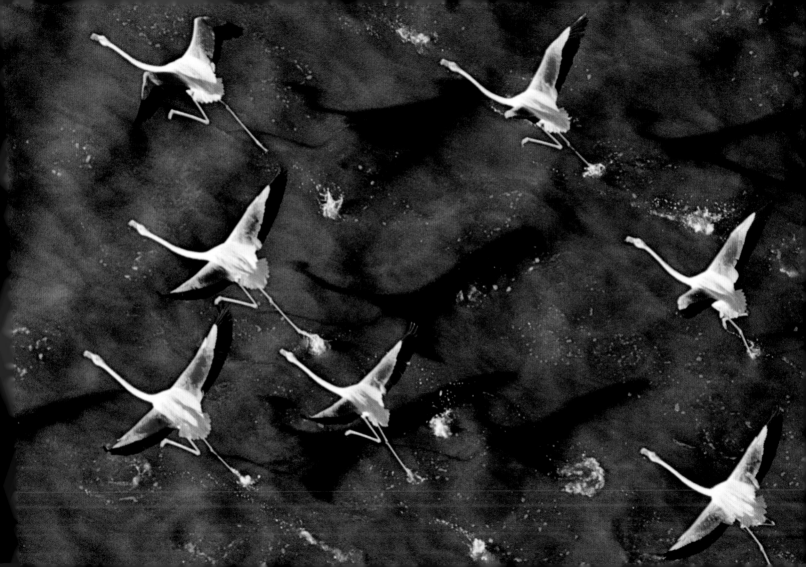

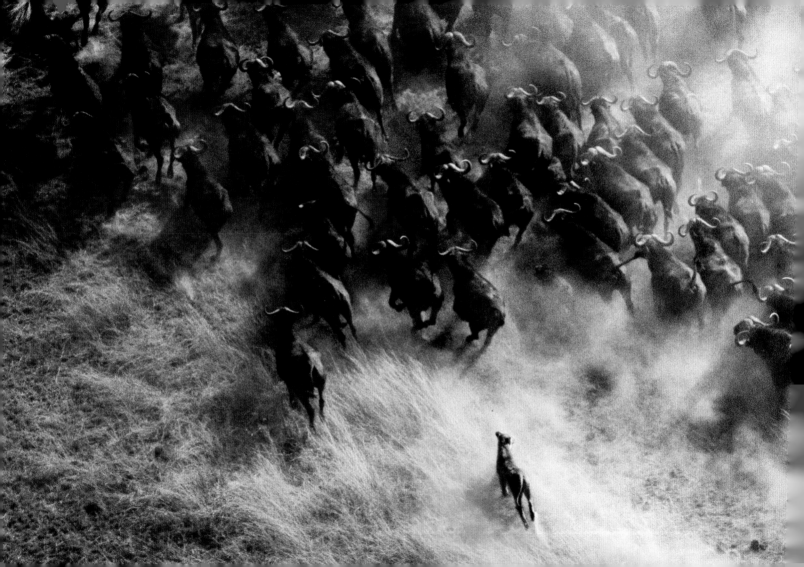

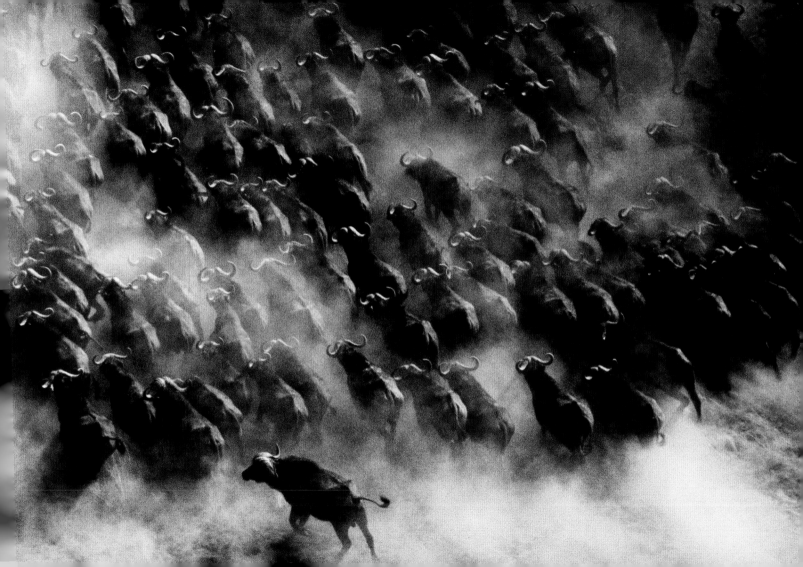

WORLDS OF ROCK AND SAND

FLYING HIGH

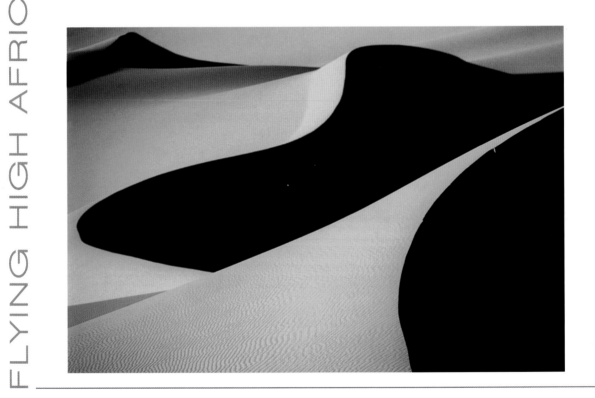

FLYING HIGH AFRICA

Elevated temperatures, dry, persistent winds and scarce precipitation are the characteristics of the dry tropical climate and indispensable conditions for the formation of a desert. The strict laws of the latitude find their perfect application in the African continent, situated on the equator with symmetric precision. The Sahara is the demonstration of a perfect desert, extending 3,100 miles long and over 1,000 miles wide, from the coast of the Atlantic to the Red Sea – three million square miles of nothing but a vast expanse of arid and naked earth.

For hundreds of miles there are no trees or a single blade of grass. As for the oases, put side by side, they would form an area barely as big as Piedmont. To appreciate the essence of the Sahara you must see it from a bird's eye view: from above the desert reveals its full splendor.

In its monotony, the Sahara is mutable: the great, vast plains of pebbles, called reg, are characteristic of this landscape and alternate with the *hammada*, infinite quarries blackened by the sun.

Contrary to popular belief, only 20 percent of the Sahara is covered in sand: a soft impalpable shroud is ruffled by the wind into small dunes that resemble the seabed or accumulated to form *ergs* and *ideyin*, the great dunes that characterize the Sahara of Algeria and Libya.

34
Sand that forms huge dunes west of Tadrart Acacus, in Libia,
is the result of an ancient process of erosion.

Worlds of Rock and Sand

The Sahara also expresses itself verticality: at its center, like islands in a stormy sea, impotent mountainous massifs rise, many exceeding 1,000 feet in height: the Ribesti, Hoggar, Tassali n'Ajjer, remains of ancient volcanoes that the wind has sculpted into stone labyrinths with ragged crests and indentations.

However, this infernal scenery also guards the desert's most benevolent feature. At the bottom of the volcanoes, along the banks of the uidian, dried riverbeds, the most precious gift of the Sahara is found: water.

Life. Around these rare springs and wells vegetation prospers, the humid soil reveals the tracks of jackals, gazelles and the fennec – a small, long eared desert fox. In the water live frogs, fish and reptiles, survivors of an endless war against aridity.

Among the mountains, man has searched for refuge, pushed by a colossal ecological catastrophe: thousands of rock paintings and graffiti represent hunting and pastoral scenes, vividly narrating the last acts of this fascinating historical period. Five thousand years ago, the Sahara, once lush and green, began its transformation into desert, where rain is an extremely rare event.

Much older and equally arid is southern Africa's Namibian desert: a strip of desolate land between the Olifants River and the Atlantic coast in Angola. Namibia's dimensions are modest, nearly 125 miles in length and 95 miles in width, but its desert is dramatic: in fact, part of the region is known as the Skeleton Coast.

Its climatic condition depends on the cold Benguela current that inexorably chills the winds from the Atlantic, provoking an elevated condensation of the humidity.

The result is very little rain (less than four inches per year) and a lot of fog, a dense belt of mist that constantly envelopes the desert,

Worlds of Rock and Sand

creating a spectral landscape. Aside from lending the area a dramatic, ghostly atmosphere and causing a chain of shipwrecks (see Skeleton Coast), the fog permits the organisms living here to prosper in an environment otherwise absolutely lacking in water. The survival strategies of plants and animals have evolved accordingly.

In order to drink, some beetles dig holes in the sand that collect and canalize the humidity; others lie upside down on the crest of the dunes simply waiting for the fog to condense on their bodies and drip into their mouth openings; snakes and lizards lick the water that forms on their scales.

To the west, the conditions are better. In the Kalahari, 193,000 square miles divided between Botswana, South Africa and Namibia, the differences are immediately visible. Where is the desert, represented as a lifeless, arid habitat? The Kalahari is actually covered in vegetation and tall, leafy trees despite its sandy terrain. The perception of emptiness in the Sahara and Namibian deserts is substituted by a claustrophobic sensation: the horizon is a barrier of grey undergrowth and visibility is not possible for more than a dozen yards. In the Kalahari, rain is also relatively abundant: between 10 and 20 inches per year. In the undergrowth, huge herds of herbivores thrive as well as Africa's predators, lions included.

So, why is the Kalahari considered a desert? The answer lies in its relationship between rainfall and evaporation, always unfavorable. In each season, the quantity of water that evaporates is superior to that which is absorbed by the soil.

This signifies that there are no permanent wells, so water is as rare a commodity as in a real desert. Even in deceptive appearances, Africa never lets us down.

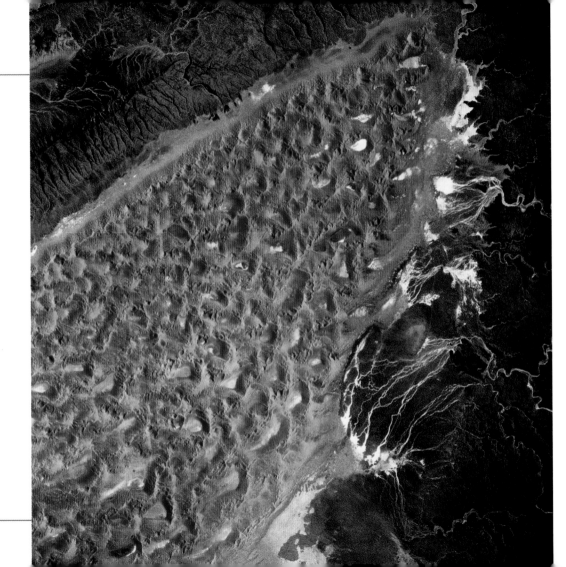

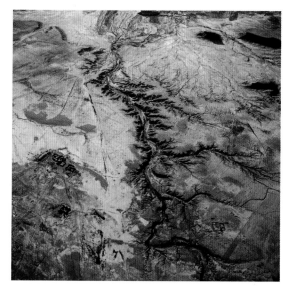

38

The dunes of Erg Tifemine stop only at the foot of the Tassili n'Ajjer Mountains, in southern Algeria.

39

A chaos of mountains eroded by the wind, alternates with dusty valleys and marks the passage between the temperate region of Marocco and the Sahara.

FLYING HIGH AFRICA

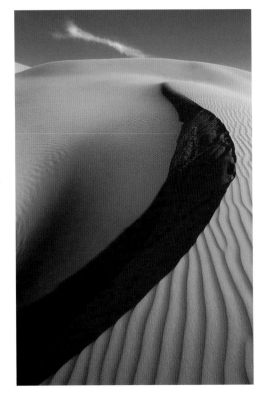

40
A great part of Libyan Sahara is occupied by immense accumulations of sand, extending for hundreds of square miles.

41
The sand gives way to rock in the Sahara zone of Acacus, in Lybia.

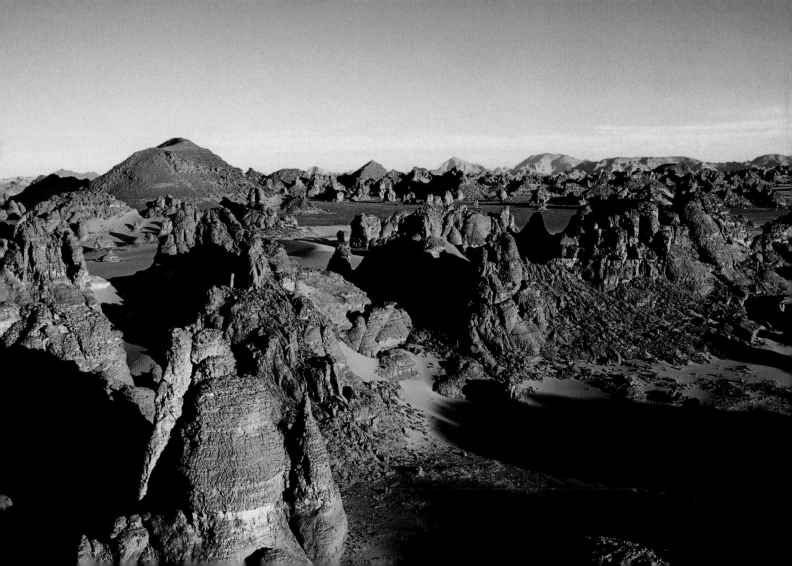

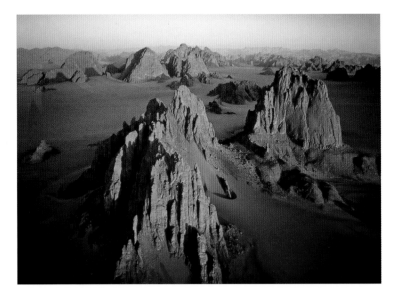

42 and 43
The sunset tinges red and orange the sandstone peaks of the Tibesti
massif, in Ciad. Everywhere, sand piles up, blown by the winds from
Libia.

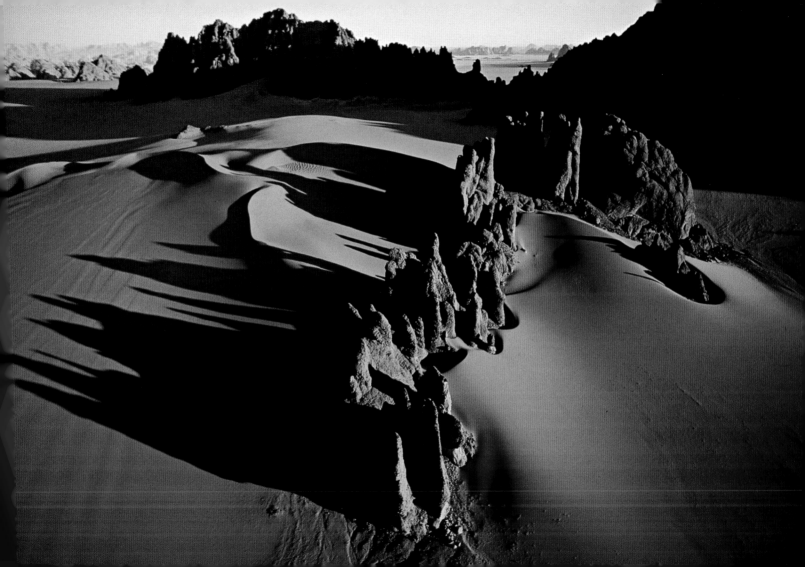

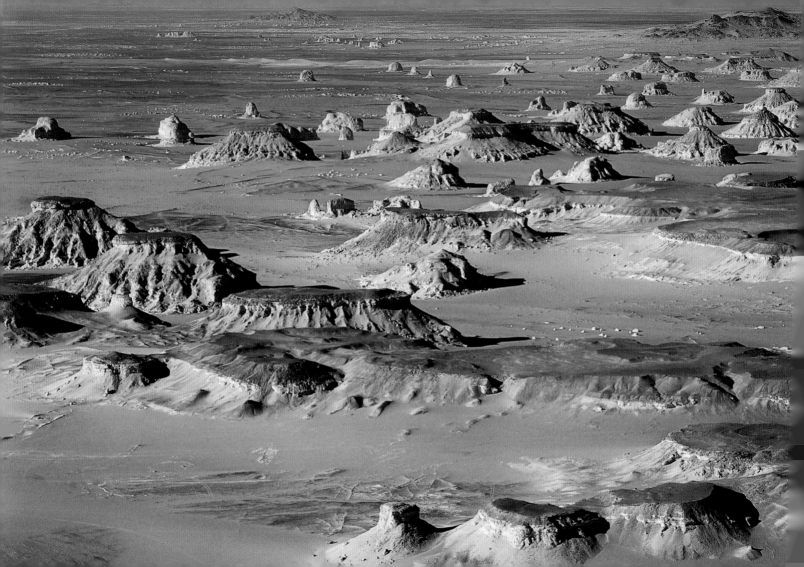

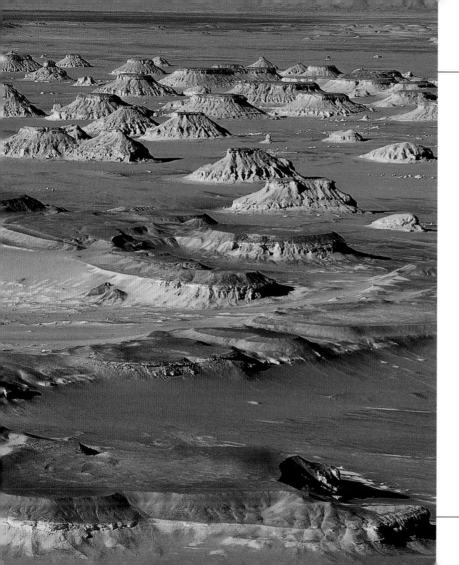

44-45
Rock formations with bizarre shapes interrupt the monotony of the horizon near the Farafra oasis, in the Egyptian Sahara.

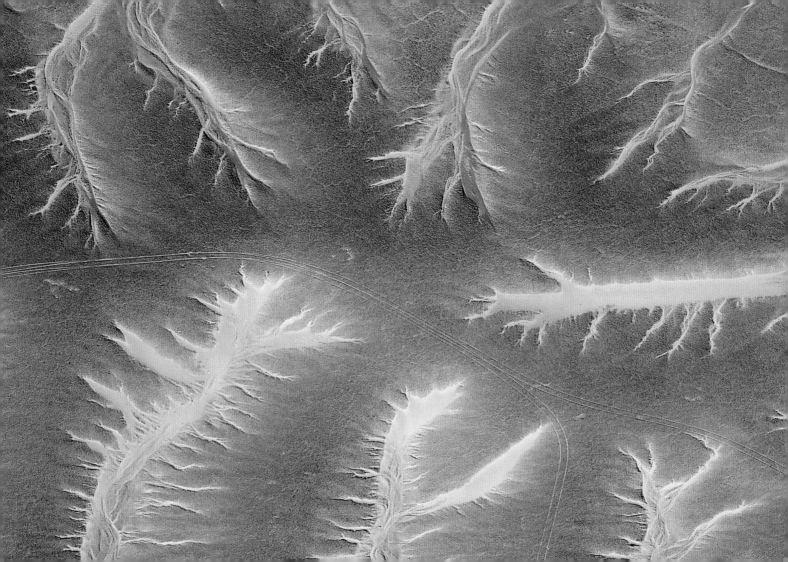

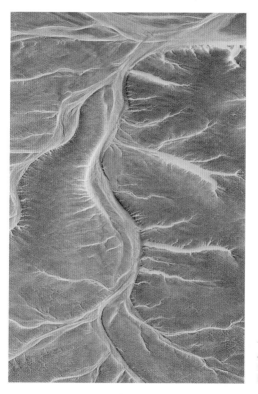

Worlds of Rock and Sand

46 and 47
The absolute lack of high ground and a disorganized fluvial system characterizes the Sahara's aspect near the Baharya oasis in Egypt.

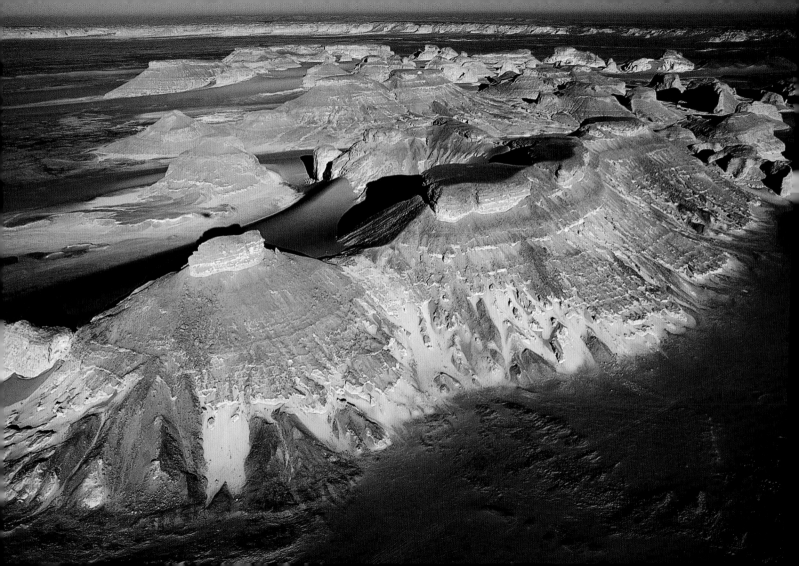

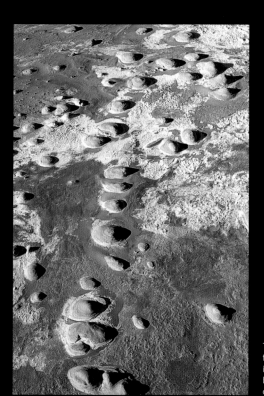

48 and 49
The White Desert extends over a surface of aproximately 2,300 square miles in the Egyptian portion of the Sahara, between the Farafra and Baharya oases.

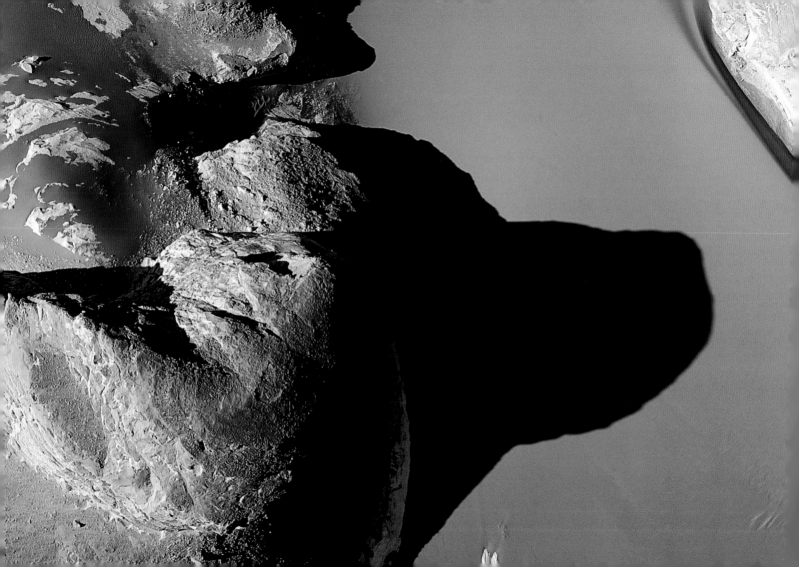

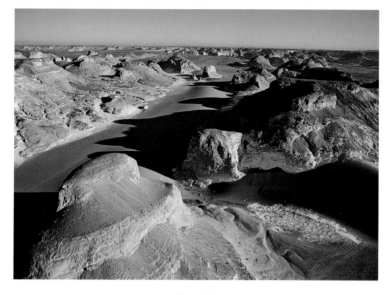

50 and 51
The rays from the setting sun paint shadows on the golden sand that surrounds the plaster-like formations of the White Desert, in western Egypt.

Worlds
of Rock
nd Sand

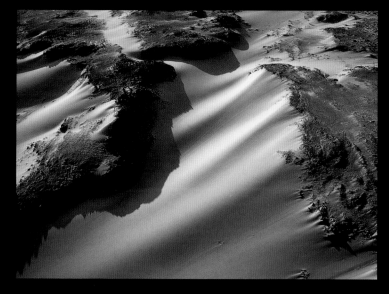

52
The ocean of dunes west of the Baharya oasis is one of the less
known parts of the Egyptian Sahara.

53
Hills of sandstone, the remains of an ancient plateau, dominate the
Nubian Desert near Abu Simbel, in Egypt.

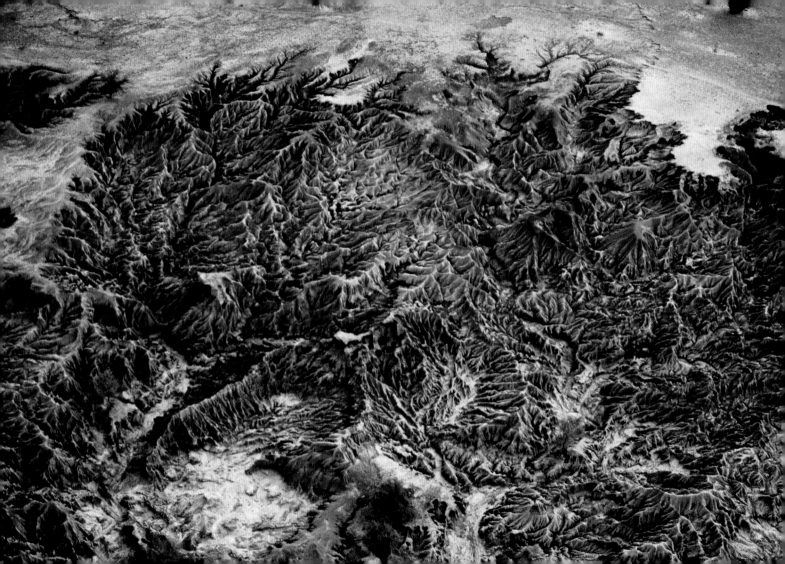

54
A deeply eroded landscape characterizes the sahelian region of Kayes, in Mlai, one of the most torrid areas in western Africa.

55
The ruins of Tichitt, found in one of the most arid and desolate areas of Mauritania, are a mystery of African archeology.

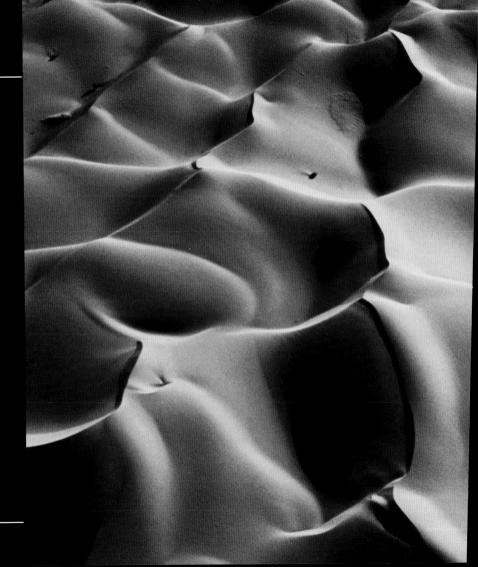

56-57
The lack of trails and reference points renders a crossing of Mauritania's dune fields a difficult and dangerous task.

58-59
The dried riverbeds that furrow the Air massif, in Niger, were once one of the most extensive irrigation systems of the Sahara.

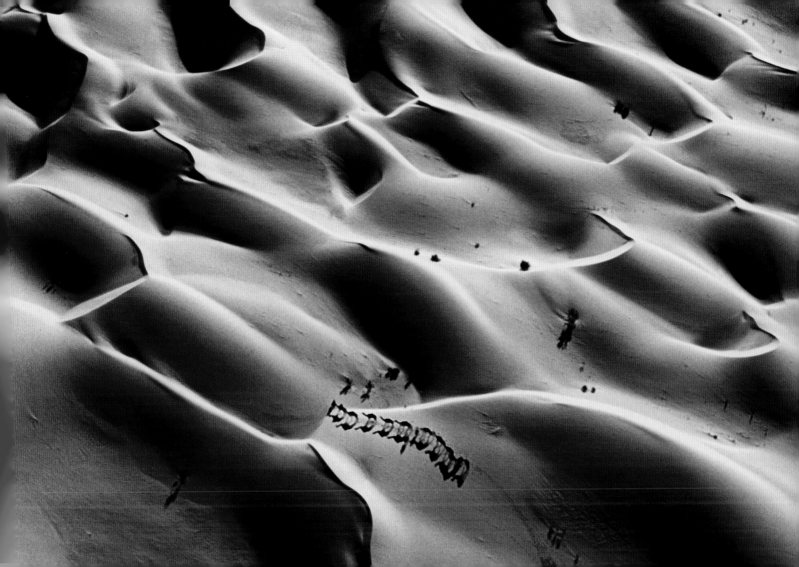

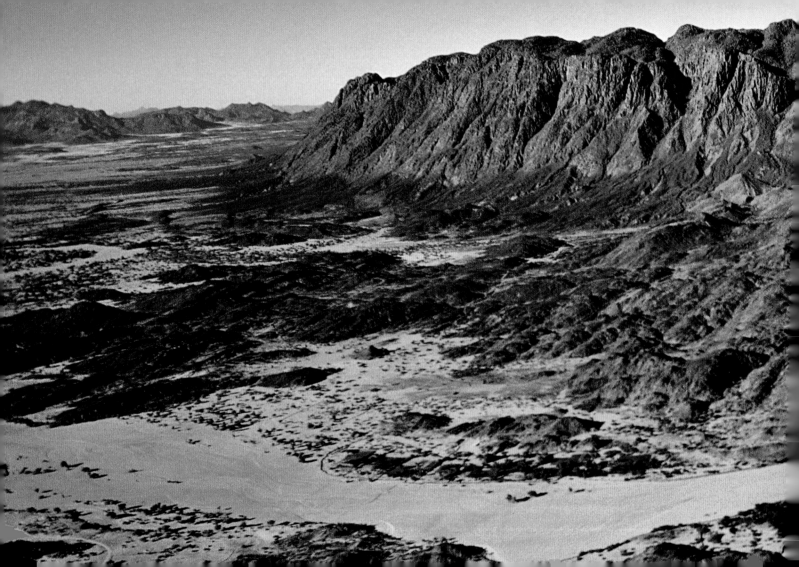

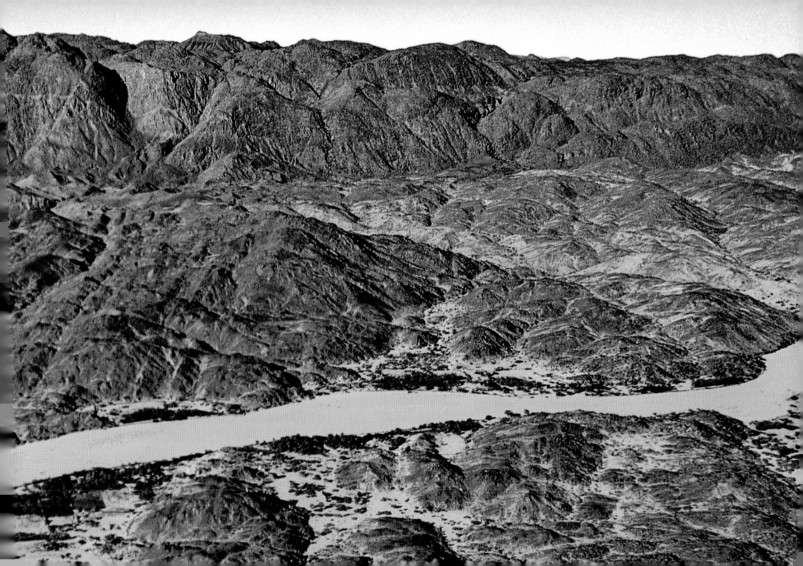

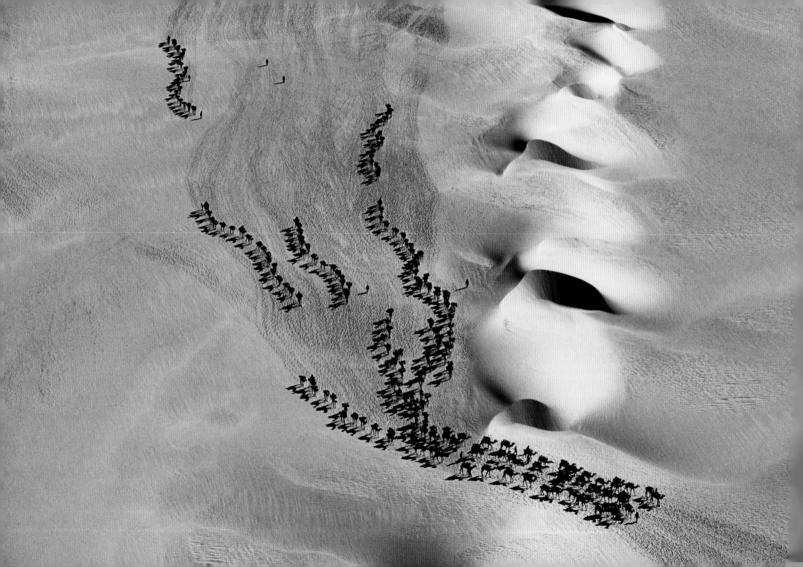

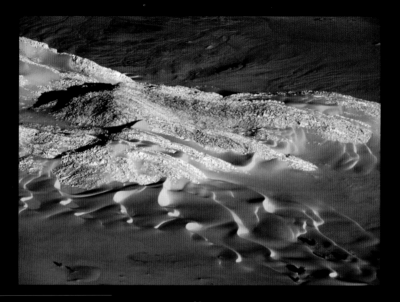

60
Thousands of dromedaries laden with salt cross the Teneré Desert each year, heading towards the markets af Air and Agdez in Niger.

61
The Temet dunes, on the northwestern edge of the Air massif, in Niger, can reach as high as 1,000 feet and are among the biggest in the Sahara.

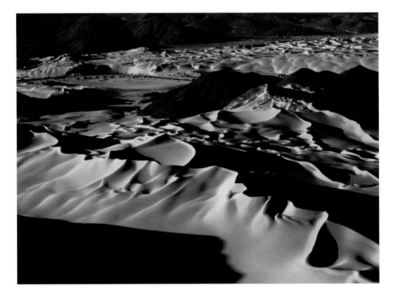

62

The dune formations are only the most obvious feature of the Teneré Desert, in Niger, mainly consisting of immense valleys of sand and pebbles.

63

West of the Air Mountains, in Niger, the Adrar Chirlet massif stands solitary over the endless sandy expanse of Teneré.

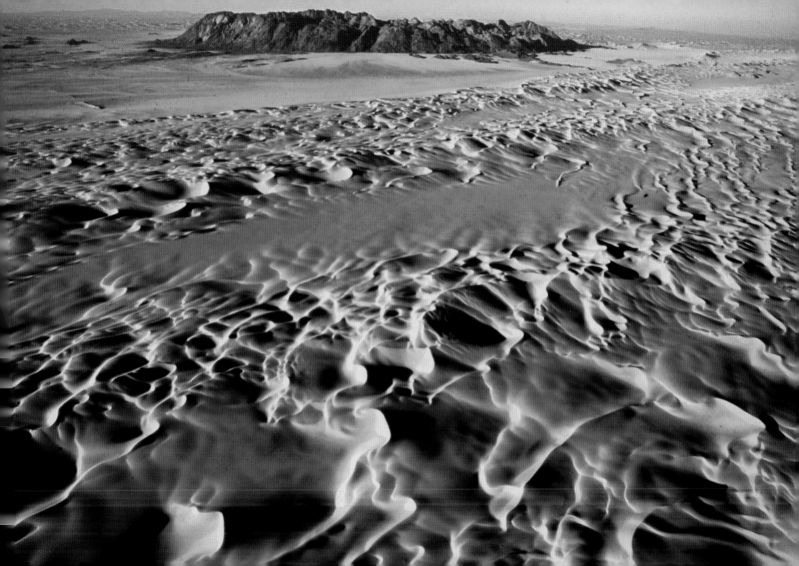

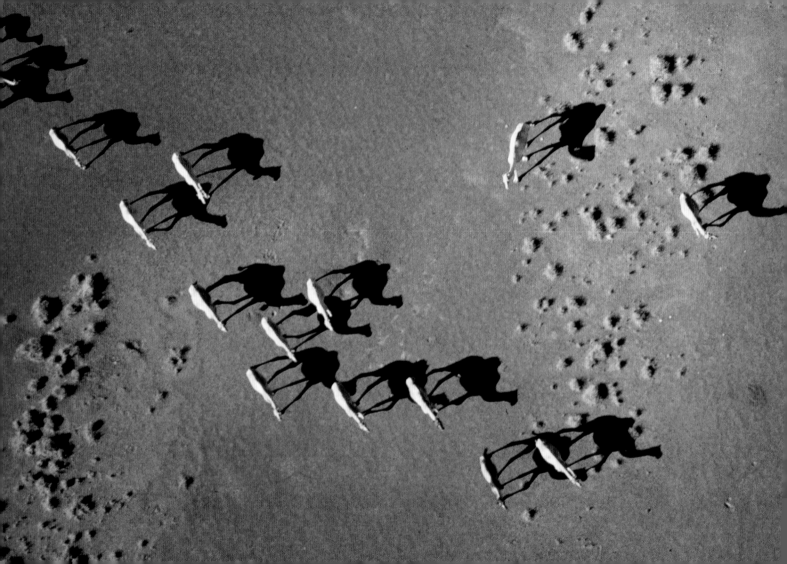

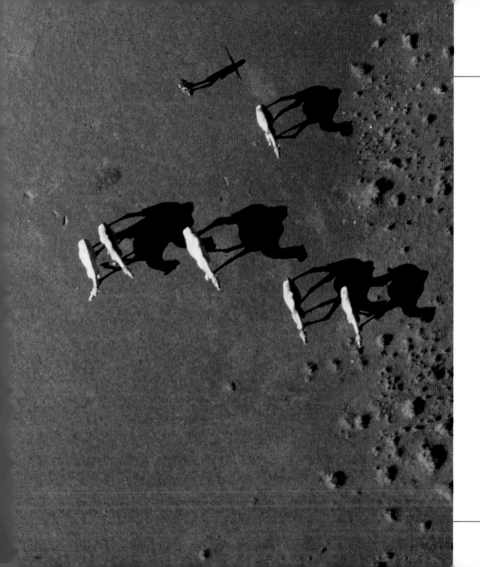

64-65
The dromedaries are the only domestic animal capable of surviving in the desolate Koroli Desert, west of Lake Turkana, in Kenya.

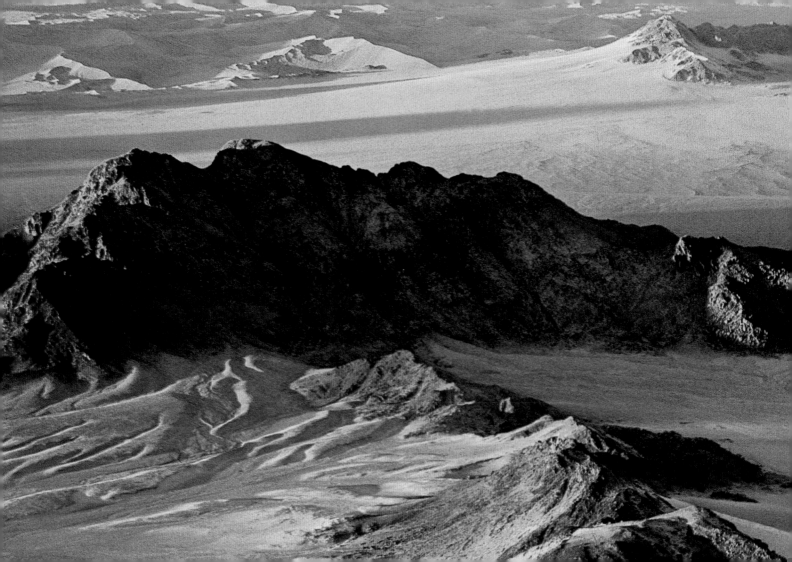

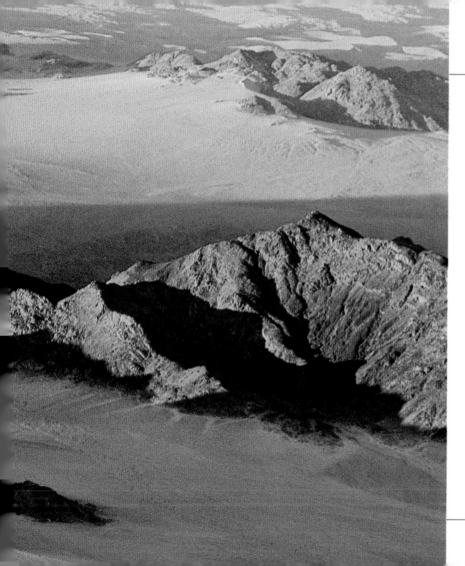

66-67
On the mountains in the Namib-Naukluft National Park, in Namib-ia, the difference in temperature between day and night can be very drastic.

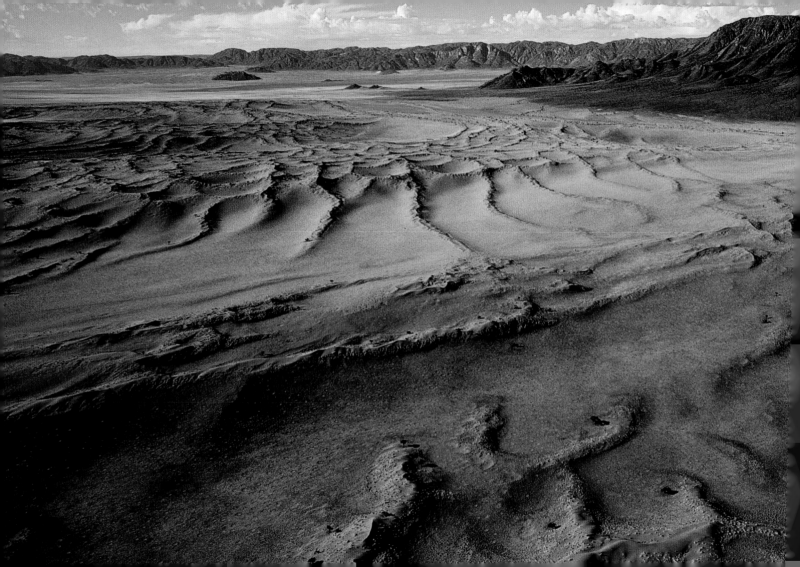

FLYING HIGH AFRICA

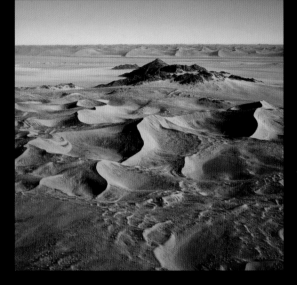

68 and 69
All the natural settings of the Namib Desert are represented on a grand scale in the 8,880 square miles of the Namib-Naukluft National Park, in Namibia.

70
The dunes and the sand accumulations dominate the landscape in the southwestern section of the Namib-Naukluft National Park, in Namibia.

71
The scarse vegetation present in the Namib-Naukluft National Park, in Namibia, is concentrated in the riverbeds of the seasonal rivers.

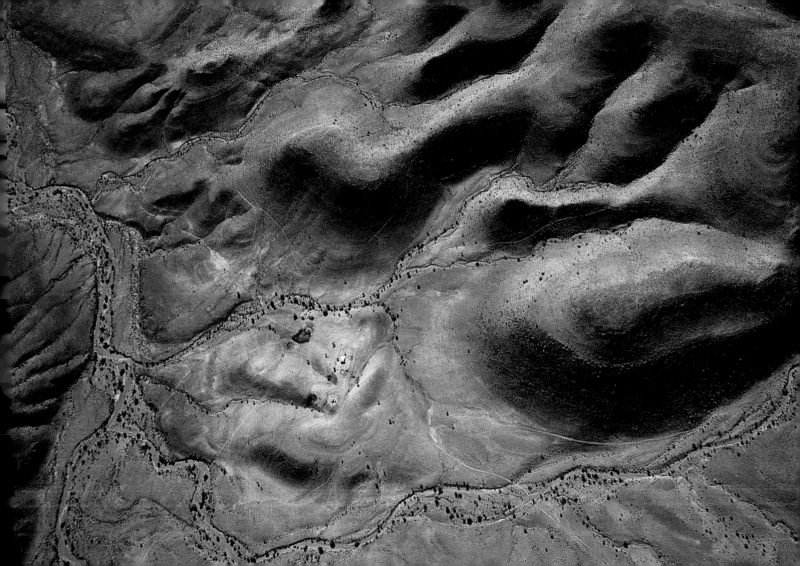

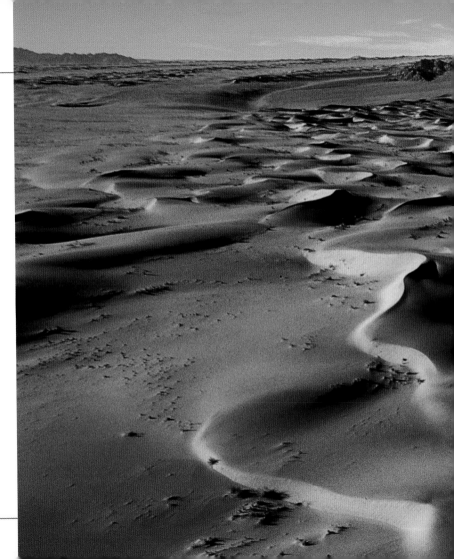

72-73
Dominant winds and the presence of natural obstacles determine the form and placement of the dunes in the Namib-Naukluft National Park.

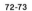

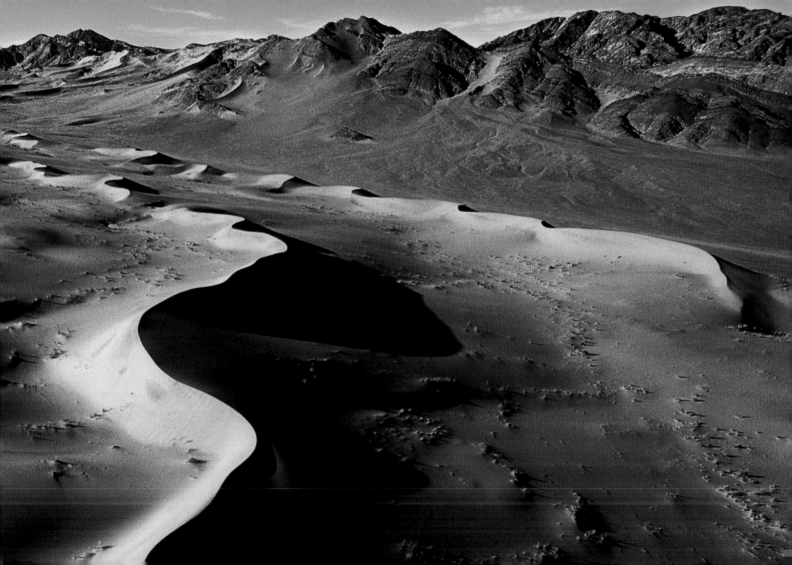

FLYING HIGH AFRICA

75
Ostriches, capable of running 45 miles per hour, are frequent inhabitants of the Sossusvlei dunes, in Namibia.

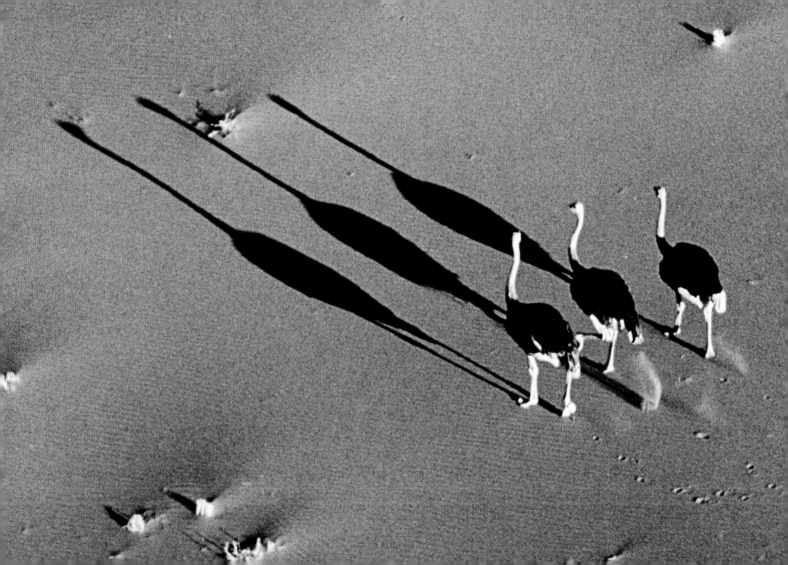

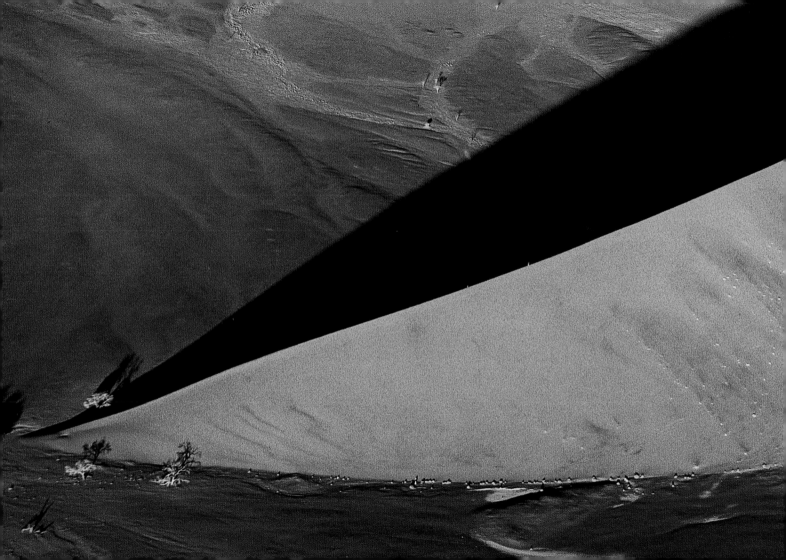

76-77
The Sossuvlei dunes, in Namibia, owe their parabolic appearance to the variable winds in this zone and are the most stable dunes in Namibia.

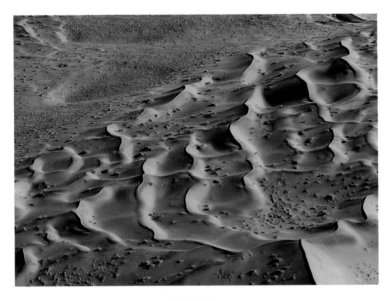

78 and 79
The vegetation that grows on the dunes is refuge and a source of food for many insects and animals that inhabit the Namib-Naukluft National Park, in Namibia.

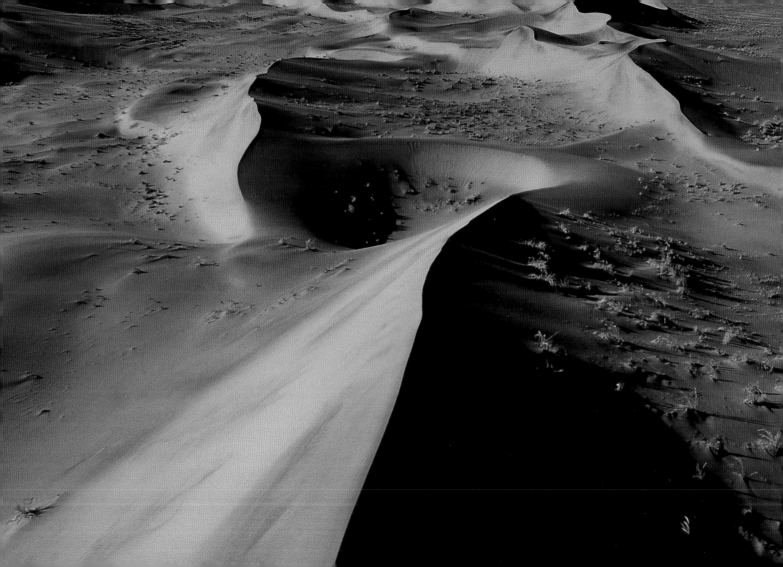

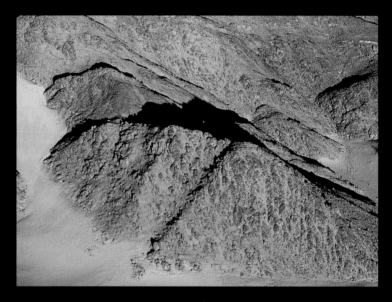

80 and 81
Sunset on the dunes of Sossusvlei, in Namibia, produces unforget-
tably beautiful contrasts of light and color.

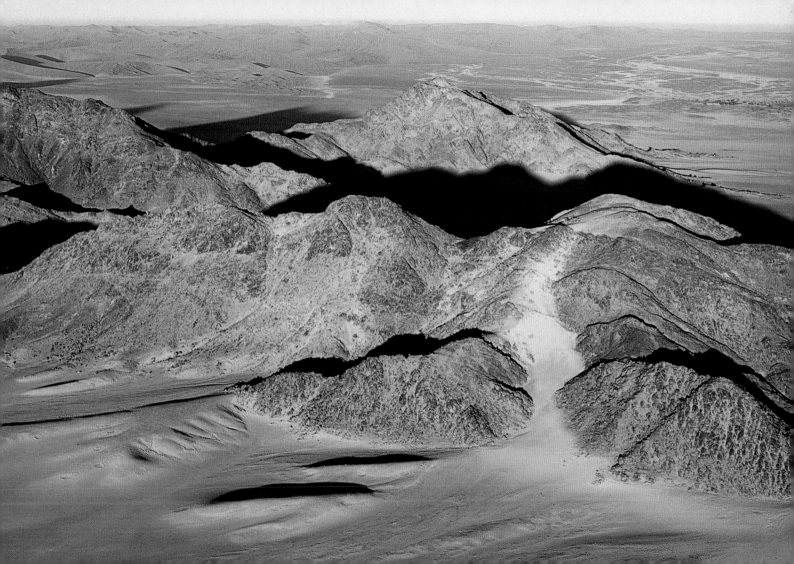

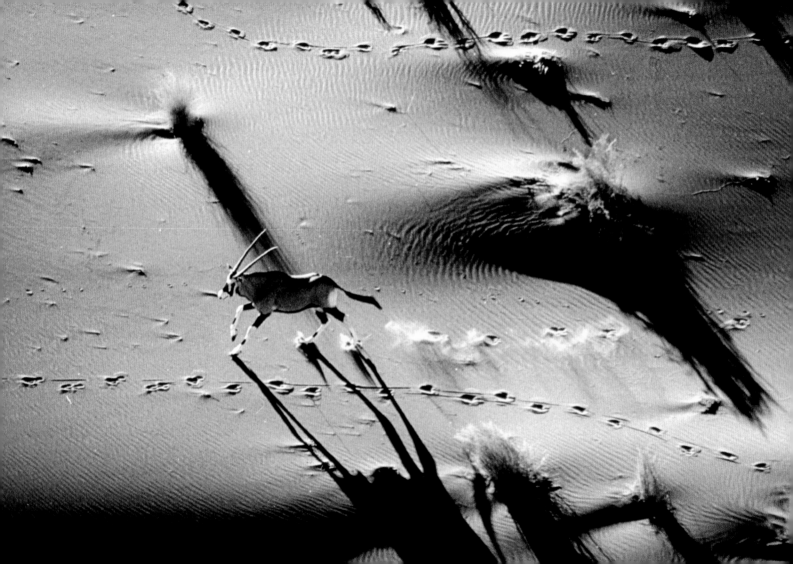

82

Particular adaptations in the environment allow the oryx to survive in the most arid zones of the Namib Desert in Namibia.

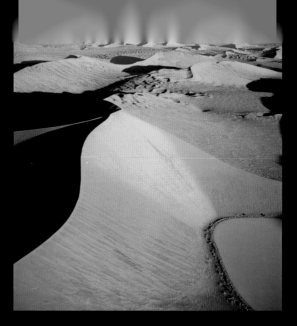

84 and 85
The red dunes of the Namib Desert, in Namibia, surround the ephemeral Sossusvlei pond, occasionally fed by the waters of the Tsauchab River.

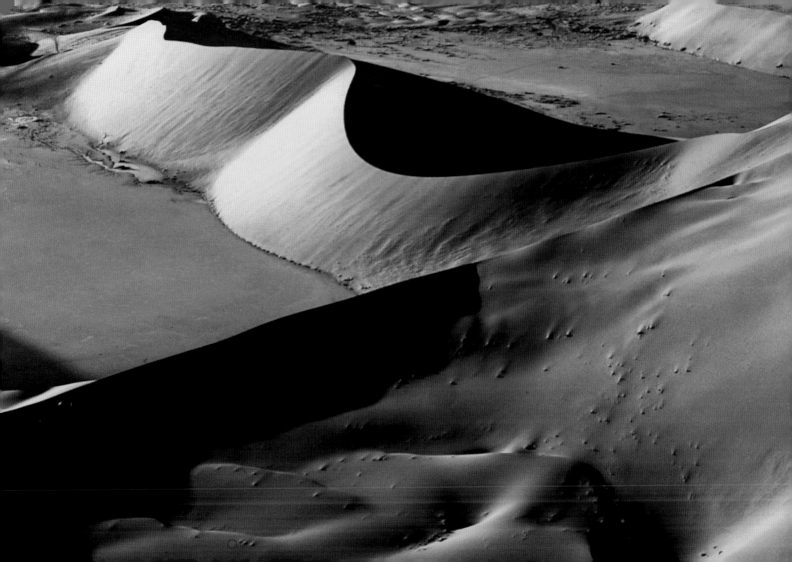

THE ORIGINS OF LIFE

FLYING HIGH

FLYING HIGH AFRICA

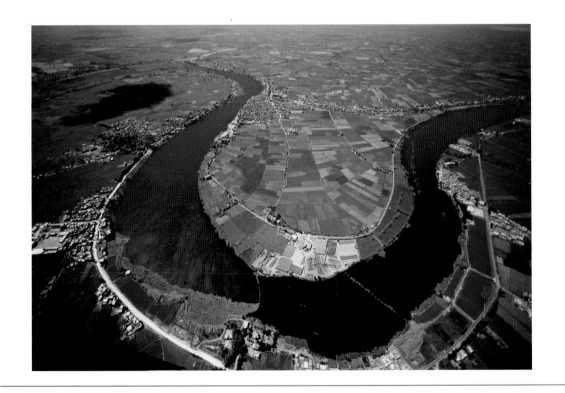

87
The Okavango River, in Botswana (left), and the Athi River,
in Kenya (right).

Traditionally, in Africa, the dead are venerated and respected. Their traces are everywhere; they seemingly could revive at anytime. The same holds true for dried up rivers and lakes that still dispense life.

For example, in some of Sahara's rivers, like the powerful Bahrel Ghazal that once flowed from Ciad Lake to the north, all it would take is an unexpected movement in the tectonics or a favorable climatic sequence to reestablish the flow of its waters towards the Ennedi, transforming the desert into garden.

Presently, Ciad Lake risks extinction, reduced to an enormous puddle. The Logoné, its only tributary, continually alters its course towards the Benoué, tributary of the Niger. In southern Africa, Ngami Lake has been dry for years, Etosha is a blinding saline valley and the Okavango halts its flow at the border of Maun, with no hope of ever reaching the Makgadikgadi Basin.

The rivers, past and present, contain within them the soul and mystery of Africa. Orange, Senegal, Limpopo, Rufiji, Ogoué, Tana and Omo are names that evoke endless plains, jungles and deserts. Creators of life or destroyers, placid for stretches and then interrupted by unexpected waterfalls and rapids,

Africa's waterways have never been easy routes of access to the inlands. They have often been obstacles; the valley of the Blue Nile, closed within the mountains of Ethiopia had only been fully penetrated in 1968, at which time the explo-

88
The Nile, near its delta, is surrounded by densely
cultivated fields.

The Origins of Life

ration of the Nile's basin, initiated over twenty centuries ago, terminated. The Nile, over 4,000 miles long, is the most extensive river in the world. Its banks have witnessed the extraordinary flowering of Egyptian civilization: the monumental pyramids arose here and still celebrate the glory of the ancient pharaohs.

It is not surprising that the source of this great river has been the most famous geographical legend of all times. The real Nile has its source in the Victoria and Albert lakes, united by a rich net of tributaries. In the past, Turkana Lake was part of that complex hydrographical system but is now isolated in one of the most inhospitable areas of the Rift Valley.

After a series of furious rapids and the Kabarega Falls, the Nile makes its entrance into the immense Sudan valley, turning into vast marshland around the Papiri Islands of Sudd. In this valley, the river loses half of its waters; only with the help of the Sobat and Blue Nile tributaries can the river successfully continue its journey across the Sahara without being extinguished by the sand. The Aswan dam represents a drastic change in environment and landscape: up to its delta, the Nile flows peacefully in a wide valley, between banks rich in vegetation and cultivated fields. The temples of Edfu, Kom, Ombo, Karnak, Tebe, the Valley of the Kings and all of Egypt's wonders accompany the Nile on its journey to the sea. The Nile has a brother in Western Africa: the Niger.

The landscape is different but the obstacles that the two rivers face are similar: both pass through zones of desert and risk being extinguished mid-flow. As well, both rivers were the backdrops to great civilizations.

After Ségou, the Niger proceeds to a huge bend in the Sahara, designing a great internal delta. In that region of borders between nomadic and sedentary peoples, the medieval dynasties of Mali and Songhai developed and the gold and

The Origins of Life

slave capitals arose: Timbuctu', Gao and Djenné. The course of the Niger, even in periods of terrible aridity has never been interrupted: just as in the past, millions of people depended, for their survival, upon its water that springs from the rainy mountains of Guinea and empties into the Gulf of Biafra after a journey of some 2,500 miles. The thick mangrove jungle that envelopes the source of the Niger introduces another world, an antithesis of the desert: Congo's rainforest, the "river that swallows all rivers." Enigmatic, primordial, solemn, the Congo is about 3,000 miles long, but it carries 40,000 cubic meters of water per second and is alimented by hundreds of tributaries and water from Tanganyka Lake – ten times the volume of water of the Nile. The Congo, unique among African rivers, does not experience hard times. Its flow is constant and unimpeded. Usually it flows serenely, in a wide bed constellated by mist-covered isles, between compact walls of vegetation. Then, suddenly, it drops roaring through the rocks, twisting itself into whirlwinds of foam. The Livingstone Rapids, that break the course of the river shortly before its entrance into the Atlantic, are breathtakingly violent but still incomparable to the power expressed by the Zambezi in the Victoria Waterfalls. Compared to these, even the famous Niagara Falls, are a tiny whirlwind in a glass of water. To describe them is superfluous, except through numbers: facade length, 5,577 feet; height, 328 feet; width from the bed, 197 feet; the cloud of vapor exhaled by the Falls is visible as far as 25 miles away. The Victoria Falls reassume the character of Zimbabwe: turbulent and only partly tamed by the huge Kariba and Cabora Bassa dams. The Zambezi is 1,721 miles long and its basin, that includes the immense lake Malati, encompasses some of Africa's most remote and uncontaminated zones. The Zambezi is a stage for the great savage wildlife, where the eternal flow of water is the only measure of time.

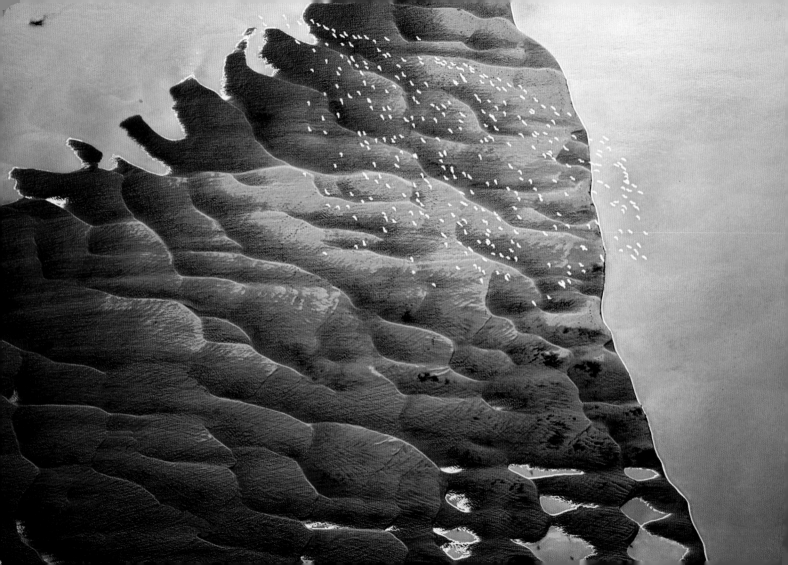

92
In Senegal, a flock of acquatic birds flies over the calm waters of the Senegal River, one of the most important waterways in western Africa.

94

Between Mopti and Timbuctu', in Mali, the Niger River disperses into thousands of canals and muddy islands, drastically reducing its water volume.

95

From the Tosaye Gorge, the Niger crosses a vast plain, heading towards Gao, the last city in Mali-crossed by it.

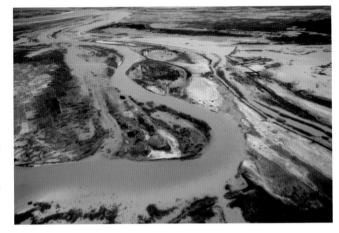

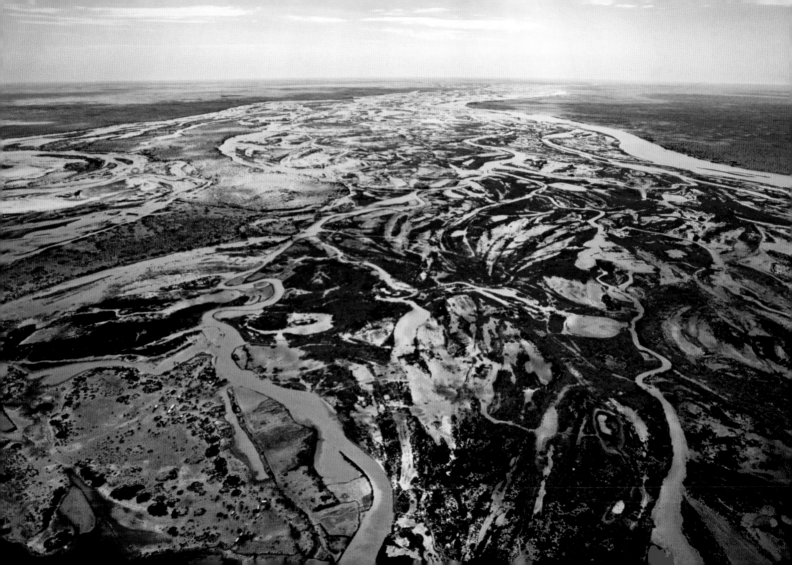

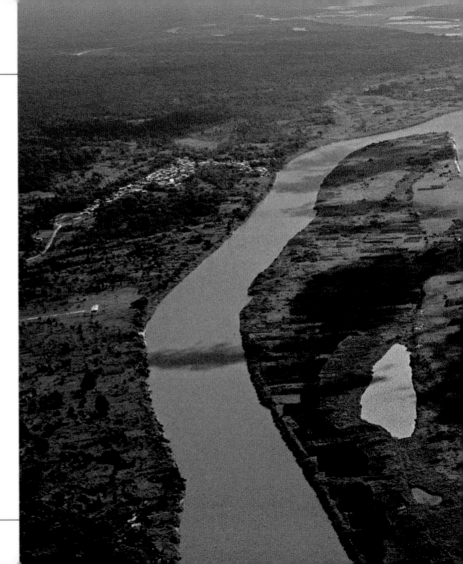

96-97

Near the Niger River's outlet to the Atlantic, it breaks into a network of streams and canals, among dense forests and sand dunes.

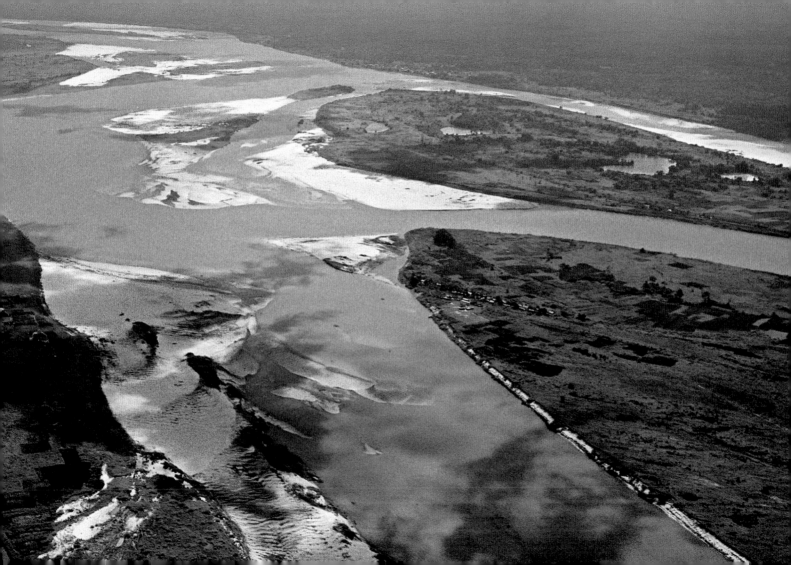

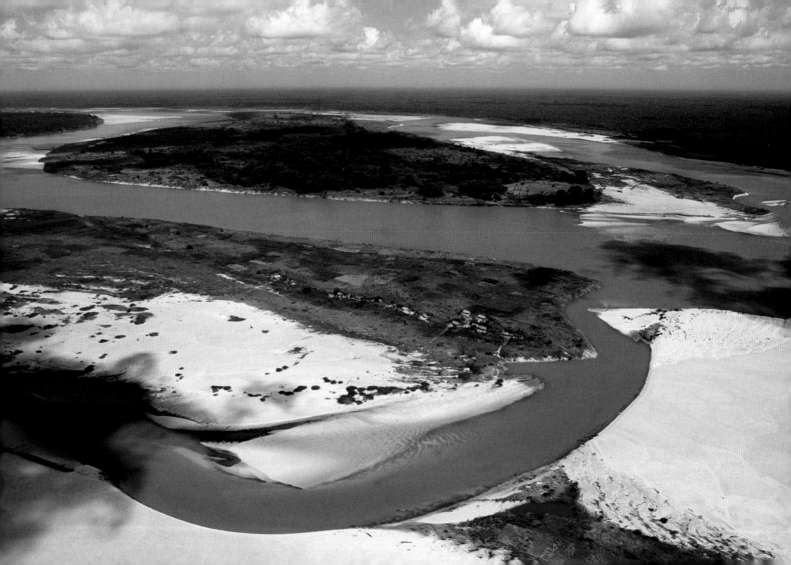

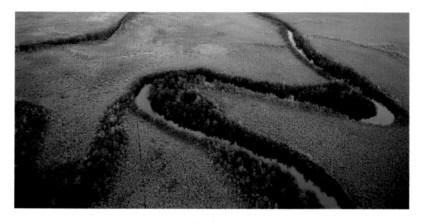

98 and 99
In a primordial setting, the Niger Delta fans out for hundreds of miles towards the Atlantic coast of Nigeria.

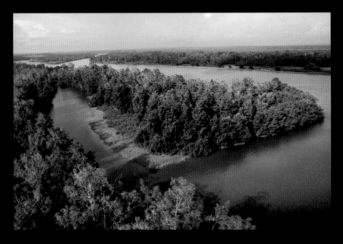

100
The Kouilou River, in the south-western Congo, winds through ponds, swamps and immense forests.

101
Numerous rivers, like the Kouilou, cross the Maycombe Mountains, in the Congo.

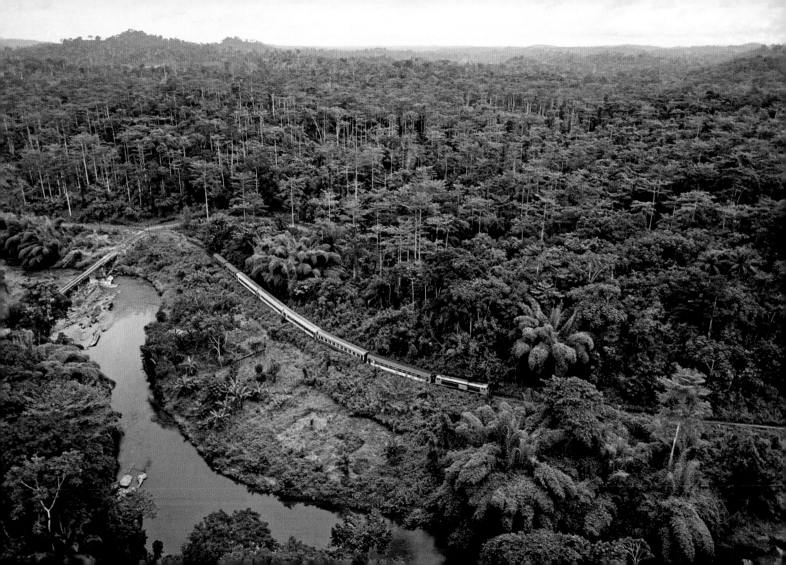

102-103
A small craft navigates the waters of the Nile, in Egypt, near the delta where colorful, cultivated fields accompany the river on its journey to the Mediterranean Sea.

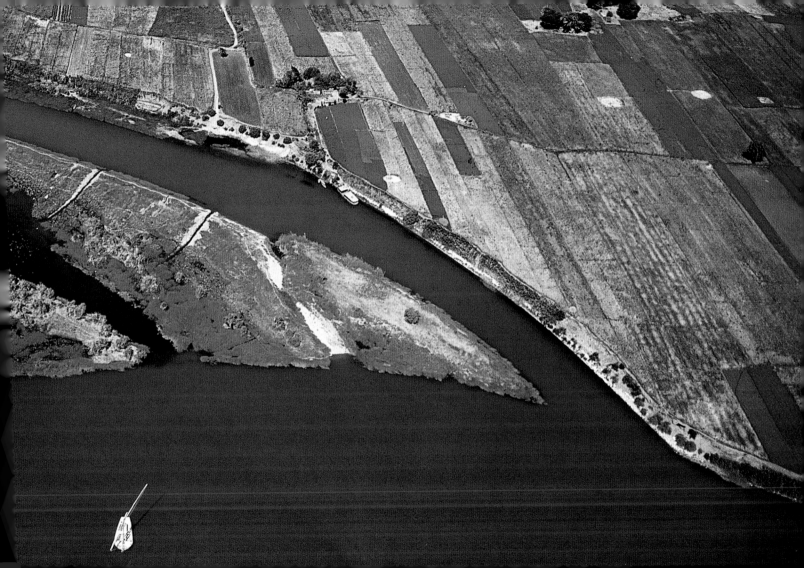

104 and 105
Aswan's countryside, the "pearl of ancient Egypt," embraces an archipelago of tiny islands with dense vegetation, including the Elephantine Island (right).

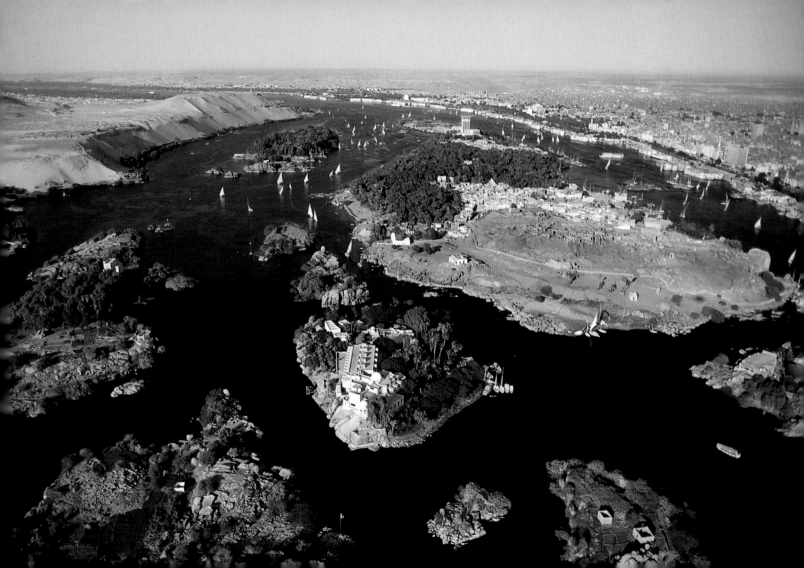

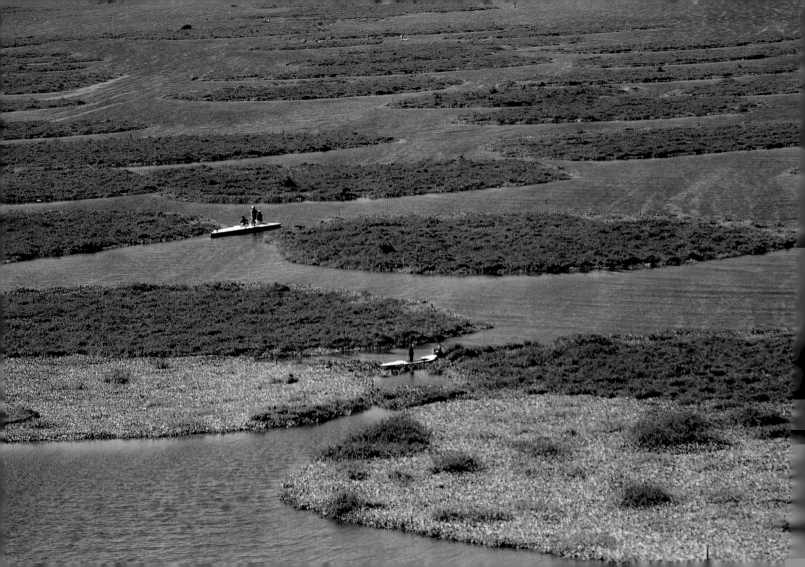

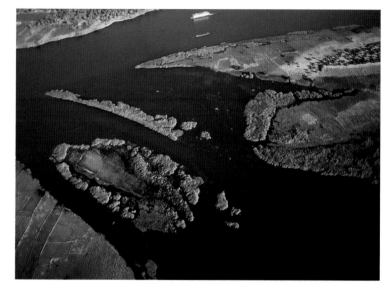

106 and 107
Manzala, a salt water lagoon, is the biggest lake that the Nile forms inside of its delta.

FLYING HIGH AFRICA

109
The gorges formed by the Blue Nile in its journey through the mountains of Ethiopia, sometimes reach a depth of almost 500 feet.

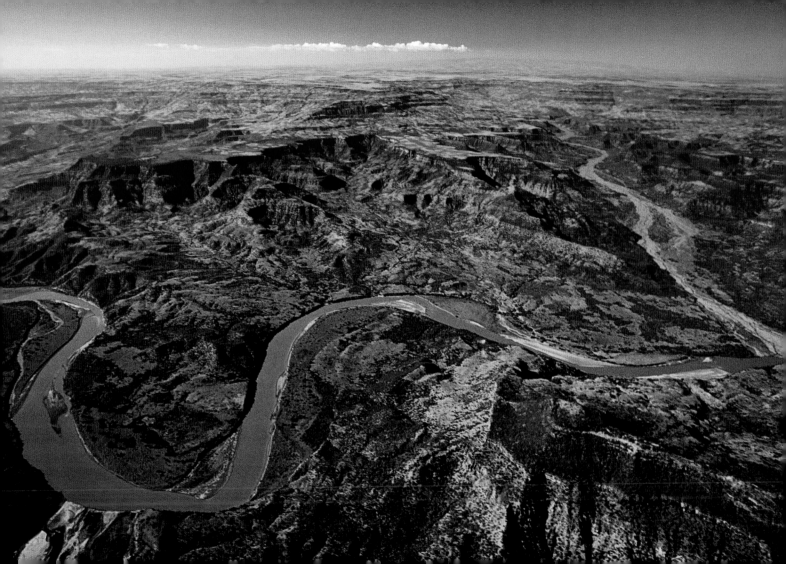

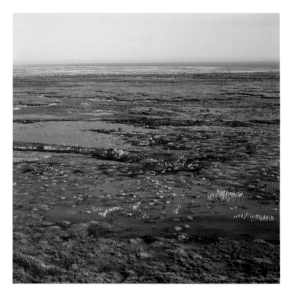

110
The swamps formed by the Omo River near the outlet of Lake Turkana, in southern Ethiopia, are a fundamental stop for migratory birds.

111
The Omo River, single important tributary of Lake Turkana, travels through some of the most remote areas of Ethiopia.

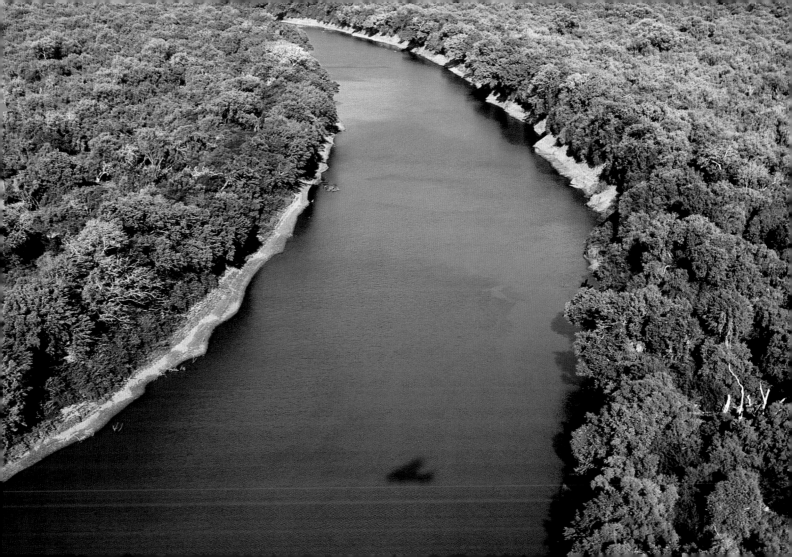

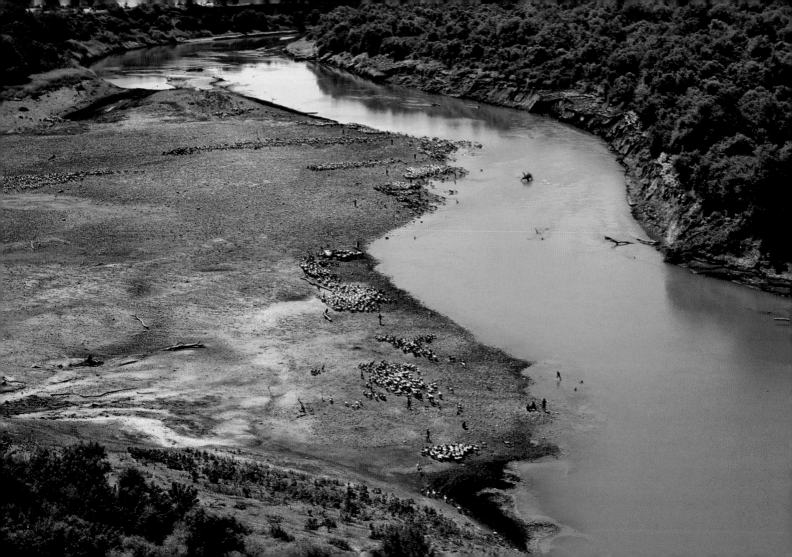

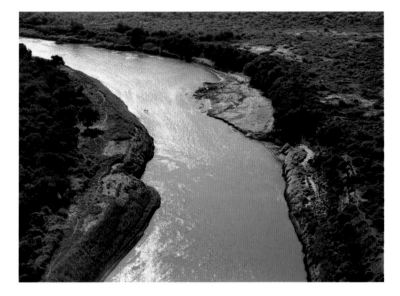

112
The presence of crocodiles doesn't stop the shepherds of southern Ethiopia from taking their herds to drink along the banks of the Omo River.

113
The territory that surrounds the banks of the Omo River, in southern Ethiopia, appears from above as an endless expanse of forest and undergrowth.

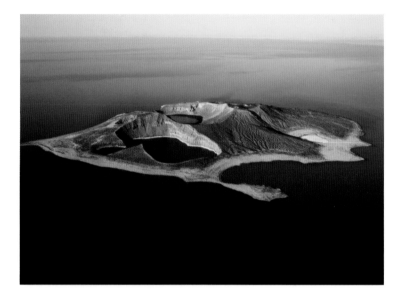

114

Central Island emerges, with its lunar landscape, from the waters of Lake Turkana. The volcanic origins of the island is evidenced by the three craters that dominate its surface.

115

Over 30,000 crocodiles populate the fish-filled waters of Lake Turkana, situated in the northern section of Kenya's Rift Valley.

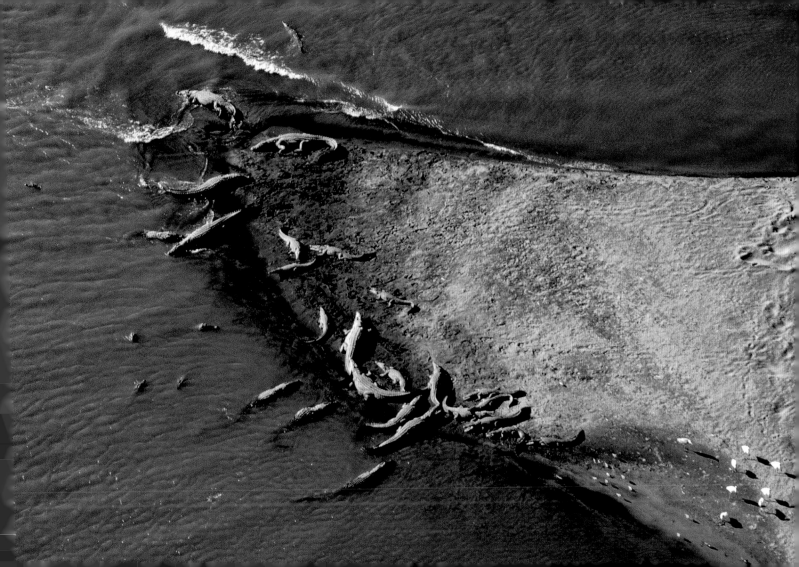

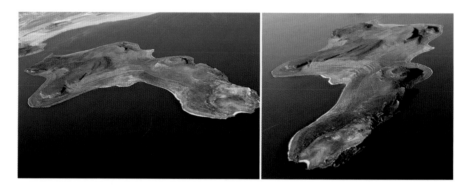

116
Unhospitable, lacking in fresh water springs and infested with crocodiles, the islands that stud Lake Turkana, in Kenya, are absolutely uninhabited.

117
The perfect cone shape of the Nabuyatom Volcano, surrounded by ash and lava, projects into the jade-colored water of Kenya's Lake Turkana.

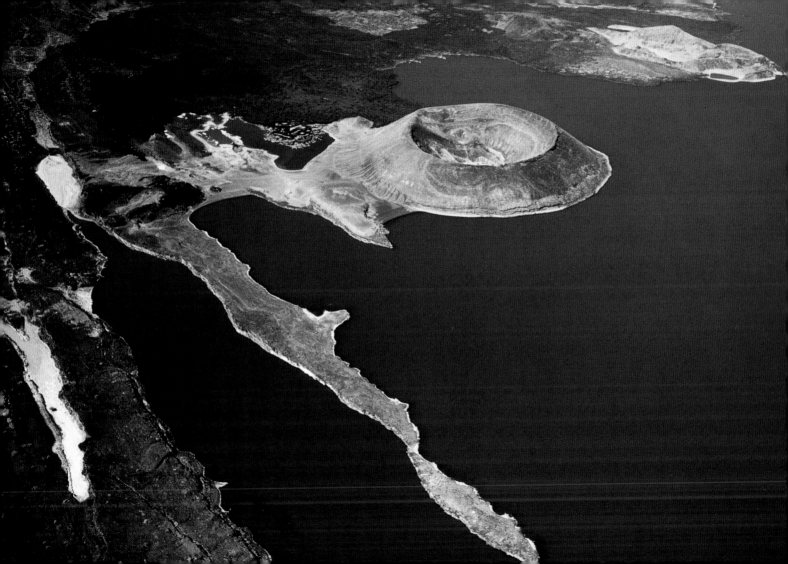

118-119
Hot springs, geysers and daz-
zling salt formations make up the
drammatic landscape that sur-
rounds Lake Bogoria in Kenya.

120-121
A great multitude of flamingos
gives a pink reflection to the wa-
ter surface of a Lake in Kenya.

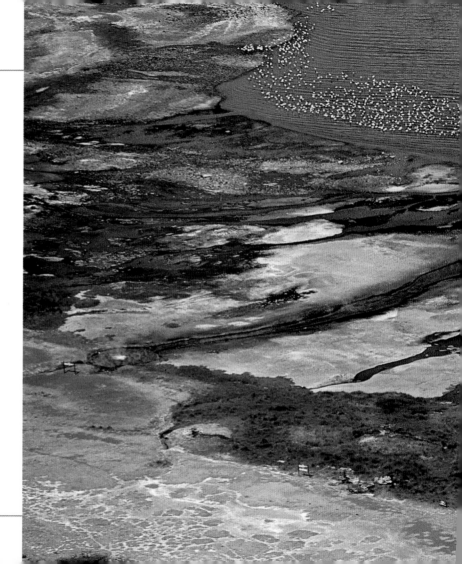

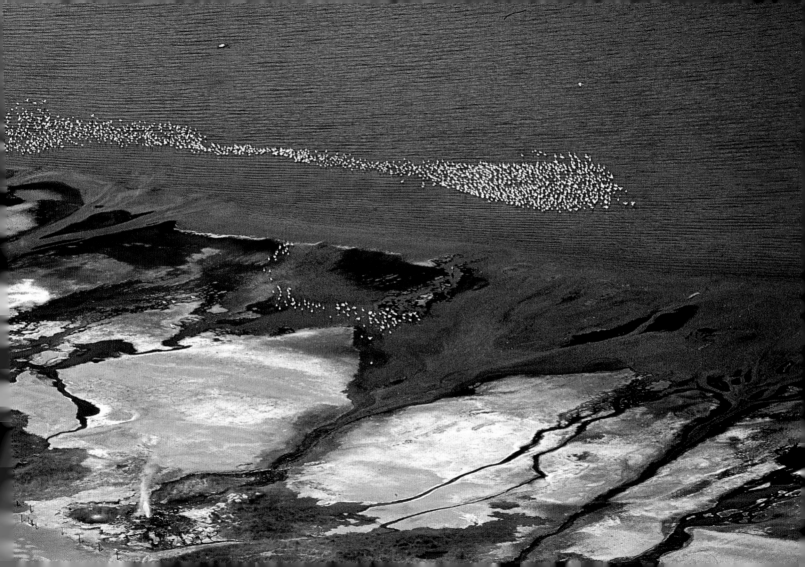

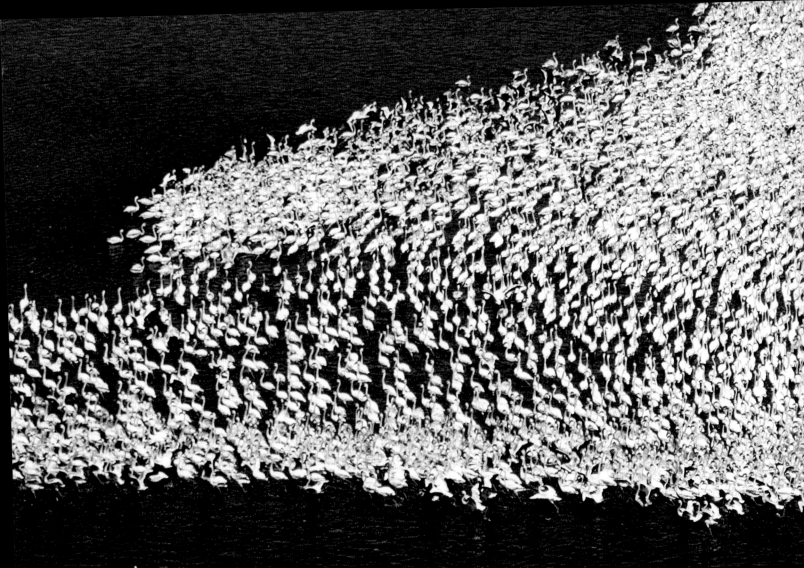

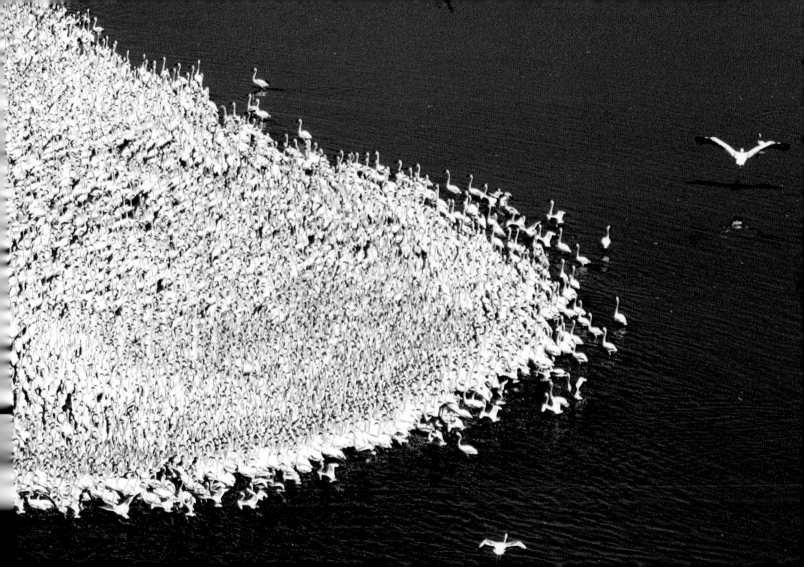

122 and 123
The abundance of water and fertile soil make the area including the Aberdares Mountains one of the most productive lands in Kenya.

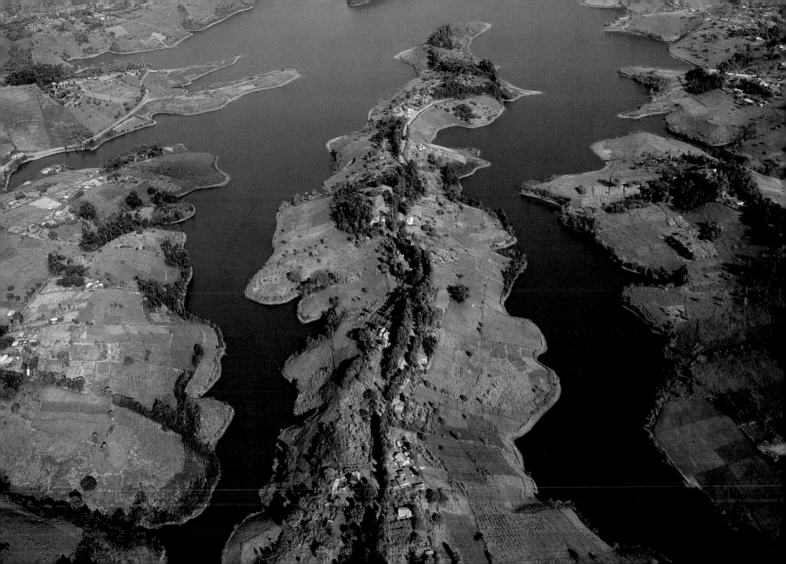

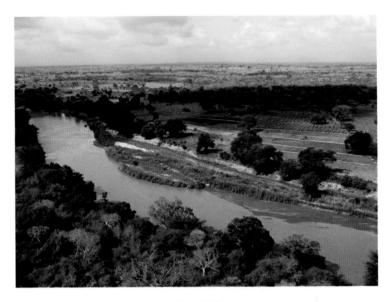

124 and 125
The murky water of the Athi River, swollen by the rains, borders the high
lands of Kenya from Nairobi to the heart of the Tsavo National Park.

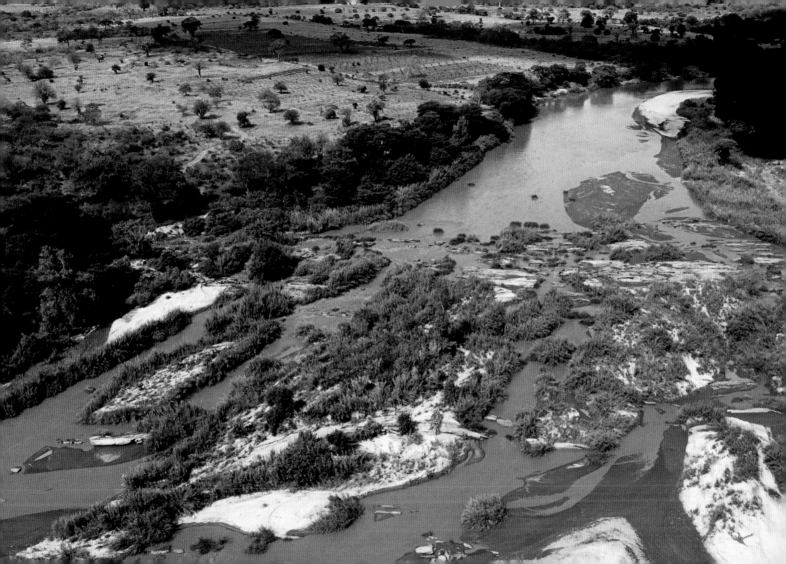

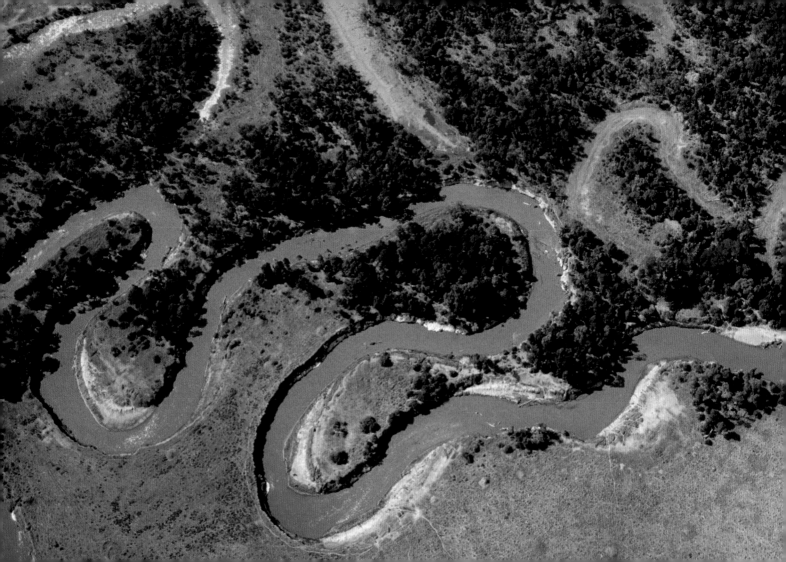

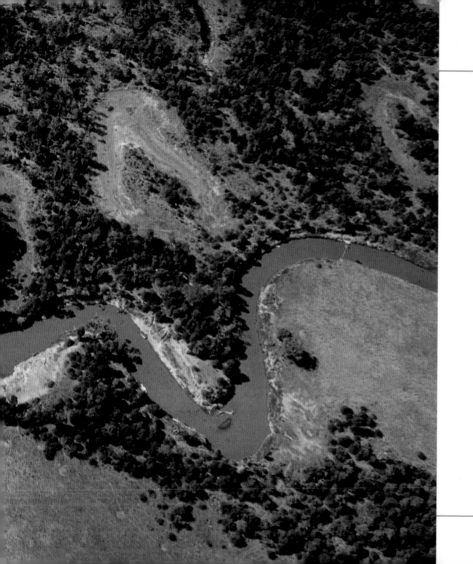

126-127
Winding through the green hills of Kenya and Tanzania, the Mara River flows slowly to its outlet into Lake Victoria.

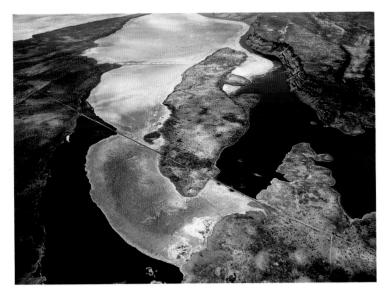

128 and 129
Most of the volcanic lakes resting on the bottom of Kenya's Rift Valley,
have very alkaline rich water.

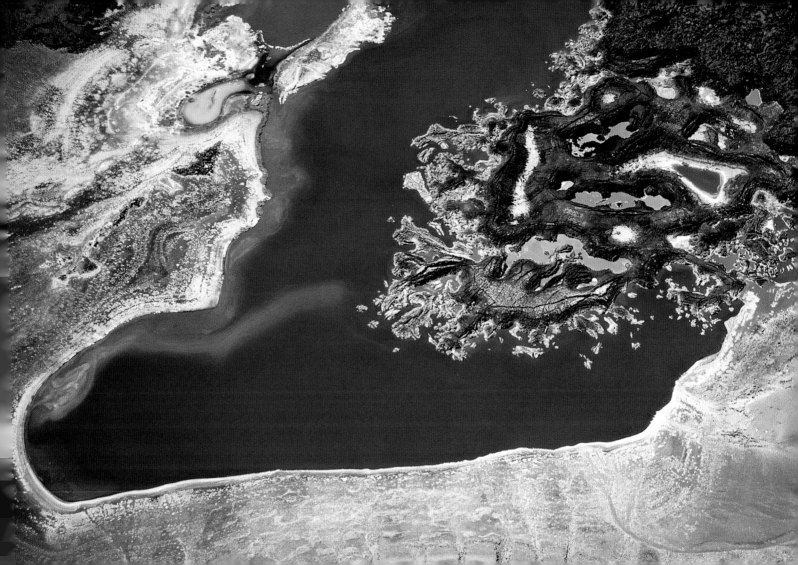

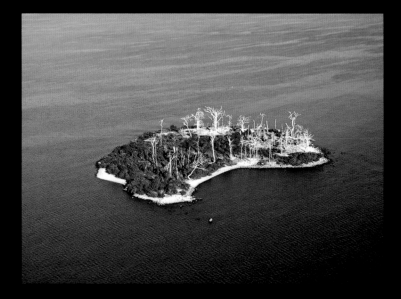

130 and 131
Some of the islands that stud the blue waters of Lake Victoria, in Tanzania, are merely tiny uninhabited rocks.

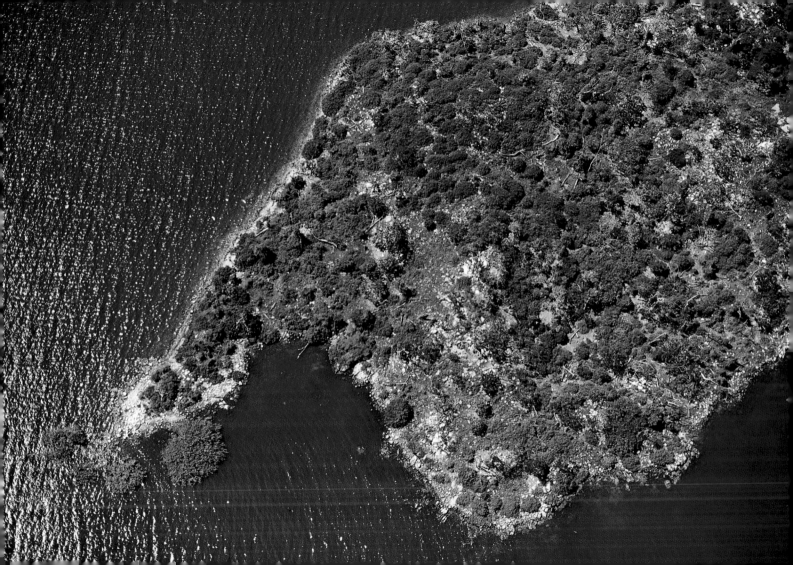

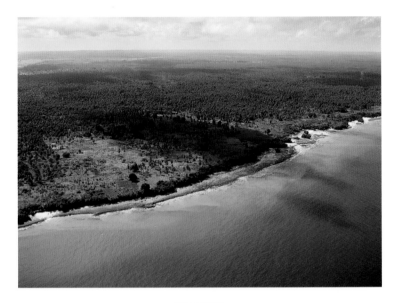

132 and 133
Victoria, resting between the states of Kenya, Uganda and Tanzania, is
over 26,000 square miles — the biggest lake in Africa.

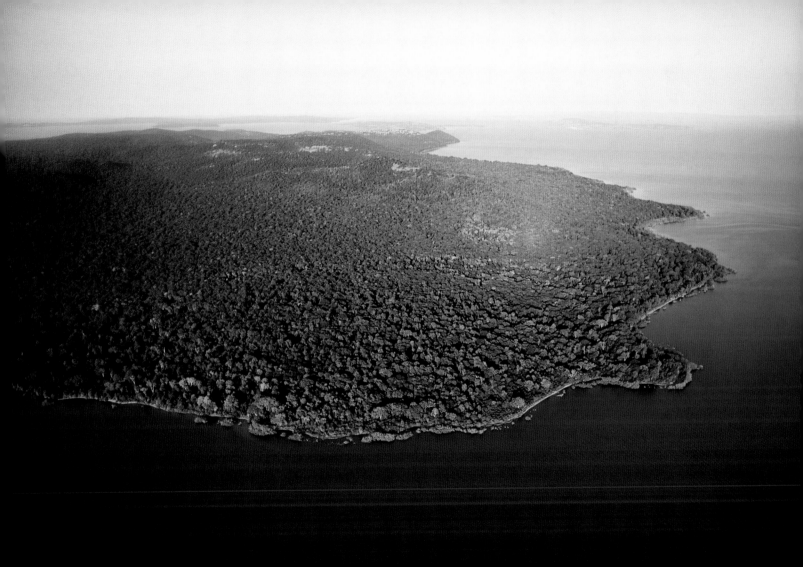

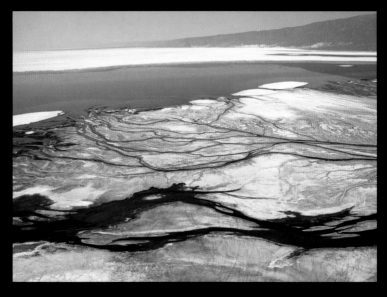

134 and 135
The tiny organisms that live in the muddy bed of Lake Natron, in Tanzania, constitute a precious source of food for the flamingos.

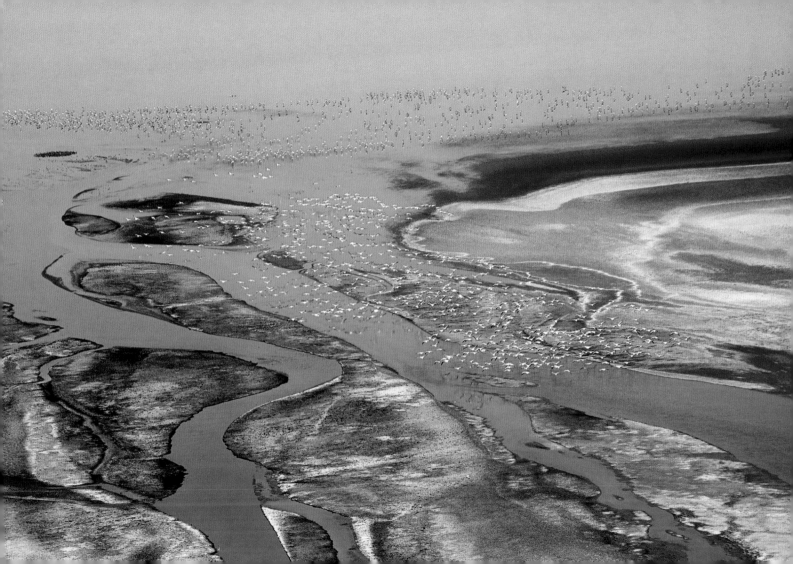

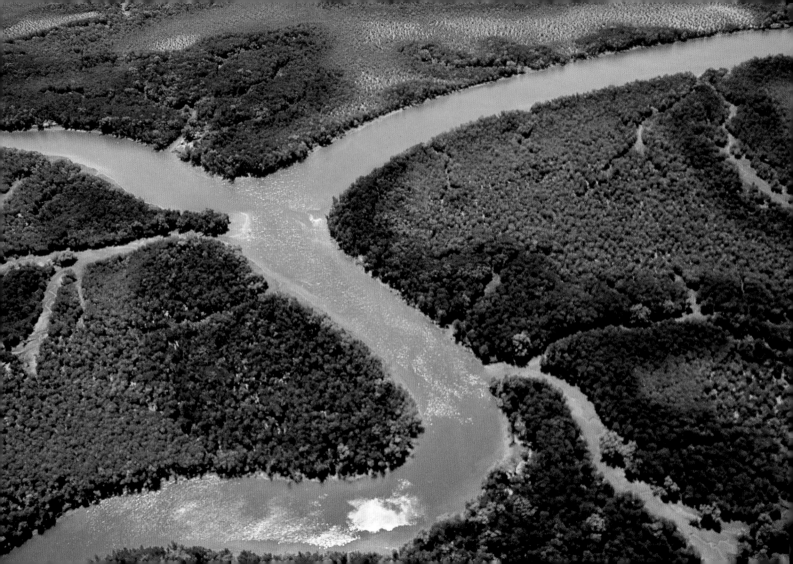

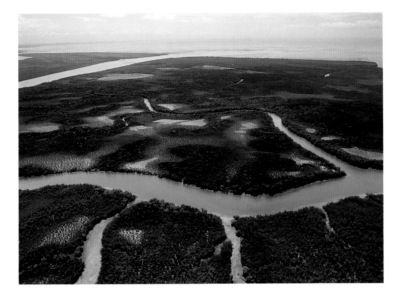

136, 137 and 138-139
The Rufiji River, in Tanzania, is still the only means of penetrating the
inland, almost uninhabited and absolutely void of roadways.

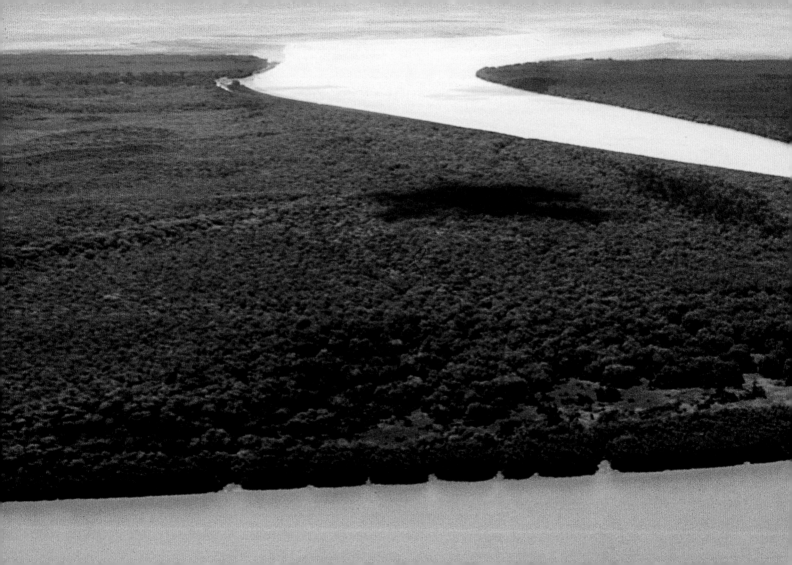

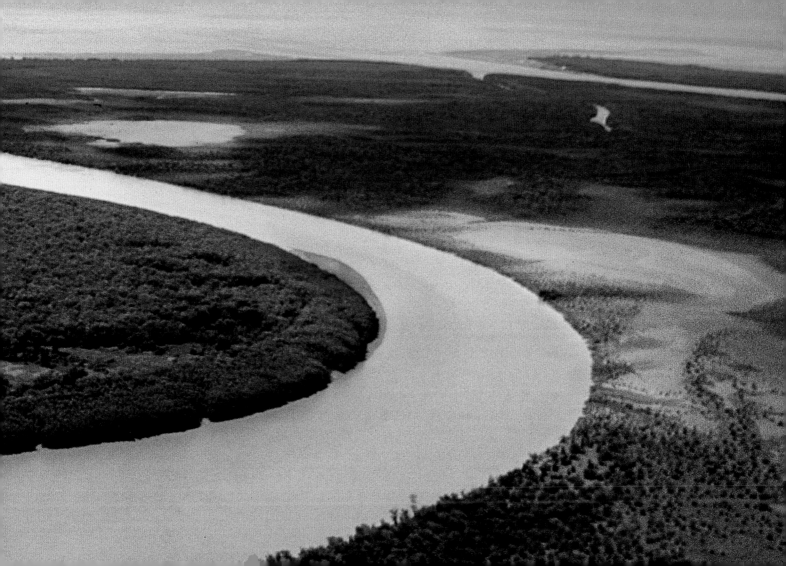

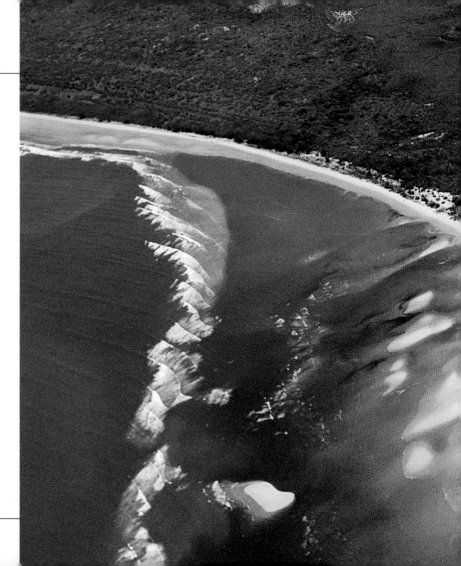

140-141
The Rufiji River, in Tanzania, empties millions of tons of sediment yearly into the Indian Ocean, forming a delta aproximately 56 miles wide.

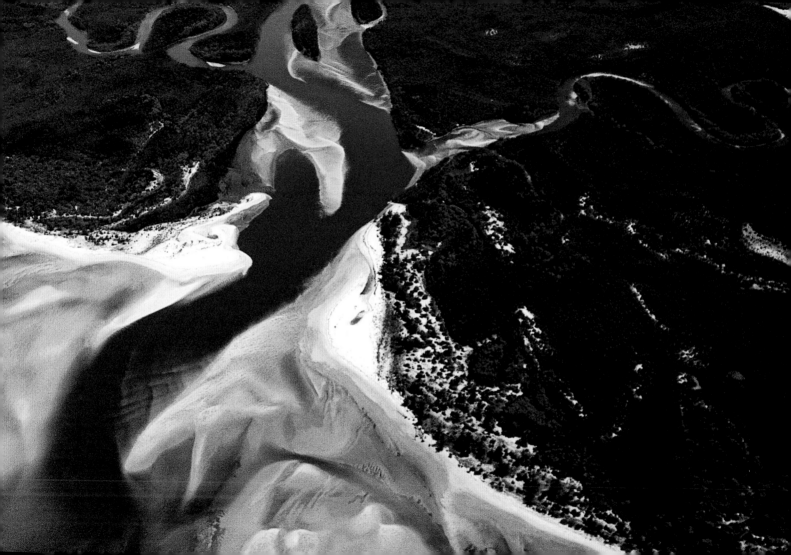

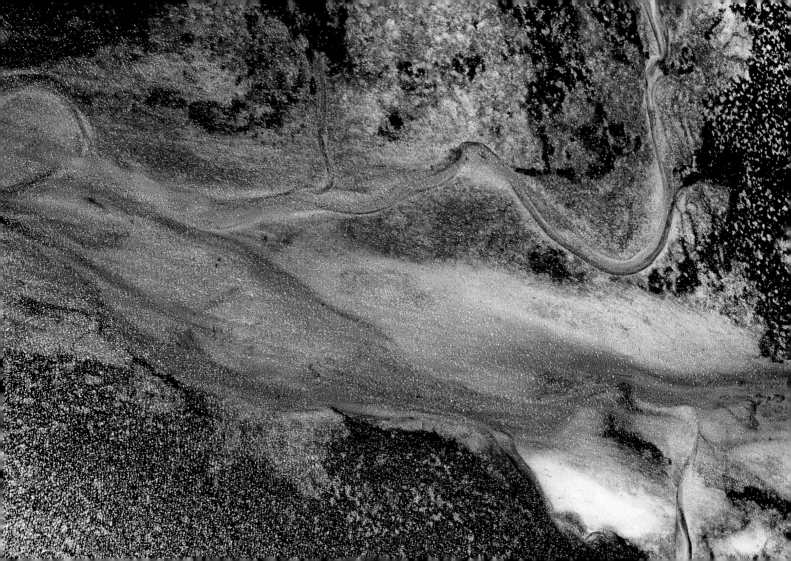

142 and 143
Lake Natron is situated in the Tanzanian Rift Valley, at an altitude of nearly 2,000 feet. Far from the waterways and lake there is an arid savana with areas of rocky desert.

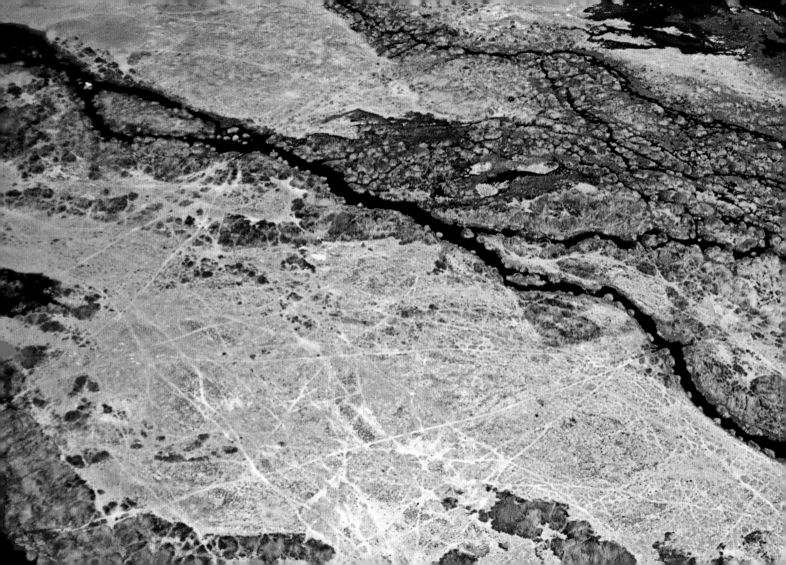

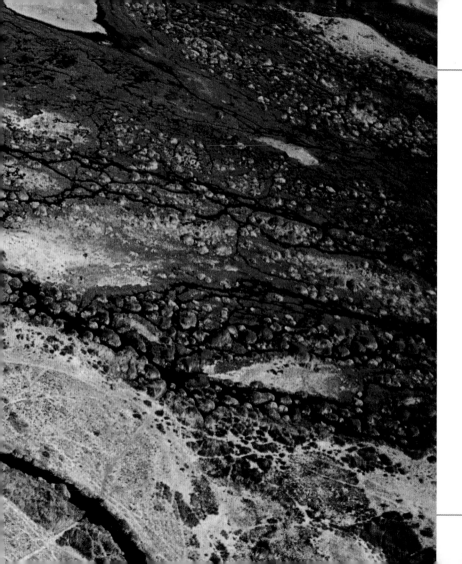

144-145
Rivulets of water and green grassy spots interrupt the obsessive monotony of the saline crust that covers the banks of Lake Natron, in Tanzania.

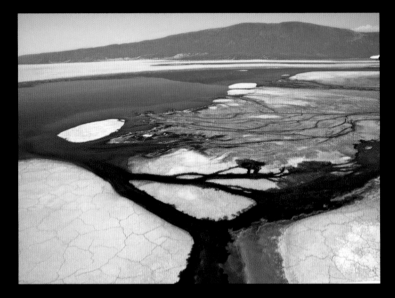

146 and 147
Arid hills and volcanic cones, still active, are reflected in the lifeless, saline water of Tanzania's Lake Natron.

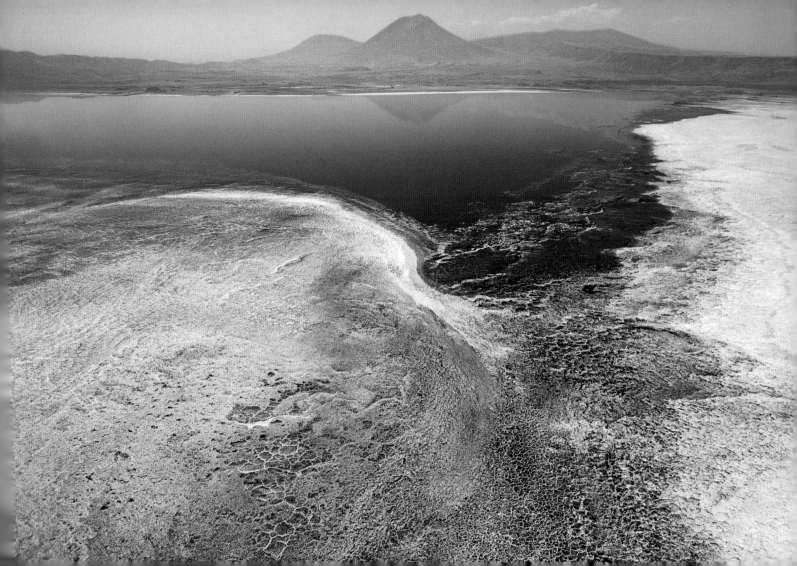

FLYING HIGH AFRICA

149
Lake Natron, in Tanzania, is favored by pink flamingos for their reproduction and nesting grounds.

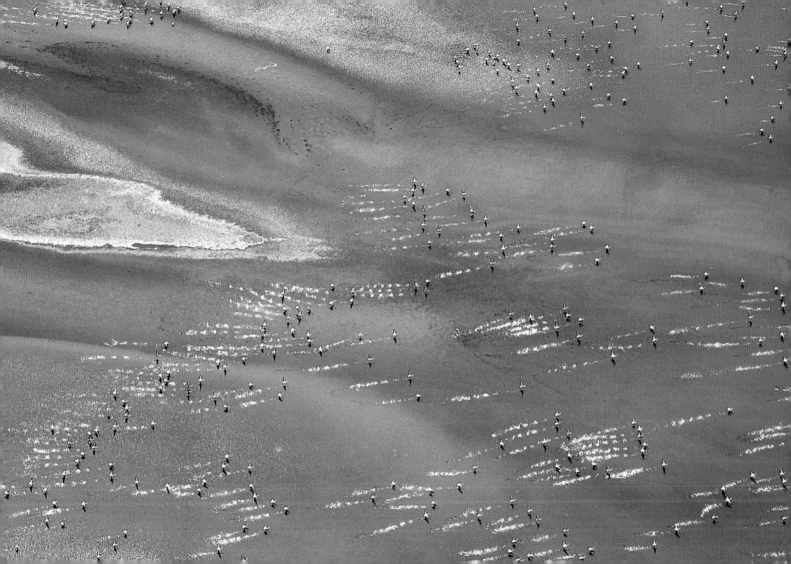

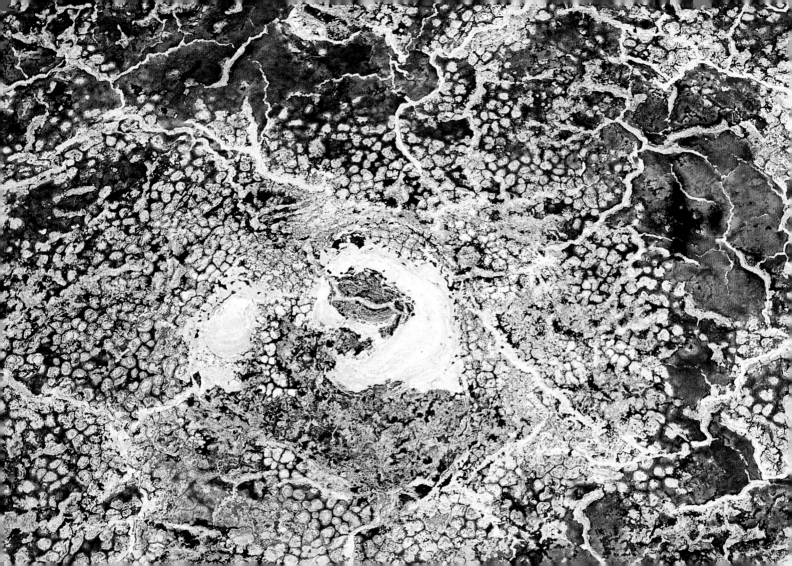

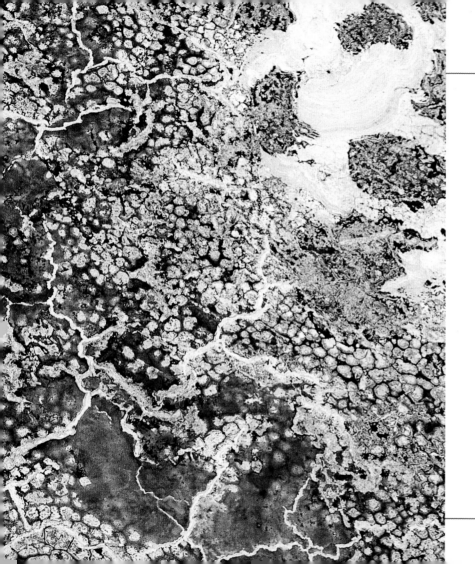

150-151
The efflorescence of natron that covers the surface of Lake Natron, in Tanzania, takes on different colors according to the impurities contained in the minerals.

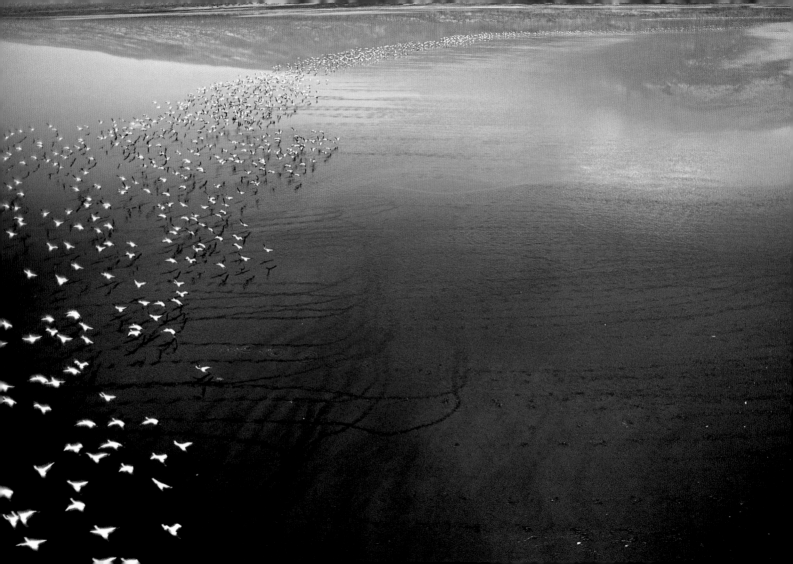

152
The shallow waters of Lake Magadi, in Kenya, are one of the favorite breeding places for eastern Africa's pink flamingos.

153
No deeper that ten feet and wedged into a desolate valley, Magadi is the most spectacular salt water lake in Kenya.

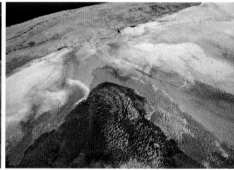

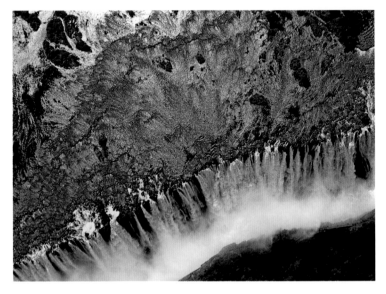

154 and 155
Zambesi precipitates in a roiling foam into the Victoria Falls, on the
border between Zambia and Zimbabwe.

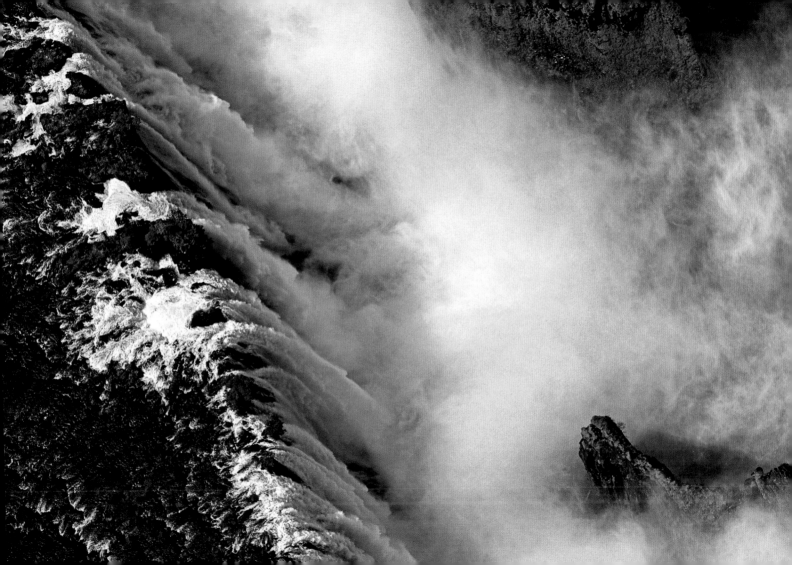

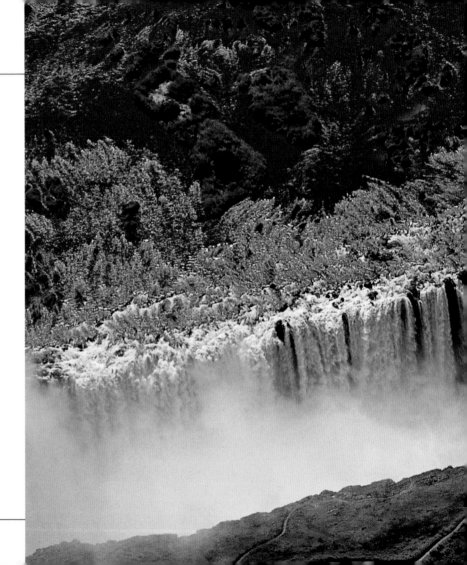

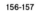

156-157
The colossal cloud of vapor that rises from the Victoria Falls, at the border between Zambia and Zimbabwe, is visibile dozens of miles away.

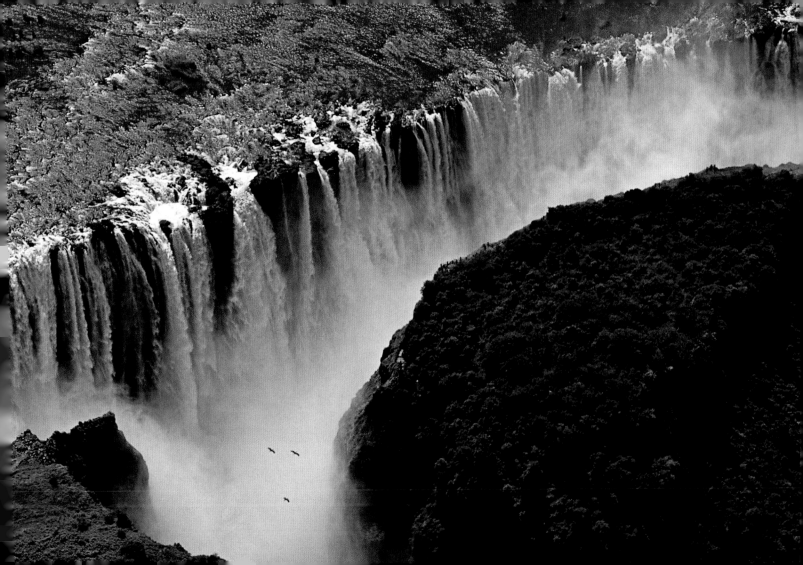

158 and 159
Among palm groves and enormous baobab trees, the Kunene River precipitates into the splendid Pupa Falls, at the border between Namibiz and Angola.

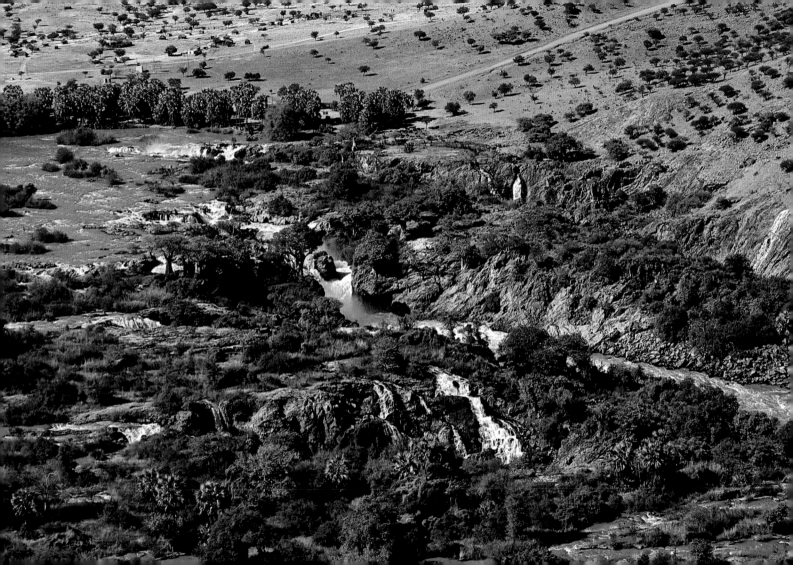

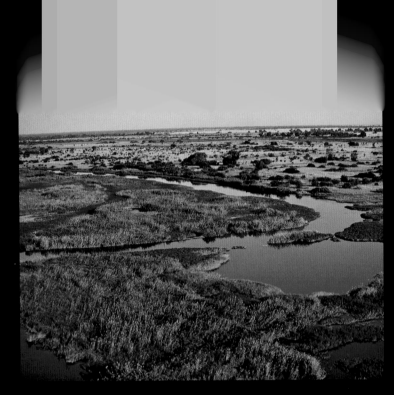

160

An extraordinary variety of animal species inhabits the marshes of Zambesi, within the Caprivi Game Reserve, in Namibia.

161

Tracing the border between Namibia and Zambia, the Zambesi River proceeds slowly between its swampy banks invaded by acquatic plants.

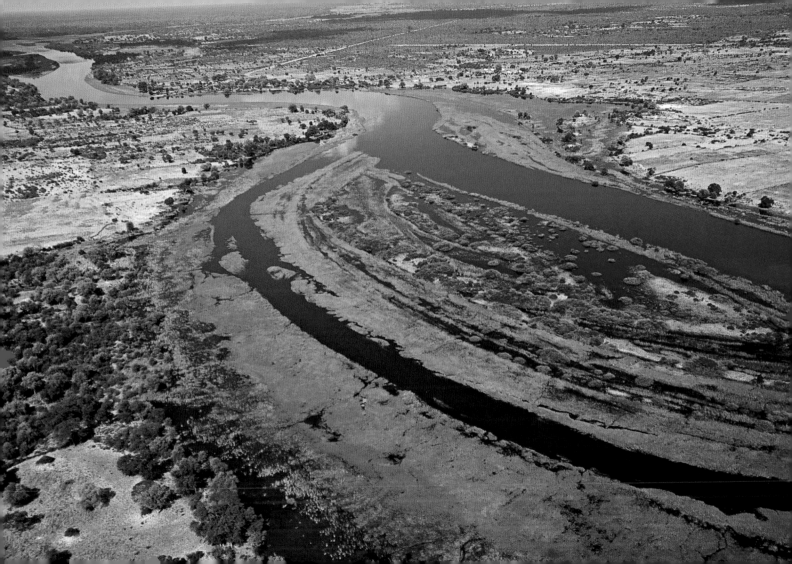

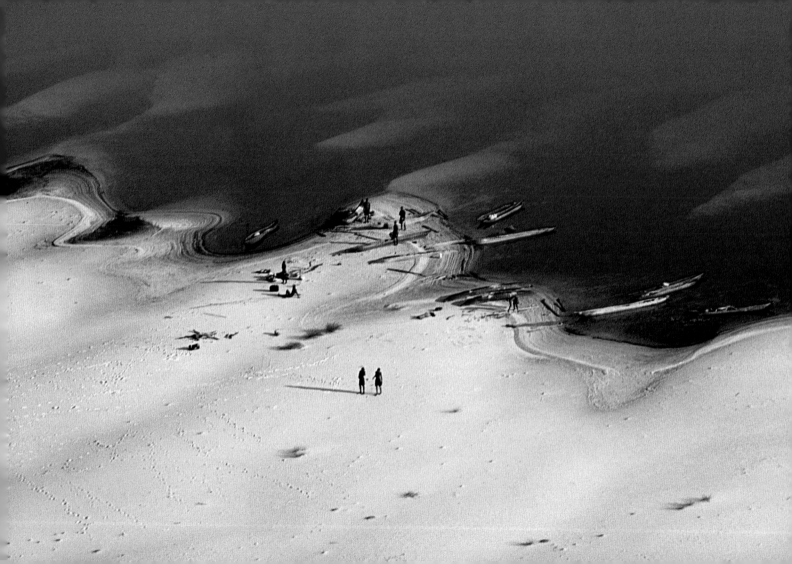

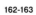

162-163
The sandy beach that begins along the banks of the Zambesi, in northeastern Namibia, is a fortunate spot for fishermen.

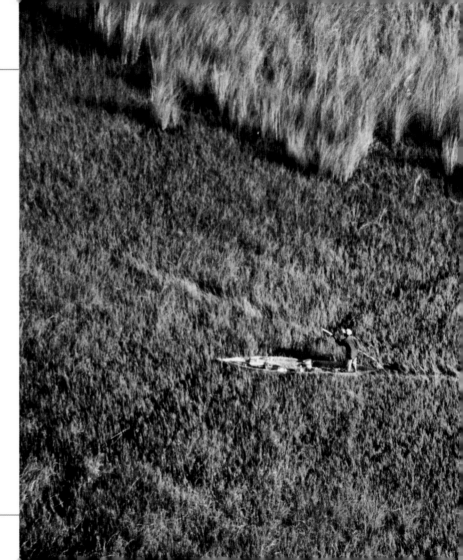

164-165

Moroso, pirogues carved from tree trunks, are the only boats capable of penetrating the Okavango River in Botswana.

166-167

Some species of antilopes are perfectly adapted to survive in the acquatic environment created by the Okavango Delta, in Botswana.

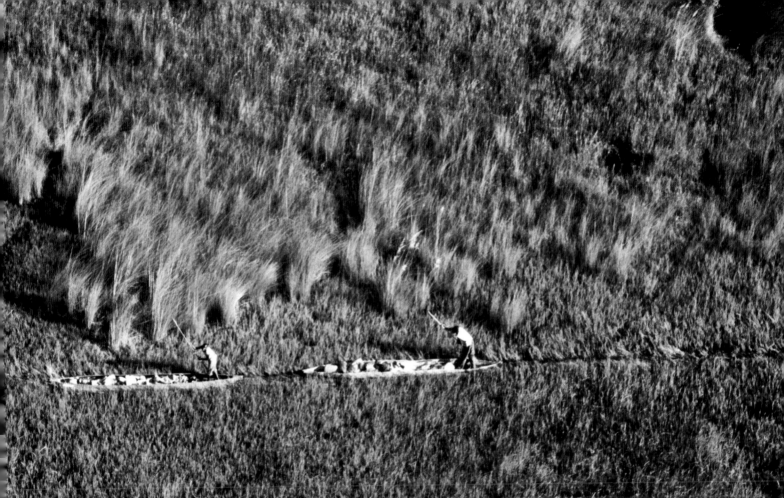

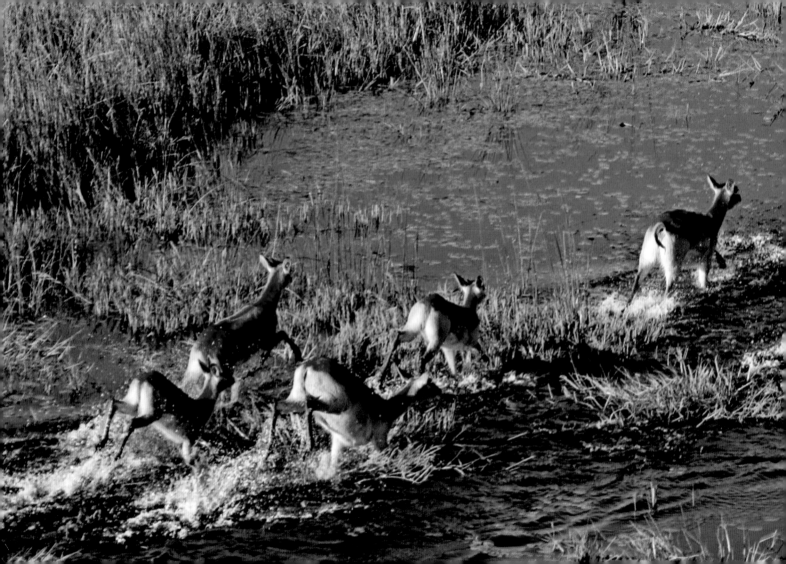

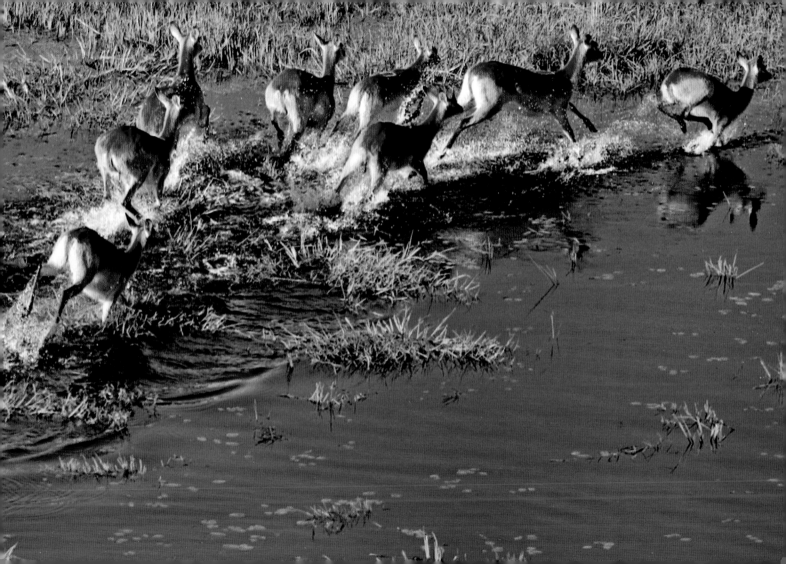

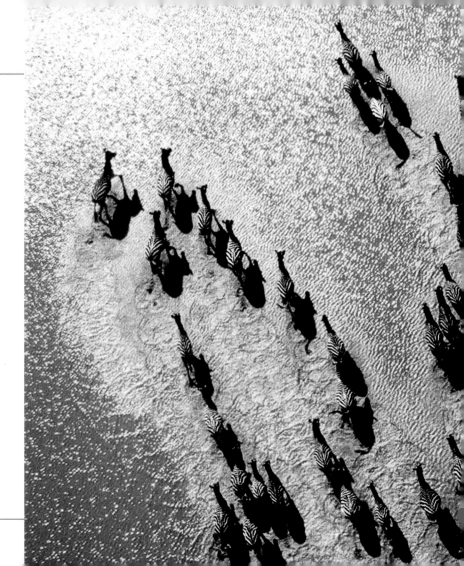

168-169

In the rainy season enormous herds of zebra and some solitary gnus gather near Makgadikgadi, in Botswana.

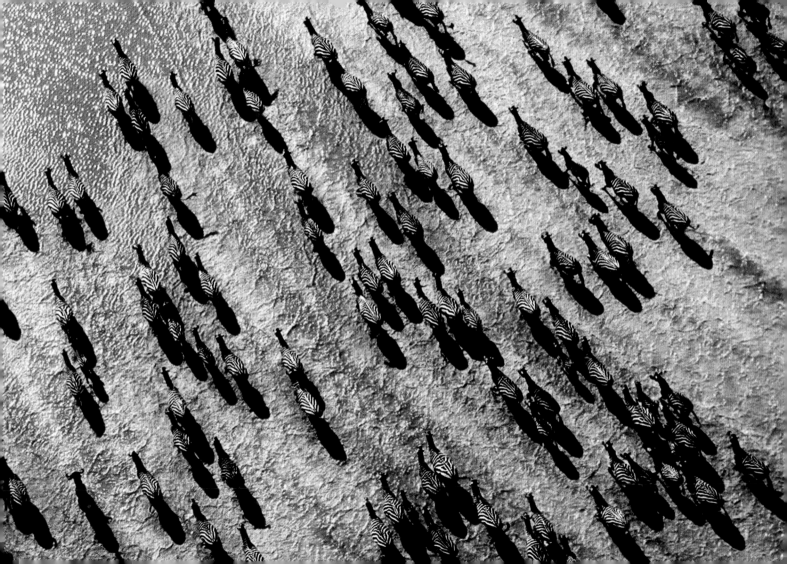

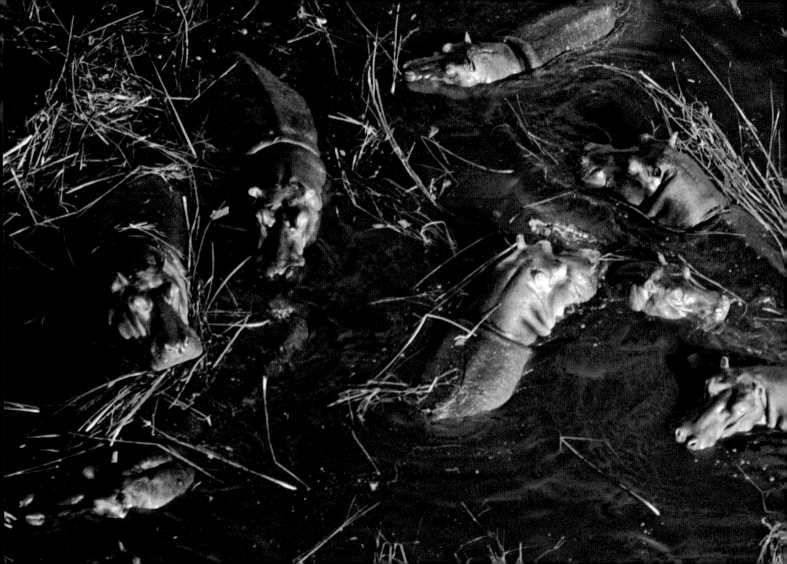

170-171
The hippopotami that live in the delta of the Okavango River, in Botswana, can easily surpass two tons in weight.

172-173
This female hippopotamus with her young advances cautiously in the limpid waters of a laguna, hidden by the tall grass in the Okavango Delta, in Botswana.

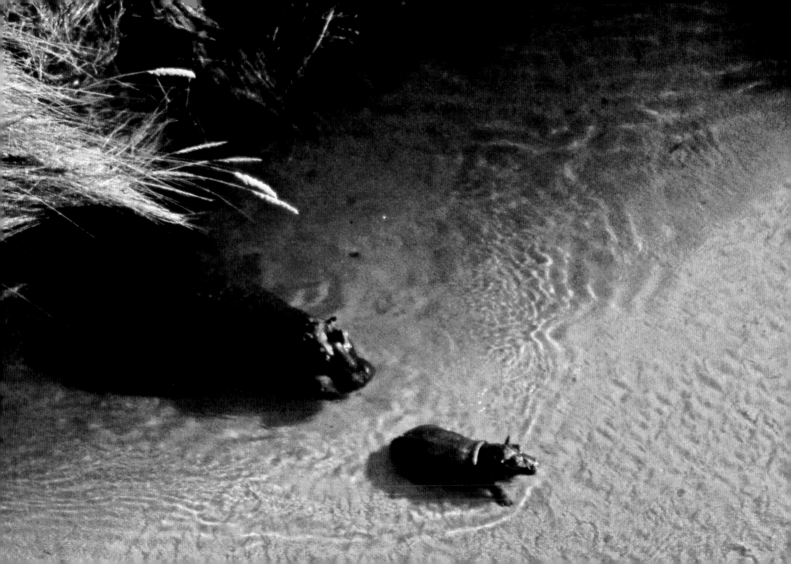

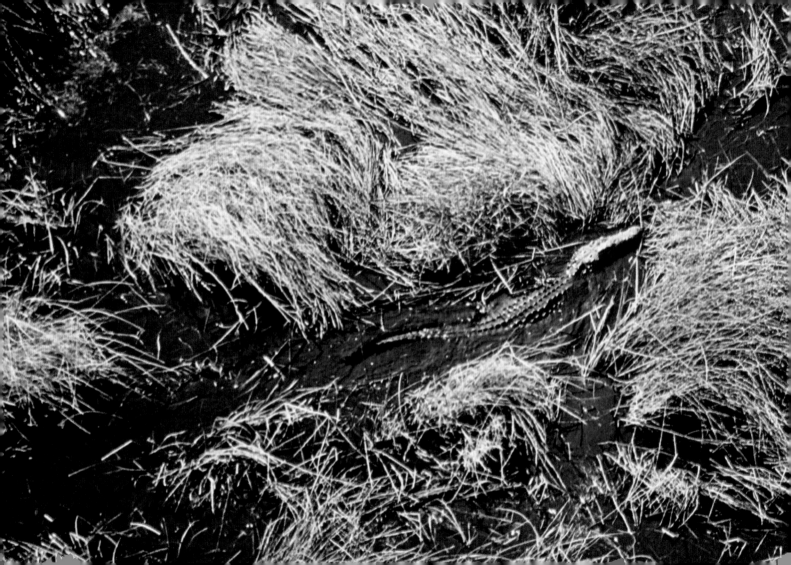

174 and 175
Perfectly camouflaged among the swamp grass of the Okavango
Delta, in Botswana, the huge crocodiles patiently await their prey.

176-177
The elephants, like many other herbivores, find an ideal environment and pasture ground in the Okavango Delta.

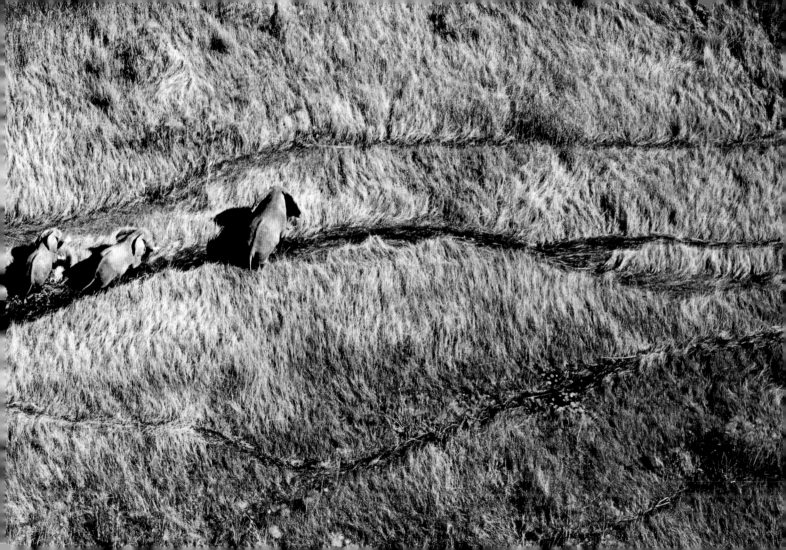

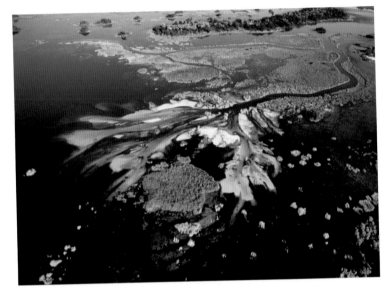

178 and 179
The waters of the Okavango River, in Botswana, disperses into the
sand of Kalahari, in a giant labyrinth of islands, canals and lagoons.

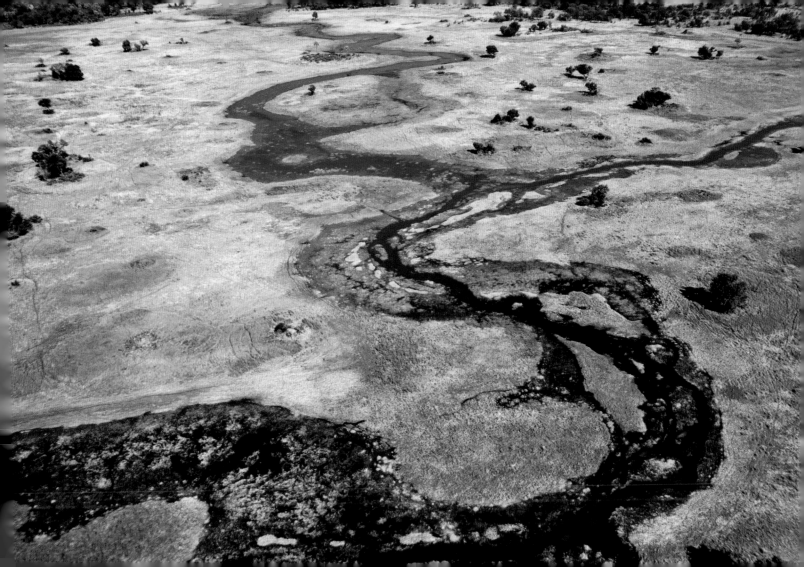

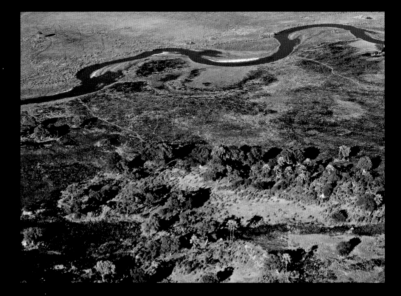

180 and 181
This secondary branch of the Okavango Delta, proceeds on a winding course through the vast prairie and undergrowth of northern Botswana.

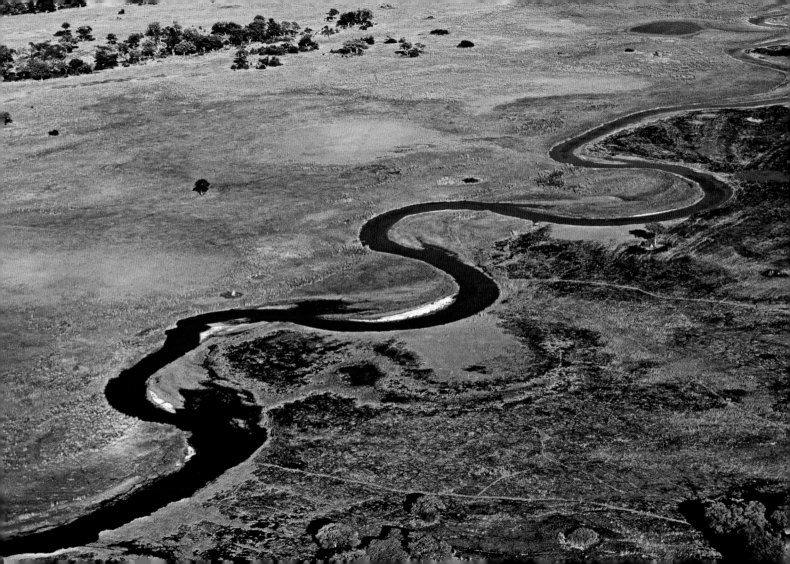

182-183
The Okavango Delta, in Botswana, is a world apart, where the confines between earth and water are often vague and evanescent.

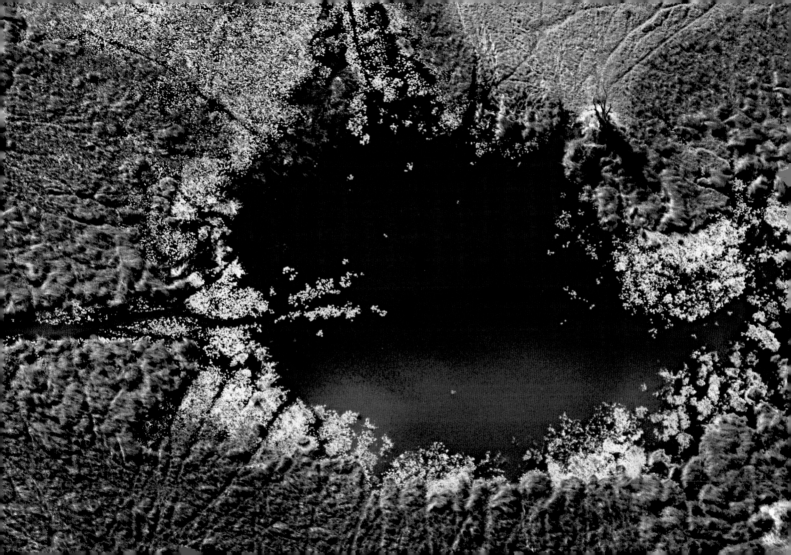

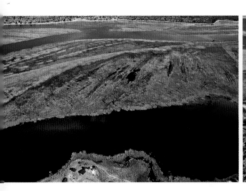
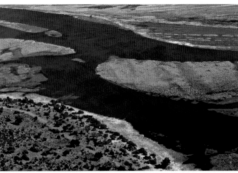

184
The proliferation of acquatic plants in the Chobe River risks to alter the natural balance in the Chobe National Park, in Botswana.

185
Amidst islands of paper reed and underwater prairies, the Chobe River makes its way to where it meets with the Zambesi, in the Chobe National Park, Botswana.

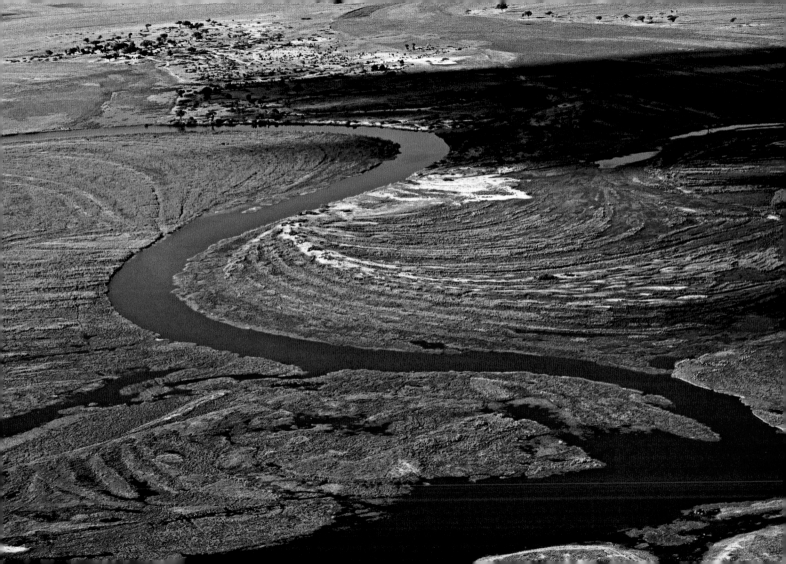

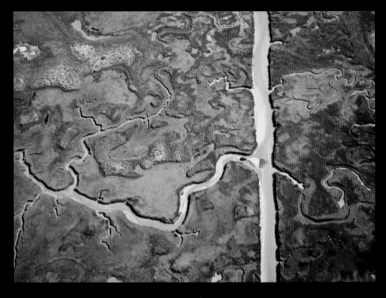

186, 187 and 188-189
Apparently desolate and deserted, the saline marshes of the West Coast National Park, in South Africa, host tens of thousands of migratory birds.

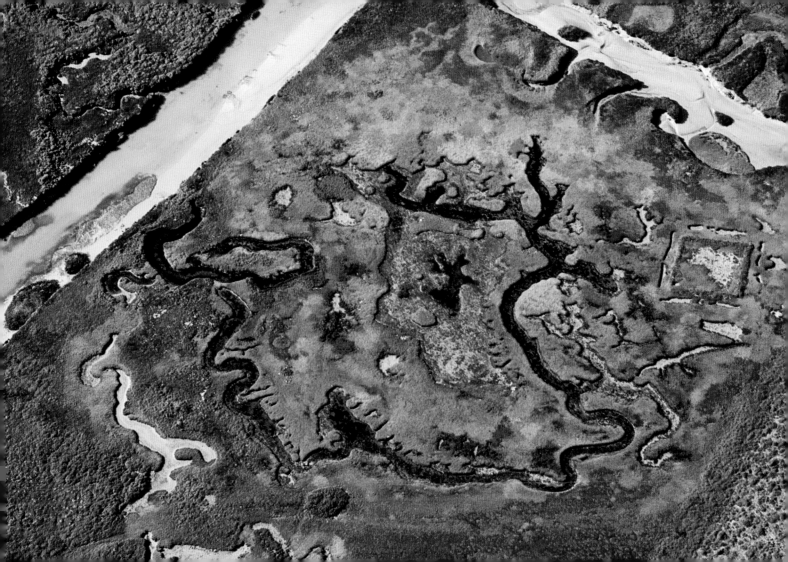

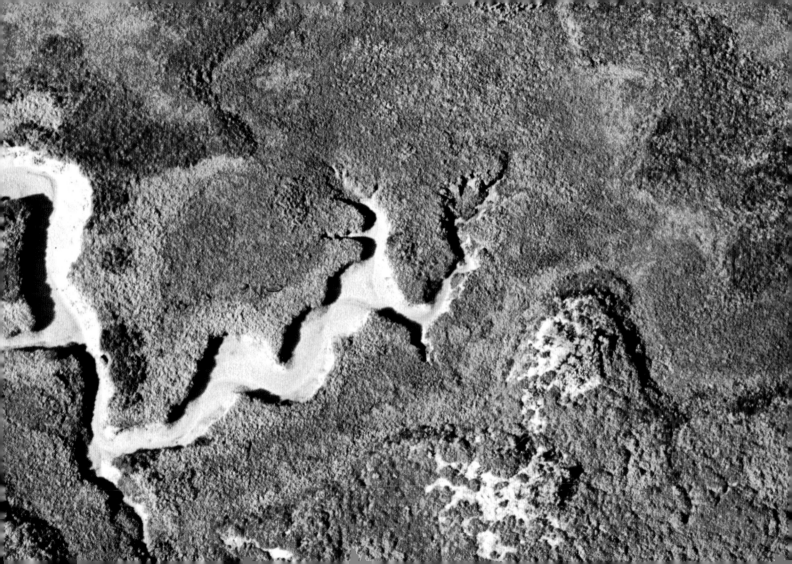

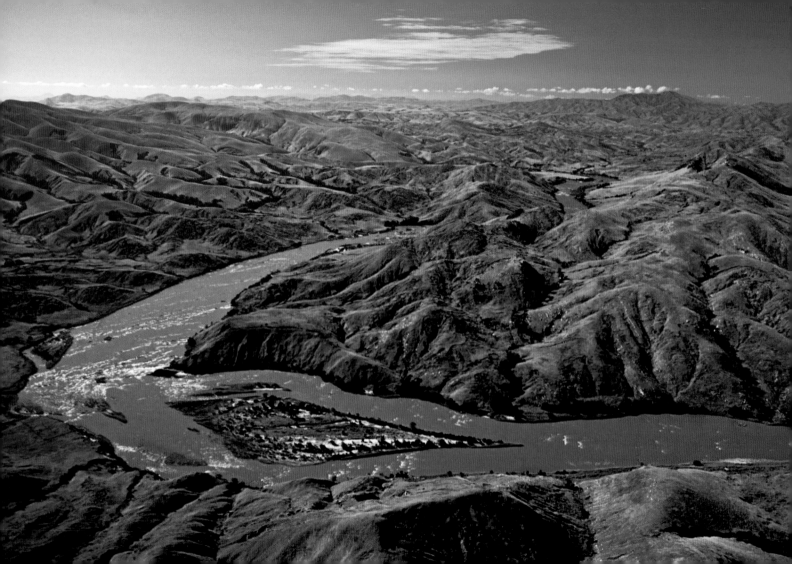

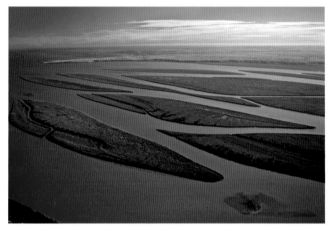

190
The course of the Mahajilo River, in western Madagascar, traverses almost inaccessibile regions, lacking in communication routes.

191
Before flowing into the sea near Mahajanga, in western Madagascar, the Betsiboka River branches into a barely outlined delta.

A GREAT
GREEN HEART

FLYING HIGH

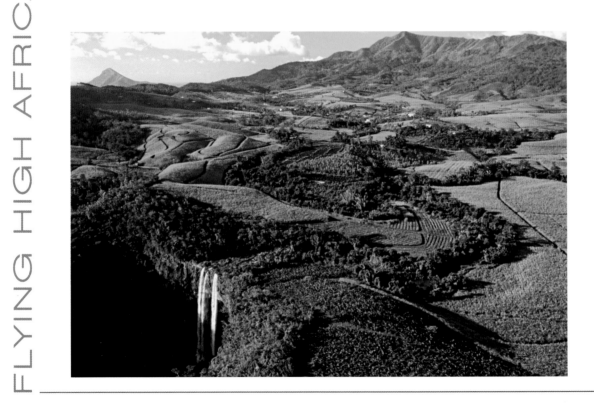

193
The forest of Maycombe, in the Congo (left), and the forest
that surrounds Lake Victoria, in Tanzania (right).

For civilized man the jungle is a nightmare, the most hostile of all hostile environments. Adventure narratives call it a "Green Hell," a place of perdition and suffering with no reference points or comforts. In fact, the rainforest is a difficult place to survive: the climate is oppressive, the insects are more numerous and dangerous than elsewhere, the humidity is unbearable.

With the absence of evaporation, sweating is abundant and drinking becomes even more necessary than in the desert. While crossing the Ituri jungle in the Congo, Stanley lost half of his expedition members, felled by exhaustion and disease.

Still, the African forest is a fascinating and complex habitat that hosts an unbelievable variety of animal and plant species. In a vertical sense, from high to low, it can be divided into various layers, each characterized by a particular microclimate. At the highest level dwell most of the animals, often gifted with special adaptations in order to move from branch to branch, and the intense solar radiation permits the growth of flowers and fruit.

The conditions change radically as we move to the lower levels where the humidity becomes extreme and the temperatures oscillate all year long between 72° and 84° F.

Only two percent of the sun's radiation reaches the soil, which therefore lacks grass and undergrowth. The living organisms that inhabit the ground level of that natural hothouse, immersed

194
Chamarel Falls, Mauritius.

A Great Green Heart

in a marine light, are usually modest in size. The *Neotragus pygmaeus*, a type of miniature antelope, weighs barely nine pounds. For zoologists and naturalists the forest is a genuine paradise, a source of interest and stupor: a new species of monkey has been recently discovered in Gabon, while the plains Gorilla have suddenly repopulated the overpopulated Nigeria. A scientific exploration of the African rainforest has only begun, but must move quickly: each day hundreds of acres of forest give way to cultivated fields or are transformed into precious wood, eliminating entire ecosystems.

The forests of western Africa that once extended uninterrupted from the Sierra Leone to Nigeria, are by now reduced to one-tenth of their original extension. Together with the buffalos, leopards and elephants, the area also hosts rare species in danger of extinction, like the miniature hippopotamus, the chimpanzee and the red colobus monkey. The Tai and Cross River national parks in the Ivory Coast and Nigeria protect the last slices of this unique habitat. The nearby Korup reserve, in Cameroon, marks the beginning of the green heart of Africa: a strip of impenetrable jungle that extends from the Atlantic coast to the Virunga mountain chain.

The Congo River basin hosts more than 10,000 botanical species, a third of which are endemic, and 400 species of mammals. This wealth of biodiversity has few comparisons elsewhere on the continent.

Not much has changed from the era of Stanley and the other early foreign explorers who dared to penetrate this region, still one of the most hostile on the planet. Its enormous extension and the lack of any trustworthy roadways impede any intensive abuse of this immense area. Inaccessible and ill adapted for any human colonization, central Africa conserves intact many of its mysteries. At the beginning of the 20th century, it seemed as though the world of nature no longer held any big

A Great Green Heart

surprises for science. However, in 1893, surprising evidence of an unknown animal emerged from the jungle of Ituri. The Pygmies, who had always hunted it for its meat, spoke of an animal that resembled a zebra, with a very long neck. This was enough to convince Harry Johnston, then governor of Uganda and passionate traveler, to begin his research.

He was rewarded for his efforts: after three years, Johnston had collected a skull and a couple of okapi skins. The successive laboratory exams revealed that this was, in fact, a new species, similar to the giraffe and until then, completely unknown.

The first live specimen of okapi was captured in 1909: 5.25 feet in height to the shoulder and weighing aproximately 550 pounds. Nothing like it had ever been seen by Western eyes before. It is impossible to imagine what secrets the African jungle has yet to reveal. The golden lemur of Madagascar was discovered only in 1987. The alimentary habits of this rare anthropomorphic monkey are very surprising: the golden lemur eats the tender stems of the giant bamboo, which contains cyanide, without suffering any effects. Madagascar is a country of contrasts. One hundred and fifty million years of absolute isolation have resulted in the evolution of an exclusive flora and fauna, unique in the world. The lemurs, 30 different species, are found only in Madagascar and in the Comores; similarly, 80 percent of the plants, half of the birds and almost all of the reptiles and amphibians on the island are endemic. The forests of Madagascar cover almost 15,444 square miles.

Their survival is in grave danger, threatened by increasing demographic pressure and by the traditional agricultural techniques based on a system of "slash and burn." Only in the reserves and national parks do Madagascar's forests conserve their primitive splendor, patrimony not only of Africa, but of all of mankind.

198 and 199
The water vapor that rises from the waterfalls in Drakensberg, South
Africa, is sufficient to sustain the growth of lush vegetation.

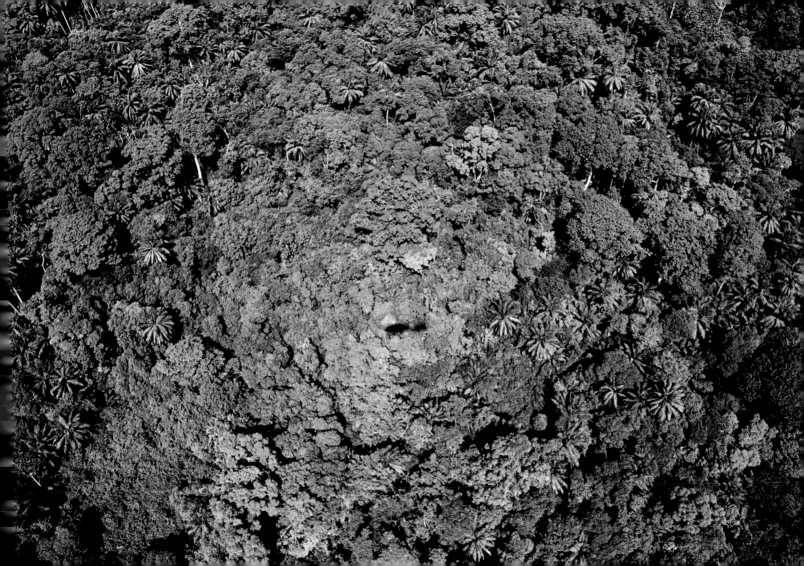

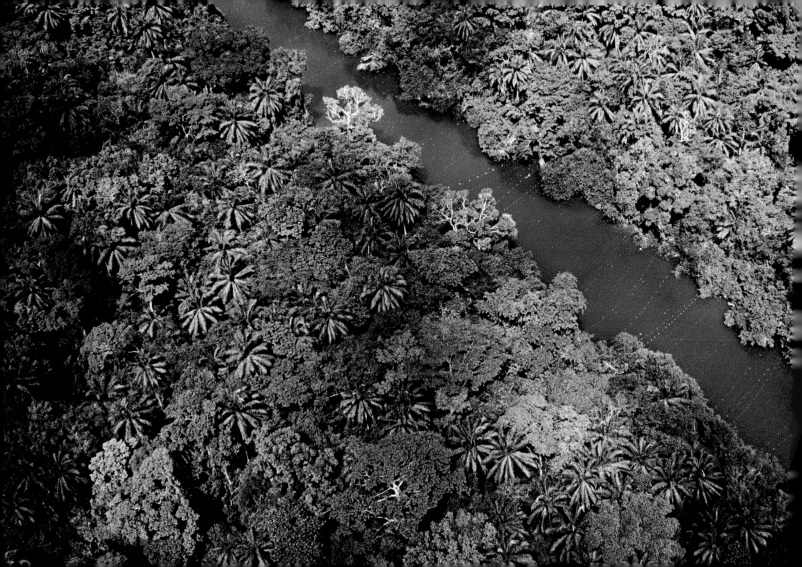

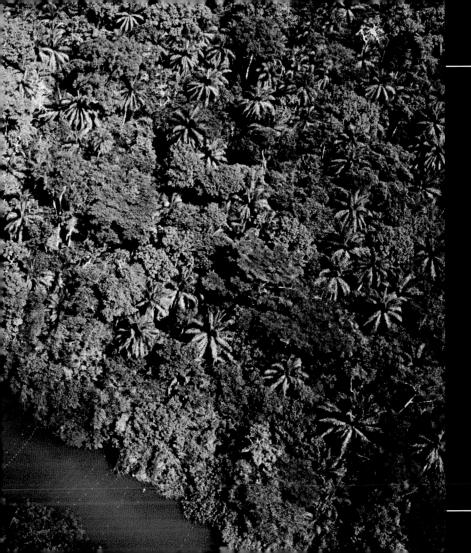

200-201
In southern Nigeria, before its entry into the Atlantic, the Niger River crosses one of the most impenetrabile and savage forests in Africa.

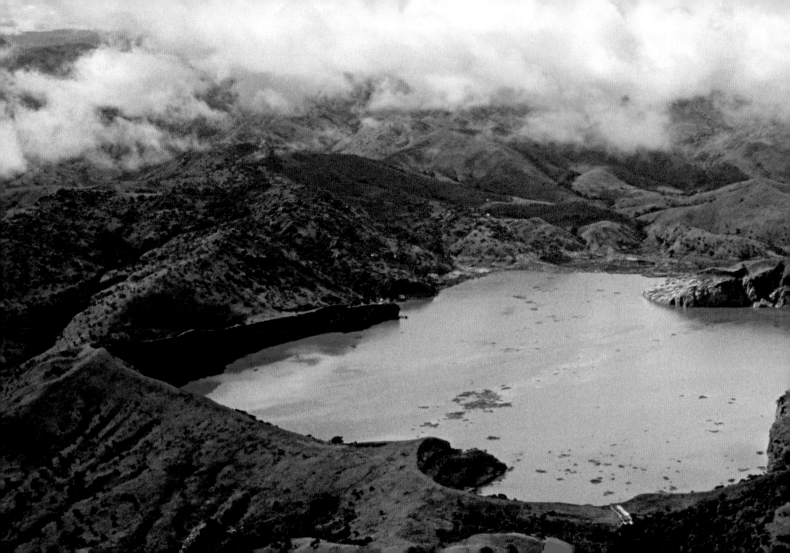

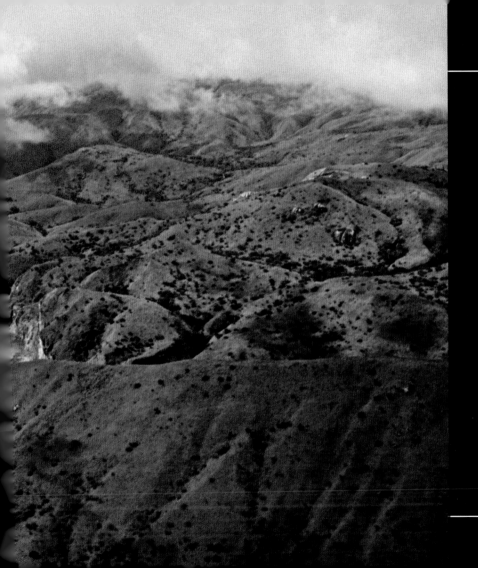

202-203
The dense rain forest that covers
a great part of the Gabon territo-
ry extends uninterrupted from
the border of the Congo to the
shores of the Atlantic.

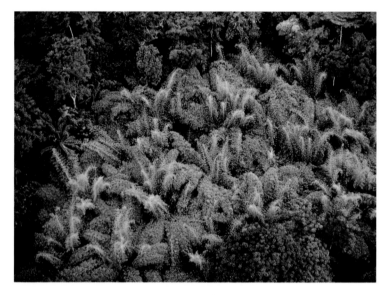

204 and 205
In the Mayombe region of the Congo, the rain forest reveals itself in all
of its splendor: the highest trees reach 160 feet.

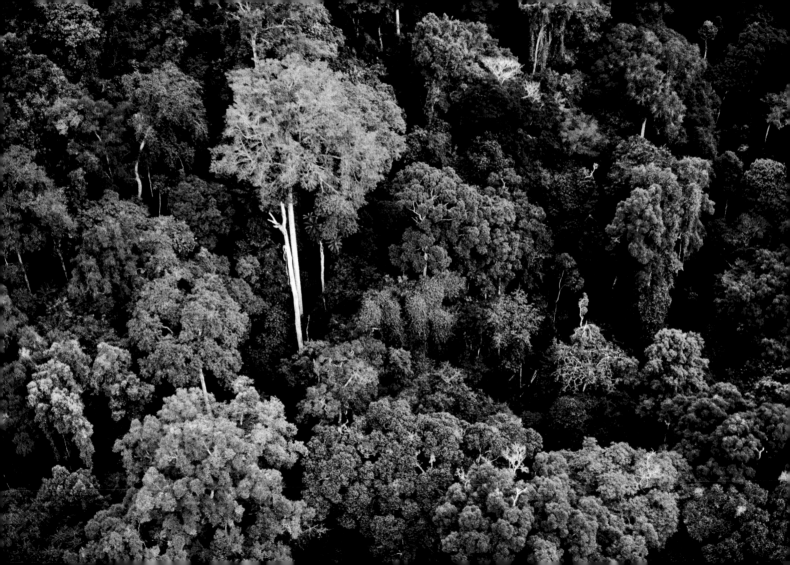

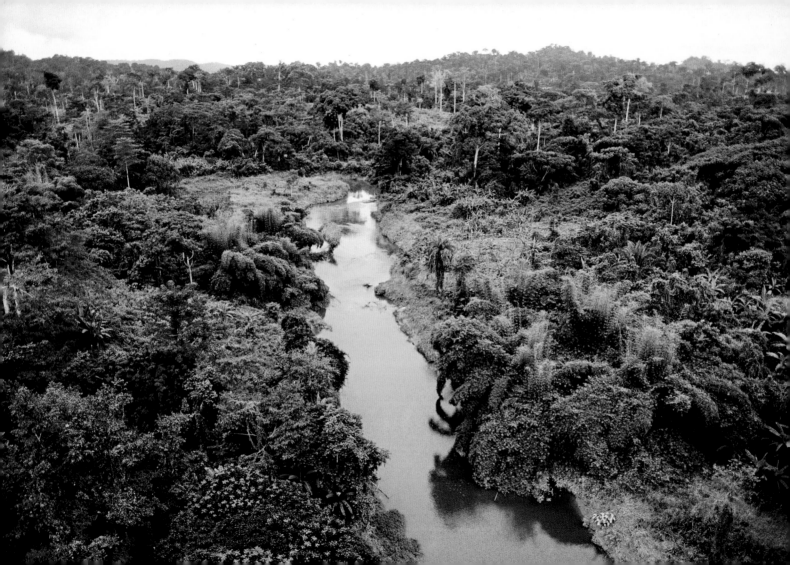

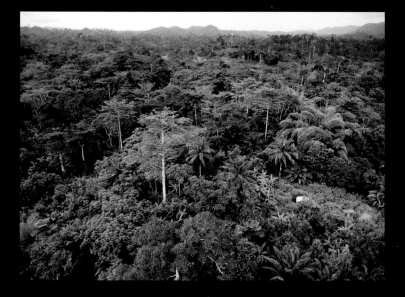

206 and 207

The Maycombe Forest is one of the reserves instituted by the governor of the Congo to protect the country's natural patrimony.

FLYING HIGH AFRIC

209
The palm fronds that emerge from the forest undergrowth are the dominating characteristic of this section of forest, facing the banks of the Kouilou River, in the Congo.

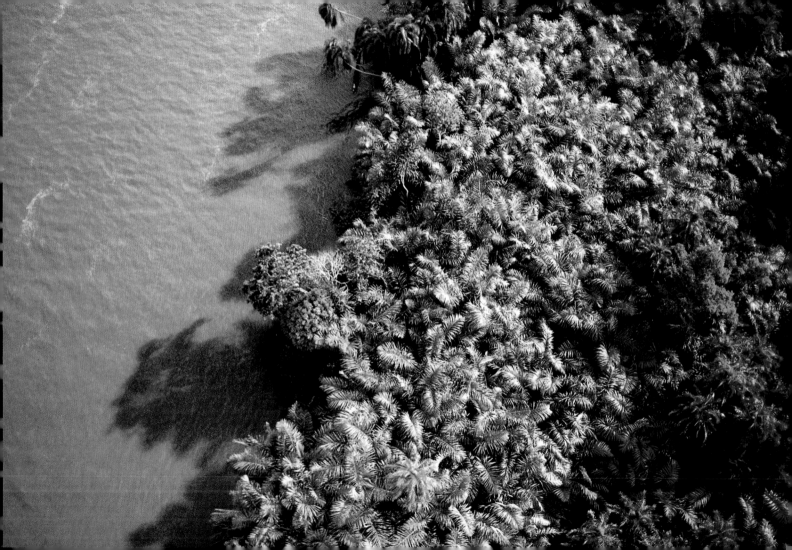

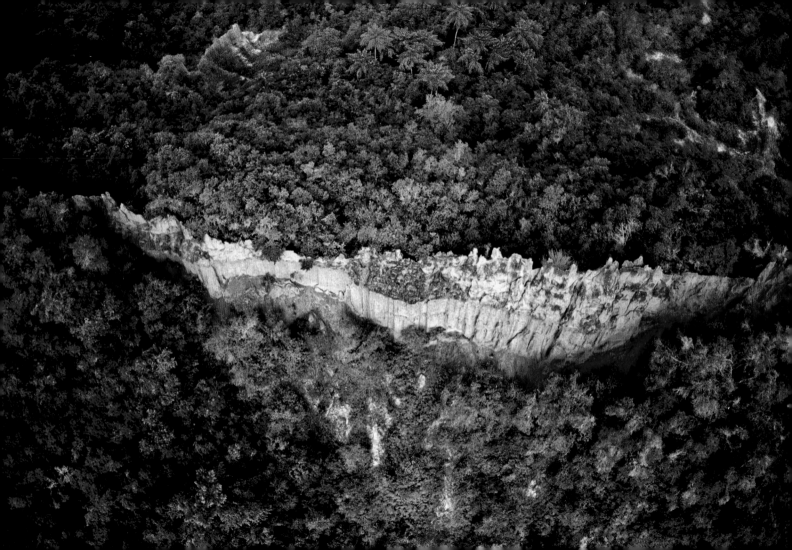

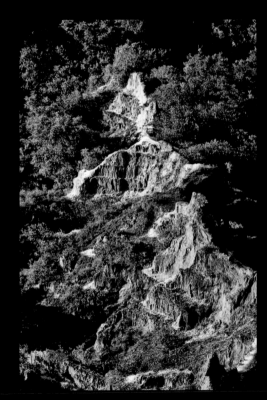

210
The contrast between the walls of eroded rock and the green forest lends incomparabile charm to the Diosso Gorge.

211
The bottom of the Diosso Gorge , in the Congo, is covered by dense jungle, from which numerous crests and peaks arise.

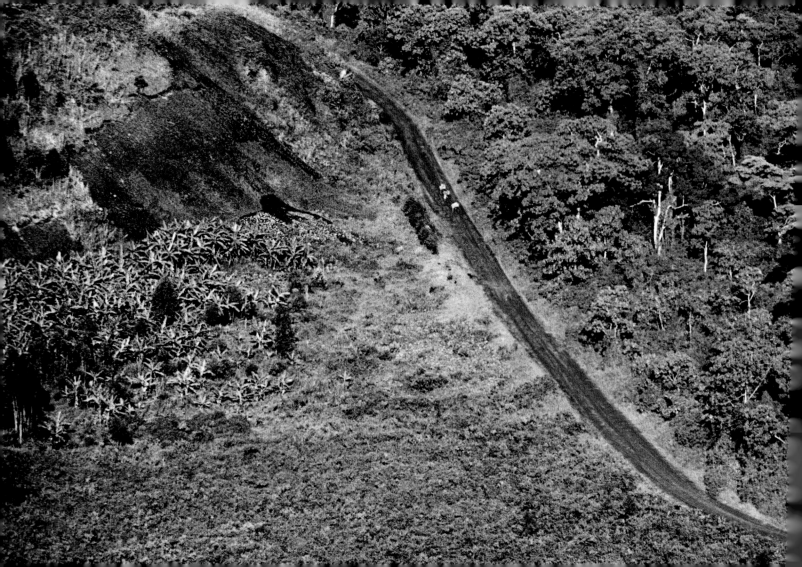

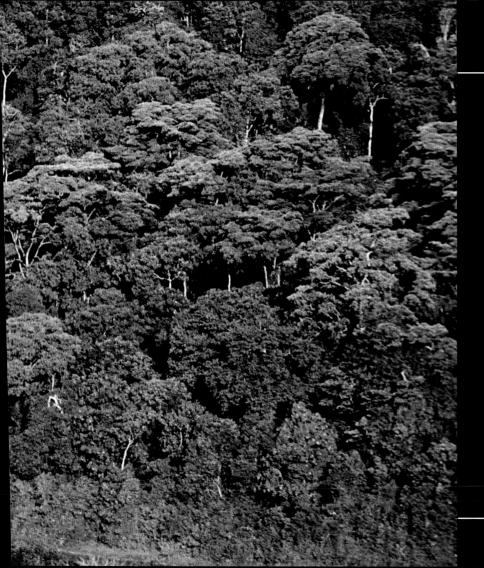

212-213
The incontaminated forests that cover the slopes of the Nyiragongo volcano, in the Congo, are an authentic paradise of biodiversity.

FLYING HIGH AFRICA

215
In the early hours of the morning, a spectral shroud of fog covers the mysterious mountain forests of Nyungwe, in Rwanda.

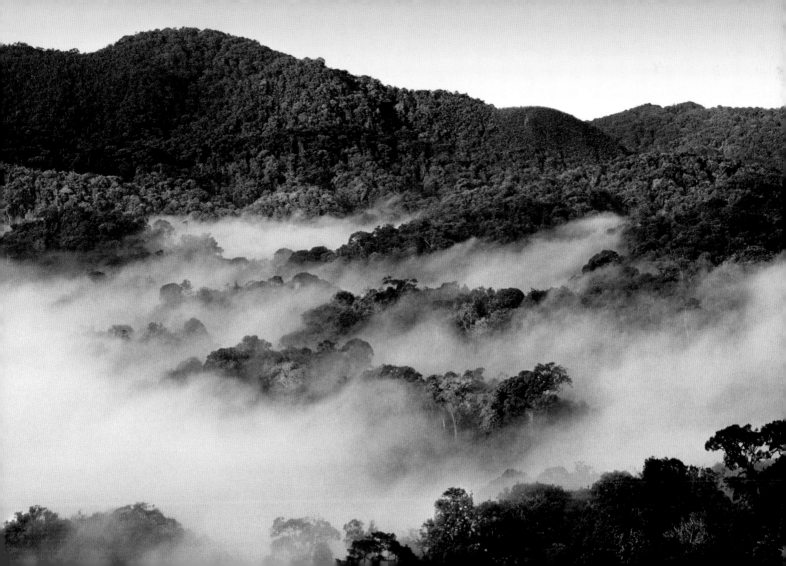

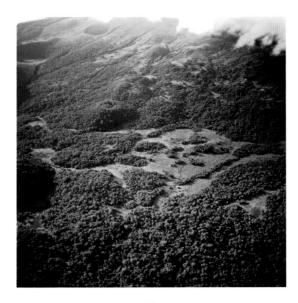

216
The Congo rain forest, one of the largest and less explored on the earth, hosts aproximately 11,000 plant species and 410 types of mammals.

217
The dense forests that cover the peaks of the Virunga Mountains, in Rwanda, are one of the last refuges for the rare mountain gorillas.

218 and 219
The inhospitable climate on the shores of Lake Victoria, in Tanzania, has discouraged human settlements, preserving ample zones of virgin forest.

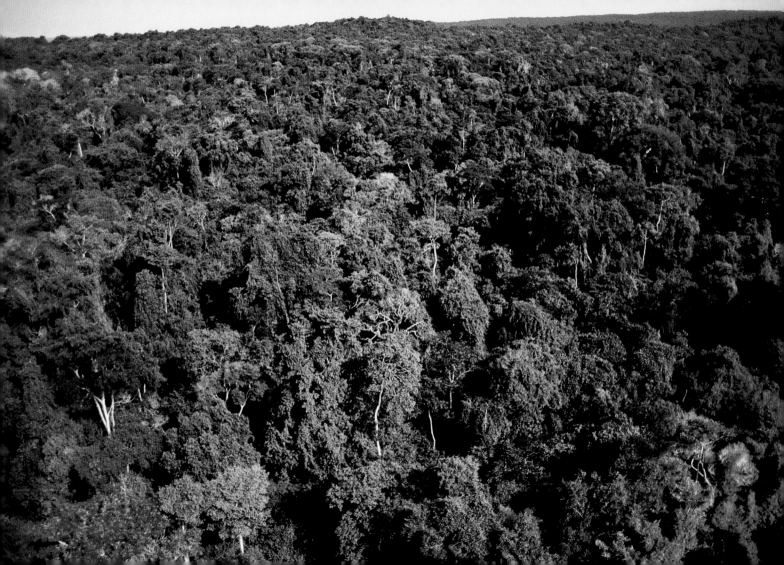

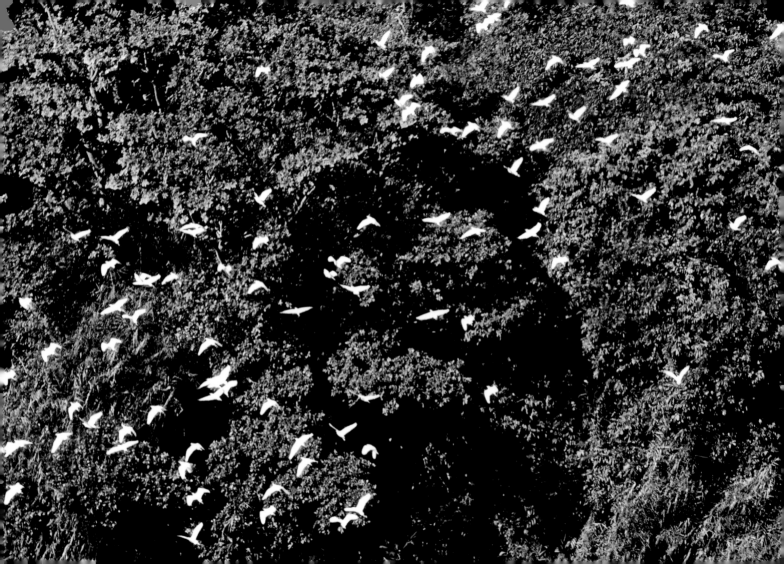

220-221
A flock of acquatic birds appear
on the backdrop of the lush veg-
etation that surrounds the banks
of Lake Victoria, in Tanzania.

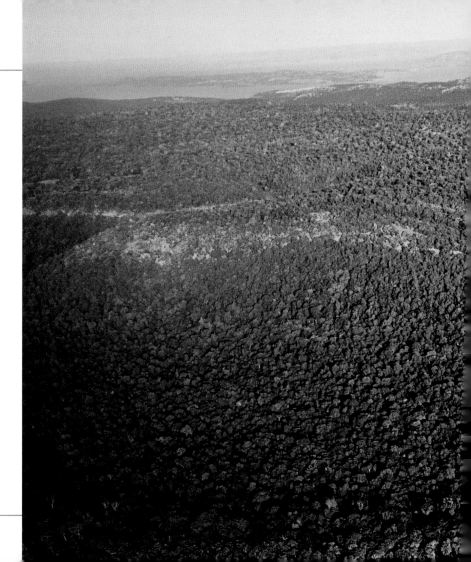

222-223
The great depression that cra-
dles Lake Victoria, here pho-
tographed from the Tanzanian
side, constitutes an ideal ecosys-
tem for the development of a rain
forest.

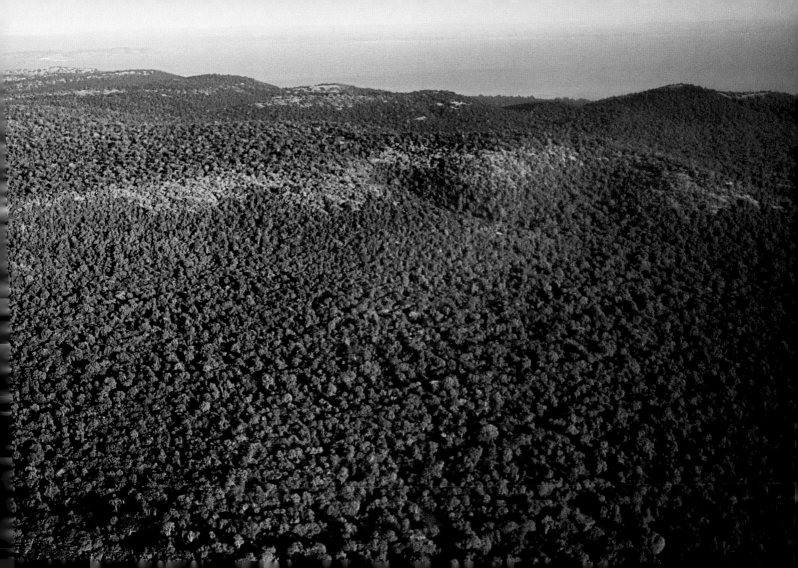

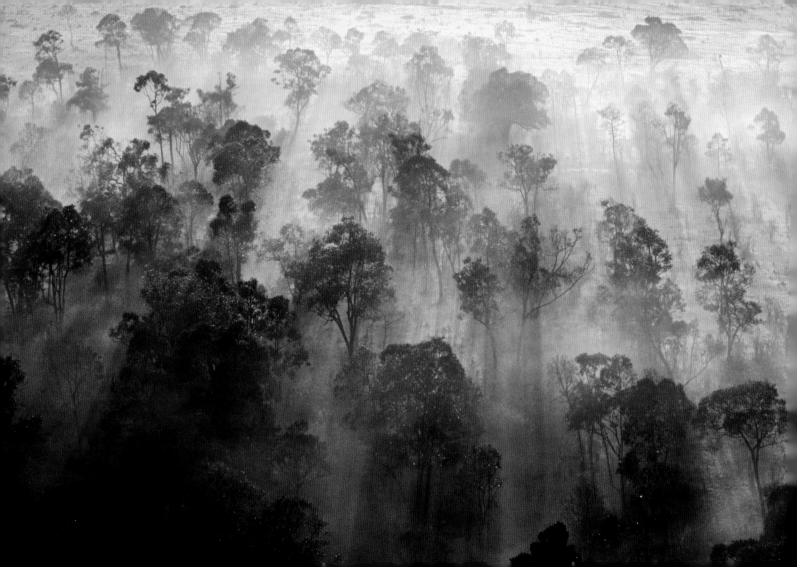

224
The light at sunrise disperses the morning mist in the deciduous forest that covers some parts of Masai Mara National Park, in Kenya.

226 and 227
Waterfalls and impetuous rivers interrupt the monotony of the dense equatorial forest that covers the Aberdares massif, in Kenya.

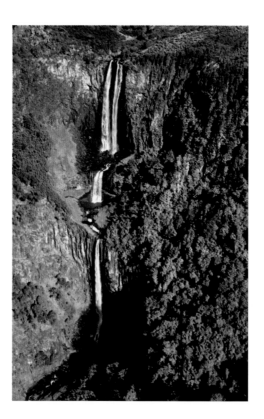

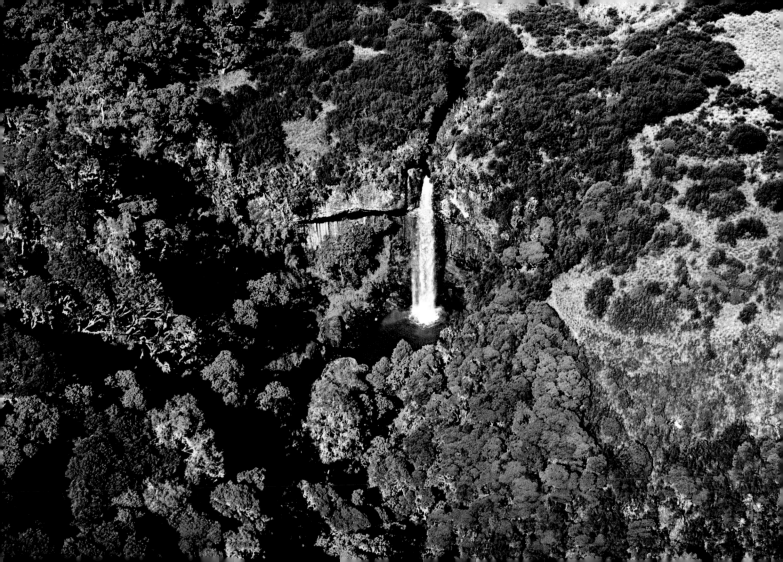

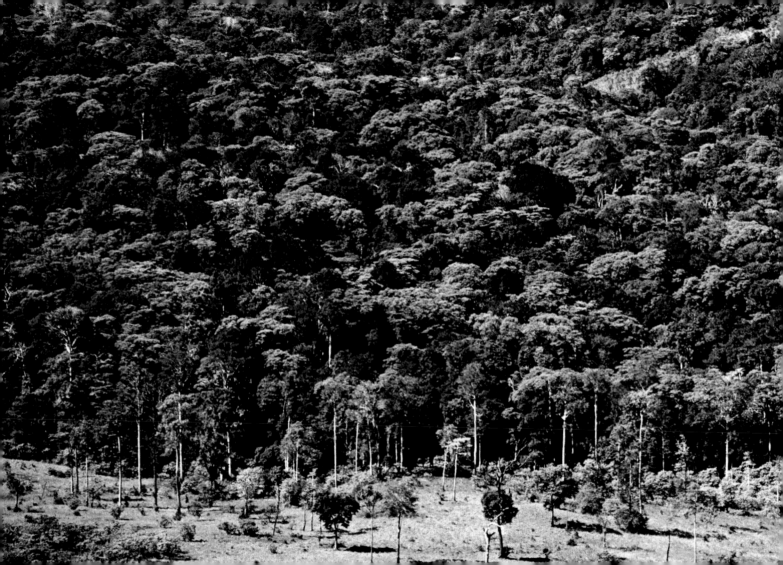

228-229
The Kakamega Forest, near Kisumu in Kenya, is famous for the abundant variety of reptile species and endemic birds of the zone.

230-231
A herd of elephants crosses an
area with baobabs in Kruger Na-
tional Park, South Africa.

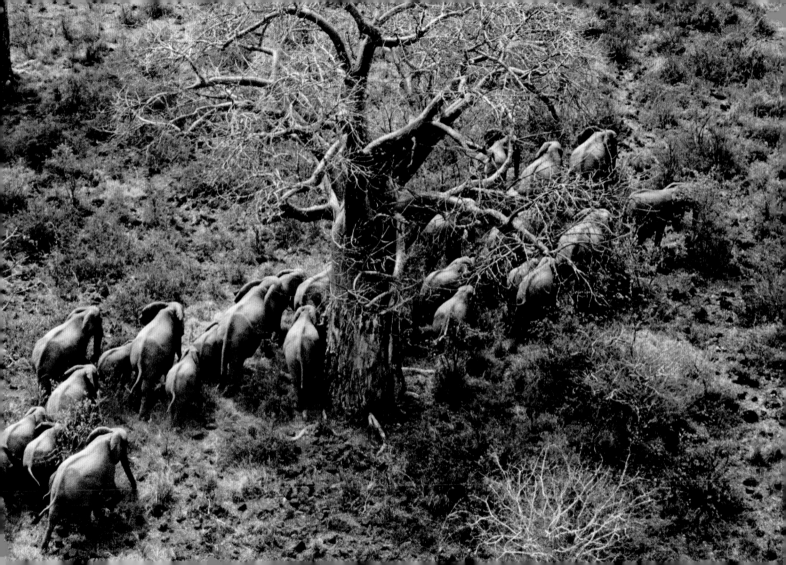

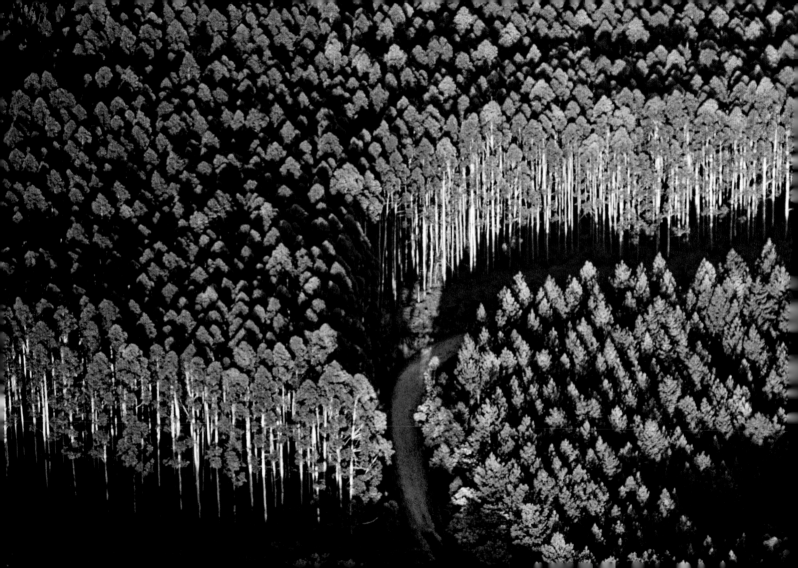

232-233
In many zones of the KwaZulu-Natal, in South Africa, the original forest has been transplanted by endless plantations of eucalyptus.

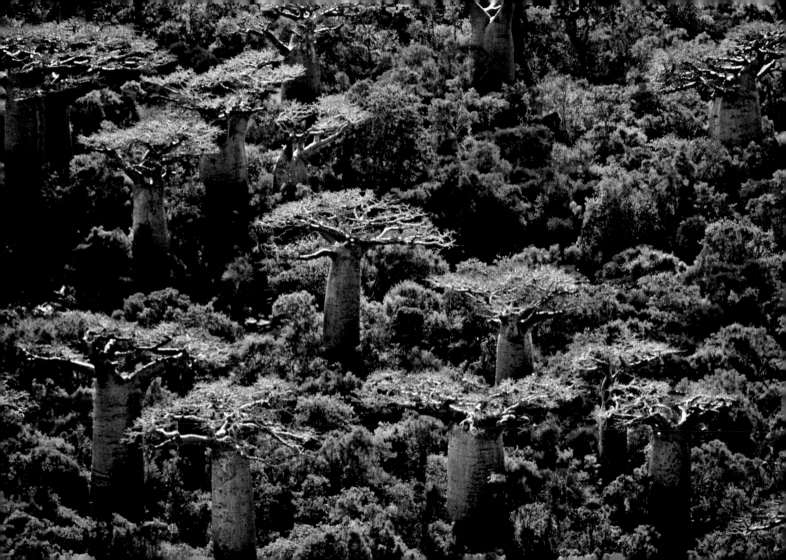

234 and 235
The forests of Madagascar, rich in animal species and endemic vegetation, are considered the naturalist's "Promised Land."

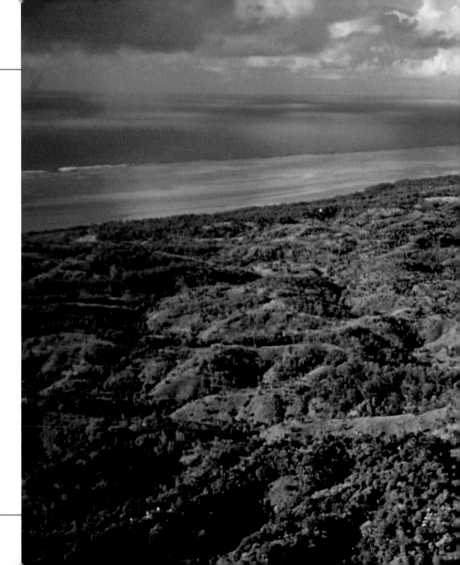

236-237
A thick shroud of lush tropical vegetation covers the internal areas of the island of Sainte Marie, on Madagascar's eastern coast.

238-239
A mangrove forest characterizes the Betsiboka River Delta in Madagascar.

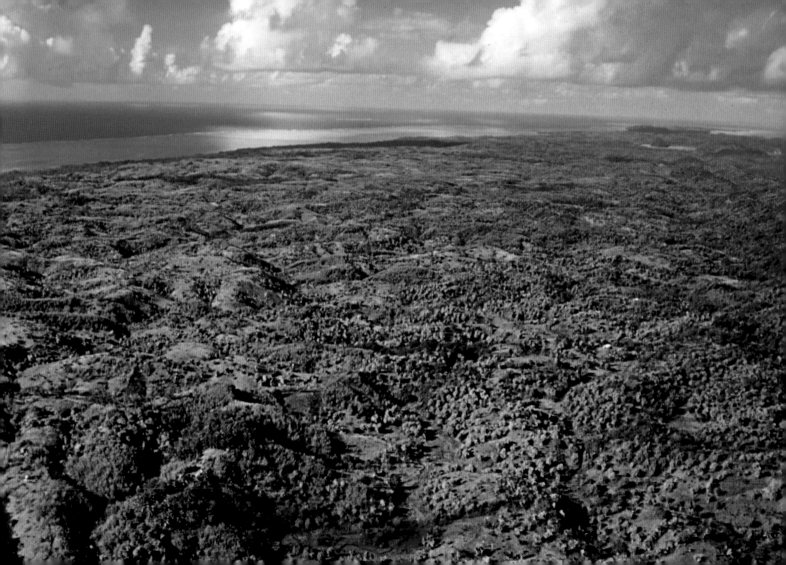

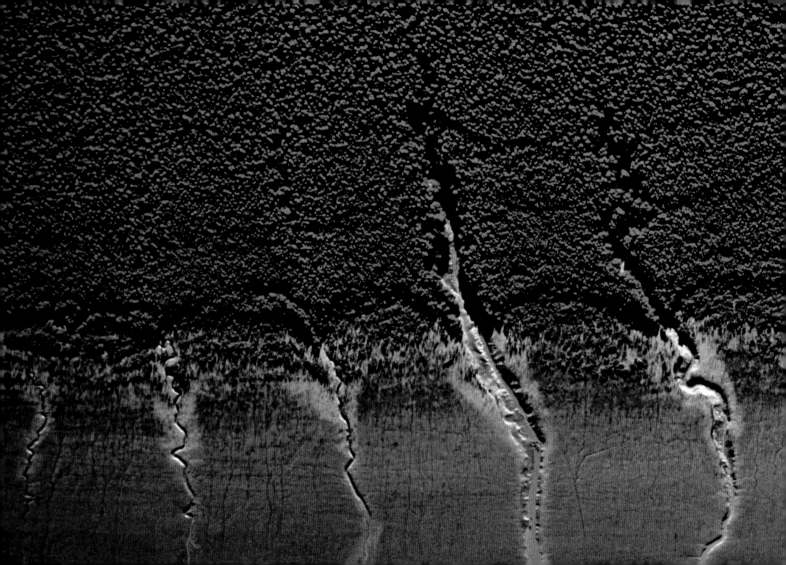

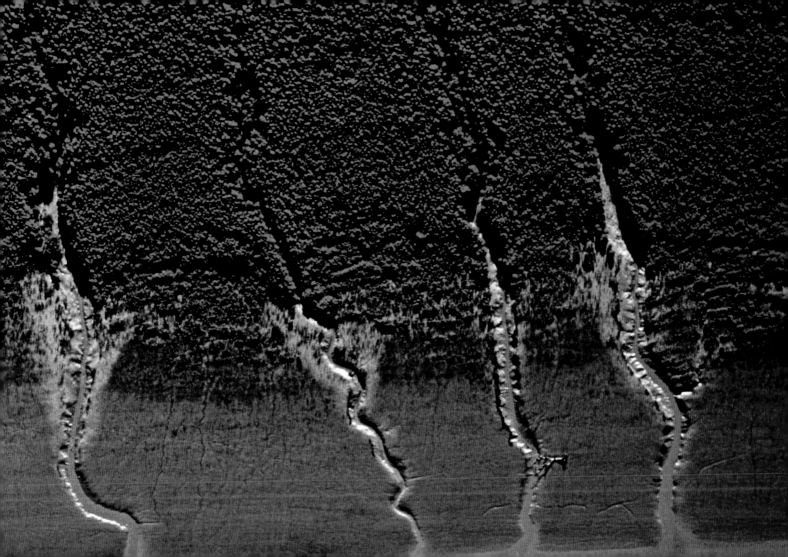

240

WHERE NATURE IS SOVEREIGN

Flying High

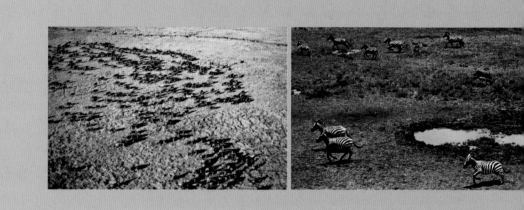

FLYING HIGH AFRICA

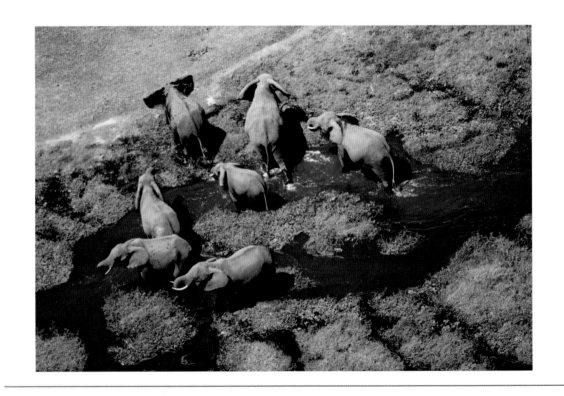

241
Gnus in the Ngorongoro crater (left) and zebras
in the Serengeti national park (right), in Tanzania.

What is the savannah? In Africa, it means all that is not forest, desert or mountains; therefore, it is brush, steppe, prairie. As far as the eye can see, are grasses and trees in varying conditions according to the amount of available water.

The savanna is a highly variable system in space and time: in the space of just a few miles, you can pass from semi-desert to humid zones where tall lush trees grow. Rains, generally seasonal, can be extraordinarily abundant or absent.

Often, the arid periods, usually from three to eight months in a year, last long enough to threaten the survival of man and animals. The grass turns to dust, wells run dry and daytime temperatures become unbearable.

For inhabitants of the savanna, mostly herbi-vores, it is imperative to migrate in search of new grazing land: millions, united in immense herds, begin their epic migration towards less hostile areas. Whoever has witnessed this unique spectacle can never forget it.

The savanna is the Africa narrated in adventure books, grandiose and primordial, bursting with life: in few other places is the fauna so abundant in quantity and variety of species.

The great African mammals, in the past exterminated by indiscriminate hunting, are now mostly confined to vast national parks. Selous in Tanzania and the smaller Addo National Park were created especially to save the remaining population of South African elephants from extinction. Amboseli in Kenya is an icon of international tourism

242
In the hottest hours, elephants seek relief in the marshes that
occupy the southern part of Amboseli National Park,
in Kenya.

Where Nature is Sovereign

whereas parks such as Gonarezhou and Mana Pools in Zimbabwe are lesser known. Parks are located in inaccessible regions like Garamba in the Congo and the parks of southern Ethiopia; others such as the historical Kruger, on the border between South Africa and Mozambique, are accessed with well-serviced streets and complete with all possible accommodation.

Each of these natural sanctuaries is unique. In these wild geographical locations, there are excellent sites where time seems to have stopped at the origins of life: Serengeti, Maasai Mara and Ngorongoro in Tanzania and Kenya and Etosha in Namibia hold visions of open spaces, grass, stone polished by the wind. In Africa, paradise has an evasive profile. The Serengeti Maasai Mara complex covers an area of nearly 640 acres, between Victoria Lake and the Ngorongoro massif. The desolate Loita plains mark the northern border of this ecosystem.

Few other regions of Africa have such a high concentration of wild animals. Numbers speak for themselves: 1,300,000 gnus; 200,000 zebras; 250,000 Thomson gazelles; 20,000 buffalos; 8,000 giraffes. If these numbers are not sufficient, add 200,000 antelopes of diverse species, a couple million ostriches, 800 elephants, 1,500 lions and an unknown number of other less obvious creatures. Put all these species within a landscape that seems constructed for a film set and you will get a vague idea of the Serengeti.

According to Gorge Shaller, who spent years of his life studying the behavior of lions in the Serengeti, it is the "quintessence of Africa." In this setting, the most amazing migration on the Earth takes place: star of this show is the gnu, symbol of the Serengeti. Rather homely and seemingly clumsy, with a large head and hump covered by a scanty mane, the gnu is actually a perfectly suited to its environment. No grass, however sturdy, can resist its jaws.

This virtue, however, poses a problem when the

Where Nature is Sovereign

population of gnus grows too high and they overgraze their habitat. With the onset of the dry season, the vegetation on the plains begins to dwindle: this is the sign for the herds to leave, the beginning of the long journey that will take them to the promised lands of the Maasai Mara, rich in water and grazing land.

The first rains mark the return to the southern prairies, last stop of a circular journey 500 miles long. Continually moving in the Serengeti, the gnus in Ngorongoro are stationary. Sounding like a hiccup, a catch in the throat, Ngorongoro is the name of a gigantic volcano surrounded by foggy forests: on the rim of its crater, at 8,200 feet, it rains often and can be very cold.

Descending s to the bottom of the caldera, almost 2,000 feet deep and surrounded by steep walls, the contrast is strident, like entering into another world. The jungle suddenly gives way to endless grassy plains, broken by acacia forests, swamps and salt lakes.

The climate and life conditions are similar to those in the nearby Serengeti savanna. All of the varied African fauna, rhinoceros and elephants included, are present in a great quantity. Often compared to a great natural zoo, within the relatively restricted space of Ngorongoro (97 square miles) each living species has a specific niche. To leave one's territory is to run great risks. This stressful situation, similar to that found in a crowded metropolis, creates anomalous behavior. At Ngorongoro the classic way of life in the savanna does not count: the laws of social coexistence, survival strategies, hunting and defense are overturned. Therefore, the gnu, stripped of its migratory instinct, forms small groups completely independent one from the other, while the hyena forms small competitive clans.

The vital space, so precious in Ngorongoro is instead abundant in Etosha, the biggest national park in Namibia. In the Ovambo language, Etosha means "place of dry water."

Where Nature is Sovereign

Exactly what is visible from above is a grey expanse lacking vegetation that resembles the bottom of an empty ocean. Geologists, not poetic by nature, say that Etosha was once an enormous lake, fed by the waters of the Kunene River.

Etosha is that which remains: a huge saline shell, twice the size of Valle d'Aosta in Italy.

The protected area, with an area of more that 5,400 acres, includes a mosaic of ecosystems that vary from open plains to seasonal forests. Even with a chronic lack of rainfall that must nourish a series of permanent wells, Etosha supports one of the richest animal populations in Africa. Elephants are omnipresent, there are tens of thousands of antelopes and you can rarely look at the horizon without seeing the silhouette of a giraffe. Like all paradises, Etosha has its problems: an endless fence separates it from the world of man, dissecting the migratory movement into two corridors and altering the natural balance between the diverse species.

The number of predators is constantly controlled and the elephants are victims of cyclical programs of selective killing. Left on its own, the park would rapidly transform itself into a desert. Etosha is a colossal laboratory in which new solutions are investigated with in an endeavor to conciliate progress and preservation: the future of the great wild African fauna depends on the results of this grand experiment.

A cloud of dust envelops this running herd of bufalo in the savanna of Amboseli National Park, in Kenya.

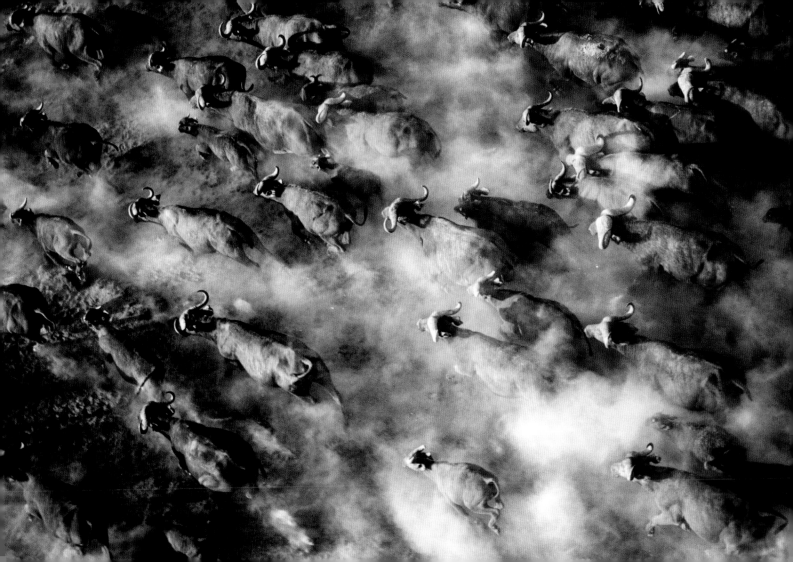

248-249
The great umbrella shaped acacia are typical of the landscape in Rift Valley at Maralal, Kenya.

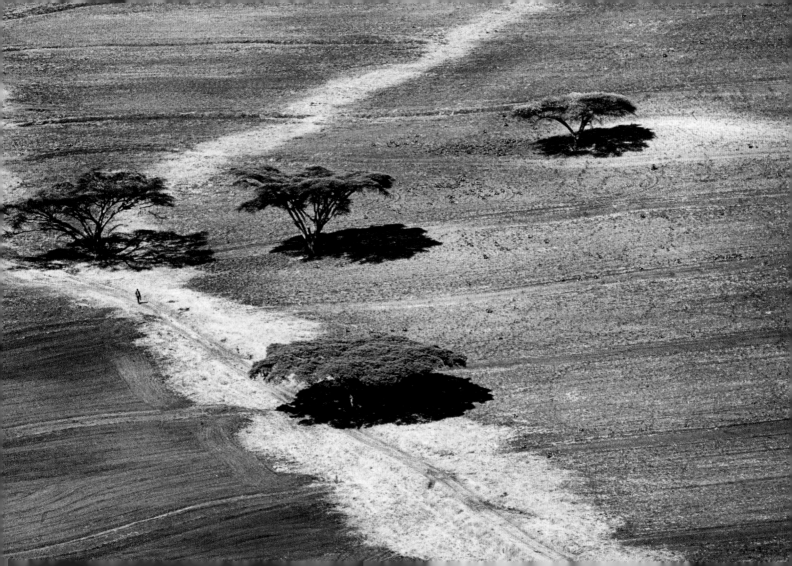

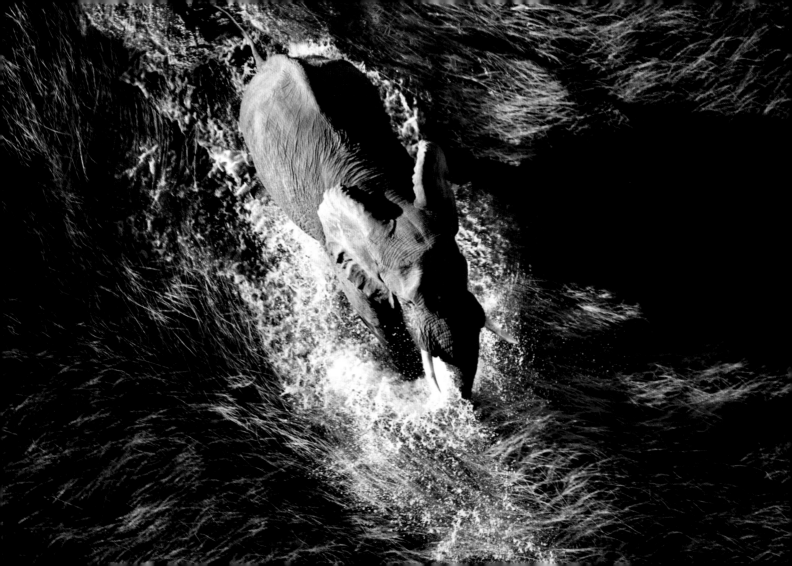

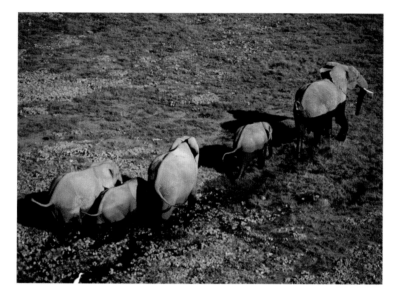

250
An elephant advances in a swamp area of the Okavango River, in Botswana.

251
The acquatic plants that grow in the swamps of Amboseli National Park, in Kenya, are a precious source of food for the elephants.

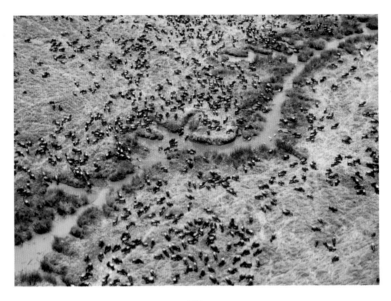

252
For the gnus that migrate towards the pastures of Masai Mara National
Park, in Kenya, the Mara River is an obstacle to overcome.

253
The abundance of water is essential for the survival of the zebras in
Amboseli National Park, in Kenya.

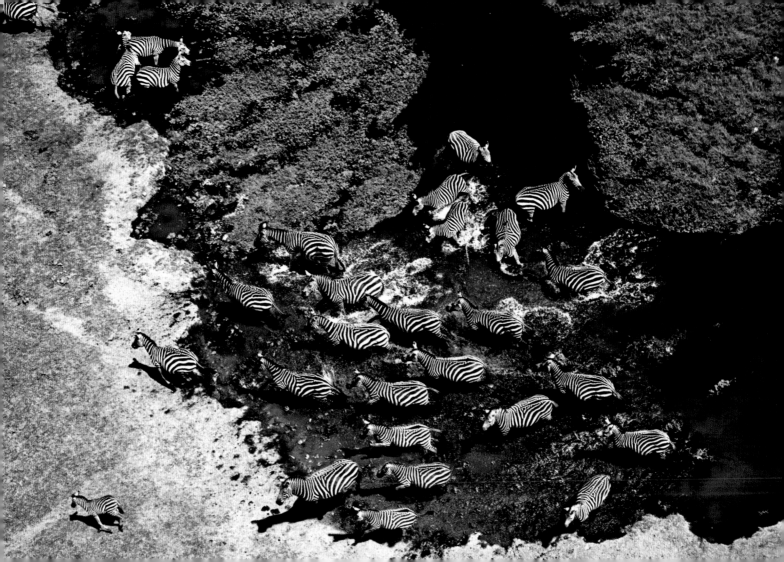

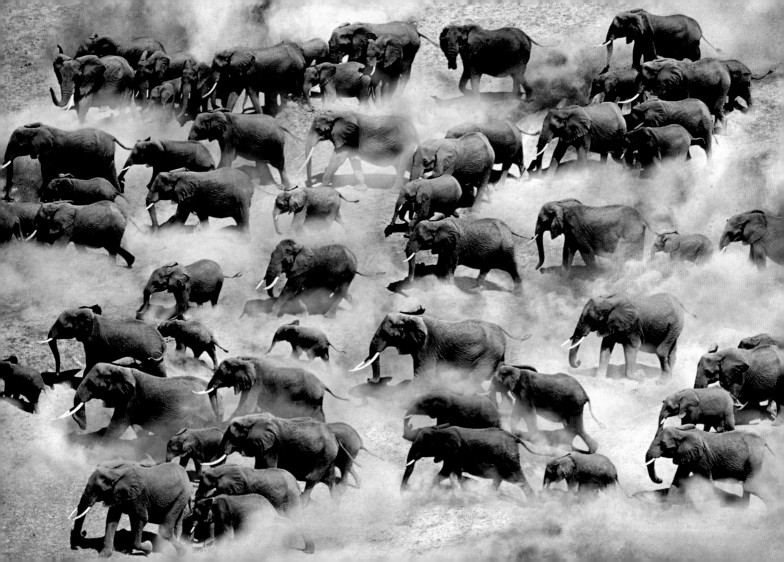

254
Elephants in Amboseli National Park, in Kenya, easily attain and surpass a weight of five tons.

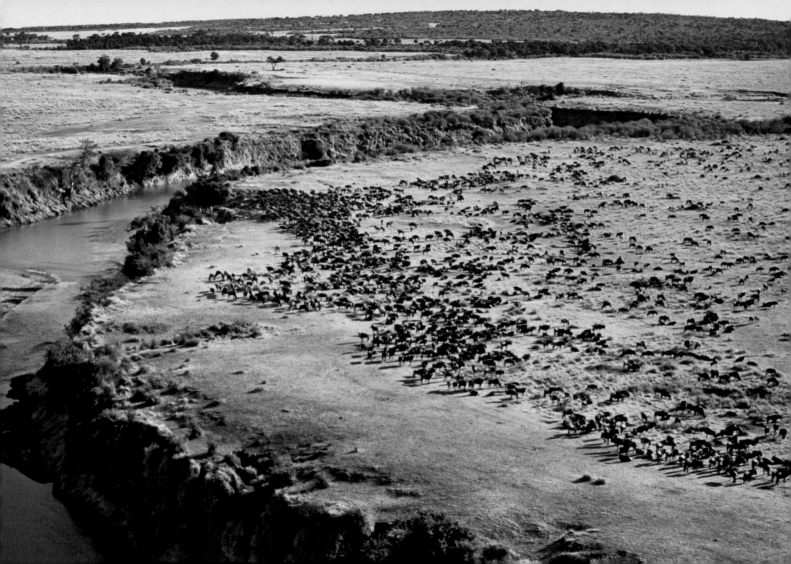

256
At the end of the dry season, hundreds of thousands of gnus gather in the prairies of the Masai Mara national park, in Kenya.

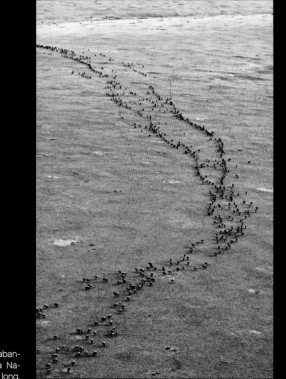

258 and 259

At the start of the rains the gnus abandon the savannas of Masai Mara National Park, forming herds 25 miles long.

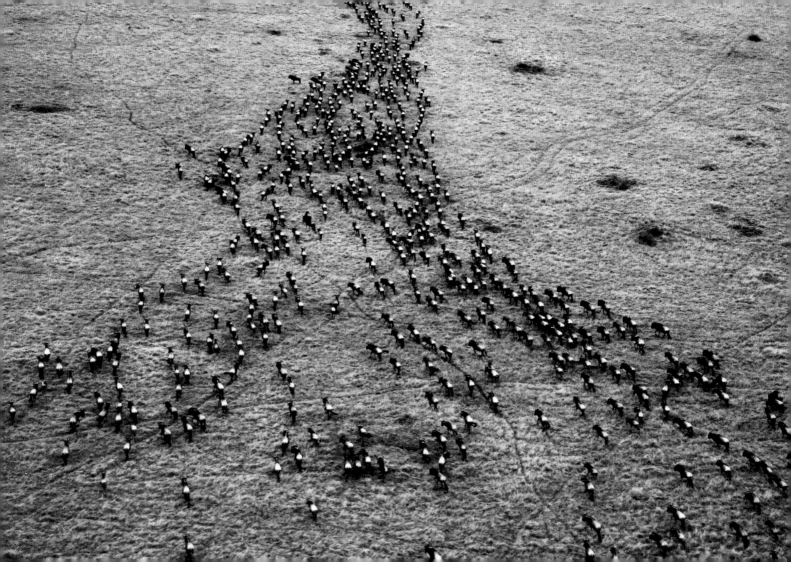

261
From the Masai Mara park, in Kenya, a herd of gnus and small group of zebras, migrate south towards Serengeti National Park.

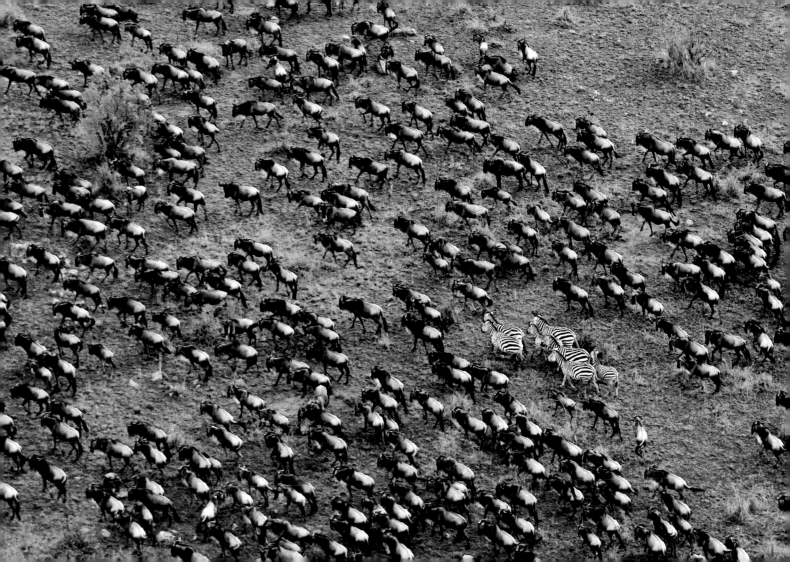

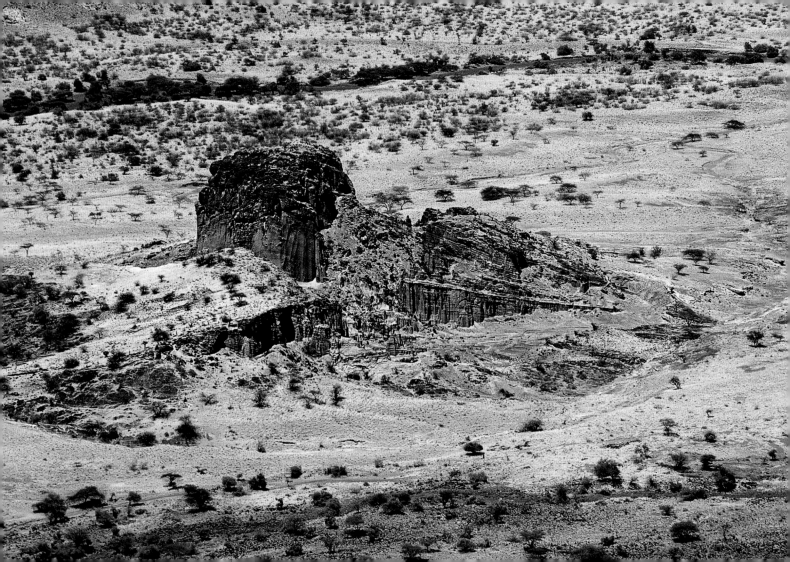

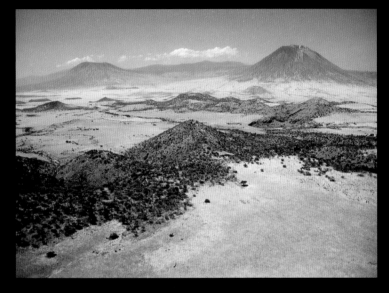

262
The suggestive Olduvai Gorge, not far from the Ngorongoro crater, is
one of the most famous archeological sites in Tanzania..

263
The volcanic cones that appear on the horizon lend a primordial
charm to the Rift Valley landscape. in Kenya.

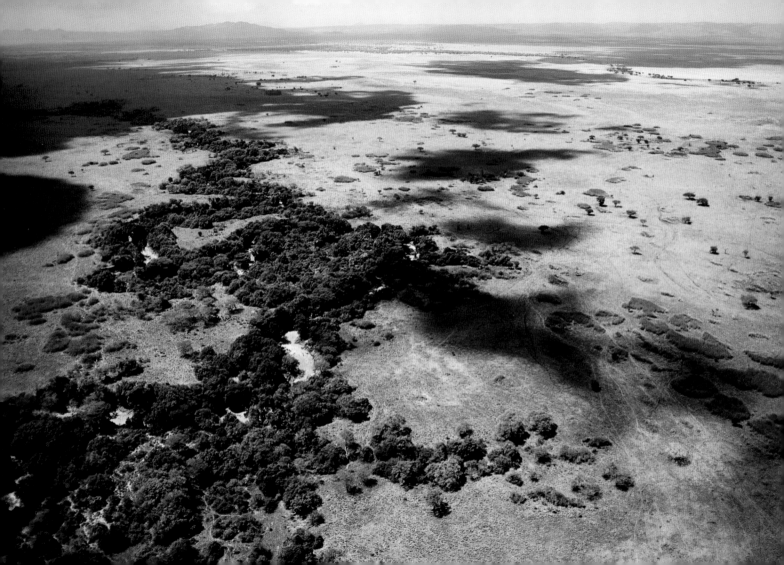

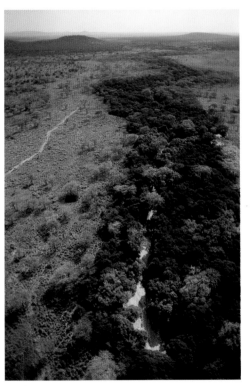

Where Nature is Sovereign

264 and 265
A long, dense forest marks the bed of the Mbalageti River in its long journey across Serengeti National Park, in Tanzania.

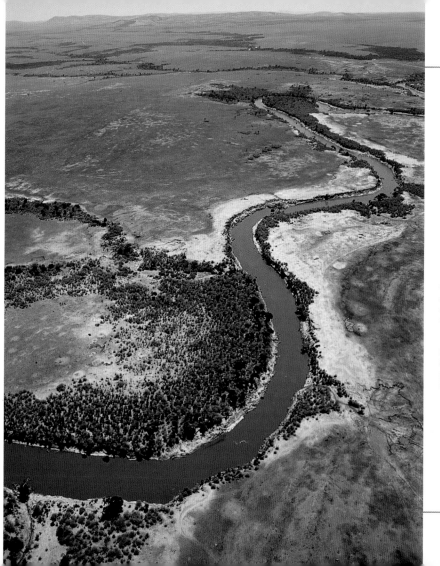

266
Savannas as far as the eye can see and clumps of deciduous forest accompany the Mara River on its way through northern Tanzania.

267
In the various ecosystems of Serengeti National Park, live approximately 30 species of great herbivores and 500 types of birds.

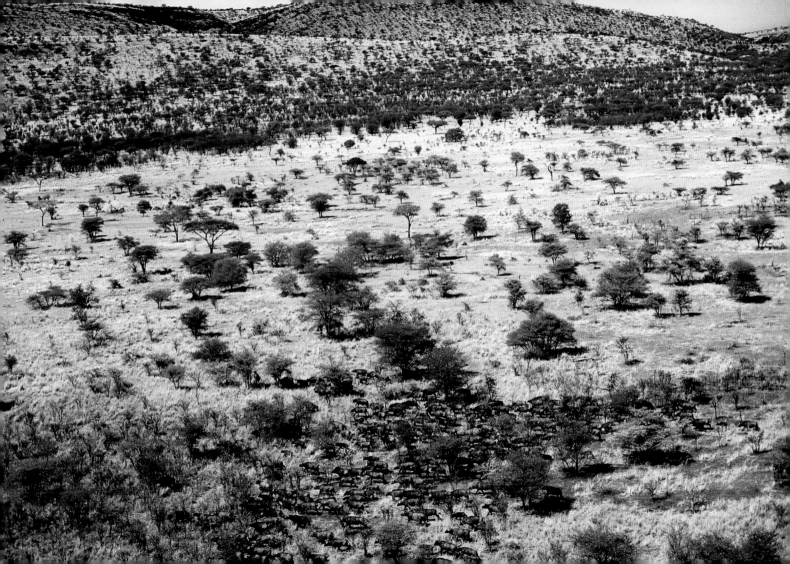

268
Savannas, bush land, rain forest and swamp define the ecosystem of
Serengeti National Park in Tanzania.

269
In the shade of an acacia, a giraffe seeks relief from the torrid heat in
Serengeti National Park, in Tanzania.

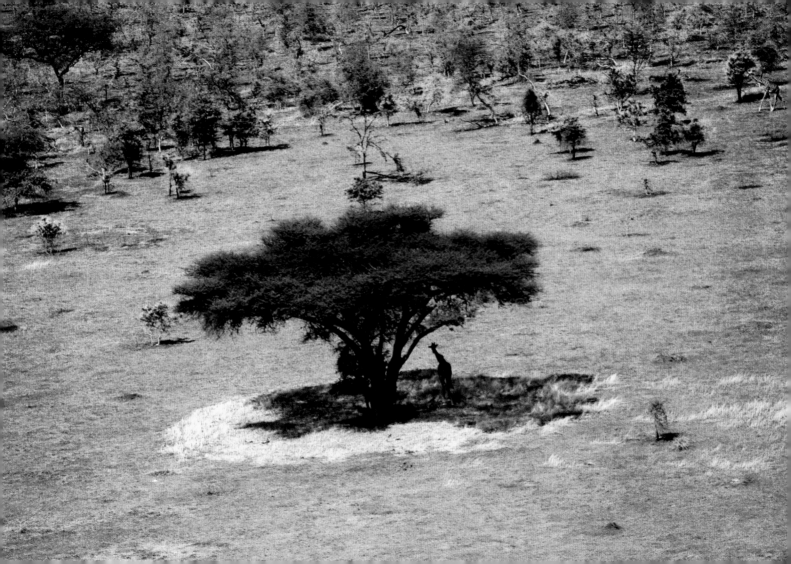

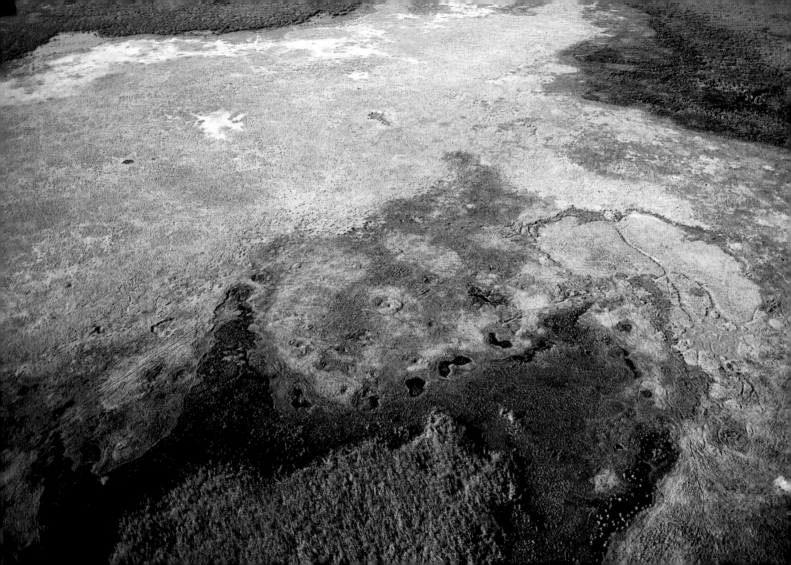

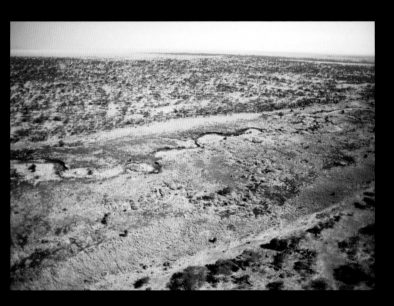

270 and 271
At the height of the dry season many ponds and marshes in
Serengeti National Park, in Tanzania, are transformed into muddy
puddles.

272-273

The shallow, calm waters of the rivers that cross Serengeti National Park, in Tanzania, are the ideal habitat for big herds of hippopotami.

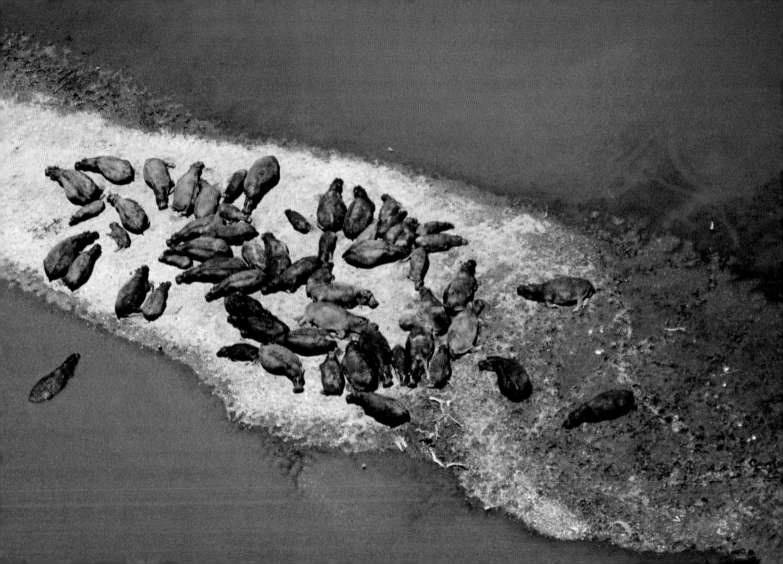

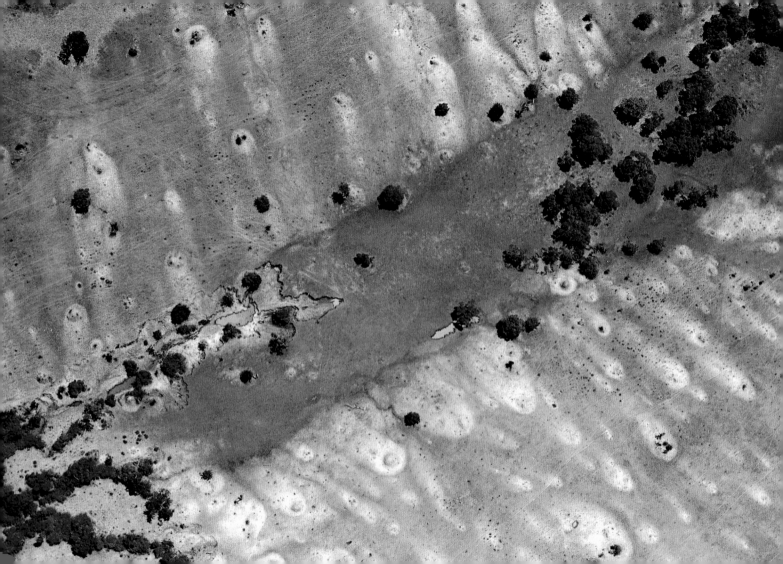

274
The cyclical alternation of dry and wet seasons influences the muta-
ble landscape of Serengeti National Park, in Tanzania.

275
The permanent rivers in Serengeti National Park, in Tanzania, are all
tributaries of Lake Victoria.

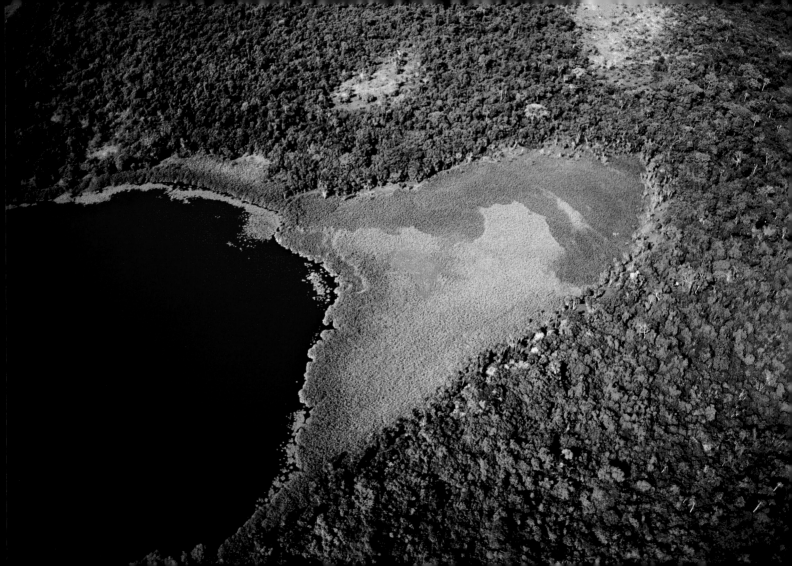

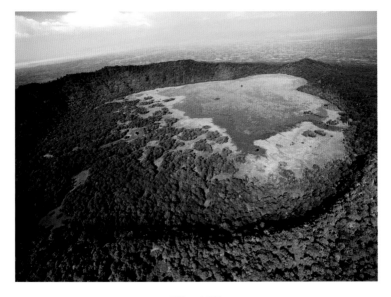

276 and 277
Small lakes sometimes form at the bottom of the craters that dapple
the plateaus of the Ngorongoro Conservation Area, in Tanzania.

278
The vast open spaces of Serengeti National Park, in Tanzania, justify the maasai origin of its name, that signifies "extended place."

279
The elephants prefer the swampy areas and the thorny brush land found predominantly in the northern part of Serengeti National Park, in Tanzania.

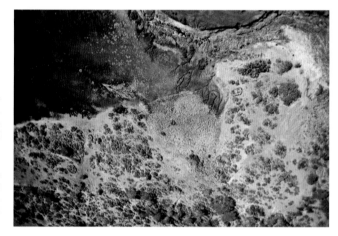

280
Natural springs feed the Gorigor swamp at the foot of the southern wall of the Ngorongoro crater, in Tanzania.

281
The form of Lake Makat, swollen after recent rains, stands out against the yellow grass in the Ngorongoro crater, in Tanzania.

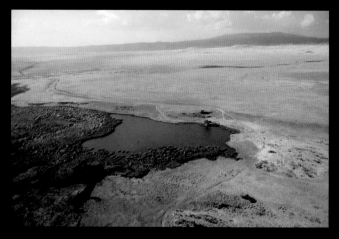

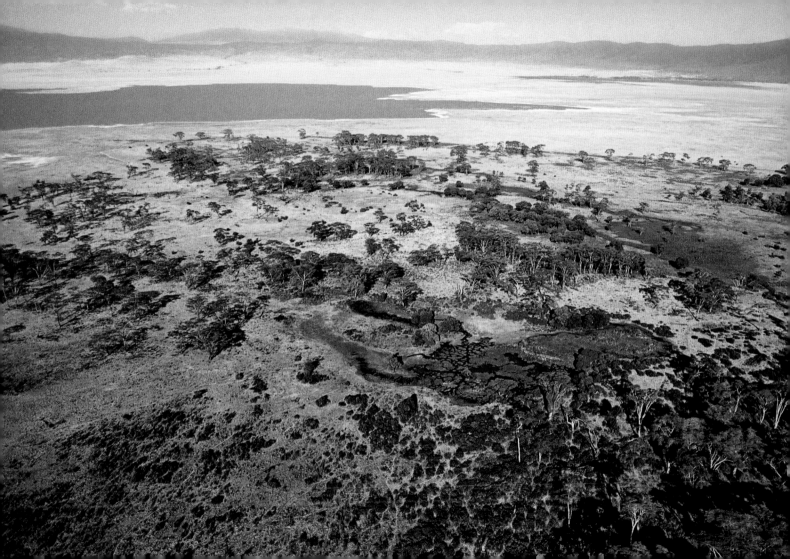

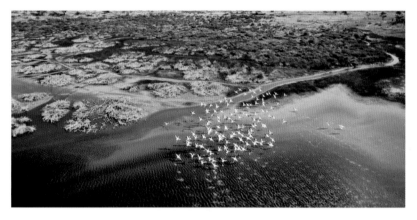

282 and 283
Great flocks of pink flamingos and a myriad of other birds populate
the swamps and marshes of the Ngorongoro crater, in Tanzania.

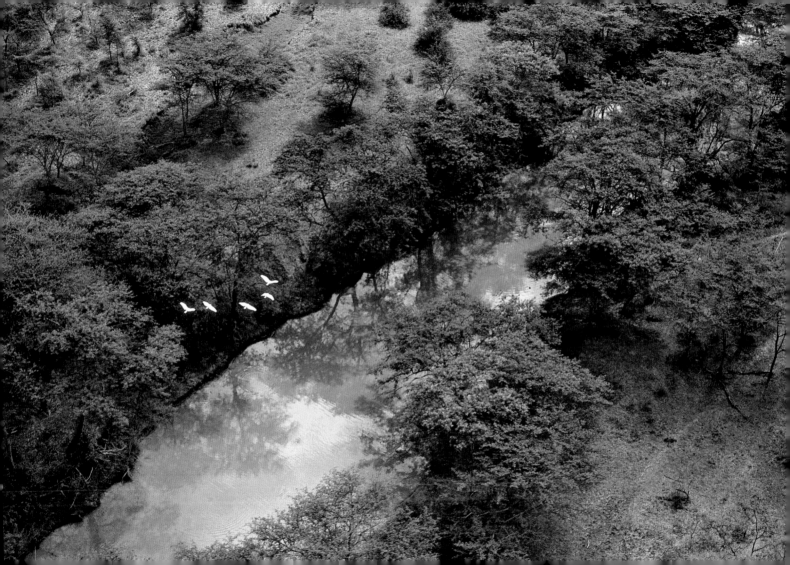

284 and 285
The vast marshes that line the shores of the Chobe River, in Botswana, attract the elephants in Chobe National Park.

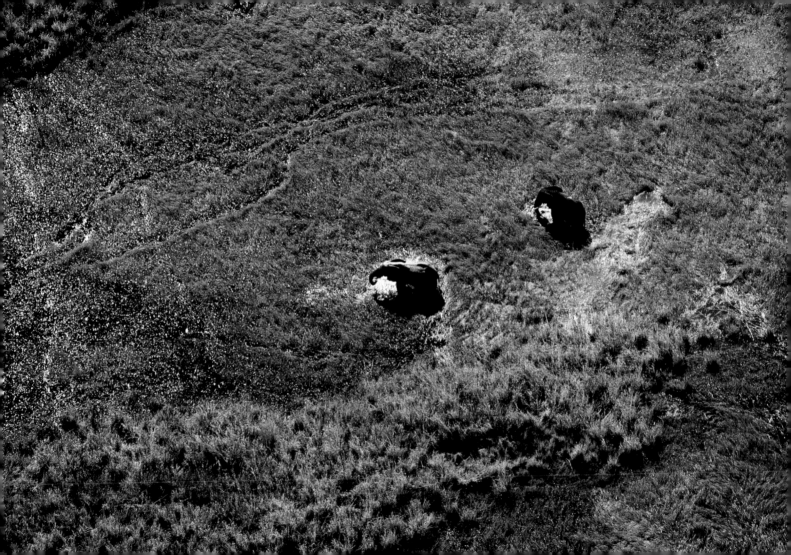

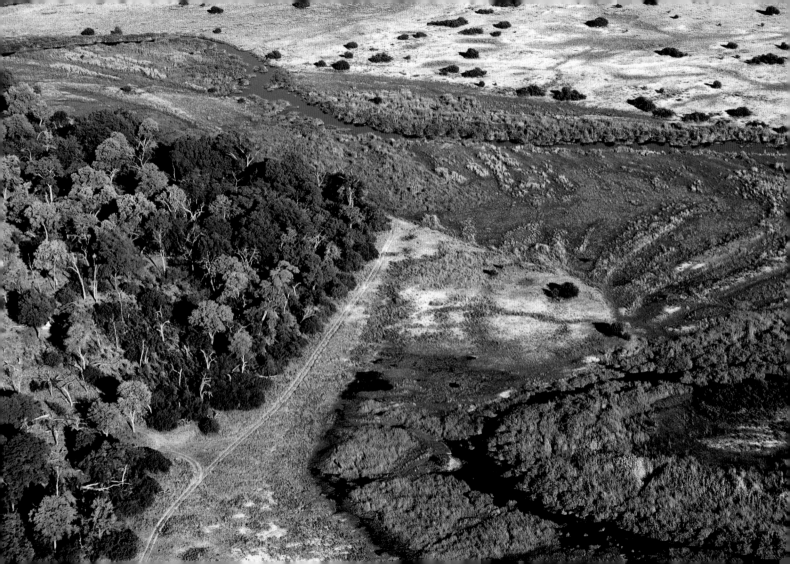

286 and 287
The northern section of Chobe National Park, in Botswana, is characterized by the presence of lagoons and vast arboreal areas.

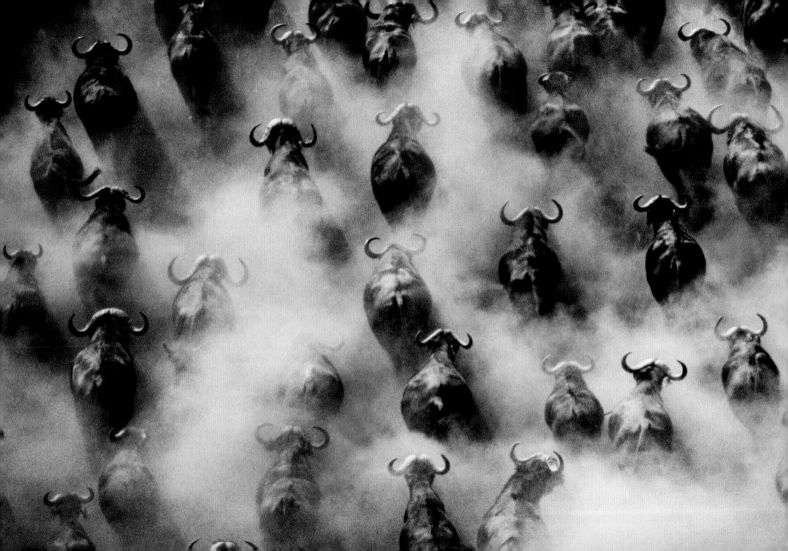

288 and 289
A herd of buffalos runs across the dusty plain of Chobe National al Park in Botswana.

290-291
A huge herd of zebras cross a field in the delta of the Okawango River, in Botswana.

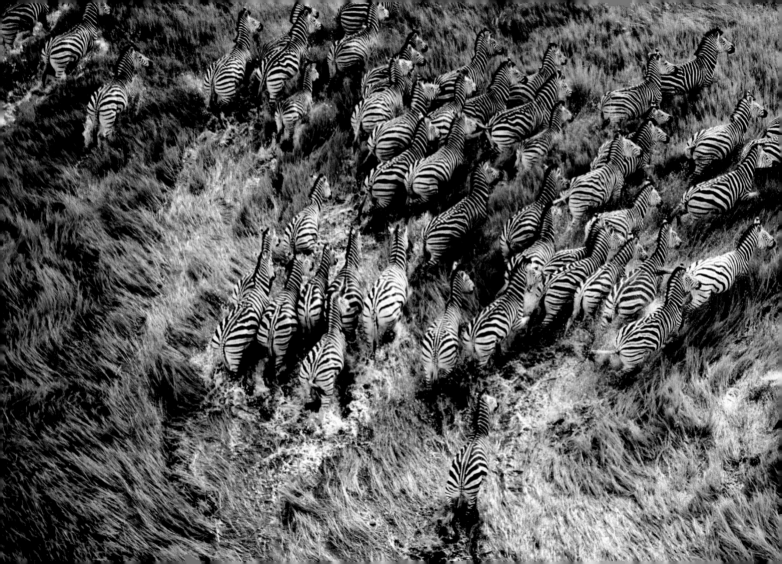

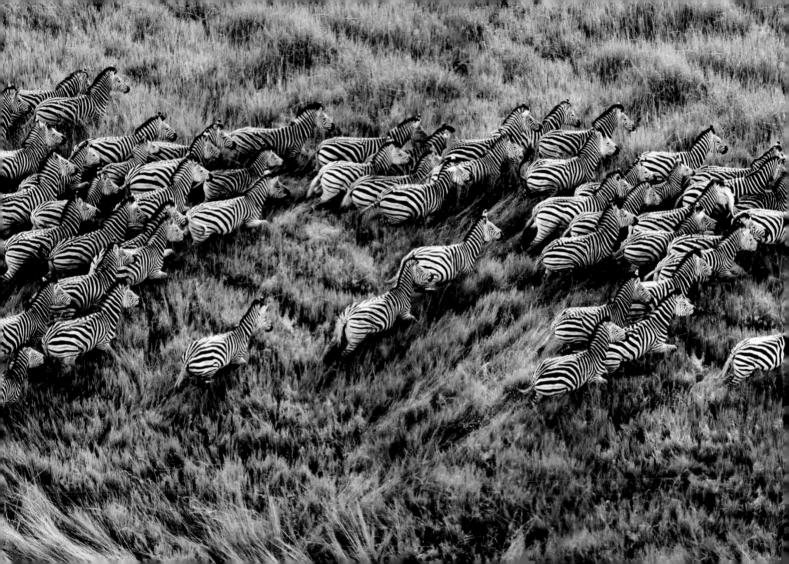

FLYING HIGH AFRICA

293
Not at all frightened by the noise of the airplane, this male lion in Chobe National Park, in Botswana, seems ready to attack.

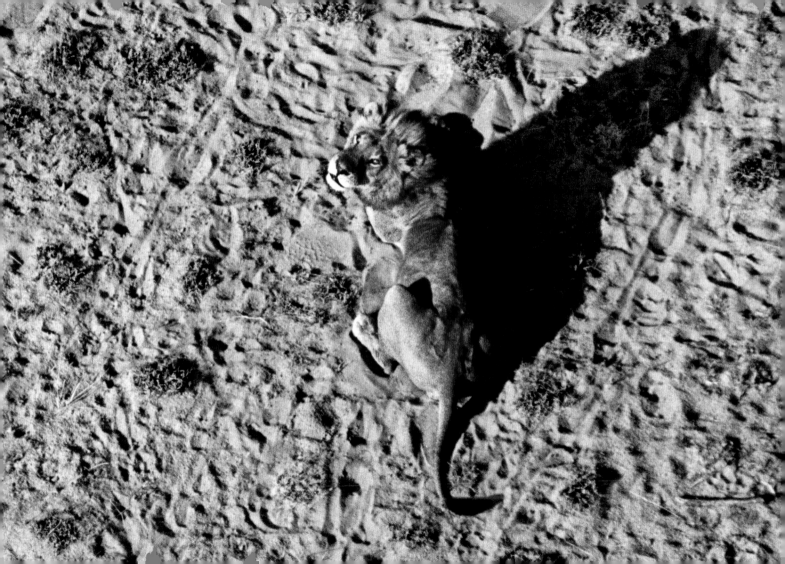

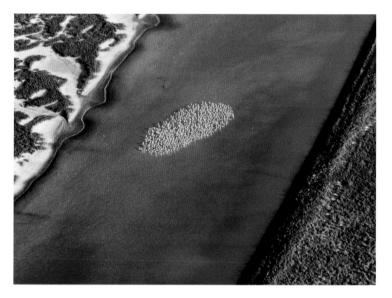

294 and 295
Great flocks of pink flamingos inhabit the canals that feed Namibia's
Lake Etosha during the rainy season.

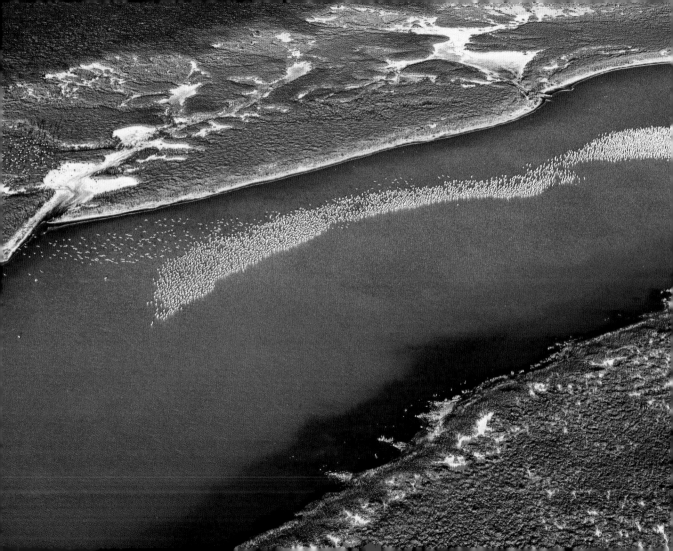

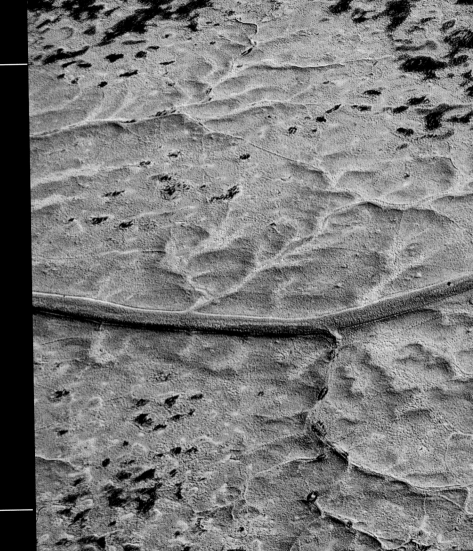

296-297

The Etosha National Park, in Namibia, from above seems like a flat, endless grey expanse.

298-299

The shallow, salt-water ponds that dapple Etosha lake, in Namibia, are destined to vanish with the arrival of the dry season.

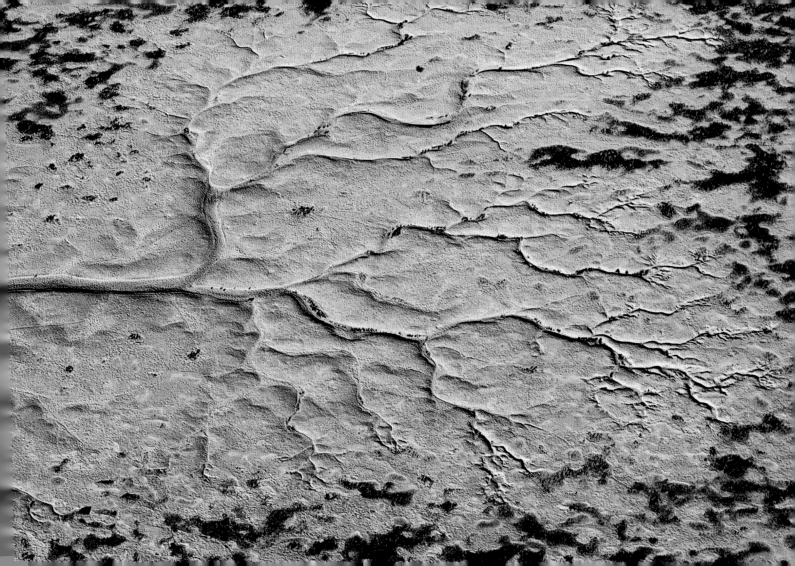

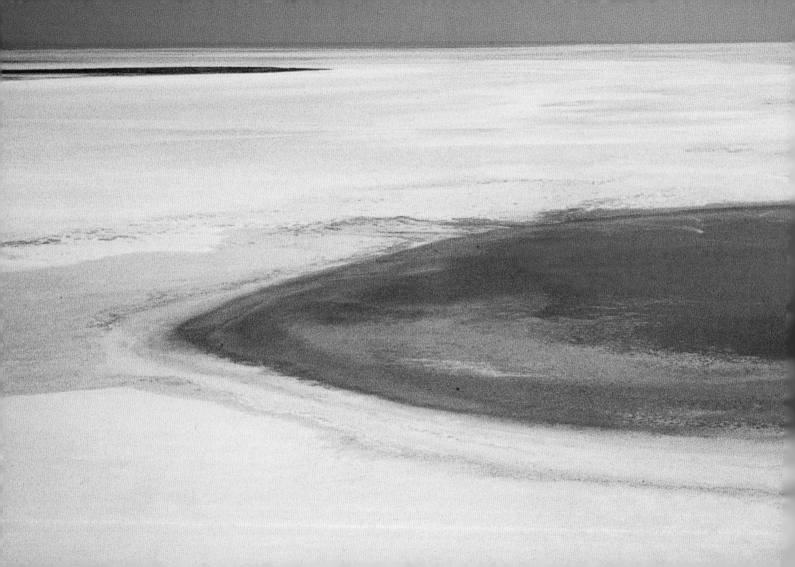

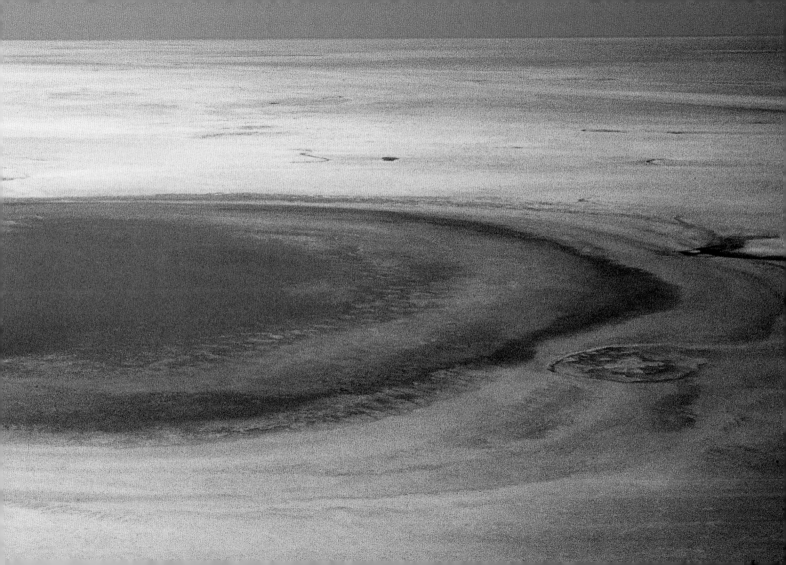

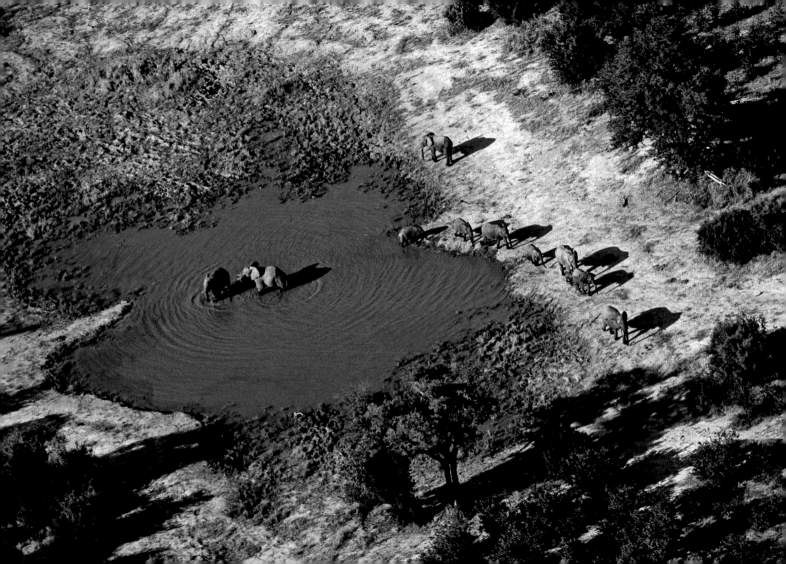

300
A mixture of water and salty dust lends the typical grey color to the elephants of Etosha National Park, in Namibia.

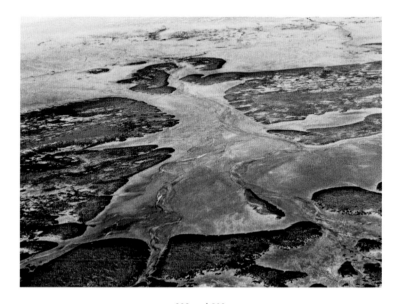

302 and 303
As these images demonstrate, the landscape in the Etosha National
Park, in Namibia, changes aspect drastically according to the season.

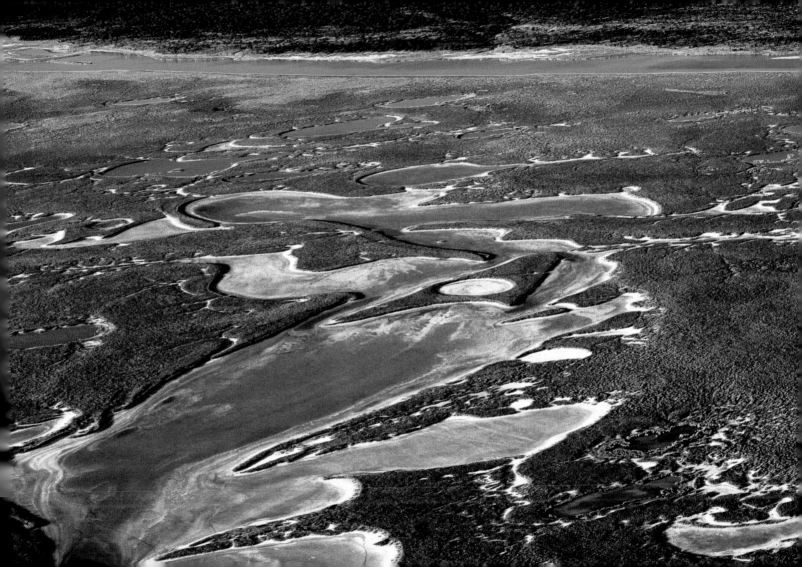

304 and 305
The grass that grows along the shore of the dry Etosha Lake, in Namibia, assures the antilopes a protein and mineral-rich nourishment.

306-307
Saline herbs and thorny undergrowth constitute the dominant vegetation in the arid zones of Etoshas National Park, in Namibia.

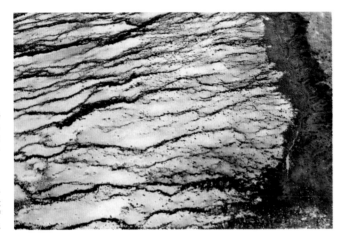

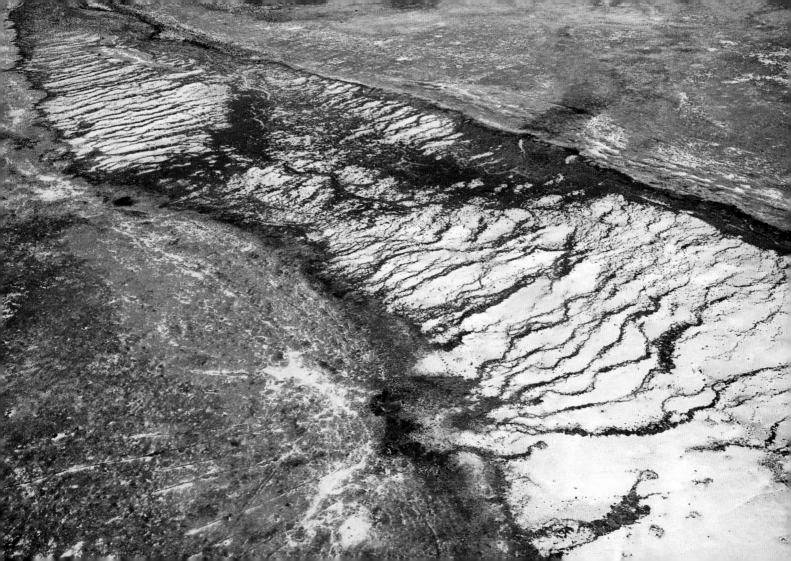

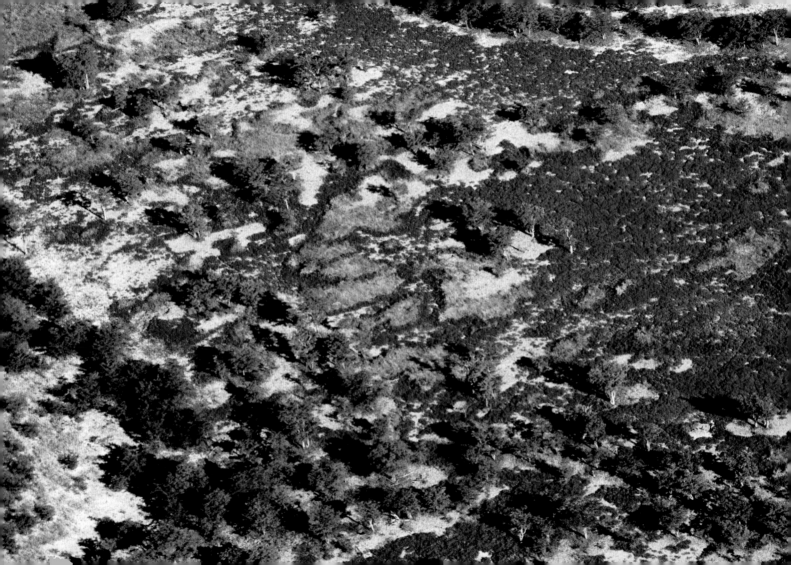

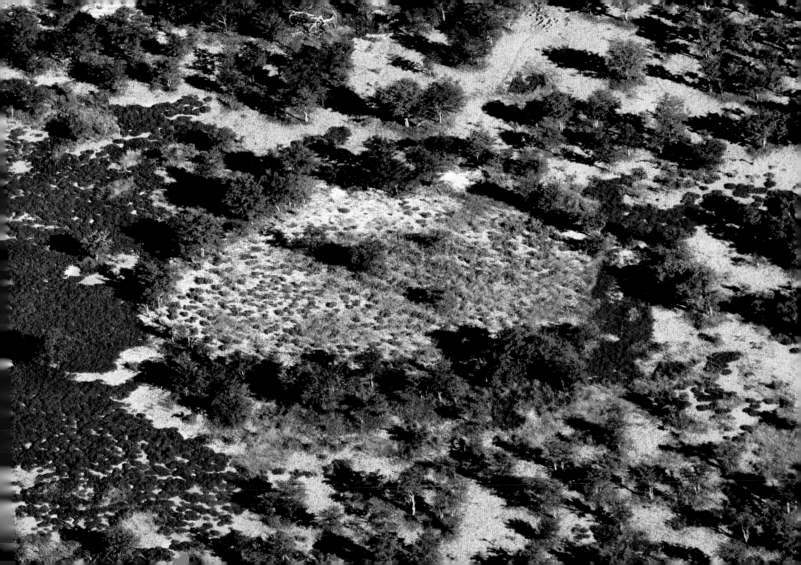

THE SECRETS
OF THE MOUNTAINS

FLYING HIGH

FLYING HIGH AFRICA

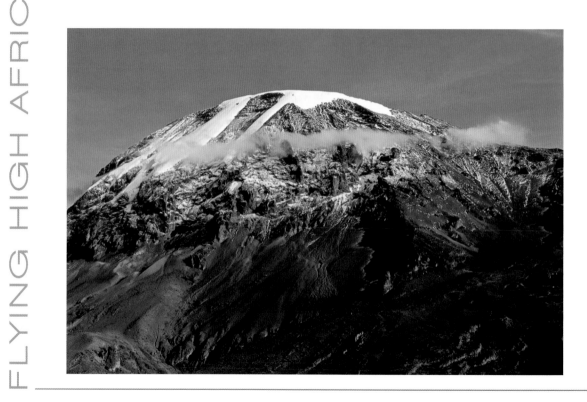

309
The rises of Morocco's Middle Atlantic (left) and the mountains of the Blyde River Valley, in South Africa (right).

In 1848 Johann Rebmann, German missionary, reappeared from a journey in Africa with some incredible news: suddenly, in his travels, he came upon a high mountain whose peaks were white with snow.

Nobody believed him: the presence of ice on the Equator, according to the geographers of that period, was impossible. Rebmann was neither crazy nor suffering from sunstroke, he had seen Kilimanjaro. The highest peak in Africa, at 19,340 feet above sea level, rises solitary in the surrounding plains as if levitating.

For the Chagga, who live at its feet, the mountain has no name; it is simply God's home. Although today Kilimanjaro is the destination of hoards of tourists, climbers and naturists of every age, the native bearers fear its rage. God sleeps, but could awaken at any moment, preceded by the disquieting smoke and rumbles that occasionally emerge from the heart of the mountain. Kilimanjaro is not dead, only dormant.

The devastating effects of ancient eruptions are visible everywhere, scattered over an area of 386 square miles.

The glaciers that envelope Kibo's perfect crater, the tortuous peaks of Mawenzi, the high altitude lava desert that separates the two peaks compose a surreal, almost supernatural landscape. Also dramatic is the variety of ecosystems: it is possible after walking for a mere three days, to pass through the arid savanna to lush forest, from moorland to an arctic environment. In 1926,

310
Kilimanjaro's silouette, in Tanzania, is visibile from almost a hundred miles away.

The Secrets of the Mountains

on the lip of the main crater, at over 1,640 feet high, the remains of a leopard were discovered. No one can explain what folly pushed him to climb that high, to a certain icy death. Kilimanjaro is a place of mystery, suitable for the Roof of Africa. Its younger brother, Mount Kenya (17,221 feet), has a less legendary essence: to begin with, the meaning of its name is clear. Kenya derives from the Kikuyu term *Kere Nyaga*, meaning White Mountain.

Even its appearance for us Europeans is reassuring: three vertiginous rocky spurs, interrupted by small glaciers, could easily fit into the Swiss Alps. Typically African, instead, is the dense jungle surrounding the base of Mount Kenya and covering the nearby massif of the Aberdares. Like Kilimanjaro, Mount Elgon and most of the mountains that dominate the region of the Great Lakes, Kenya is also volcanic.

Other volcanic mountains are Virunga, which occupies the border zone between Congo,

Ruanda and Uganda, as well as Mikeno, Karisimbi, Sabinyo, Muhavura, Nyiragongo and Nyalamgira. Some of these volcanoes reach as high as nearly 15,000 feet; all are above 9,000 feet. Savage, remote, known to be the last refuge for the mountain gorillas, the Virunga volcanoes are known to be extremely active: two of them, the Nyalamgira and the Nyiragongo, have recently been the protagonists of spectacular eruptions, with fatal consequences for the populations dwelling at their feet. In fact, Virunga, in the local language, means "place of fire."

If Virunga is fire, Ruwenzori is water: a true rainmaking factory. The colossal massif, reaching 16,762 feet at the Margherita Point, extends to the border between Congo and Uganda for over 62 miles in length and 31 miles in width: from it the Nile takes its strength, the tributaries that aliment it transform it into a powerful river. The snowy peaks of the Ruwenzori, baptized with the names of queens and explorers, are

The Secrets of the Mountains

the legendary Moon Mountains, imagined by Erodutus and discovered by Stanley 1700 years later. Fantastical definitions that describe the site, domain of the incredible: in no other place on Earth does nature manifest itself with such magnificence. Sixteen inches of monthly rain make Ruwenzori one of the most humid places on the continent.

The vegetation that elsewhere maintains incredible proportions, is here affected by a sort of gigantism: the heath grows 33 feet high, groundsel and lobelia form phantasmagorical forests, the moss forms a thigh high carpet. Enormous worms, 23 inches long, slither in the undergrowth.

The wonders of the African mountains are infinite: what secrets hide in the jungle that covers Mount Cameroon (13,451 feet), solitary sentinel of the Gulf of Guinea? Has the Ethiopian tableland, rich in water and carved by deep valleys, really revealed all of its mysteries?

Its profile, with broken, flattened peaks, called *ambe*, are similar to the mountains of the Sahara: the Tassili n'Ajjer, Tibesti, Hoggar and Ennedi, fruits of geologic disasters preceding man's memory, arise like cathedrals in an ocean of sand.

To the northwest, Morocco's Atlantic mountain range, reaching 13,671 feet in altitude in Toubkal, separates the desert from the Mediterranean and the Atlantic.

In the far south, other chains are full of peaks, needles, columns pyramids and all the possible forms that a child's fantasy can identify in a living stone formation. Like teeth, seen in Drakensberg or the Dragon's Mountain, last bastion of the coral reef that extends from Cape Good Horn beyond Lesotho.

For the Bushmen, Drakensberg was a sacred place, like every mountain in Africa, big or small: a piece of land that approaches the sky, reaching towards the world of the spirits.

315
Interminabile slopes of pebble and crushed stone separate the cultivated fields of
this village from the snowy peaks of Toubkal, Morocco's highest mountain.

316-317
During the winter season an abundant blanket of snow covers the Toubkal massif
and the highest peaks Morocco's High Atlantic.

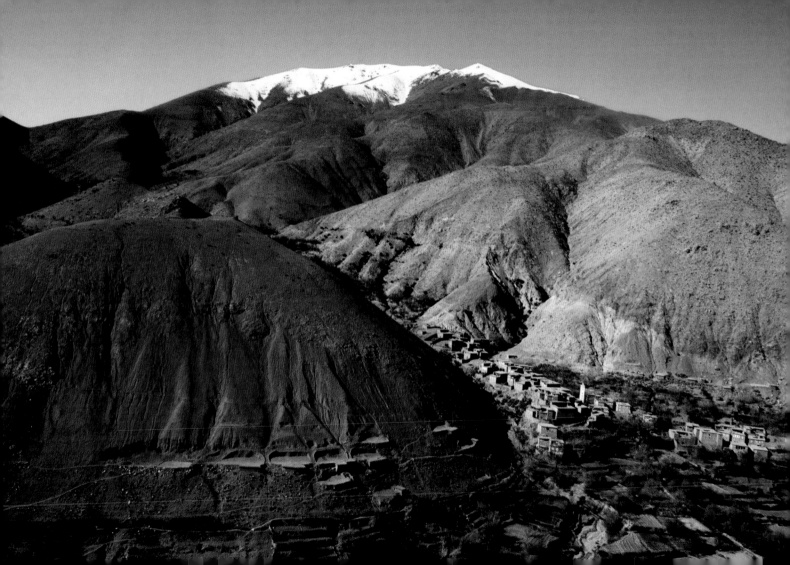

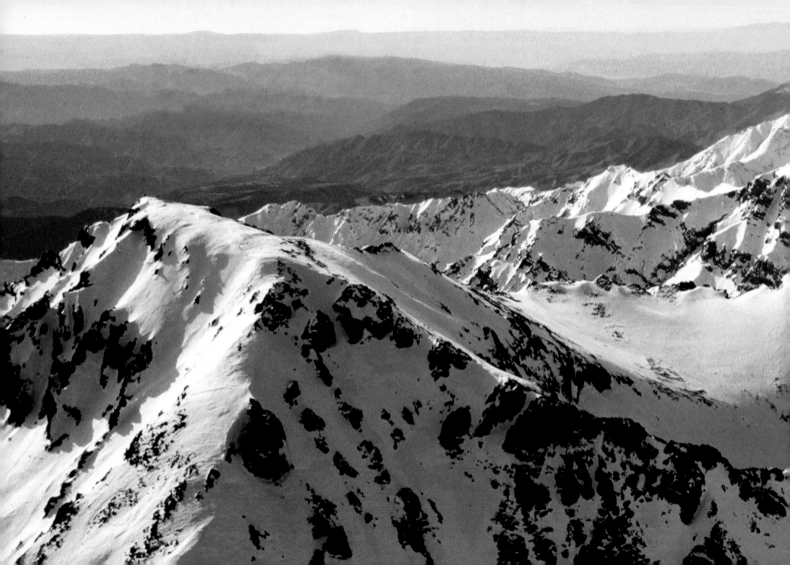

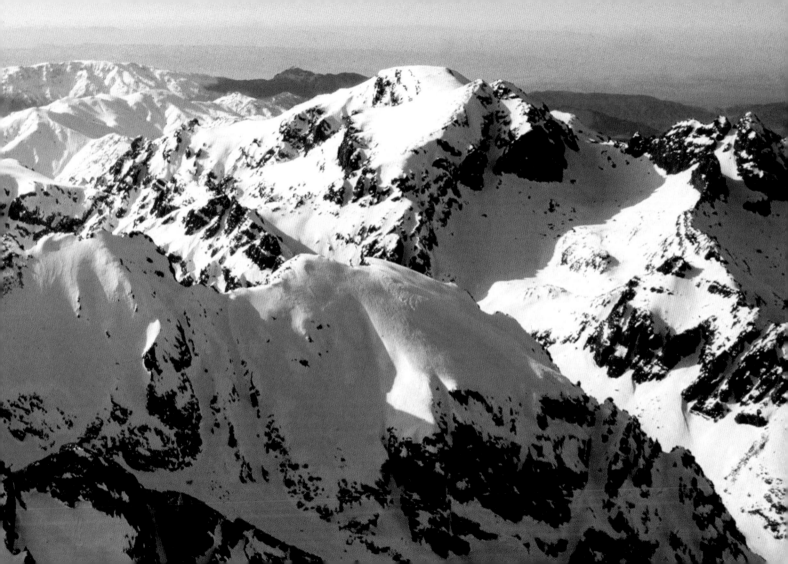

318
The mountainous land of the Canary islands, in front of Morocco's Atlantic coast, are cultivated on terraced land and render well.

319
A mass of clouds blown by the wind envelops the impressive peaks of Morocco's High Atlantic mountains.

320-321
La Falaise of Bandiagara, in Mali, is a long wall of sandstone that extends from north to south, from Douentza to the outskirts of Bankas.

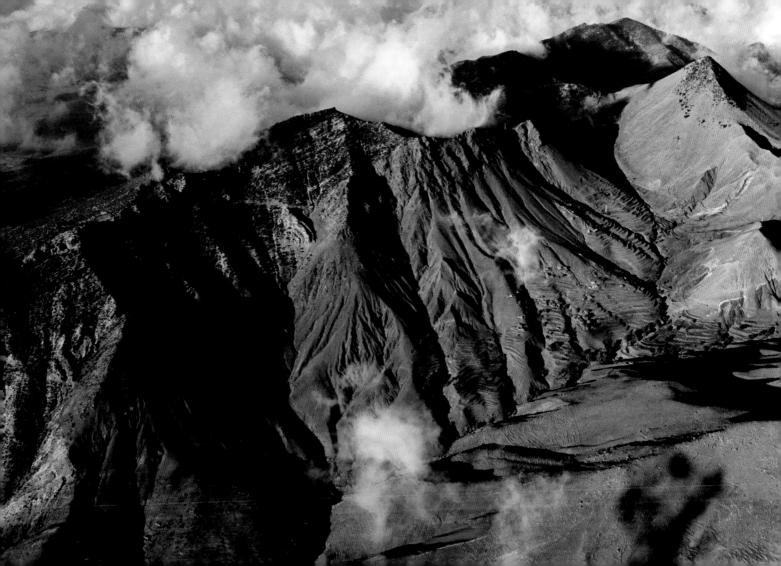

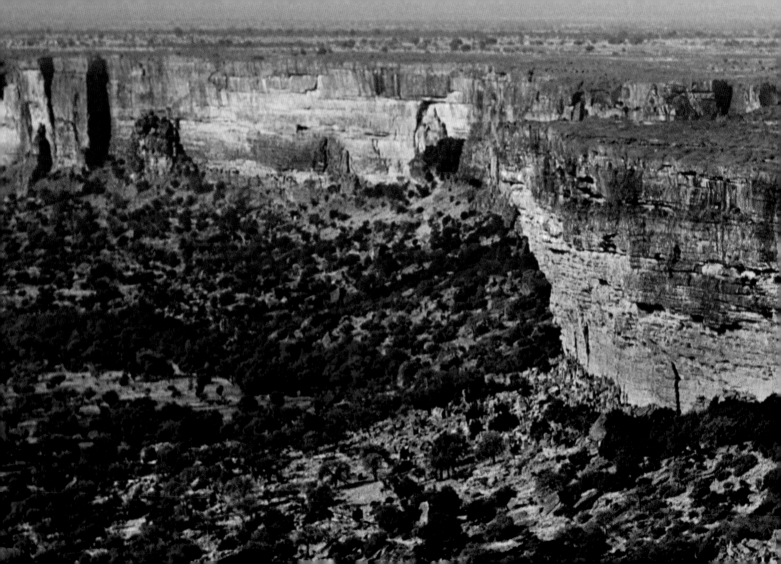

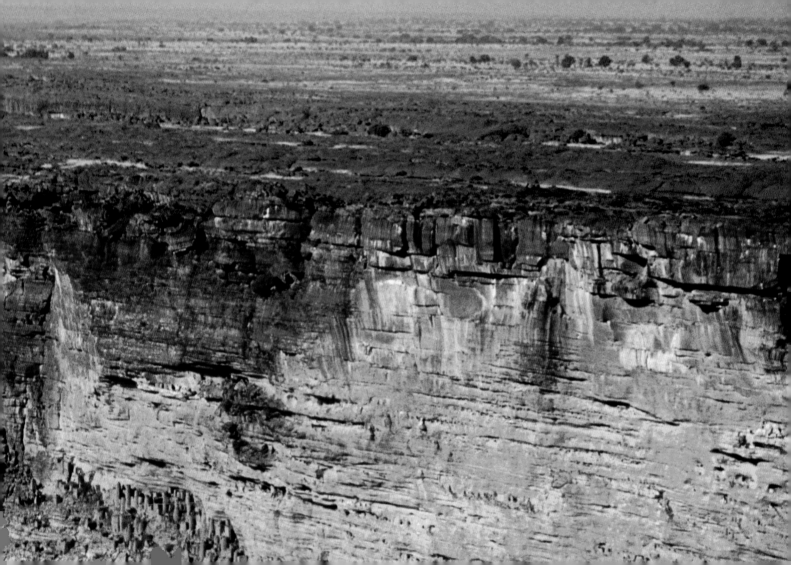

322
The forest that covers the steep ridges of the Simien Mountains, in Ethiopia, hosts rare animal species.

323
Deep valleys line the volcanic rock of the Simien massif, culminating in the 5,157-foot high Ras Dejan, the highest peak in Ethiopia.

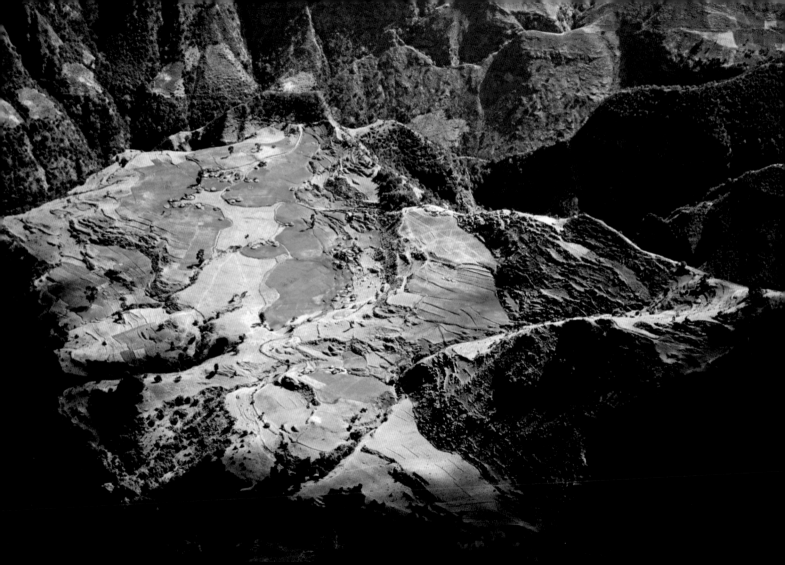

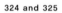

324 and 325
The craters of ancient volcanoes dramatically testify to the imponent eruptive activity in the past that has sculpted Ethiopia.

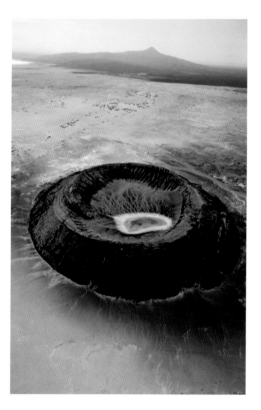

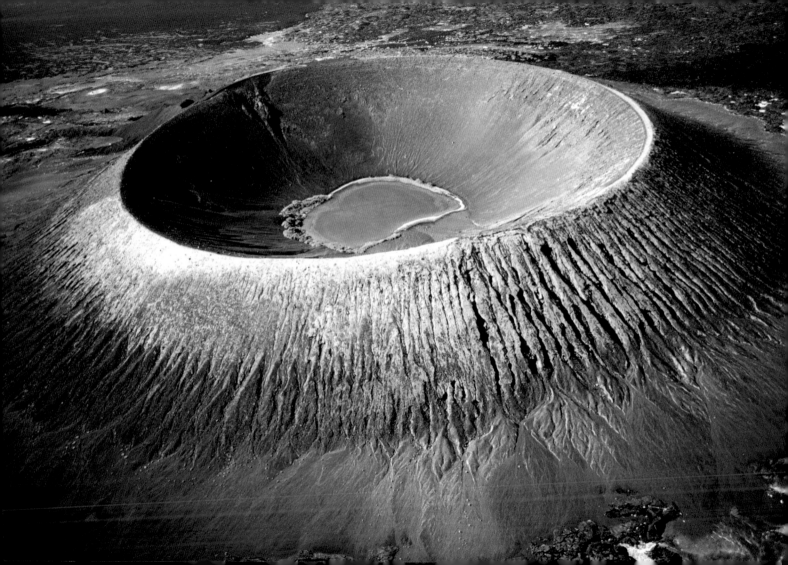

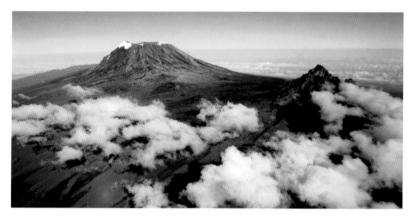

326
A vast desert separates the Kibo and Mawenzi, the two highest peaks of the Kilimanjaro massif, in northern Tanzania.

327
The volcanic massif of Kilimanjaro, in Tanzania, emerges isolated from a layer of clouds that covers the surrounding plains, as far as the eye can see.

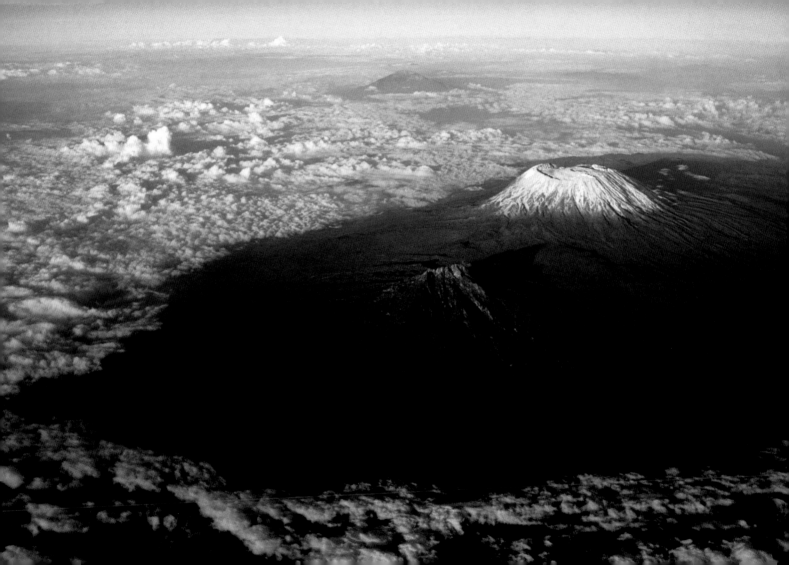

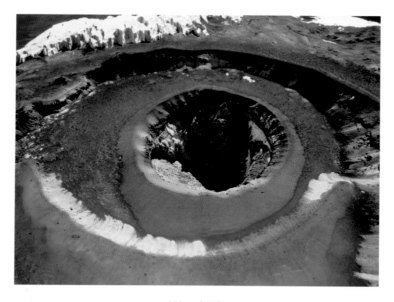

328 and 329
A thick layer of ice lines the northern ridge of Kilimanjaro's internal crater, over 2,625 feet in diameter, in Tanzania.

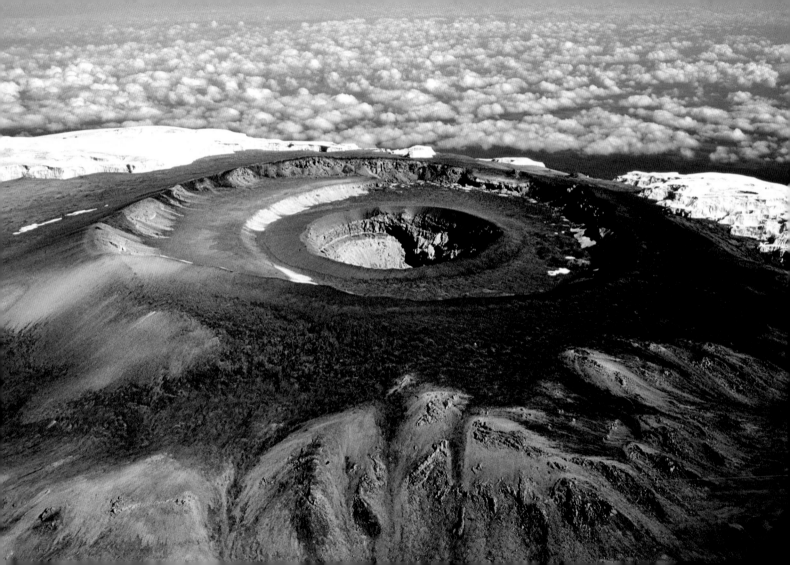

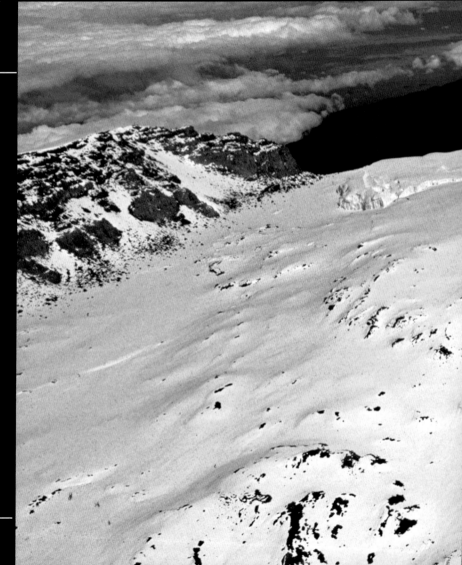

330-331
The glacier that surrounds the Kibo crater and the highest peaks of Kilimanjaro, in Tanzania, are rapidly melting.

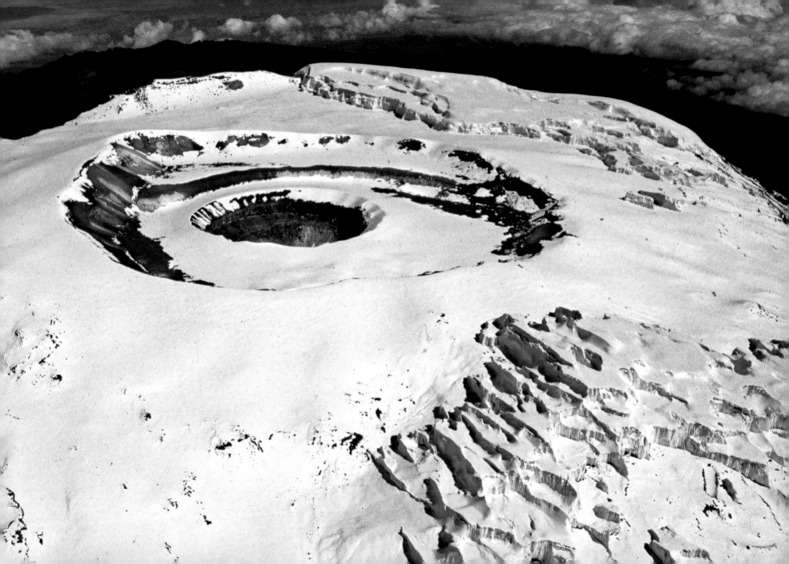

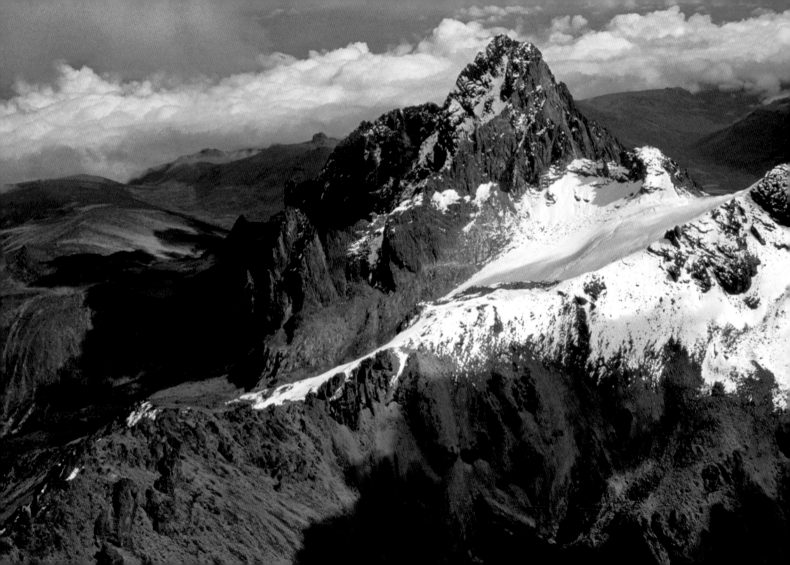

332-333
According to local legend from the inaccessibile peak of Mount Kenya, in Kenya, God first contemplated the newly created universe.

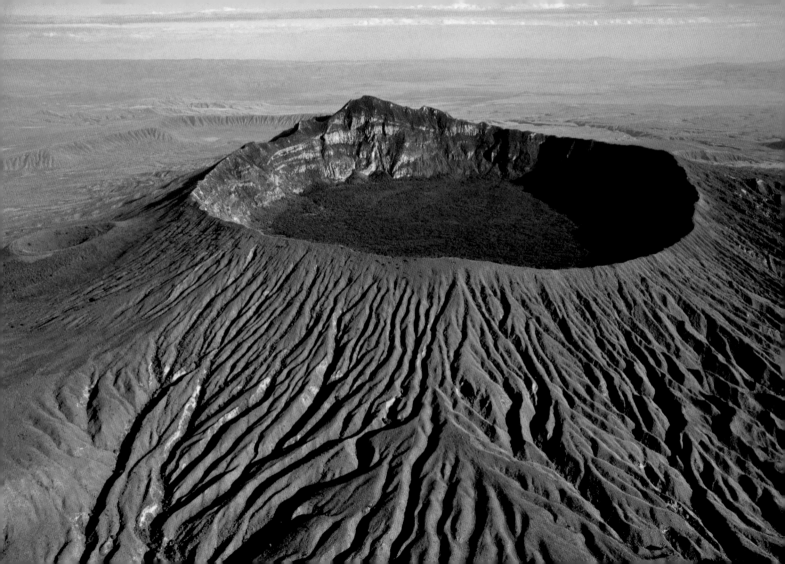

334
A network of ancient lava cracks lines the sides of the Longonot vol-
cano, that emerges from the Rift Valley near the Naivasha Lake, in
Kenya.

335
The forest on the bottom of the Longonot volcano's crater, in Kenya's
Rift Valley, is populated by herds of bufalo and other wild animals.

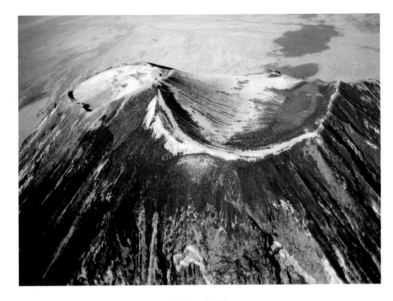

336 and 337
A thick crust of white lava saturated with natron clogs the still active
crater of the Ol Doinyio Lengai Volcano, in northern Tanzania.

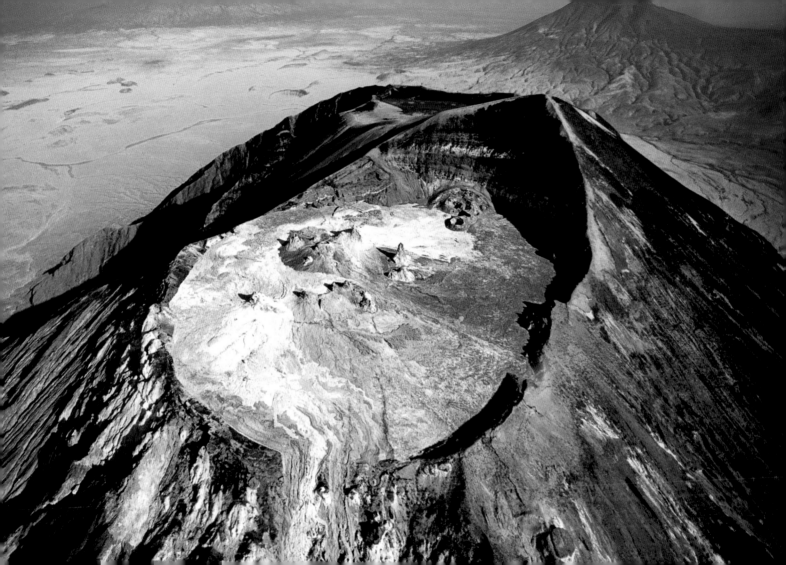

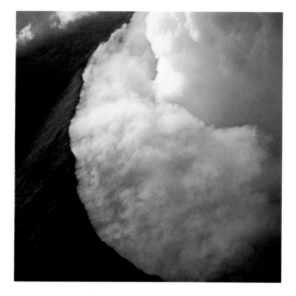

338 and 339
The Nyiragongo, aproximately 11,350 feet high, is one of the two active volcanoes of the Virunga mountains. Their eruptions regularly devastate vast areas of the eastern Congo.

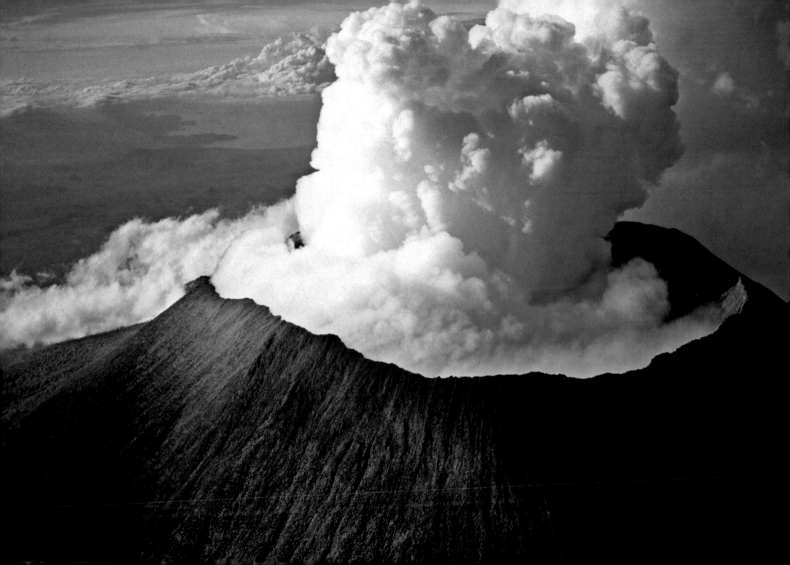

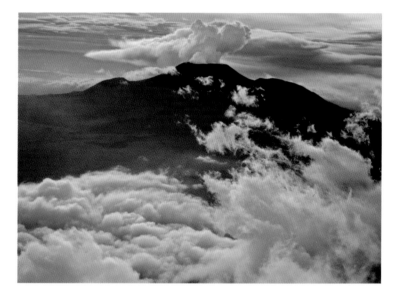

340 and 341
The rain forest on the slopes of Nyiragongo, in eastern Congo, are one
of the last refuges of the mountain gorillas.

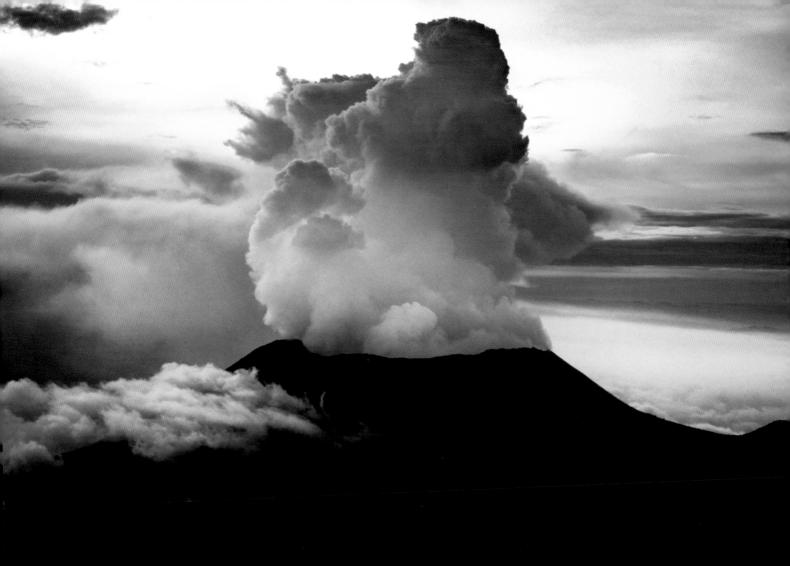

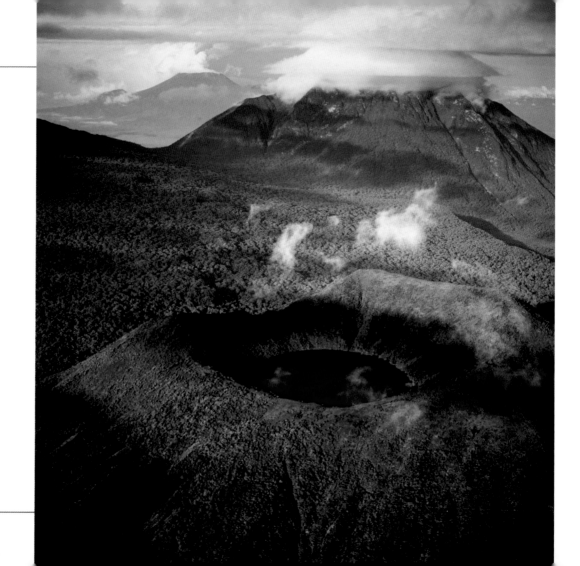

342
The profile of Mikeno, half hidden by the clouds, creates a backdrop
to the lake that fills the crater of the Visoke volcano, in eastern Congo.

343
On Rwanda's side of the Virunga Mountains, ample tracts of forest
have given way to cultivated fields.

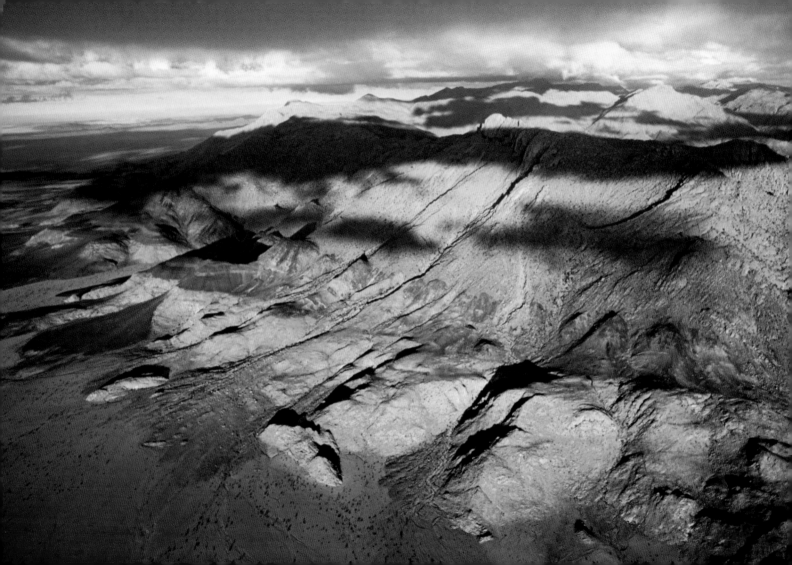

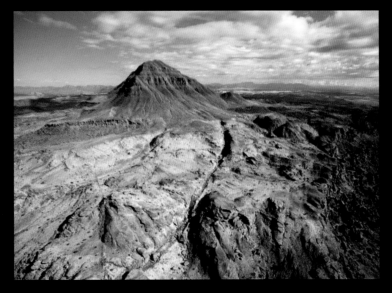

344 and 345
The Brandberg massif, in the Damaraland region, is the highest moun-
tain in Namibia, with its 8,465 feet in height.

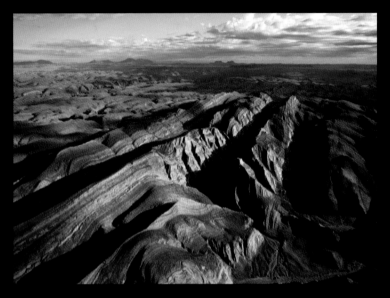

346 and 347
The rare rains in Namibia's Damaraland, feed the waterways and springs that sprout from the deep gorges in the Brandberg massif.

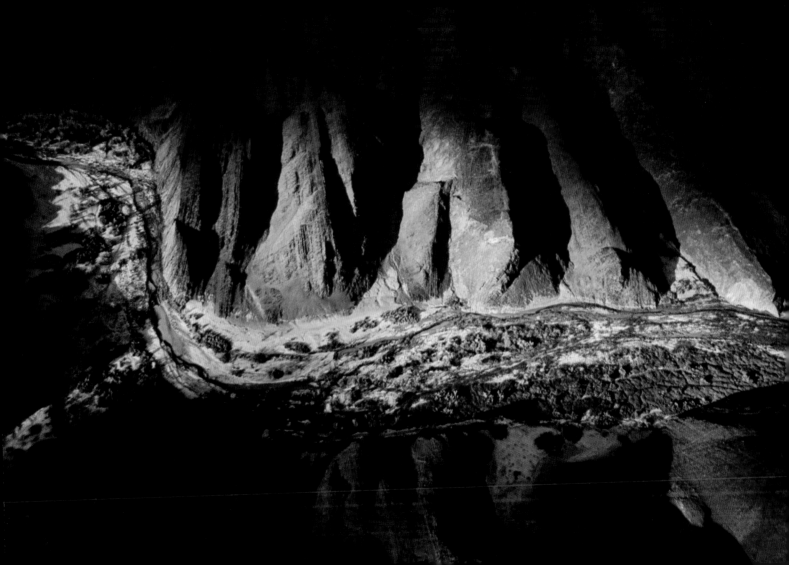

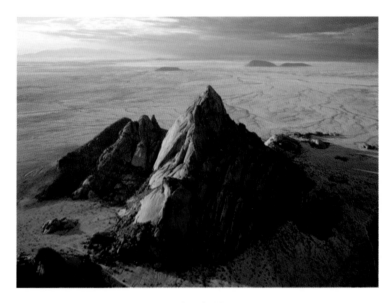

348 and 349
The pinnacles and majestic granite crests of the Spitzkoppe rise solitary from the immense plains of Namibia's Damaraland.

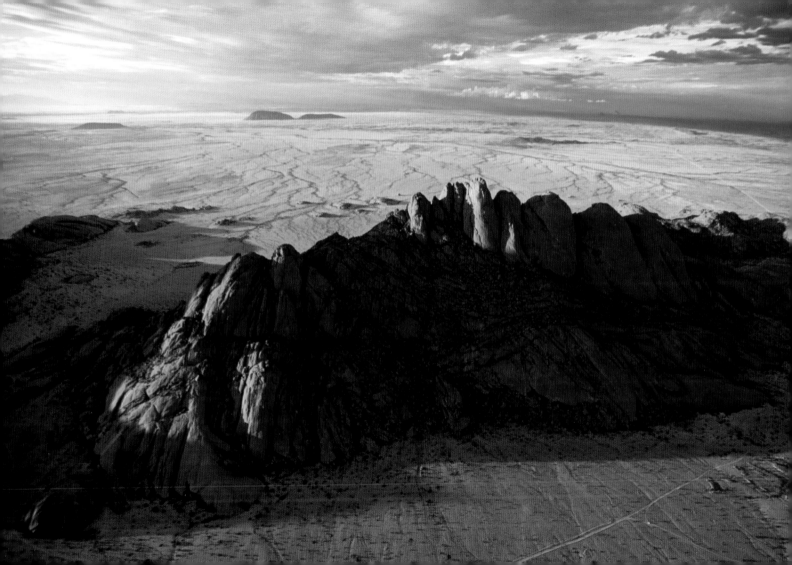

351
Remote and beaten by the relentless sun, the Brandberg massif, in Damaraland, is still one of the most unexplored regions in Namibia.

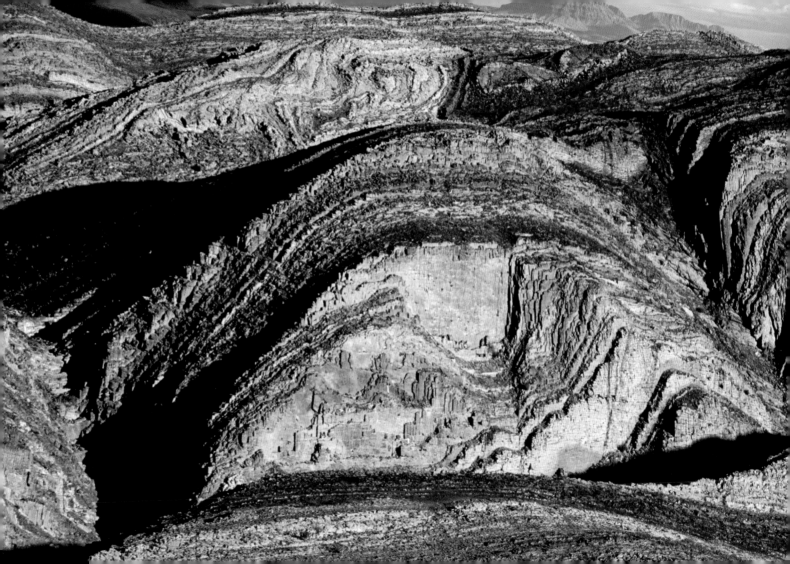

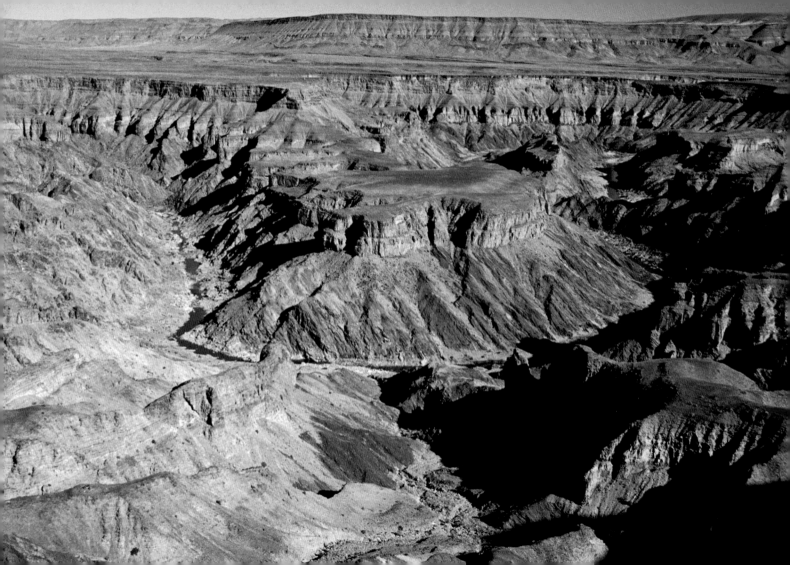

352
In its journey through southern Namibia, the Fish River has carved spectacular canyons, hundreds of miles long and hundreds of feet deep.

354 and 355
The Naukluft Mountains, 6,560 feet high, contain the principal springs of the rivers that cross Namib-Naukluft National Park, in Namibia.

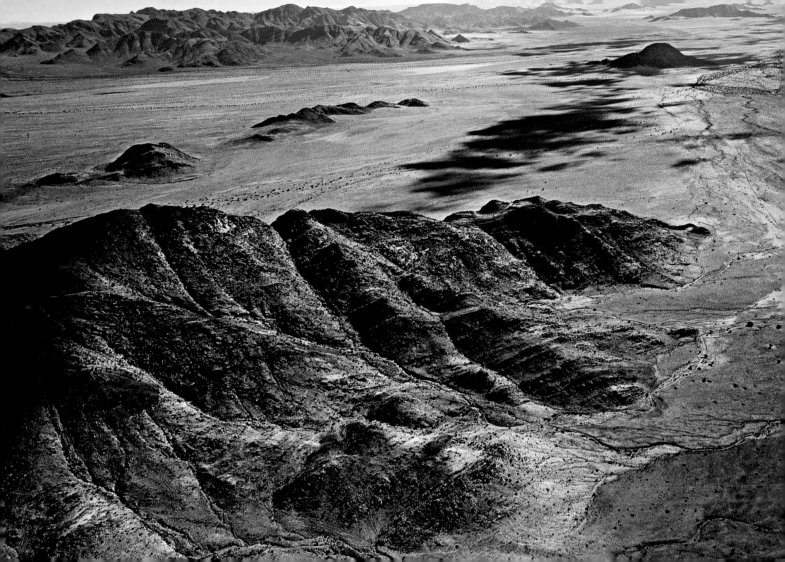

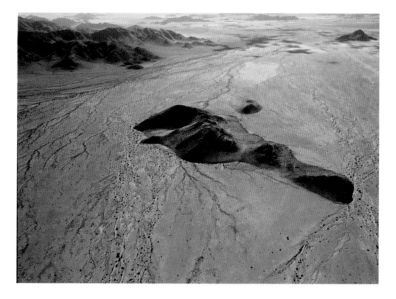

356 and 357
The dunes, mountains and plains of Namibia's Namib-Naukluft Na-
tional Park create a variety of specific yet interdependent ecosystems.

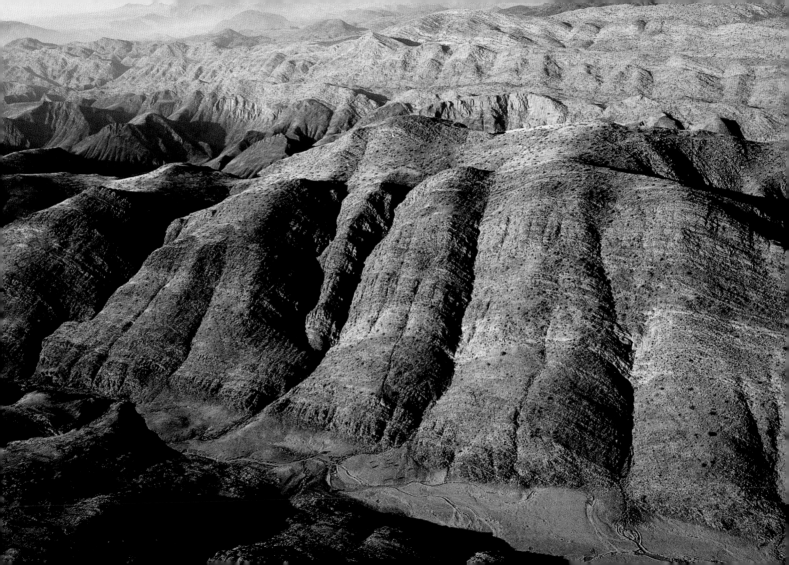

359
Like the walls around a giant fortress, the Drakensberg chain rises above the clouds that cover the hills of South Africa's Natal.

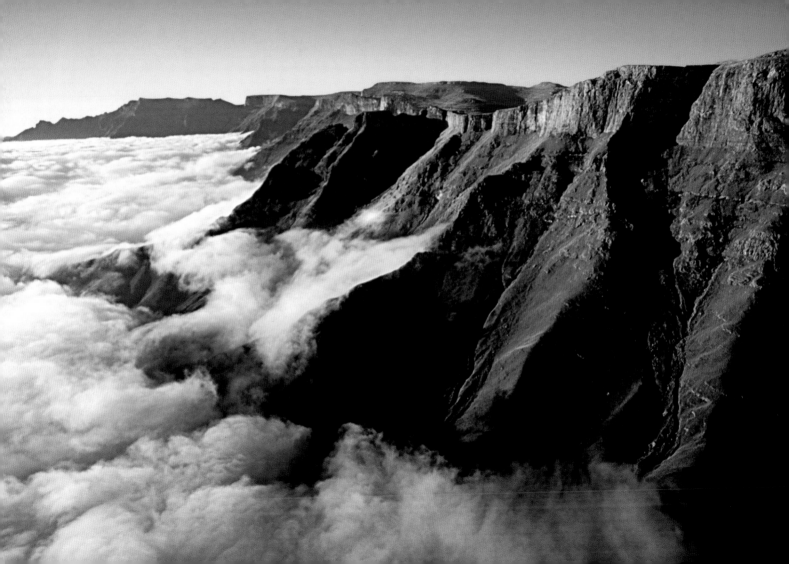

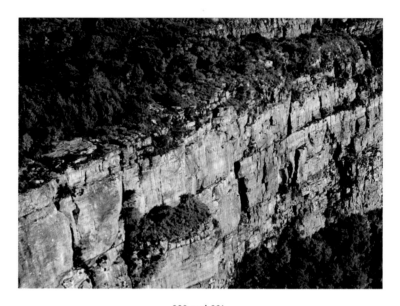

360 and 361
Thick undergrowth covers the base of the rocky wall that drops down
to the deep Blyde River Valley, in northeastern South Africa.

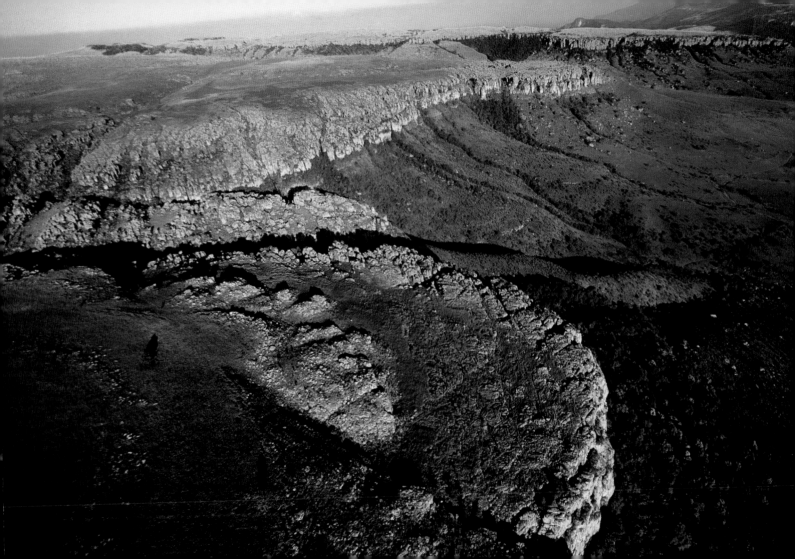

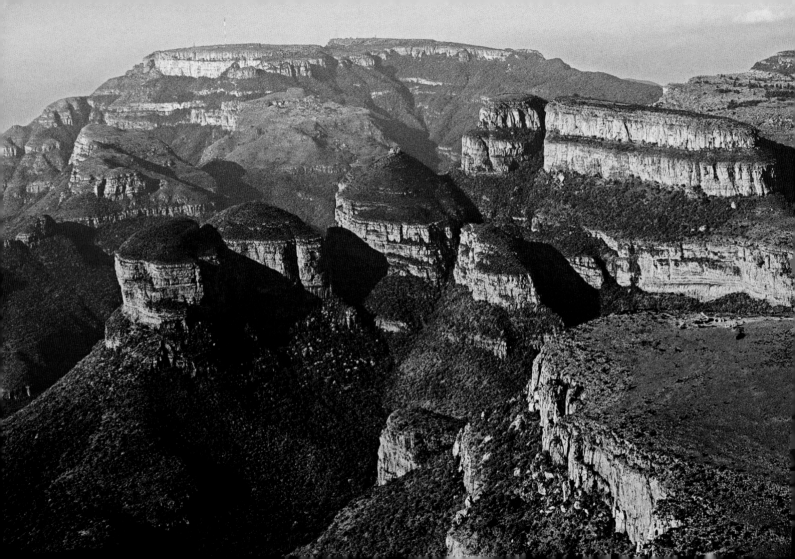

362 and 363
The quartz stone that constitutes the structure of the mountains, traversed by the Blyde River, in South Africa, has ancient origins.

FLYING HIGH AFRICA

365
The sandstone pinnacles, canyons and the huge valley of Isalo offers one of the most suggestive sights in southern Madagascar.

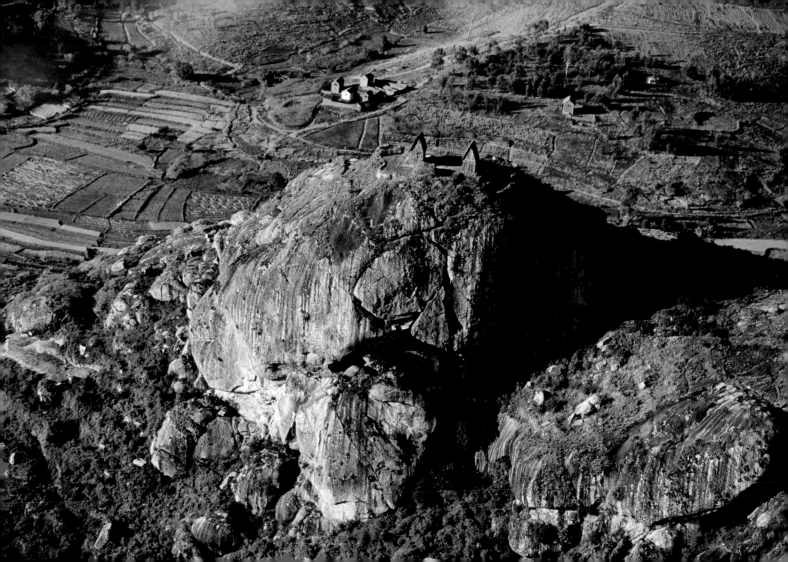

366 and 367
The Tsingy of Bemaraha, limestone nee-
dles eroded by water and wind, are the
heart of one of the most beautiful na-
tional parks in western Madagascar. In
the natural labyrinth created by the lime-
stone, 11 species of lemurs find refuge.

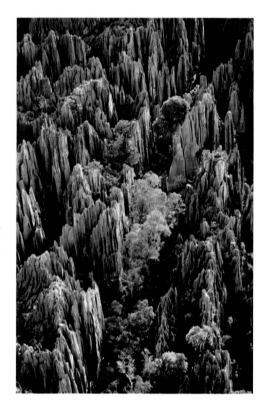

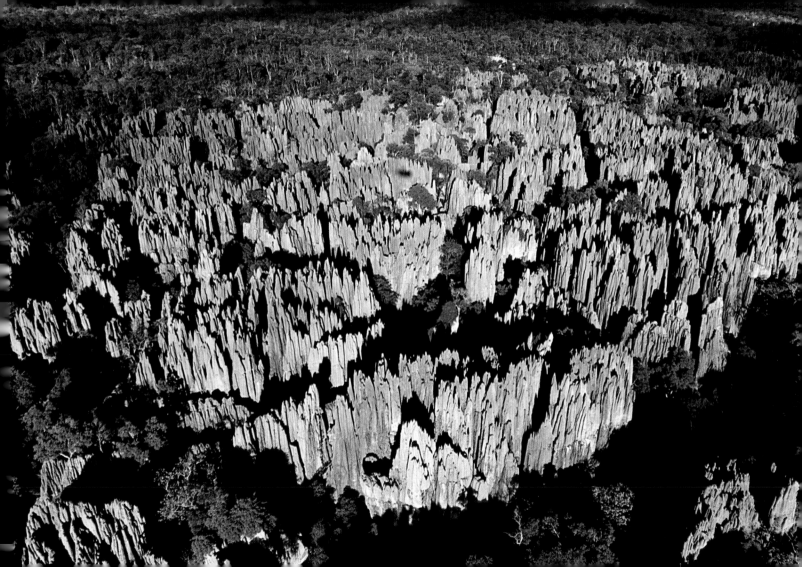

FLYING HIGH AFRICA

369
The sandstone formations that constitute the Isalo massif, in southern Madagascar,
design a unique, surreal landscape.

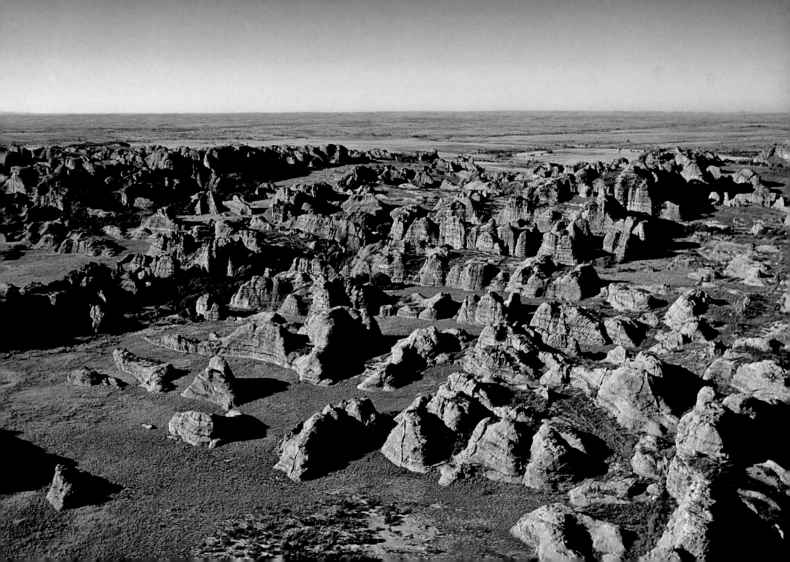

370 and 371
The deep gorges that line the mountains around Antananarivo, in Madagascar, are transformed into rivers during the rainy season.

372-373
Isalo, in southern Madagascar, is a massif modelled by the action of the wind and erosion.

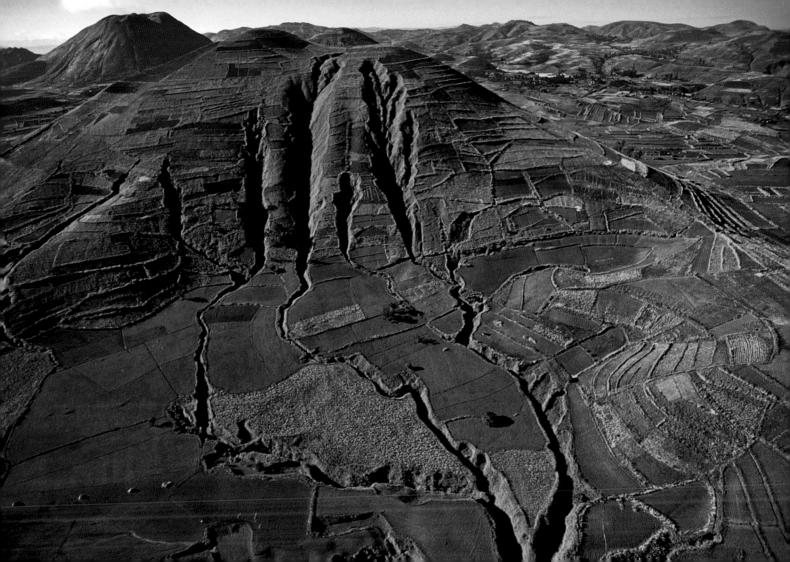

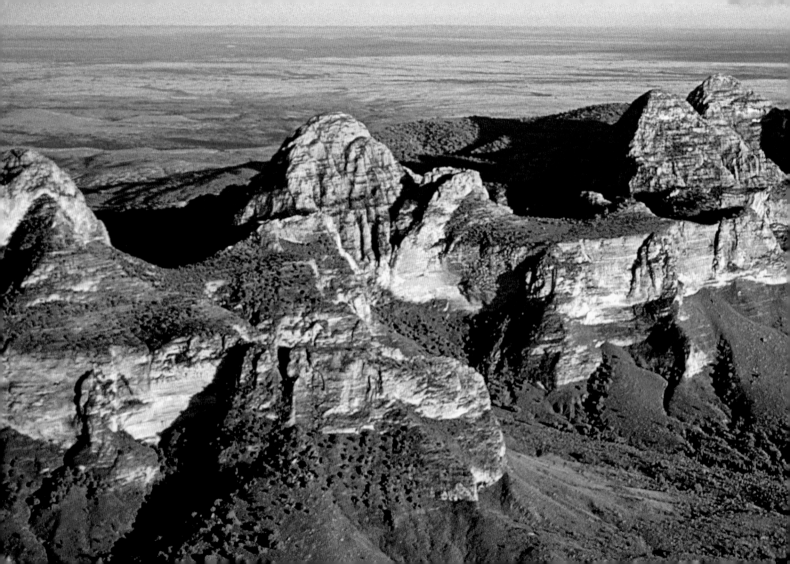

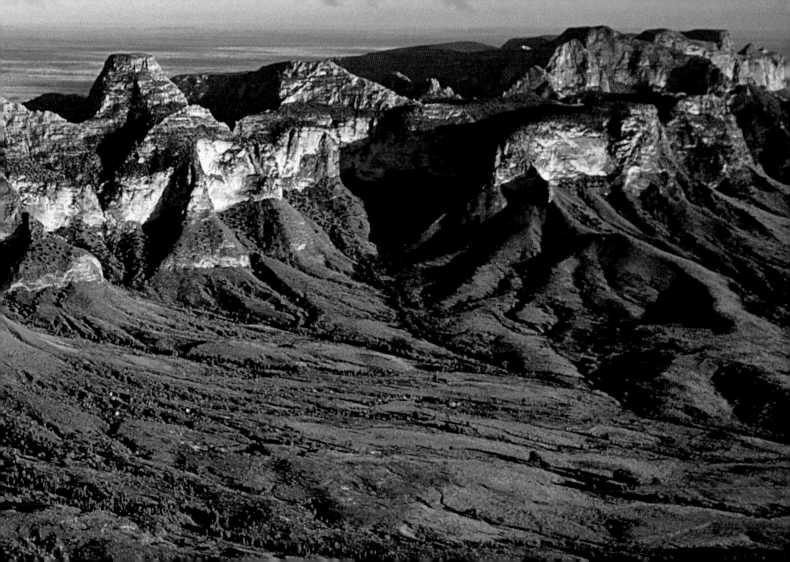

HORIZONS OF SKY AND WATER

FLYING HIGH

FLYING HIGH AFRICA

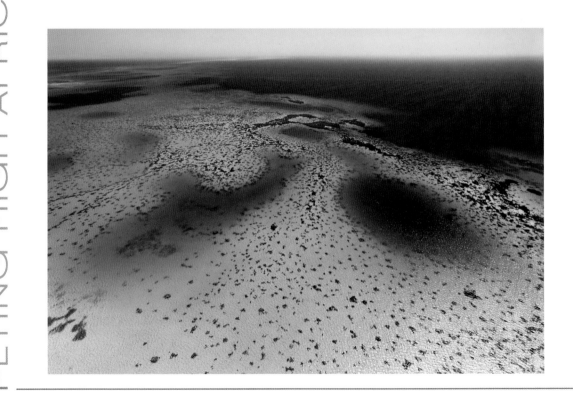

375
Sand banks and forest characterize the shoreline of the
Indian Ocean in Tanzania.

In the ratio between land surface and coastal development, Africa takes the last place. To over 11.5 million square miles of inland corresponds only 18,641 miles of coast, a little less than Europe, which is three times smaller. A look at any map will make this clear: there are no jutting peninsulas, protected bays or fluvial estuaries penetrating the inland.

Africa's perimeter is disarmingly simple: low and sandy, invaded by vegetation or completely deserted, the African coasts are generally rectilinear, like the mountain chain that constitutes the continent's primitive skeleton.

Thus, to the east, the coast aligns along the great tectonic fractures that extend in chaotic succession from the Red Sea to Mozambique.

Where two or more ditches meet, the coastal profile assumes a geometrical aspect, forming regular angles: the so-called "Oriental Horn" that includes Somalia and Ethiopian Ogaden, is the most evident example of this phenomenon.

The changes in tide, the wave movement, the formation of the coral reef and man's influence enrich this scenery without changing its fundamental characteristics.

Today Africa's coasts host big ports and modern cities, the silhouette of oil rigs can be seen on the blue horizon at sea, new streets have improved previously deserted regional development and international tourism has taken possession of the most beautiful beaches.

Progress, with its positive and negative aspects,

376
The Red Sea coral reef near Hurgada is the center of
underwater diving tourism in Egypt.

Horizons of Sky and Water

is advancing with giant steps, but only in episodes: interminable tracts of African coast, for indifference or destiny, have remained virgin, almost unexplored. Except for the Mediterranean coast, inhabited from the most ancient times, human settlements are rare.

There are more huts than solid houses, more *pirogues* (dugout canoes) than ships, more fires and oil lamps than light bulbs. Seen from the sea, Africa's coast seems dark, silent and charged with mystery. Beyond the Gibraltar Straight, past Casablanca and Agadir, nature dictates the law. In southern Morocco and Mauritania, the Sahara runs to the Atlantic Ocean without intermediaries; the contrast between desert and sea is precise, absolute.

The Canary Islands with their high volcanic peaks are invisible from the mainland. Distant Madera is not even imaginable. Farther south, rocky promontories alternate with sandy lagoons: the outlet of the Senegal River designs a border with the savanna. Then there is Dakar, cultural and economic capital of the region, and the Capo Verde islands, a handful of volcanoes rising from the sea.

Lush coconut palms and tall green trees announce the forest on the Gulf of Guinea. The Ivory Coast, the Pepper Coast, the Gold Coast and the Slave Coast each have a name that tells a story. Niger's delta, suffocated in a labyrinth of mangroves, should be called the petroleum coast: here overpopulated Nigeria and all of Africa hold an important role.

After the unhealthy Calabar Lagoons, we encounter a green wall: Mount Cameroon, which the Phoenicians called the god's chariot. In front of Fernando Po, the first of a chain of islands that arrives under the Equator, the West coast becomes a dead end.

Suddenly Africa bends drastically to the south and seems to go on forever. At least this was what the exhausted sailors on Diogo Cao's

Horizons of Sky and Water

Caravel felt, directed unawares towards the muddy Congo estuary. Cao continued along today's Skeleton Coast anchoring at Cape Cross. Perhaps Namibia's desolation discouraged him because he immediately turned back: in his report, he does not even mention the numerous colony of otters that inhabit that stretch of beach.

What a shame: Cape Good Hope, door to the fabulous Indies, was just around the corner. In South Africa, it is simply called "the Cape" as if it were the only one in the world. Under its steep cliffs two oceans, the Atlantic and the Indian, symbolically meet.

From that point, the coast, rocky and rich in natural ports, gradually curves towards the north. It becomes marshy near the Zambesi delta and then continues uniformly, often adorned with coralline formations, up to Cape Guardafui. The desert again makes its appearance, facing the blue waters of the Gulf of Aden and the Red Sea. The Suez Canal marks the entrance into the Mediterranean Sea. Scattered in the Indian Ocean is a constellation of islands: the mysterious Socotra, a piece of Africa that has become Yemen; Pembra, Mafia; Zanzibar, splendid and perfumed with spices; and the fertile Comores, crowned by palm trees. Finally, the only big African island, fourth in the world for its size, is Madagascar, 226,641 square miles of tableland, forest, prairie and mountains.

Isolated from the rest of the world, Madagascar has conserved a unique flora and fauna. The number of endemic reptiles, mammals, birds and fresh water fish is incredible.

Lemurs, giant chameleons, brilliantly colored frogs, archaic carnivores with a civet's face and cat-like claws: everything is stupefying, surprising in this paradise of biodiversity. Madagascar is one of Africa's thousand faces, staring onto the blue horizon of the sea.

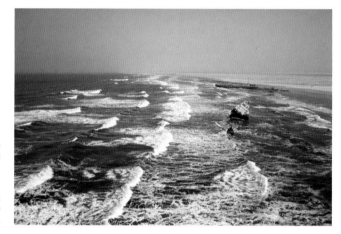

380
Dozens of relics litter the atlantic coast of Morocco, south of Dakhla city.

381
The waves of the Atlantic ocean break without fail on this solitary beach near Larache, in Morocco.

Atlantic Ocean

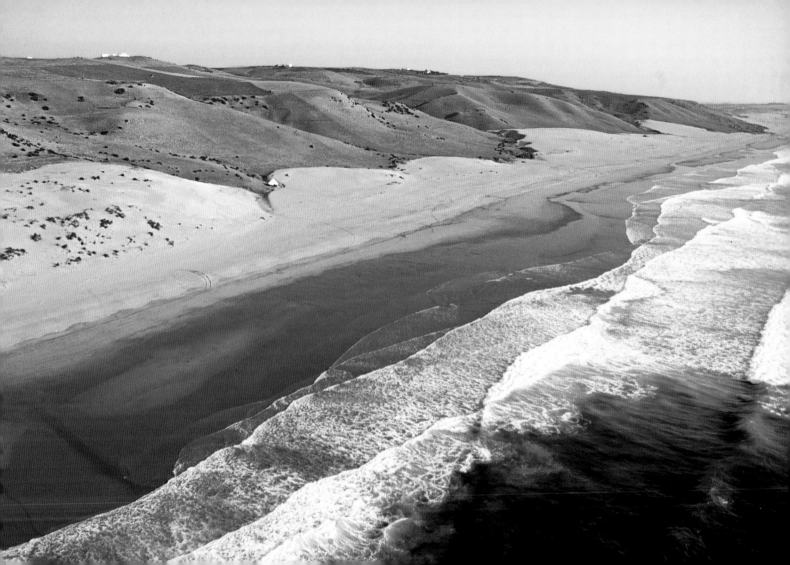

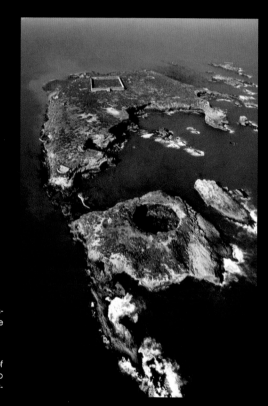

382

The Purpourairies Islands, in front of Essaouira, in Morocco were known by the ancient civilization as Scarlet Islands.

383

At Tangier, on the Moroccan coast of the Gibraltar Strait, the mountains drop to the sea in a succession of rocky terraces.

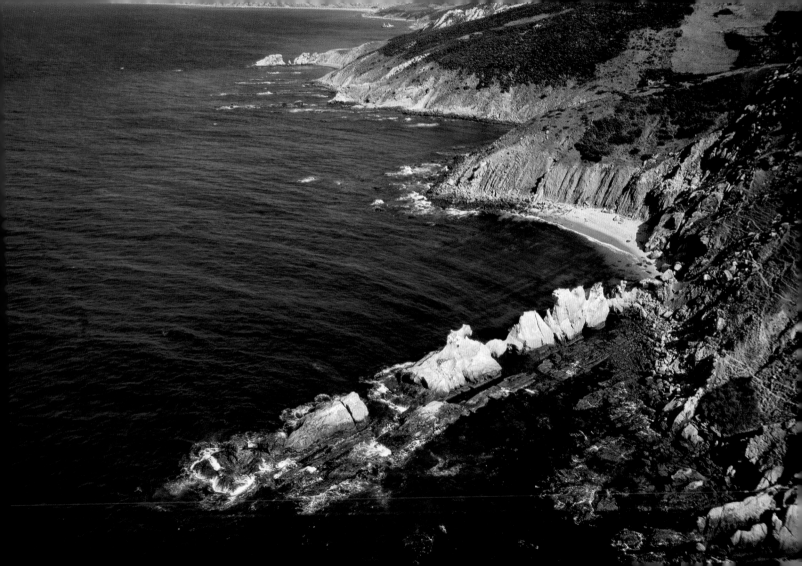

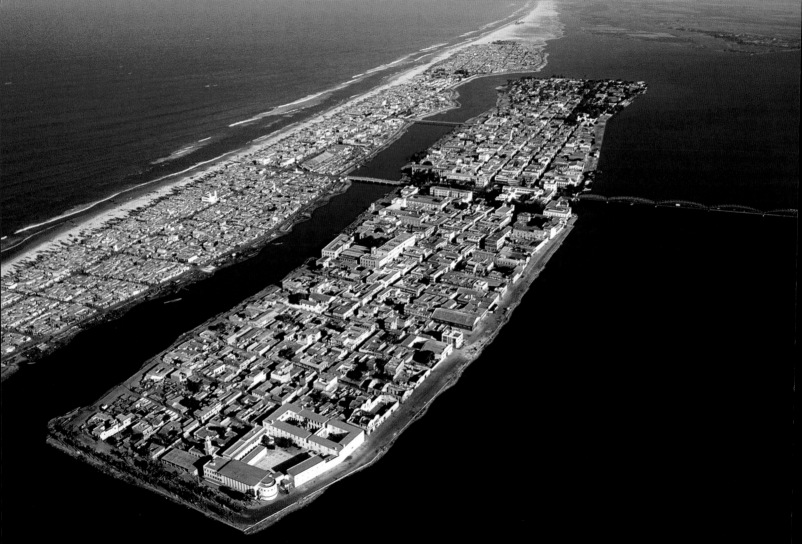

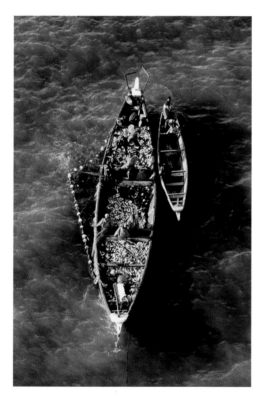

384 and 385
St. Louis Island, Senegal, is home to an
important fishing port and market.

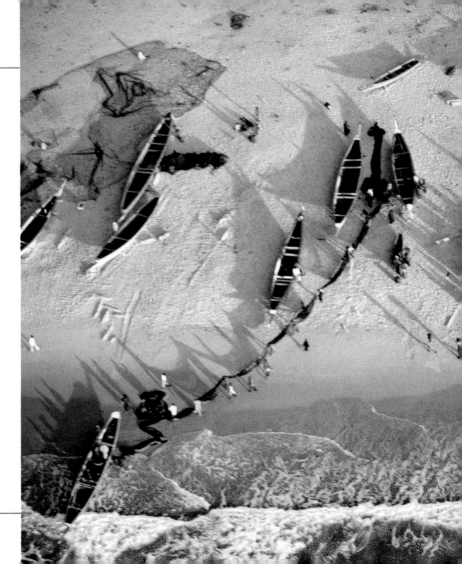

386-387
To daily challenge the waves of the Atlantic on these fragile pirogues is a risk that the Senegalese fishermen face with a sense of fatalism.

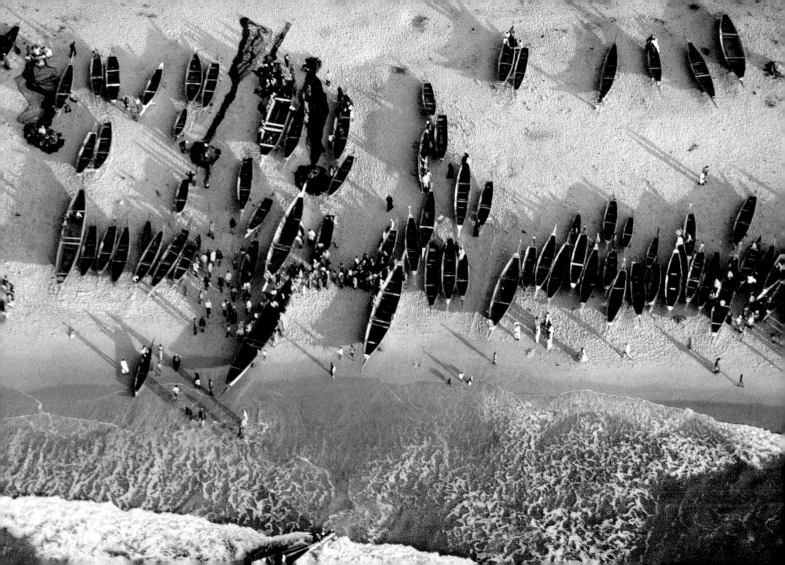

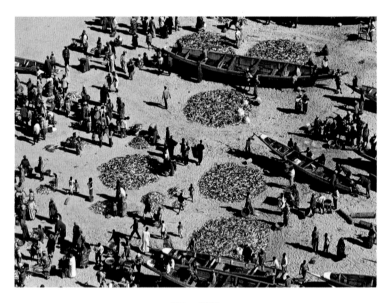

388 and 389
The abundant catch of a day's fishing in the Atlantic attracts crowds
of buyers and the curious on the beach of Dakar, in Senegal.

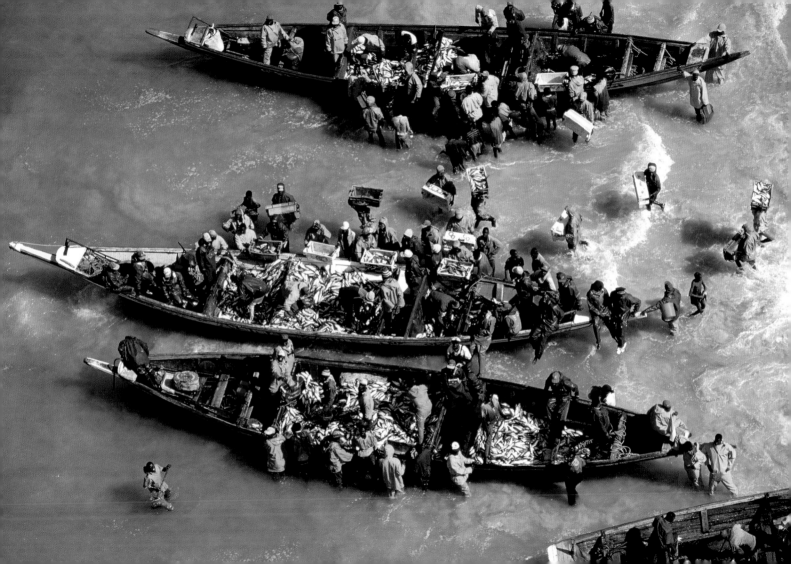

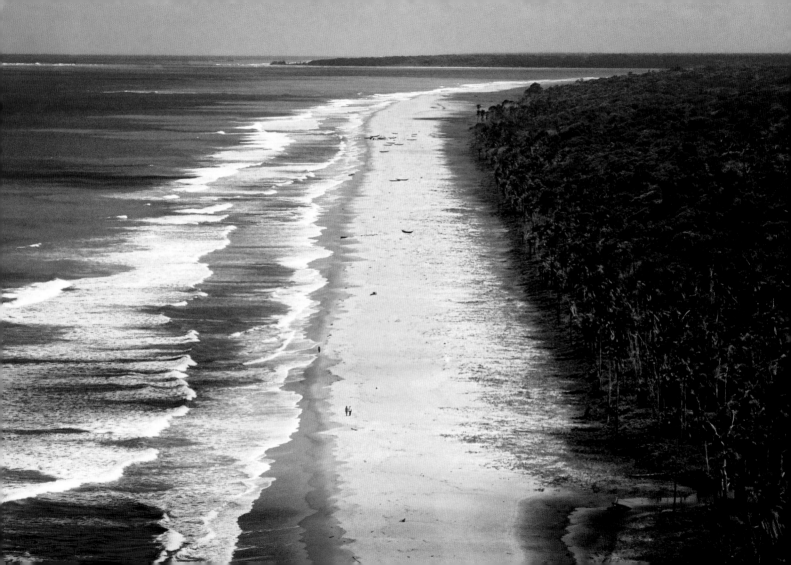

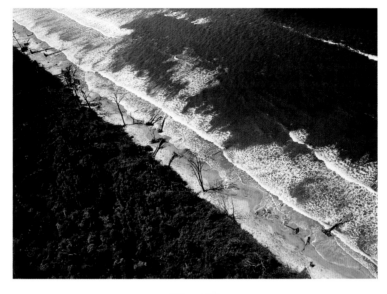

390 and 391
Full of sand and fluvial sediment, the coast along the Niger Delta, in
Nigeria, lacks ports and important urban settlements.

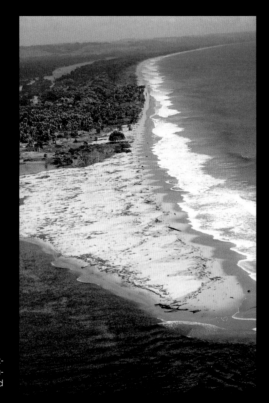

392 and 393
Near Pointe Noir, in the Congo, the Atlantic coastal zone is generally low, usually interrupted by fluvial estuaries and hemmed by sandy beaches.

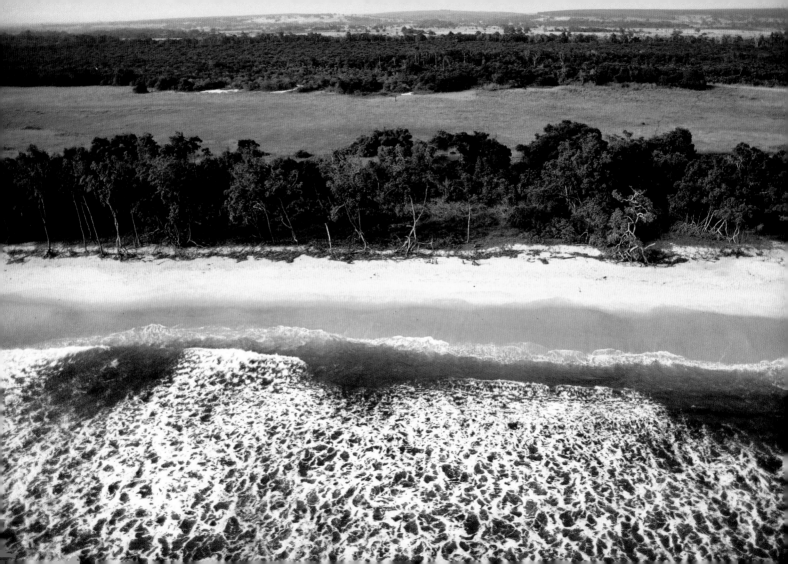

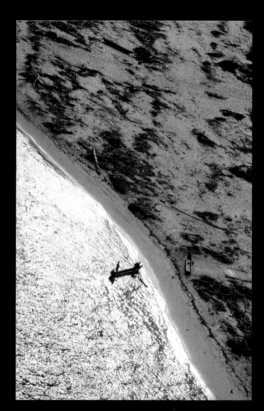

394 and 395
Near Pointe Noire, in the Congo, tracks on the sand and a few pirogues betray the presence of a nearby fisherman's village.

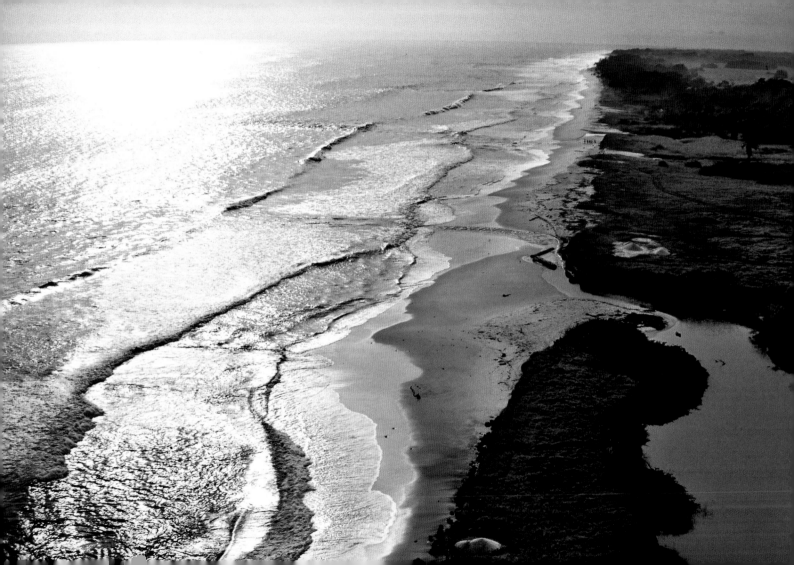

396
The waters of the lagoon on the Atlantic coast of Namibia supply shel-
ter and nourishment to many forms of life.

397
The salt mines along Namibia's deserted Atlantic coast are an au-
thentic paradise for migratory birds.

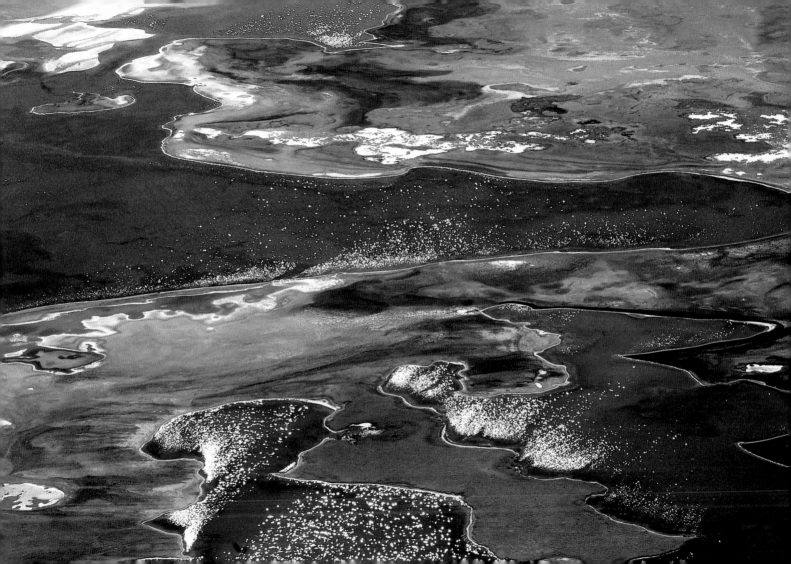

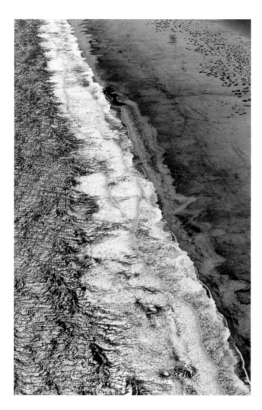

398

The Coast of Skeletons, in northern Namibia, extends from Swakopmund to the borders of Angola.

399

Nearly one million sea lions, united in colonies, inhabit the desolate shore of the Coast of Skeletons, in Namibia.

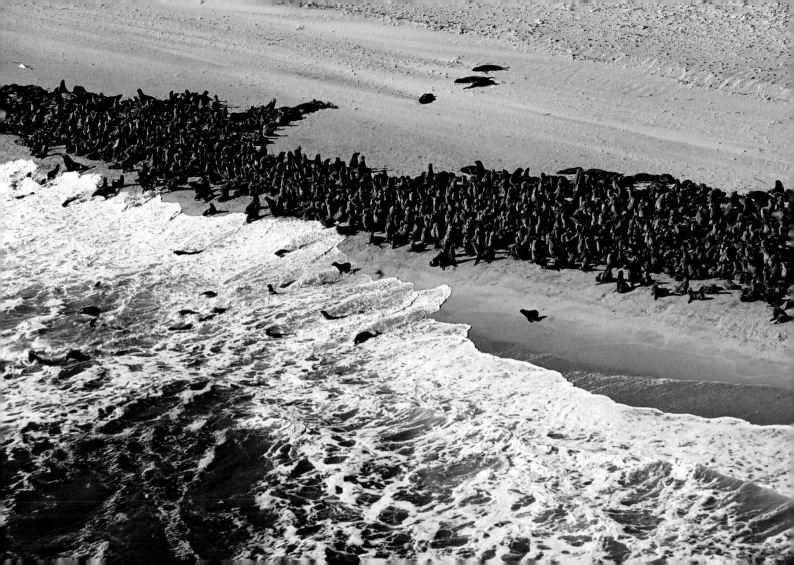

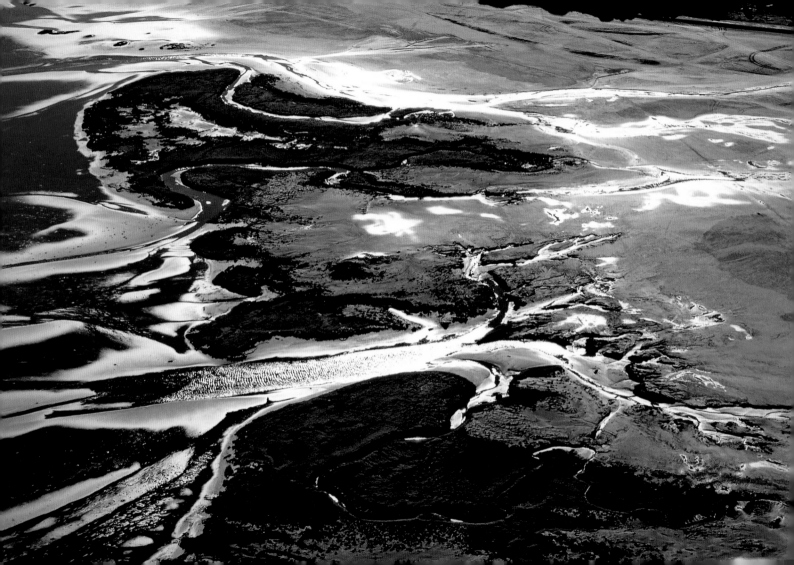

400 and 401
The coastal area of Namib-Naukluft, Namibia's largest protected zone,
is absolutely deserted and uninhabited.

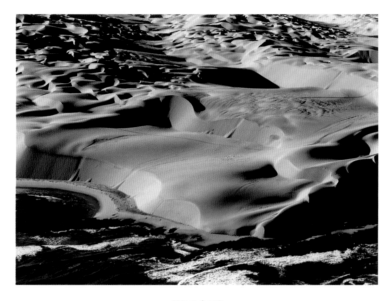

402 and 403
Together with the dunes of Sossusvlei, the rock formations cut by canyons and the Namib desert, the sandy dunes next to the Atlantic Ocean, in these images, represent the main territorial areas on which the Namib-Naukluft Park, in Namibia is located.

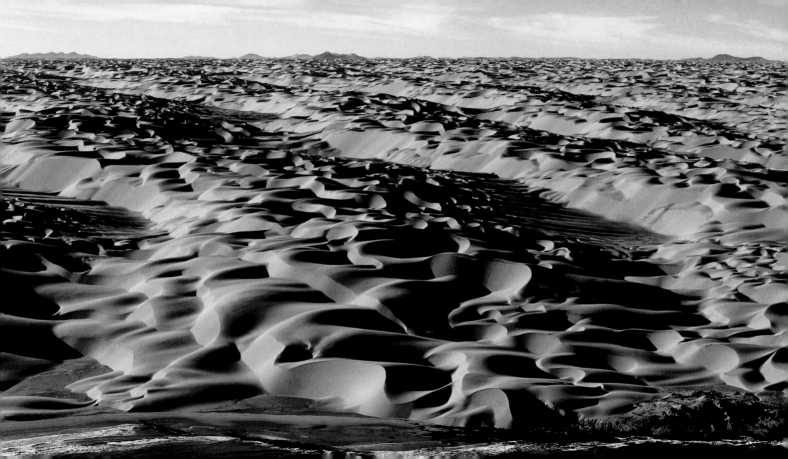

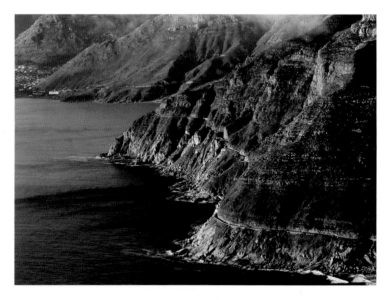

404 and 405
The street that winds up the slopes of Chapman's Peak, in Cape Good
Hope's peninsula, offers some of the most beautiful landscapes in
South Africa.

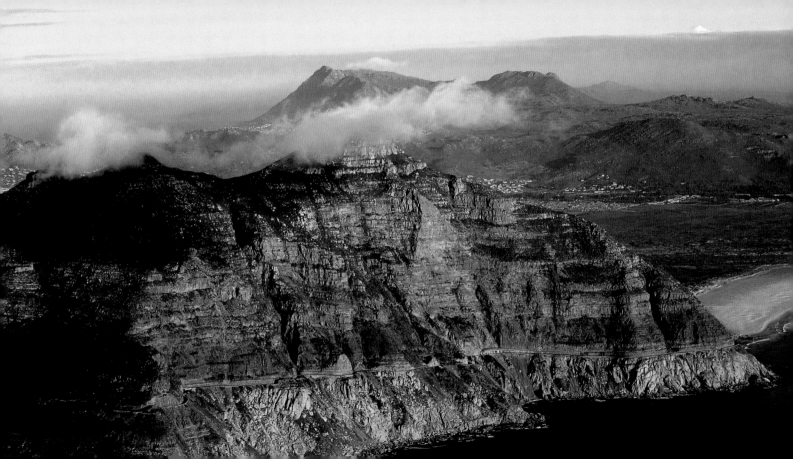

407
This whale with its calf was captured in a moment of rest during the annual migration along the South African coast.

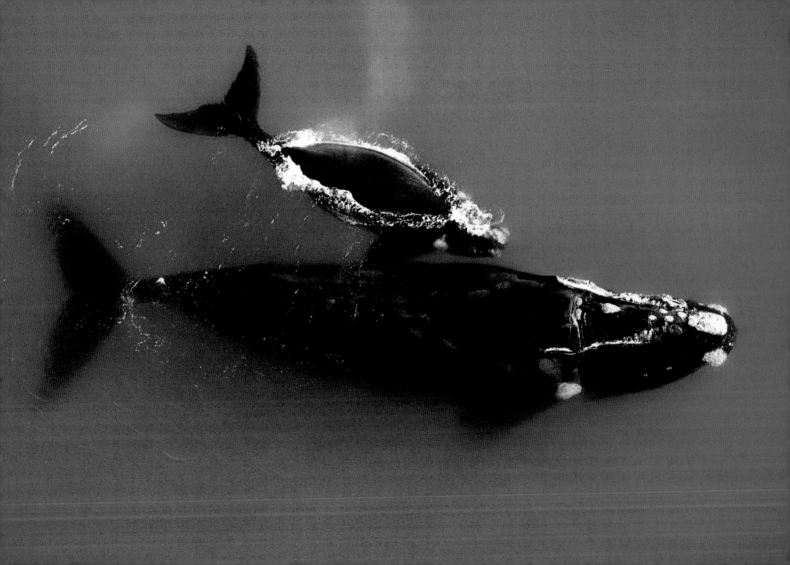

408
The warm current of Agulhas makes the waters of False Bay tepid and one of the favorite tourist spots in South Africa.

409
A lighthouse illuminates the sillouette of the False Bay coast, that extends to the east of Cape Good Hope in South Africa.

411
Ample green areas and modern sport complexes separate the heart of Cape City, in South Africa, from the residential zone of Sea Point.

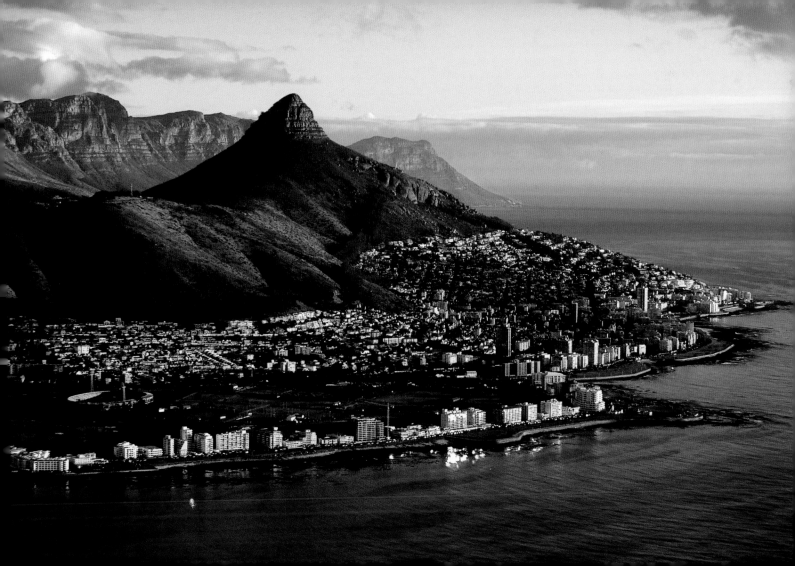

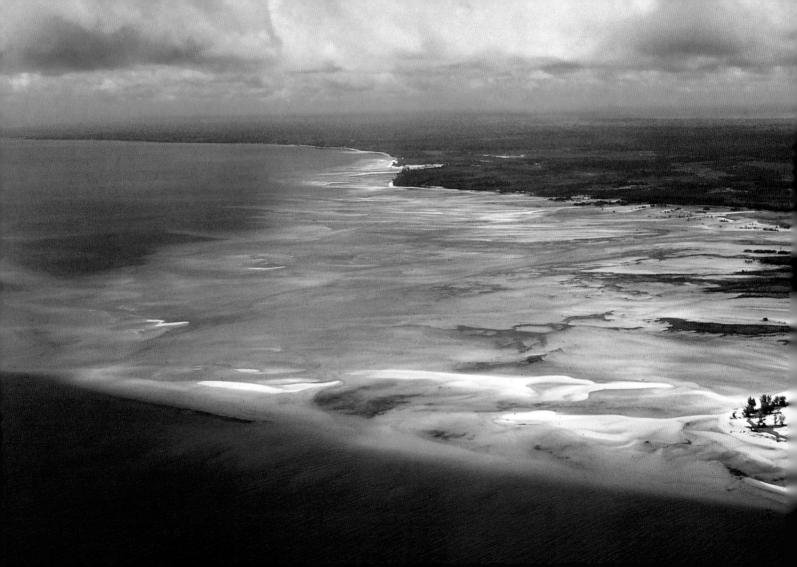

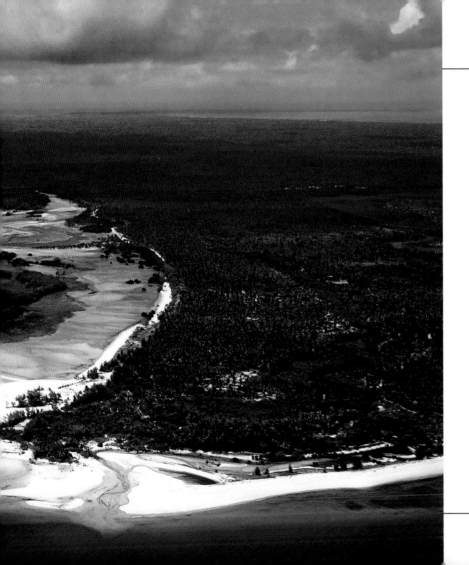

Indian Ocean

412-413 and 414-415
Tanzania's coast, which faces the turquoise waters of the Indian Ocean for about 500 miles, is nearly incontaminated.

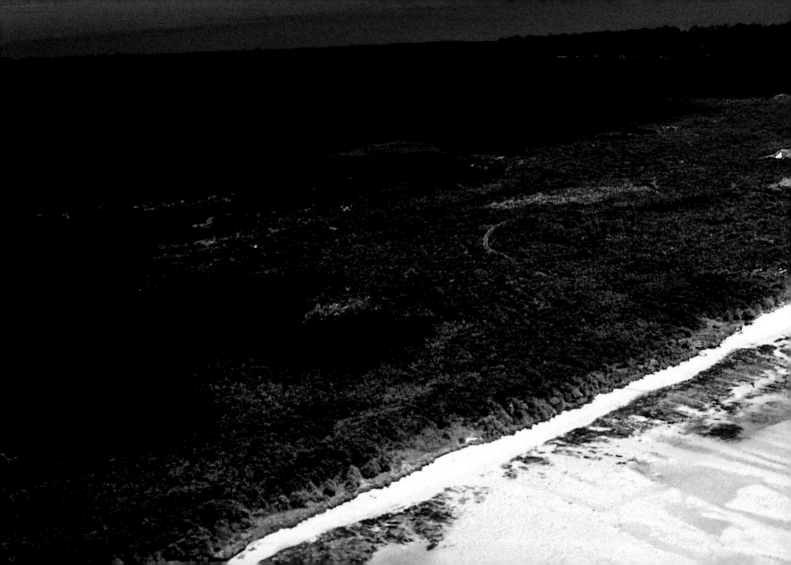

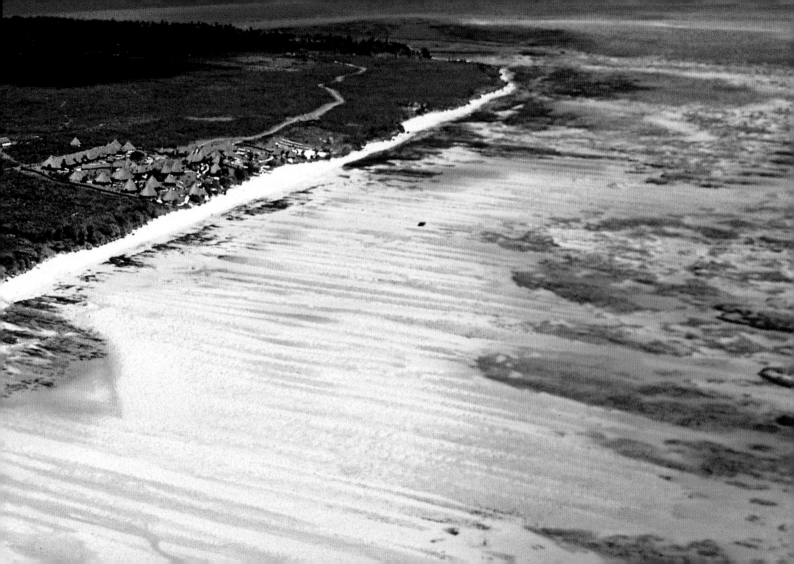

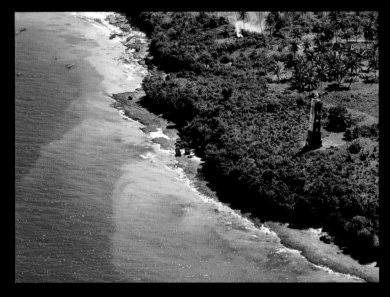

416 and 417
The coast of the Indian Ocean, in Tanzania, is generally sandy and
lined by palm and cocoanut trees and mangroves.

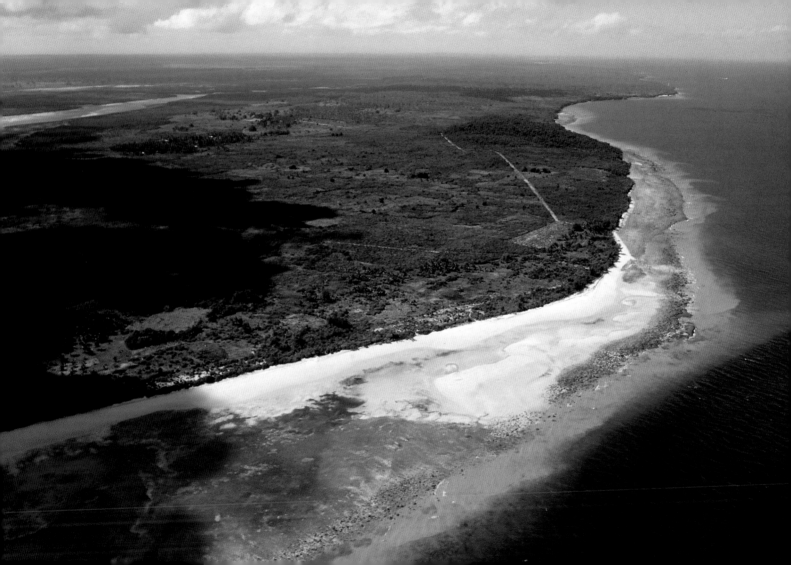

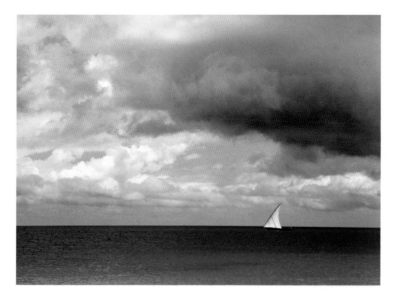

418 and 419
The smallest islands that dot the coast of the Indian Ocean, in Tanzania, are often merely sandy risings bordered by coral reefs.

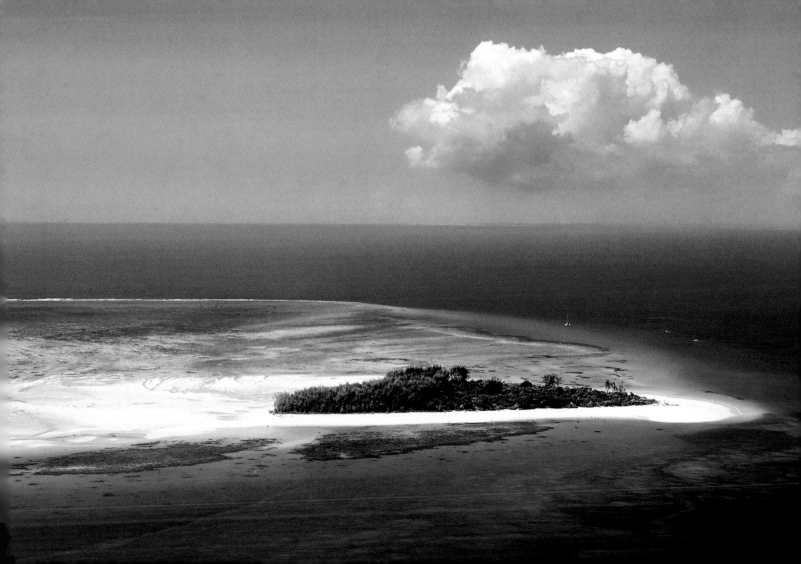

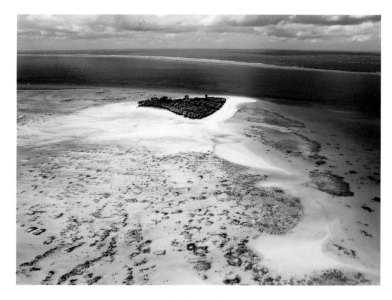

420 and 421
Seen from above, the Indian Ocean that laps the coast of Tanzania,
is as smooth as oil and shimmering with thousands of colors.

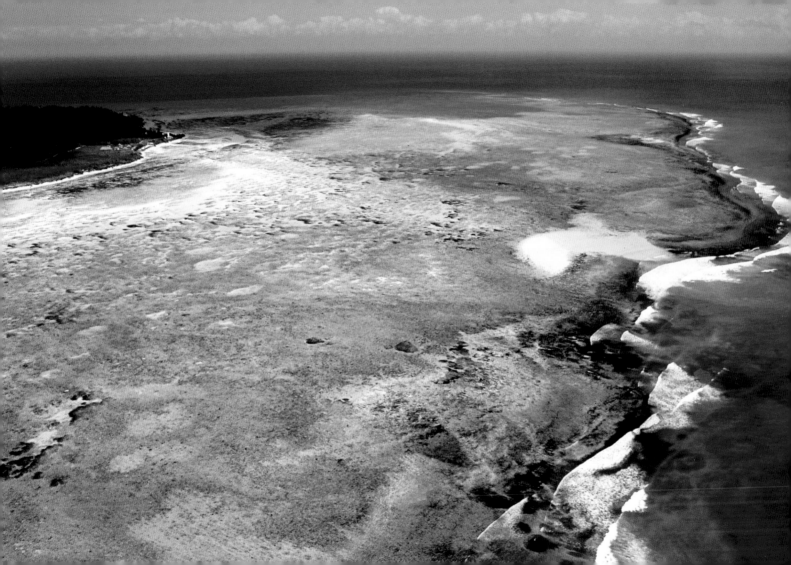

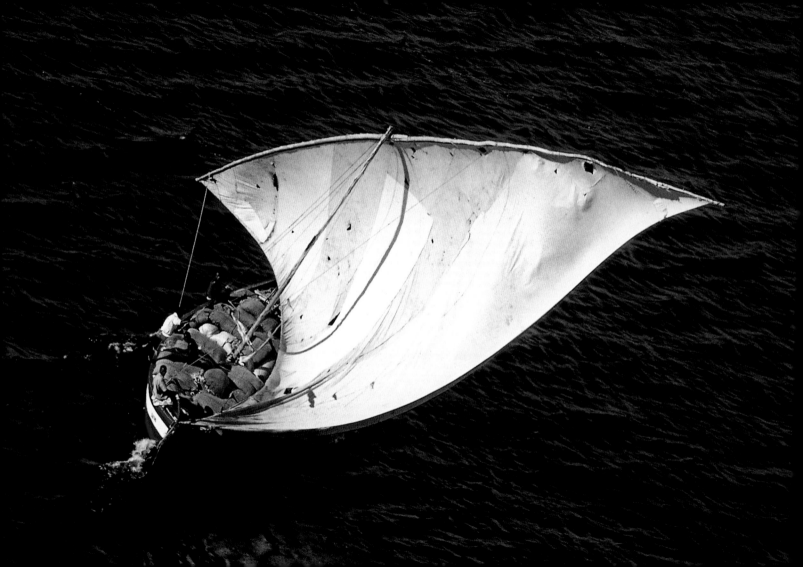

422-423

The traditional fishermen's boats in the Indian Ocean, Tanzania, are complete with a triangular sail manouvered by a series of ropes and pulleys.

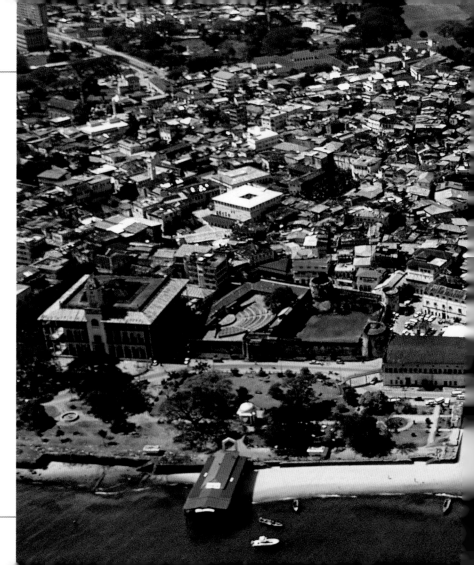

424-425
The oldest houses and palaces in the city of Zanzibar, Tanzania, are mostly built of madreporitic stone.

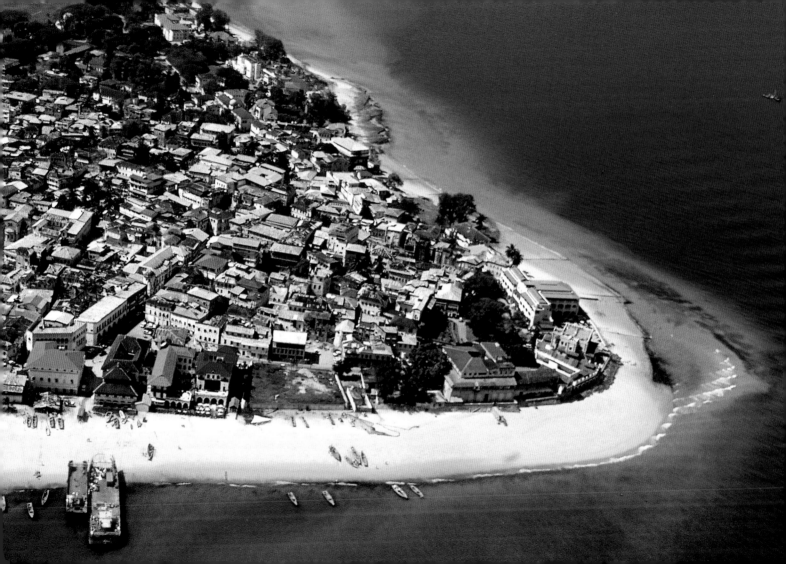

426 and 427
The splendid coral banks that line the coast of the Indian Ocean, in Kenya, represent a dangerous trap for navigation.

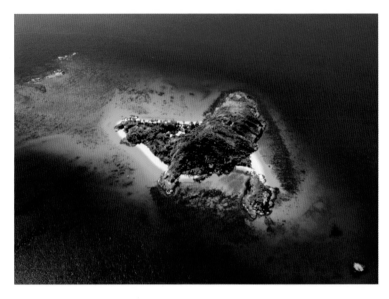

428
The island of Nosy Tsara Bajina, a few dozen miles from the northern coast of Madagascar, is reknown for its beautiful marine beds and sandy beaches.

429
The sandy beaches of the Nosy Iranja Island of northern Madagascar, are among a few of the places where sea turtles reproduce.

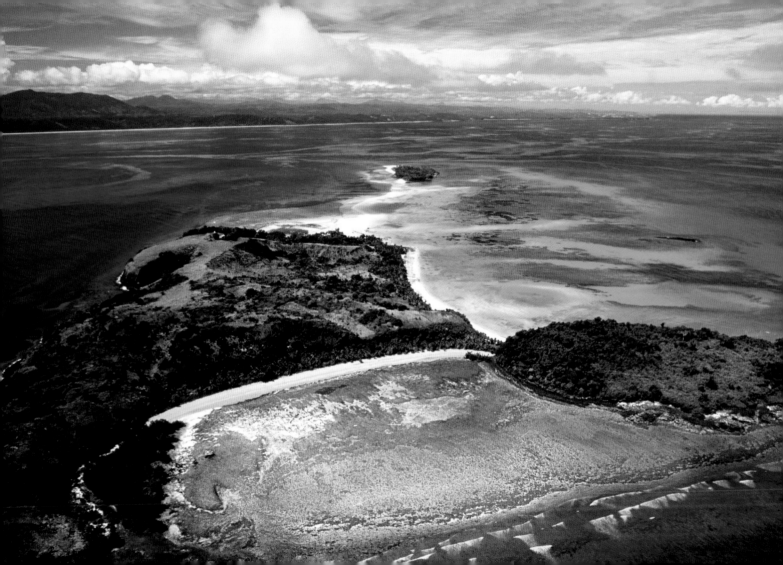

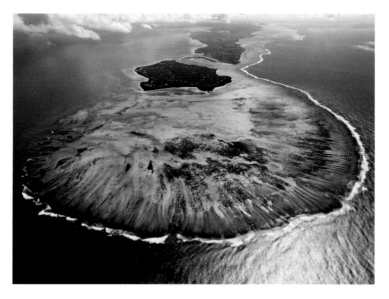

430
The southern section of the Sainte Marie Island, near the eastern coast
of Madagascar, is surrounded by a spectacular coral reef.

431
The Canal des Pangalanes, that follows the eastern Madagascar coast
up to Toamasina, is accompanied by coastal lagoons, like this one.

432 and 433
Most of the islands within the Seychelle archipelago, in the indian ocean, like Ile St. Pierre (left) and Ile La Digue (right), are real natural paradises.

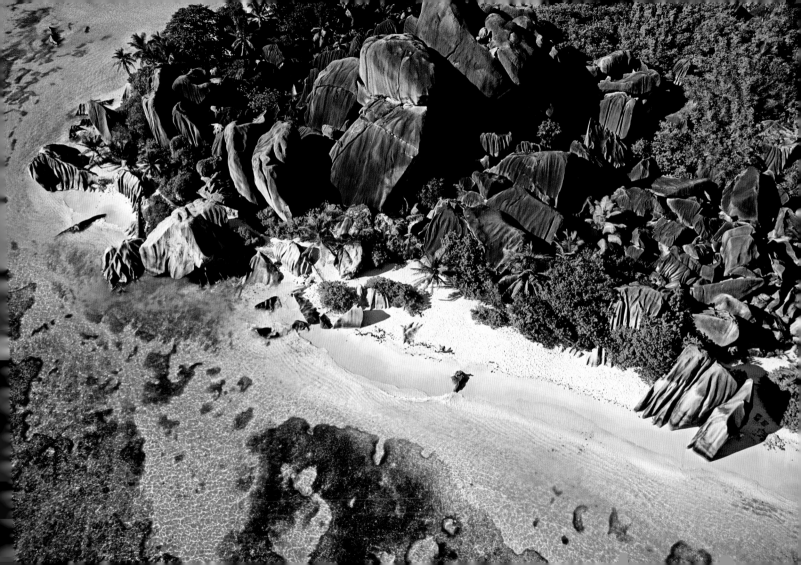

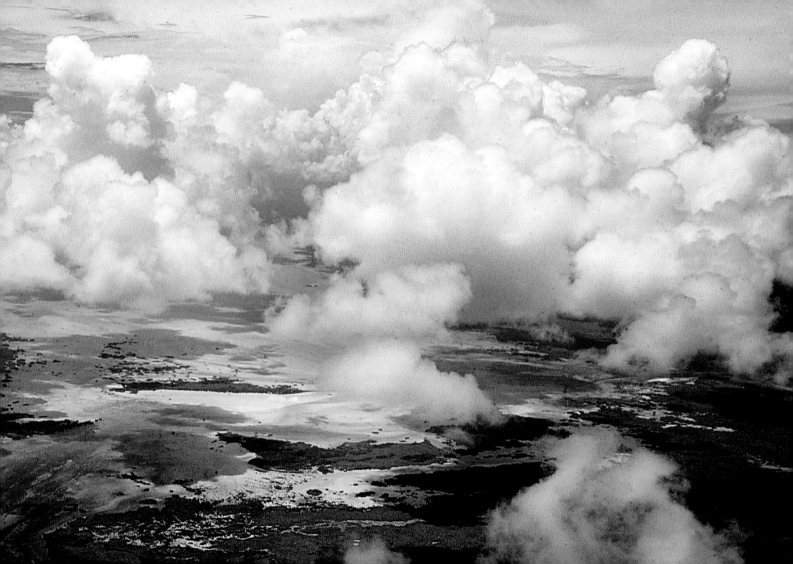

434 and 435
Aldabra is a coral atoll of the Seychellees, which hosts a distinctive island fauna.

436 and 437
Mahe is the largest island of the
Seychelles and houses many
parks, including the St. Anne Ma-
rine National Park.

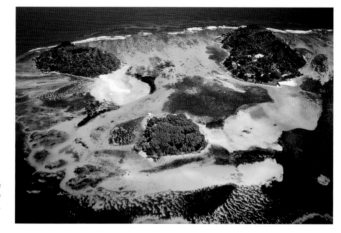

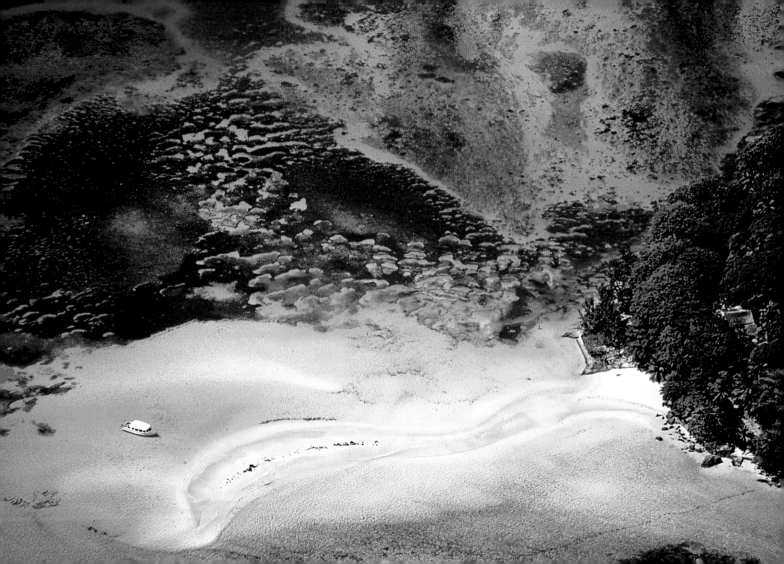

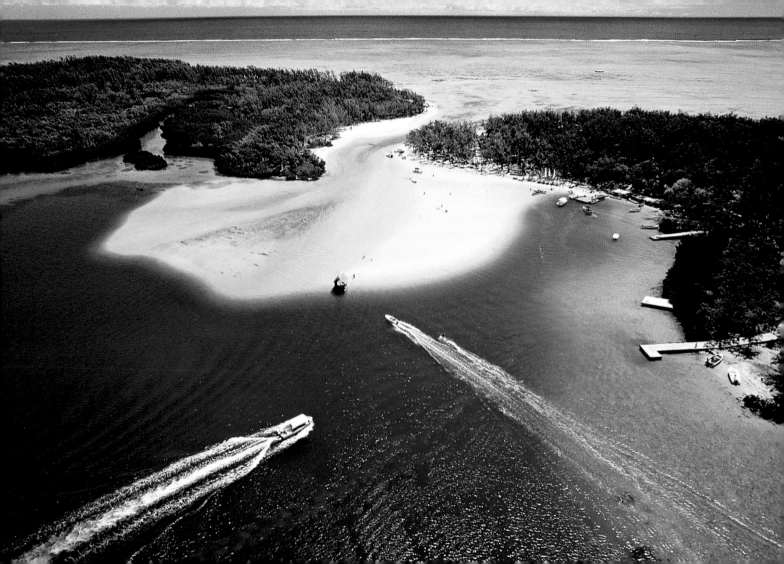

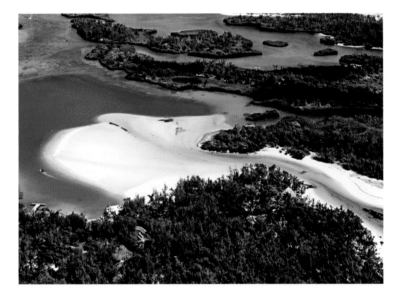

438 and 439
The surface of Mauritius is mostly covered by tropical forest that extends up to the island's sandy beaches. Here is the spectacular Ile aux Cerfs.

440-441
The coast of the Mauritius island, 500 miles east of Madagascar, is mainly constituted by basaltic rock.

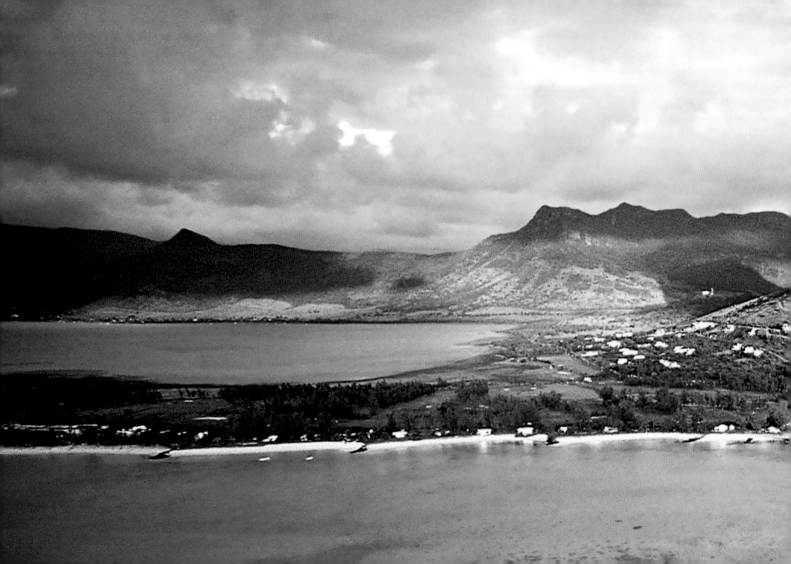

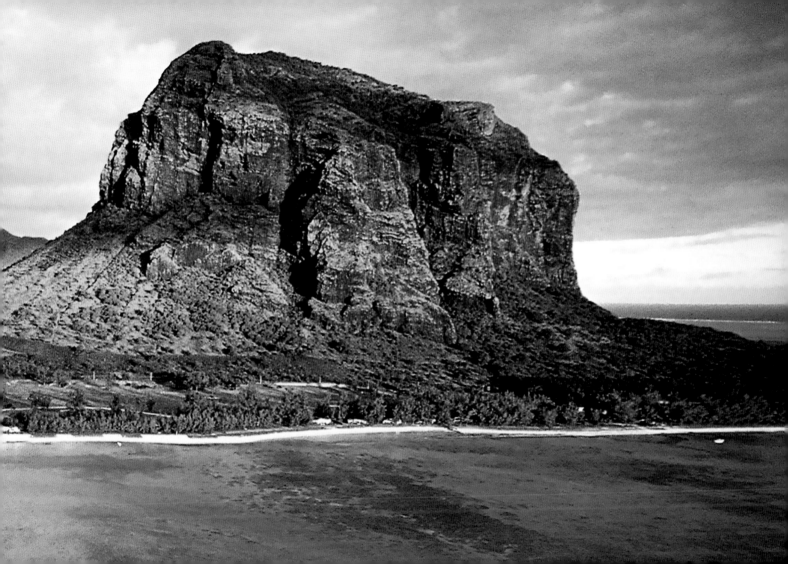

442 and 443
The coast of the Mauritius Island presents many coral reefs.

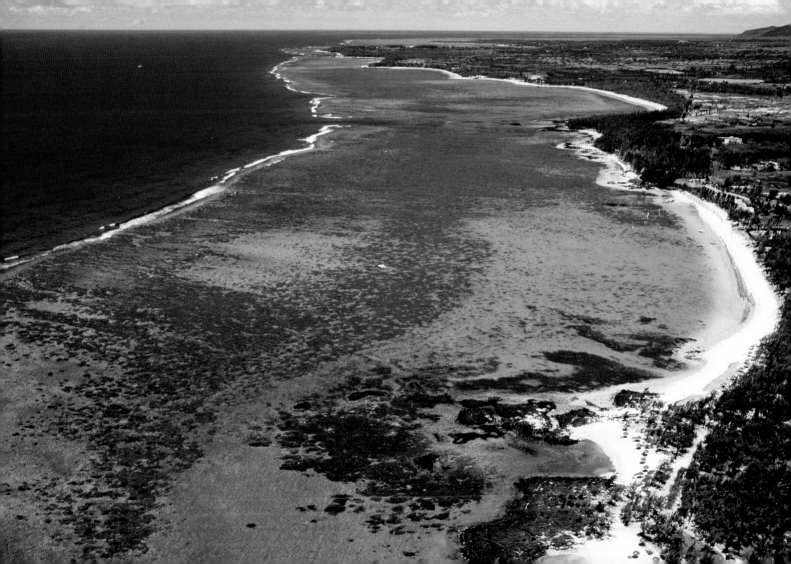

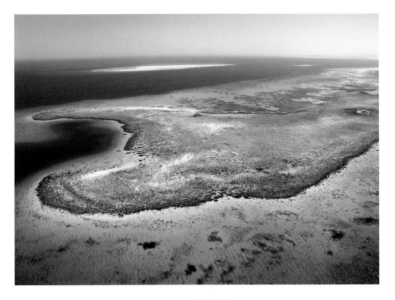

444 and 446-447
The coral reef that extends along the Red Sea coast near Hurgada, in Egypt, offers incomparably beautiful sights.

445
Giftun Island, an hour's navigation from Hurgada, in Egypt, is one of the most spectacular underwater parks in the Red Sea.

Red Sea

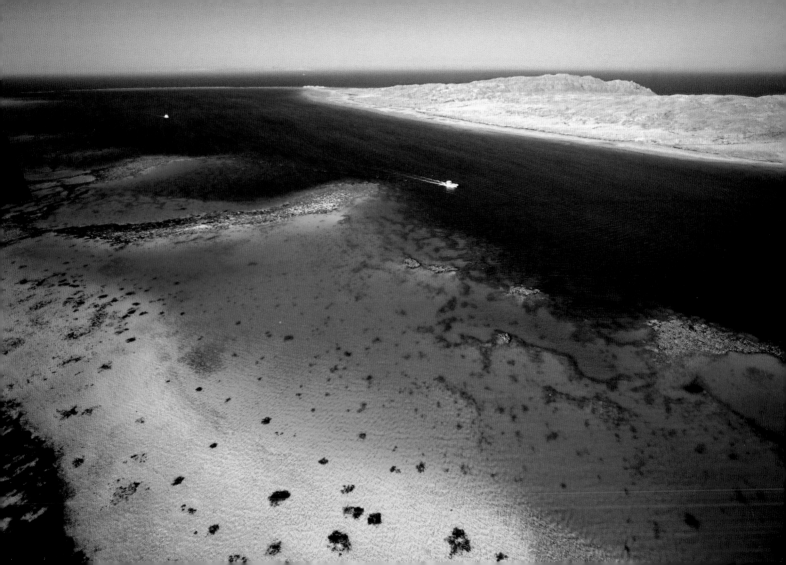

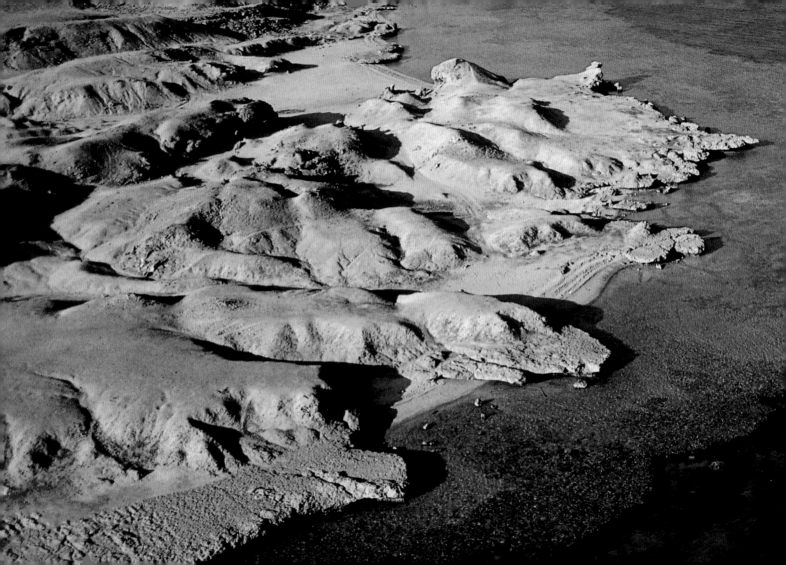

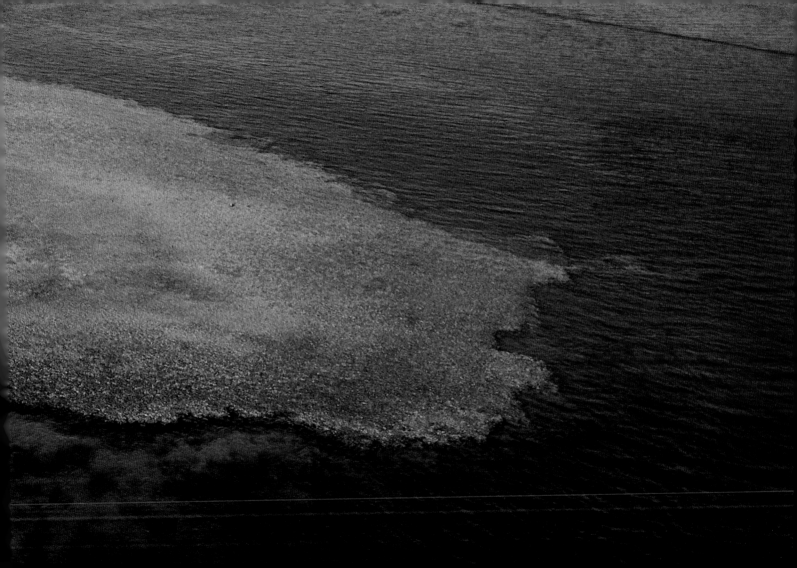

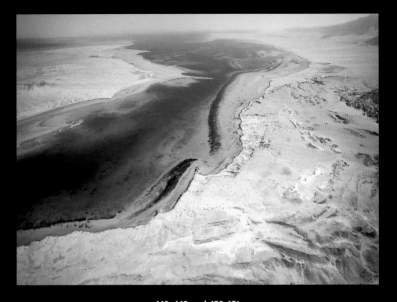

448, 449 and 450-451
The images portray diverse points of the Egyptian coast on the Red
Sea, where the desert meets the turquoise water.

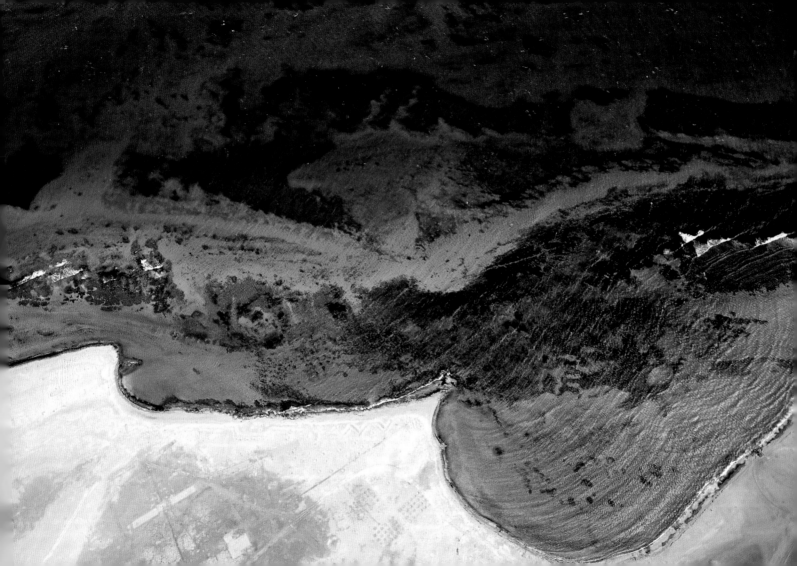

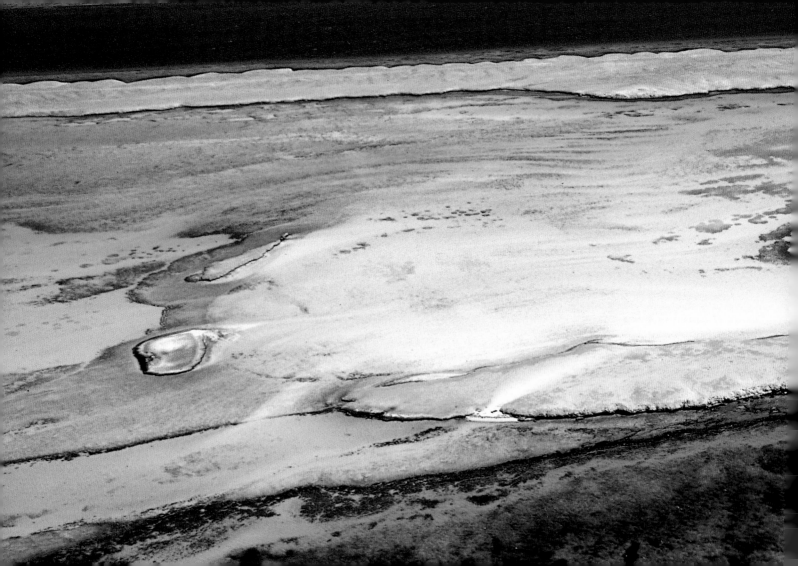

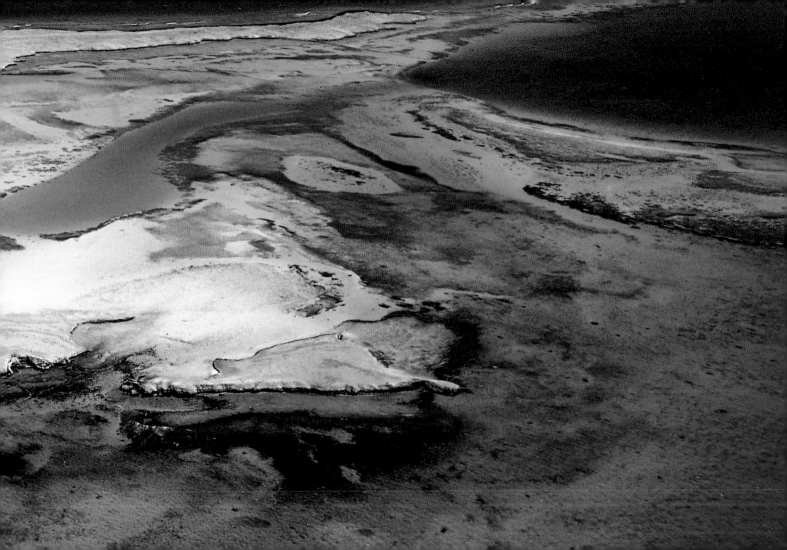

453

In Egypt, the encounter between the sands of the Sahara and the blue waters of the Mediterranean Sea sometimes has an extremely essential nature.

Mediterranean Sea

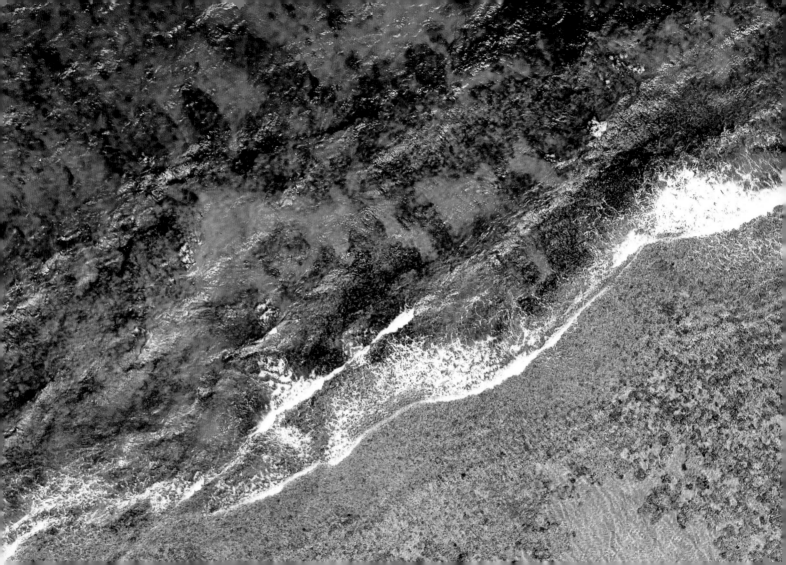

454 and 455
The secluded bays that open onto Egypt's Mediterranean coast have always been a favorite place for human settlement.

456-457
In this desert tract of the Egyptian coast, the waters of the Mediterranean are extraordinarily limpid and transparent.

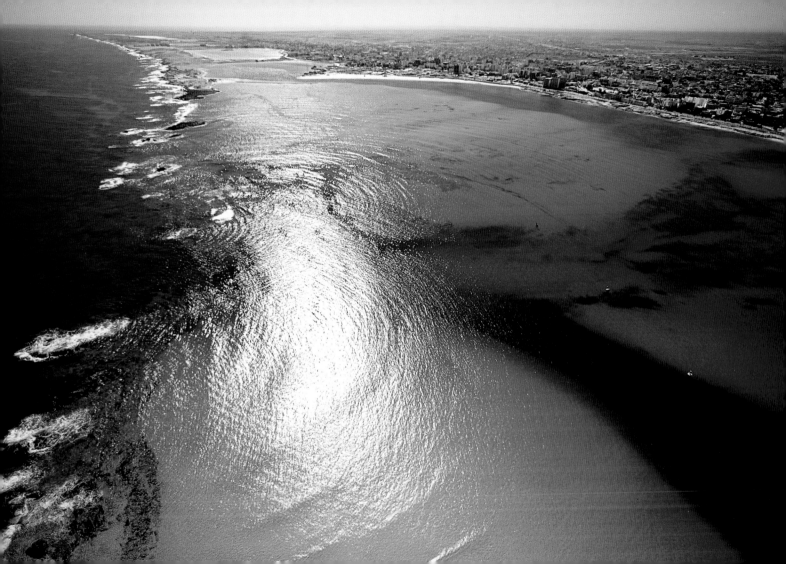

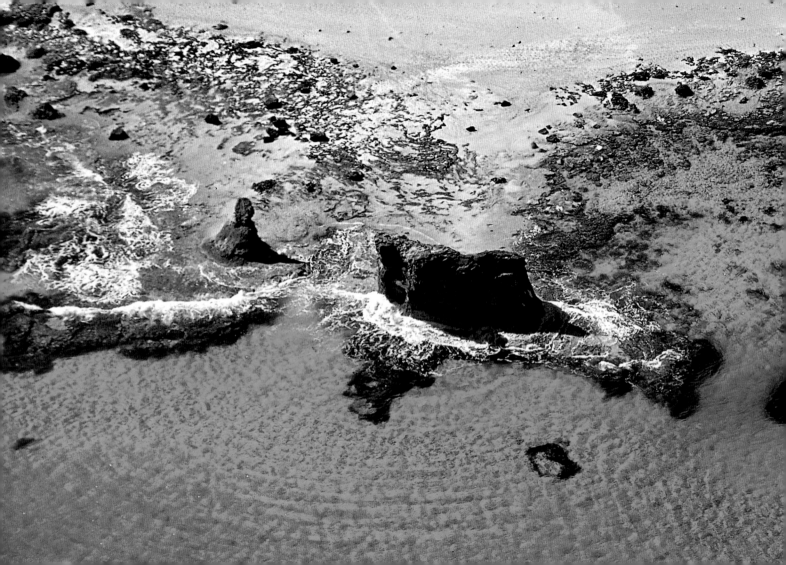

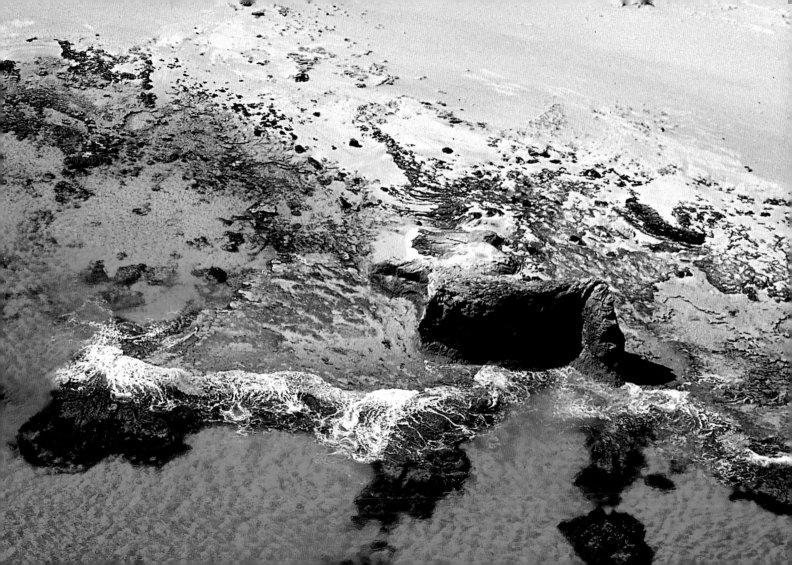

LIVING IN AFRICA

FLYING HIGH

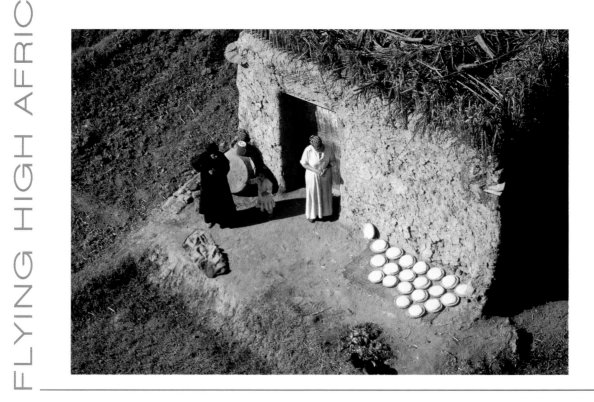

459
Cultivated fields in the Mwea area (left) in Kenya and the Maasai villages in the Amboseli area (right).

Africa's ethnographic maps are illegible: a jungle of thousands of names that attempt to define groups, subgroups, tribes and clans. The African populations are so numerous that scholars (often without asking the permission of the "subject") are often forced to categorize the "devil with the holy water." In fact, the name Turkana often also identifies the Dodoth, historically arch- enemies.

As well, the academic map is static while people are mobile, mixing among themselves and migrating. At times, the groups disappear, or they resuscitate, like the El Molo, fishers of Turkana Lake. Reduced to a mere hundred individuals and absorbed by the Samburu society, the El Molo were on the brink of cultural extinc-

tion. Death, even if virtual, always makes for news: the El Molo suddenly became the destination of anthropologic and tourist pilgrimages. The El Molo soon realized that allowing foreigners to photograph them generated more income than their difficult fishing activity in a crocodile-infested lake.

They increased in numbers and found their lost El Molo identity. There are no static points in Africa. The picture is one of continuous change and the traditional African societies now face serious problems for survival. Wars, natural catastrophes and massive urbanization are powerful forces, capable of rapidly changing the existing order.

At least for the time being, however, the old mo-

460
Dwellings on the west banks of the Nile at Luxor, Egypt.

Living in Africa

del of life continues to work. For example, nomadic lifestyles still seem to be the only way to make use of the arid land, otherwise useless. All of the peoples of the Sahara are necessarily nomadic tent dwellers: the Tuaregh, Peul, Tebu, Mauri, Kababish, Beja and Chaamba as well as the Berber groups from southern Morocco. Once ferocious pillagers and uncontested lords of the desert, they are presently goat, cow and camel breeders.

The Tuaregh accompany this activity with the commerce of salt, abundant in the Sahara but a rare and precious commodity in the heart of Black Africa. Cut into big bricks or pressed into smaller loaves, salt transported in caravans across the desert and traded for other goods such as dates, grains and other agricultural products of the savanna.

The dromedary is more convenient than the truck: it consumes no fuel, needs no maintenance and never breaks down. If it dies, it is not abandoned along the route, but recycled into useful products for the nomad economy. Emblematic of this world of mutable, unstable confines is the tent. Size and dimension may change in relation to the environment and the wealth of the owner, but all match the requirements of nomadic life: quickly dismantled and easily transportable.

The Moroccan Berber's black tent can be completely loaded, support poles and all, onto the back of one dromedary. The Tuaregh tents are much more voluminous, round constructions of goatskins sewn together and able to accommodate ten people. Other nomadic breeders are the Maasai from Kenya and Tanzania, the Turkana, Borana, Somali and a great part of the population that inhabits the region between the western edge of the Rift Valley, the African Horn and southern Sudan.

The Pygmies of the Congo basin and the Kalahari Bushmen also practice a reduced form of

Living in Africa

nomadic lifestyle. Both groups survive by hunting and gathering wild fruits, the most ancient form of economy. Their homes consist of shelters made of branches or other material found in the area.

The rest of the continent, moderately rich in water and not too hostile to human presence, is utilized as agricultural land for extensive plantations, such as in the Ivory Coast, in South Africa and northern Sudan, or, more often, subsistence farming, tied to the ancestral rhythm of the seasons. The house, a permanent modular structure, substitutes the tent or shelter made of flexible branches.

Constructed in clay or vegetable fibers, circular or rectangular, sometimes similar to small castles such as among the Somba of Benin, current classification identifies approximately 30 different types of housing structure. The African home is not only a nocturnal refuge or place to cook or entertain; its shape is partly tied to climatic factors. These homes represent the spiritual needs of their constructors, a place for the ancestors as well as the living. In Madagascar, a melting pot of races and meeting point between Africa and Asia, the house is oriented according to precise astronomic rules. For instance, the headboard of the bed always faces north-west.

The house of the Dogon echoes the shape of a seated man: the different sections represent the head, trunk and appendages, while the entrance represents the genitals. The structure of the village, the disposition of the huts and the different quarters reproduce the social hierarchy as well as man's relationship with the universe. To live in Africa is to affirm one's intimate relationship with one's community, with a cultural space defined by tradition and by a network of metaphysical ties with supernatural forces: to live, maintaining one's identity and dignity generation after generation.

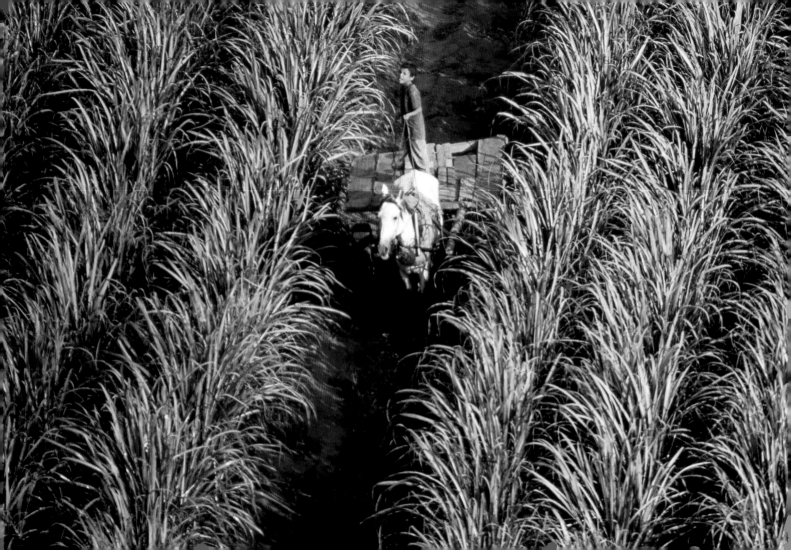

464-465
The production of this sugar-cane plantation is severely conditioned by the lack of appropriate tools, common to Moroccan agriculture.

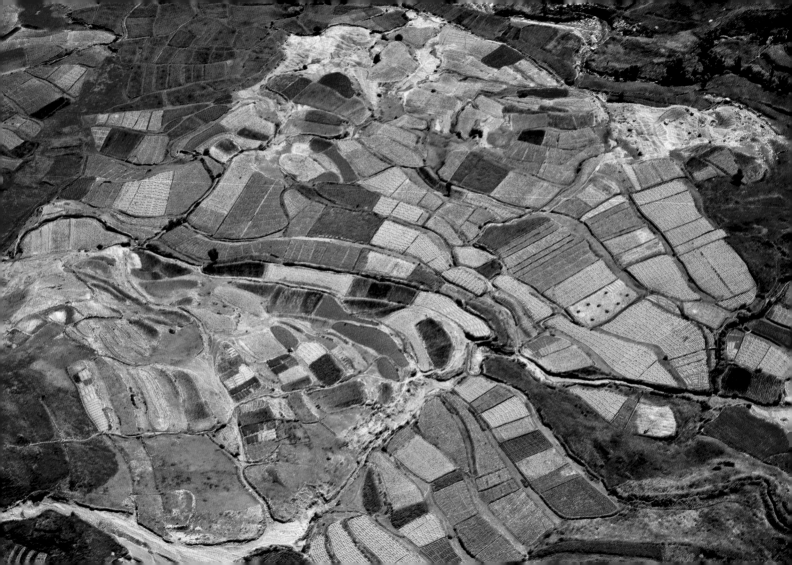

466

Notwithstanding the difficult environmental conditions, a dense network of cultivated patches cover the highlands on the Atlantic facing the mountains of Morocco.

467

Orderly rows of trees mark the confines of the cultivated fields on the slopes of the Rif Mountains, in northern Morocco.

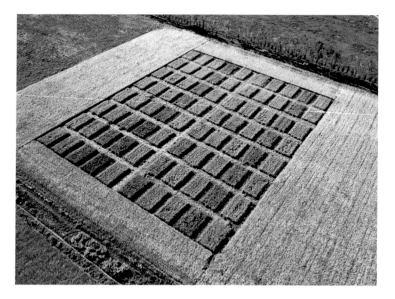

468

More than half of the cultivatible land in Morocco is destined to the cultivation of grains, a constantly increasing production.

469

The extraction of salt, concentrated mostly along the Atlantic coast near Casablanca, plays an important part in the Moroccan economy.

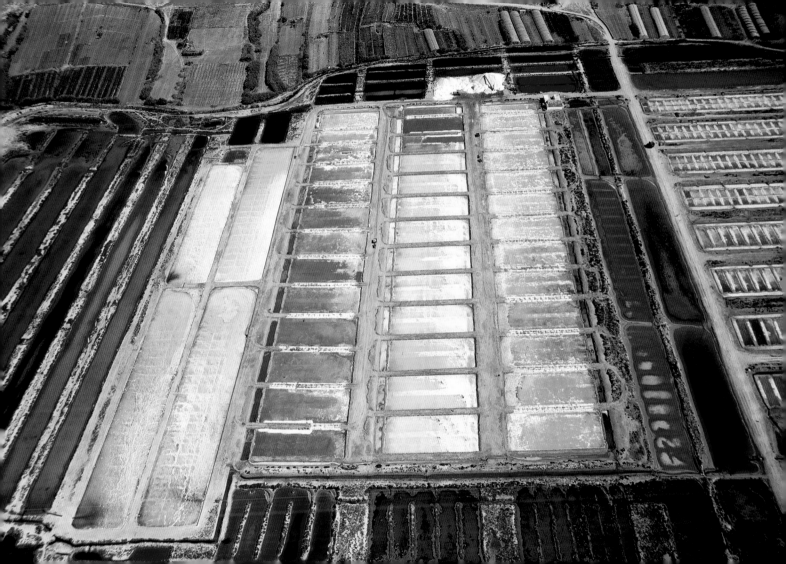

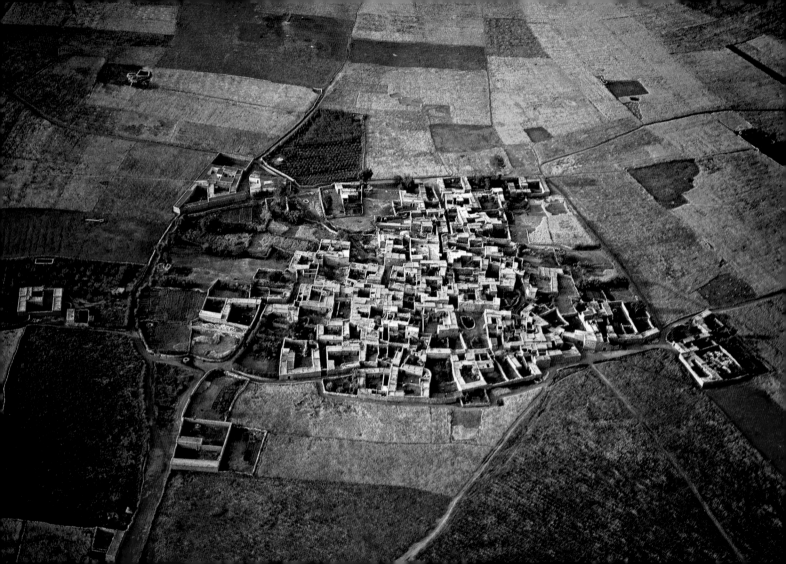

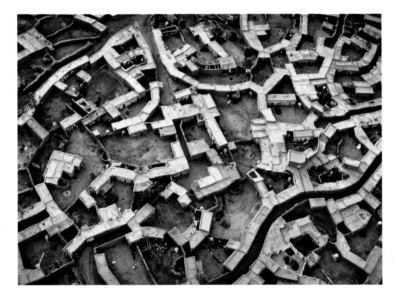

470
Customary law establishes the rights for the use and ownership of cultivatible land, surrounding this village in the High Atlantic zone of Morocco.

471
In Morocco's rural areas, methods of construction of the traditional earthen houses, have remained unaltered through the centuries.

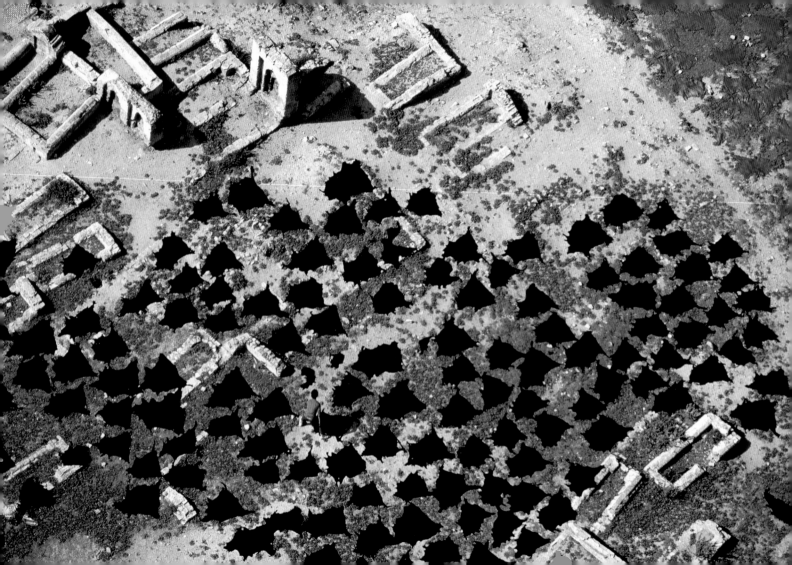

472
The skins, hung out to dry in the ruins of this old cemetery, will soon be transformed into fine leather objects, in the Moroccan artisan style.

FLYING HIGH AFRICA

475
Laid out to dry in the sun, among the palm groves south of Cairo, Egypt, these freshly picked dates will later be ground into flour for consumption.

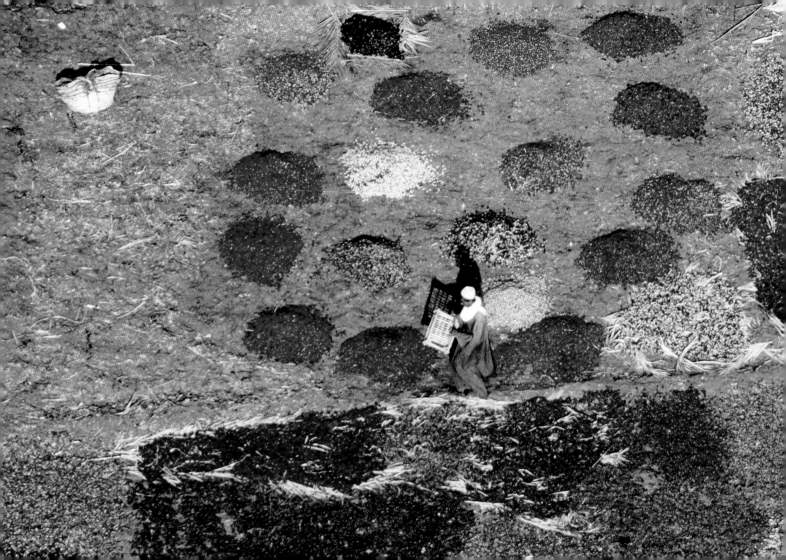

476-477
Selected according to type and quality, these dates picked near Cairo, Egypt, are mostly destined for exportation.

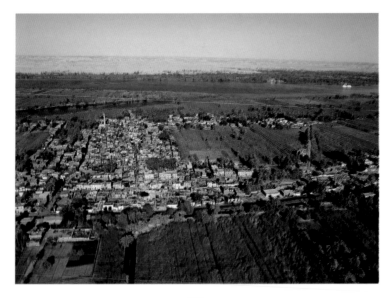

478

For millenia, the arid regions of the Eastern Desert, just beyond the course of the Nile, have represented the final boundary of the world inhabited by man.

479

A geometry of forms and colors characterizes the densely cultivated landscape that extends along the fertile banks of the Nile at Luxor, Egypt.

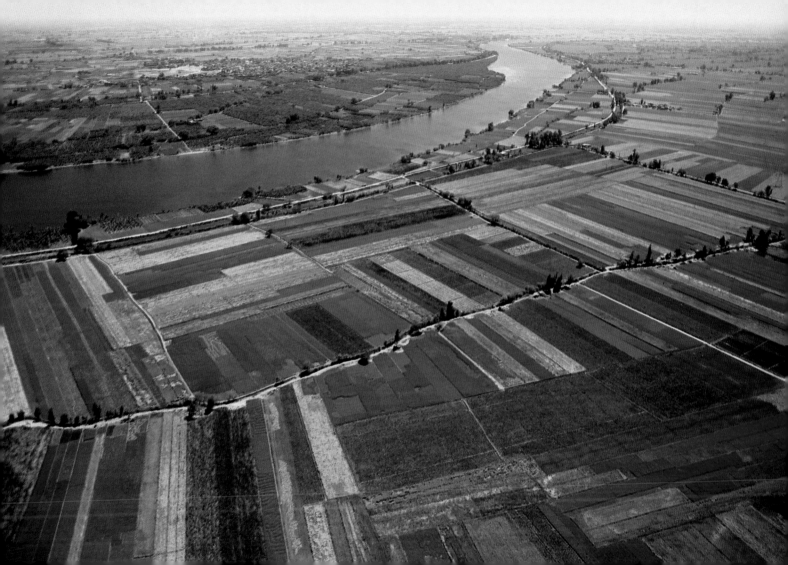

480
The unchanging rhythms of agricultural labor have always influenced
the inhabitants of this small village in Luxor, Egypt.

481
The harvest season is a moment of arduous work for these farmers,
intent on their labor in the countryside near Luxor, Egypt.

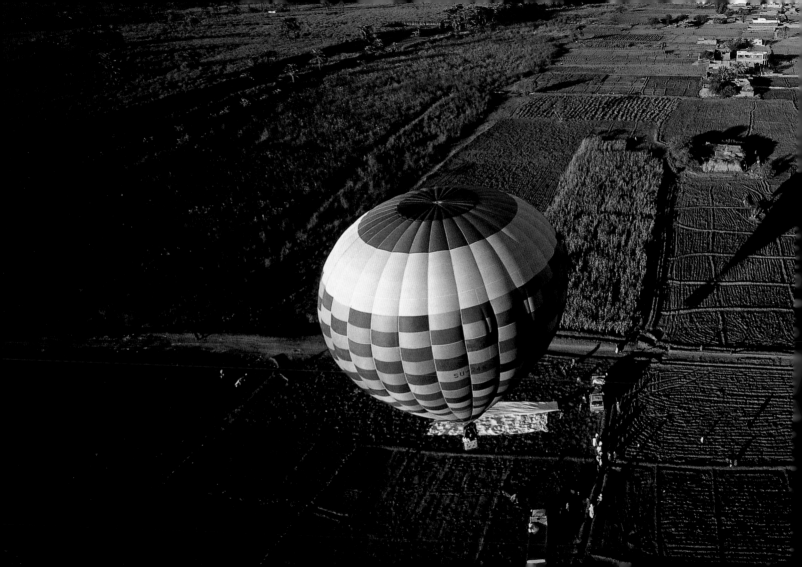

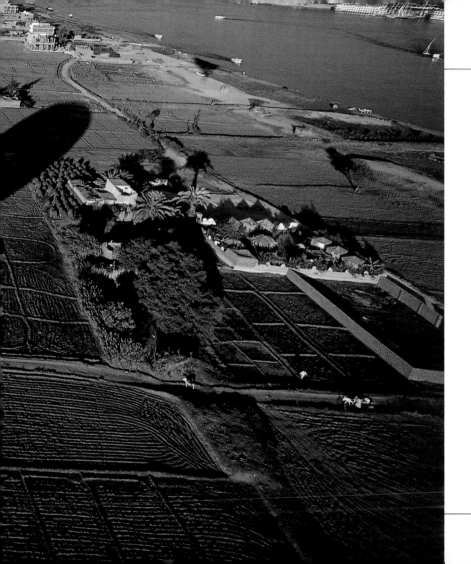

482-483
A compact agricultural area, with farmhouses, lines the western banks of the Nile in Luxor, Egypt.

484 and 485
The barrier of soil that surrounds these fields in Kiffa, Mauritania, serves to aid in irrigation.

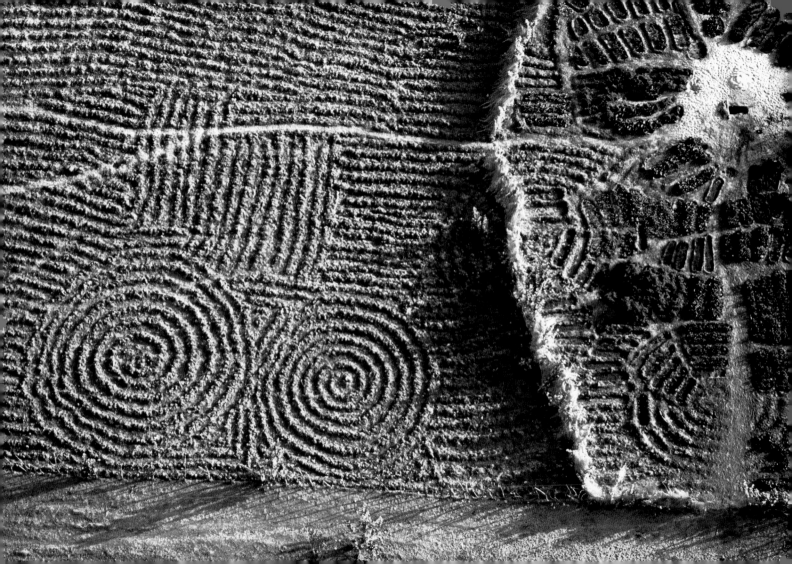

486
The water necessary to irrigate these fields near Kiffa, Mauritania, is hand pumped daily from open-air wells.

487
Characteristic fences of palm leaves protect the vegetable gardens in Tichitt, Mauritania, from the sand and dry desert winds.

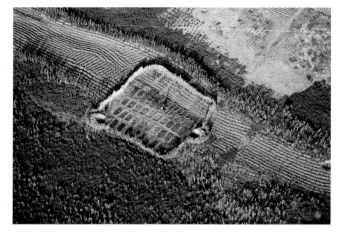

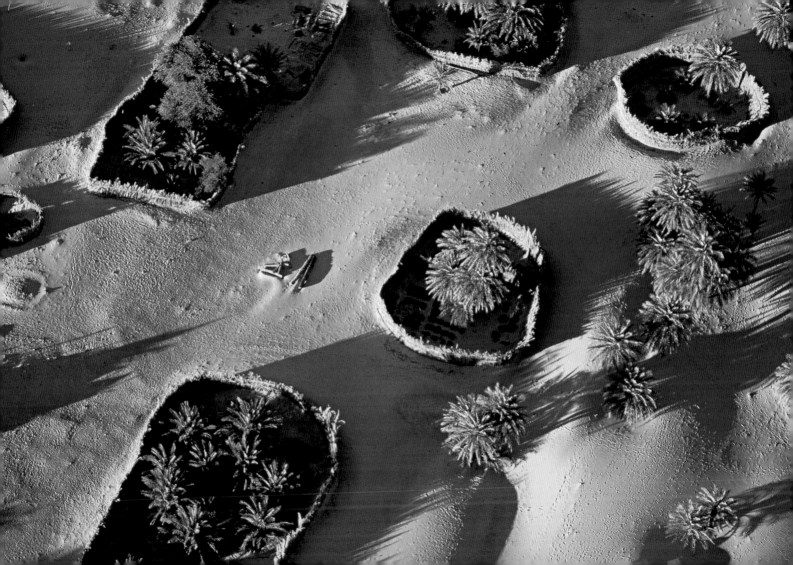

FLYING HIGH AFRICA

489
The livestock markets, like this one photographed at Nouakchott, Mauritania, also serve as important social events.

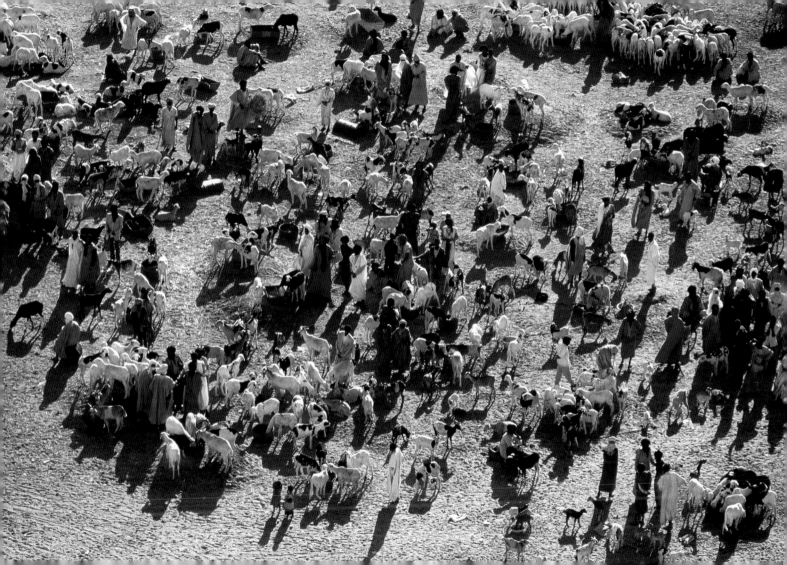

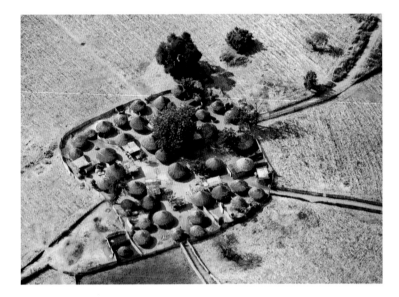

490
The structure of this village in the Kayes zone, Mali, punctually reflects the solid social and familial structure of its inhabitants.

491
The methods utilized for cultivation in the Gao region of Mali are the result of centuries of adaptation to the difficult environmental conditions.

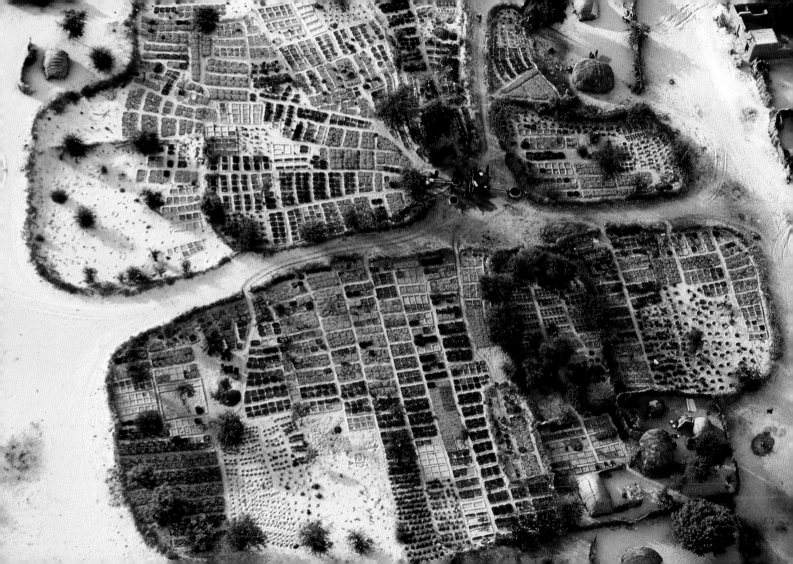

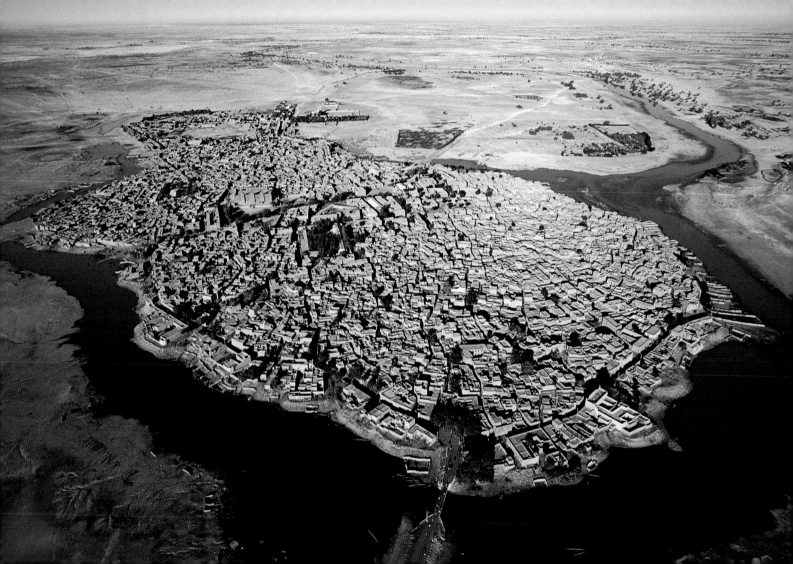

492

Founded around the year 1000 on the banks of the Bani River, the city of Djennè was one of the wealthiest and most important trading centers in ancient Mali.

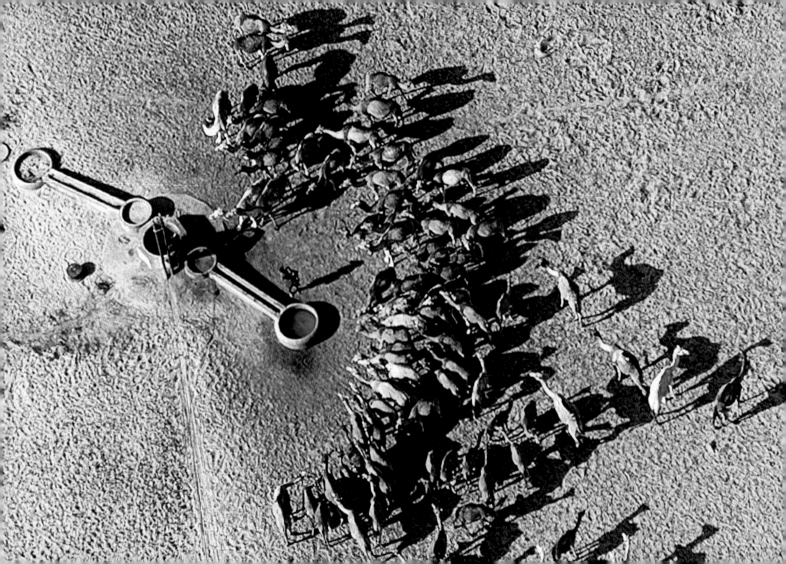

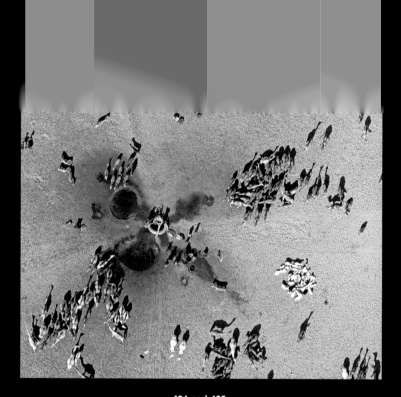

494 and 495

The presence of permanent wells establishes the course of the cara-
van routes that cross the Sahara in the regione of Timbuctu', in Mali.

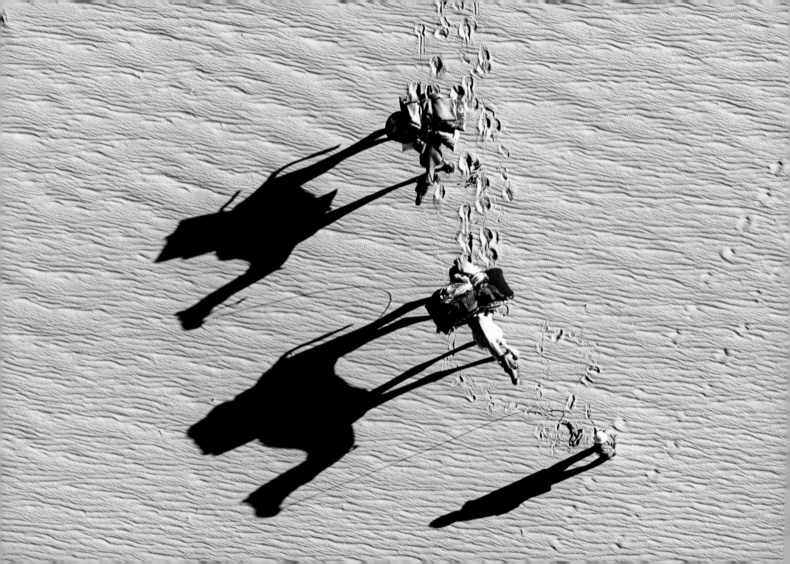

FLYING HIGH AFRICA

496
The caravan routes that cross Mali's Sahara, north of Timbuctu', are often just faint
tracks in the sand.

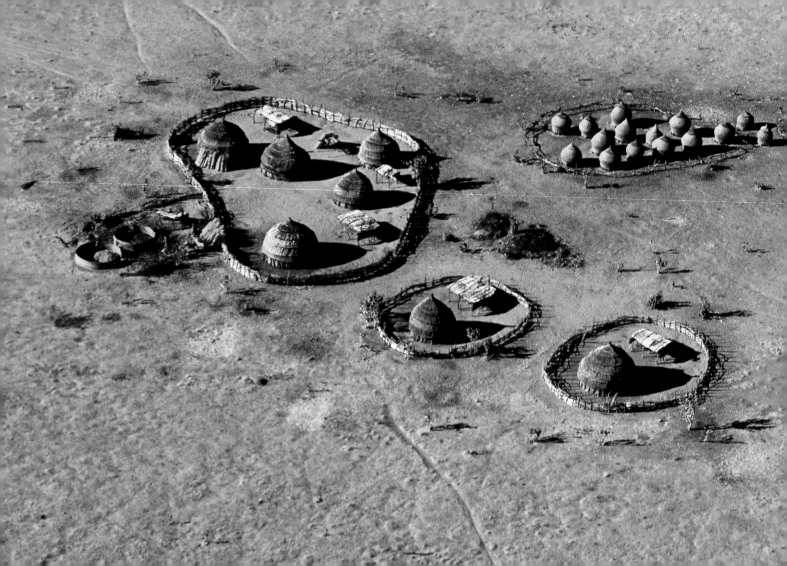

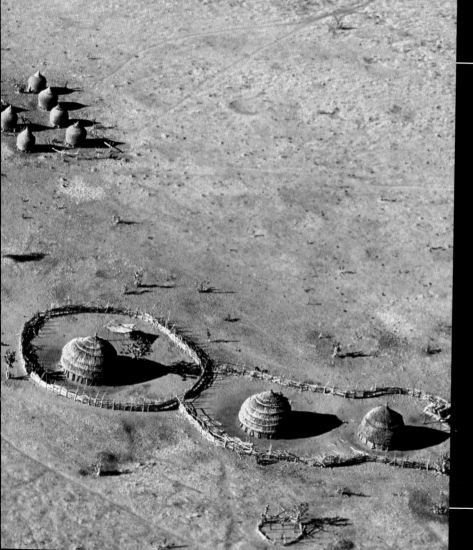

498-499
The supply of grains conserved in the granaries permits the inhabitants of the Tahoua region in Niger, to face long dry spells.

FLYING HIGH AFRICA

501
Simple earth huts compose this settlement near Tahoua, in Niger.

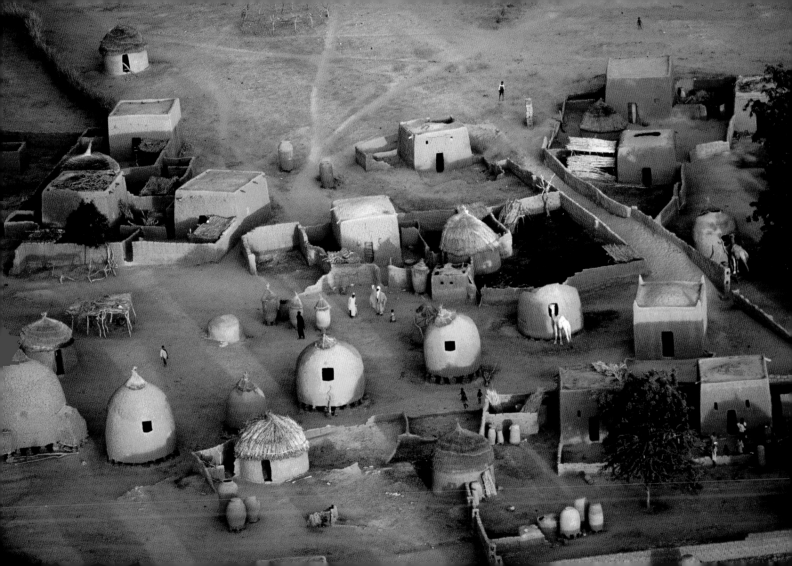

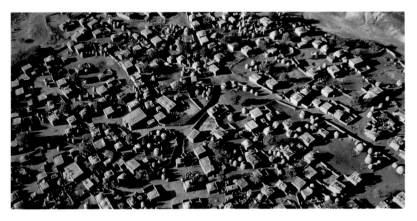

502
The villages that rise along the plains surrounding Tahoua, Niger, have always served as meeting places for nomads and sedentary farmers.

503
The fortified village of Fachi, surrounded by dazzling salt mines, lies isolated between the dunes of Tenéré's Erg, in western Niger.

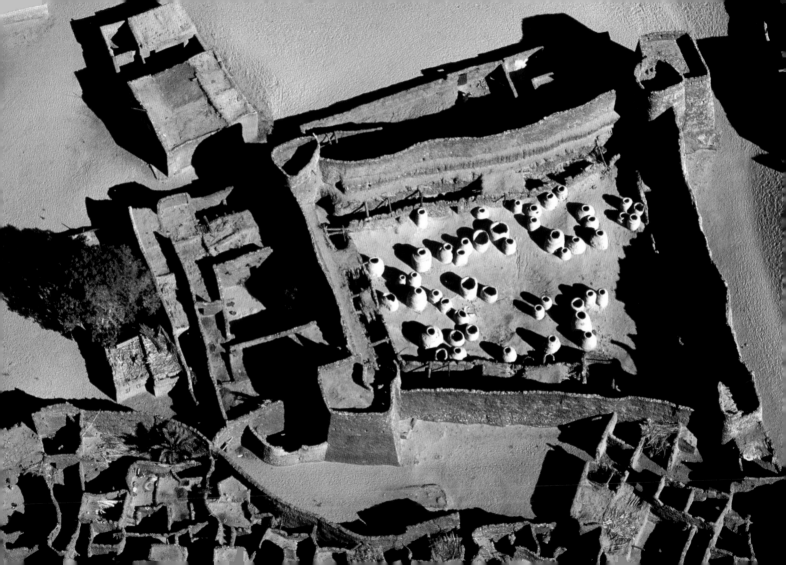

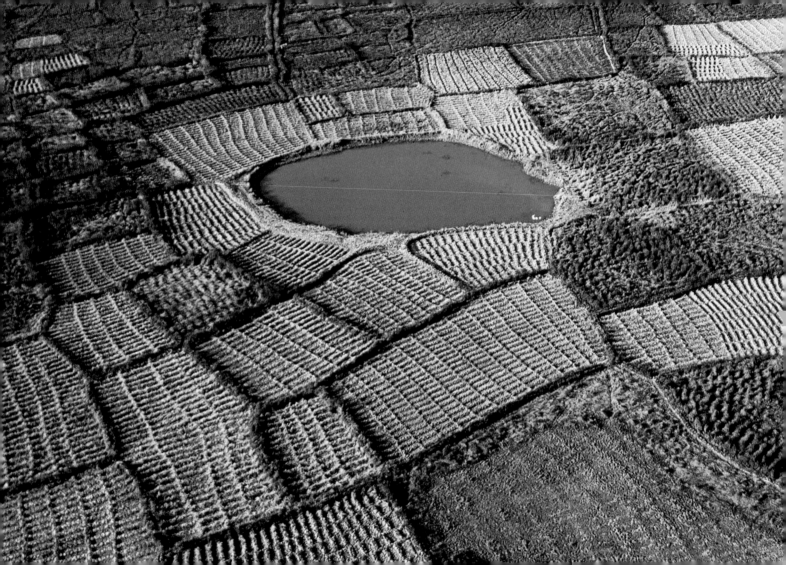

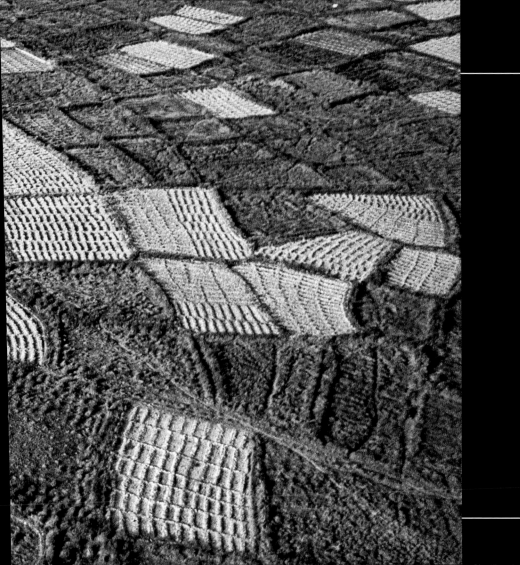

504-505
Thanks to the abundant rains and fertile soil, rice is the dominant crop in the Casamance region of Senegal.

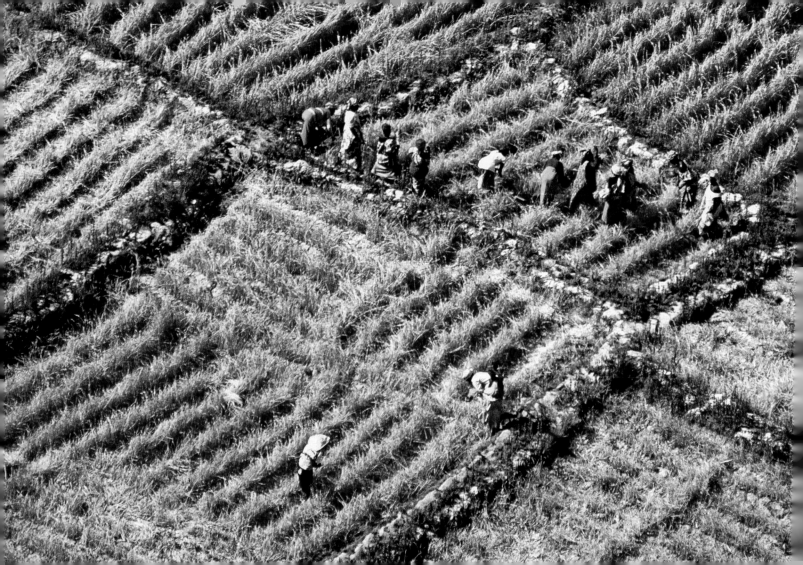

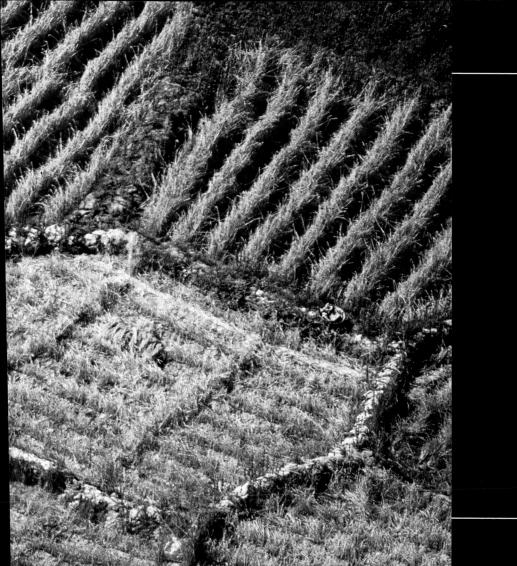

506-507
In the absence of mechanical means, collective labor is a dire necessity for rice farmers of Casamance, in Senegal.

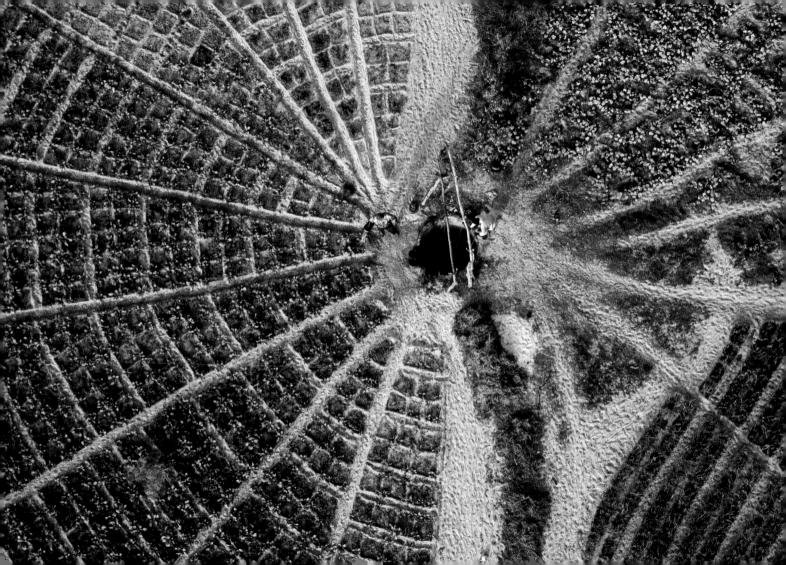

508
Irrigation canals placed in radial arrangement around a well permit the farmers to
work more efficiently.

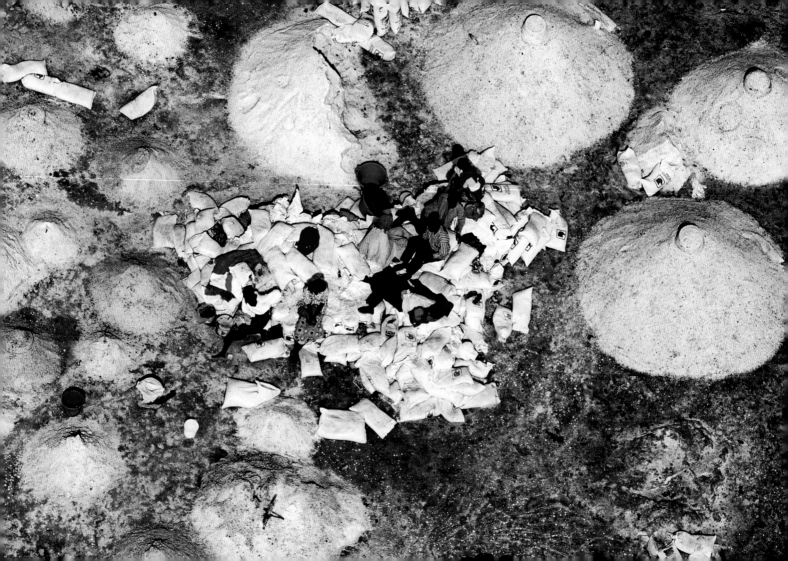

510
Salt gatherers take a break on the banks of Lake Rosa, in Senegal.

512-513
After the ritual bargaining on prices, the salt extracted from the water of Lake Retba, in Senegal, will be put on sale in the markests of Dakar.

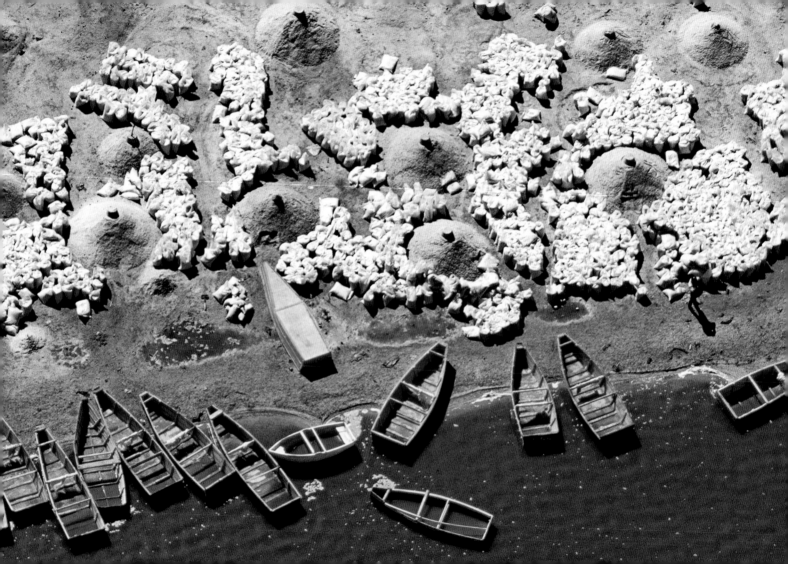

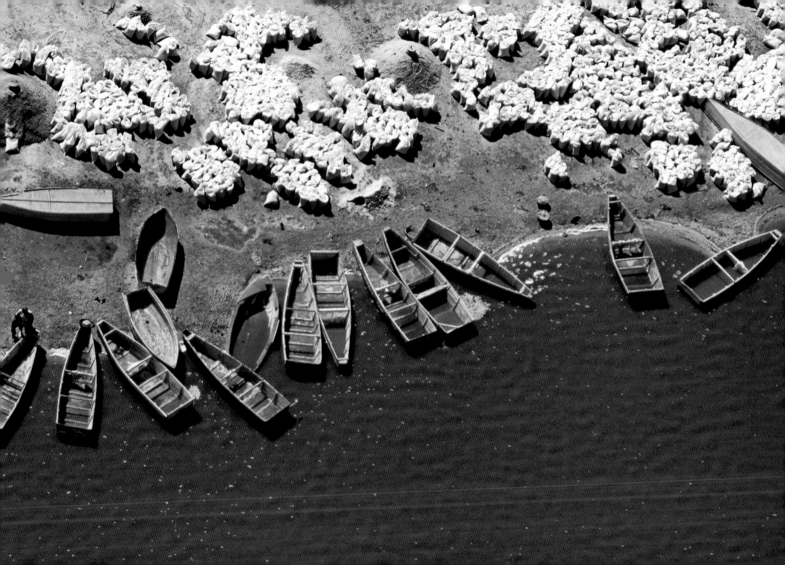

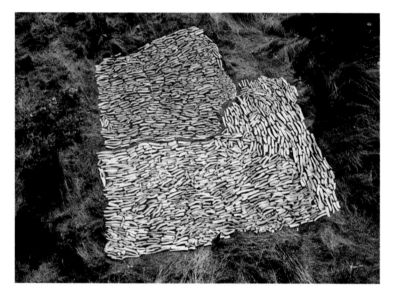

514 and 515

Yams are the most widespread crop among the people of the Ivory Coast. Its roots, dried and cooked, are one of the basic foods of the farmers on the Ivory Coast.

516-517

Pineapple cultivation, although less important than that of cocoa and coffee, is one of the main agricultural economic factors on the Ivory Coast.

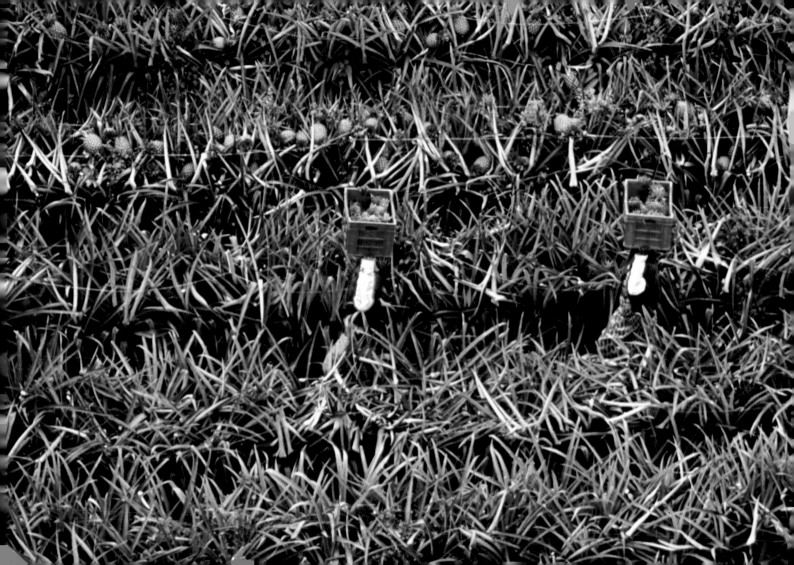

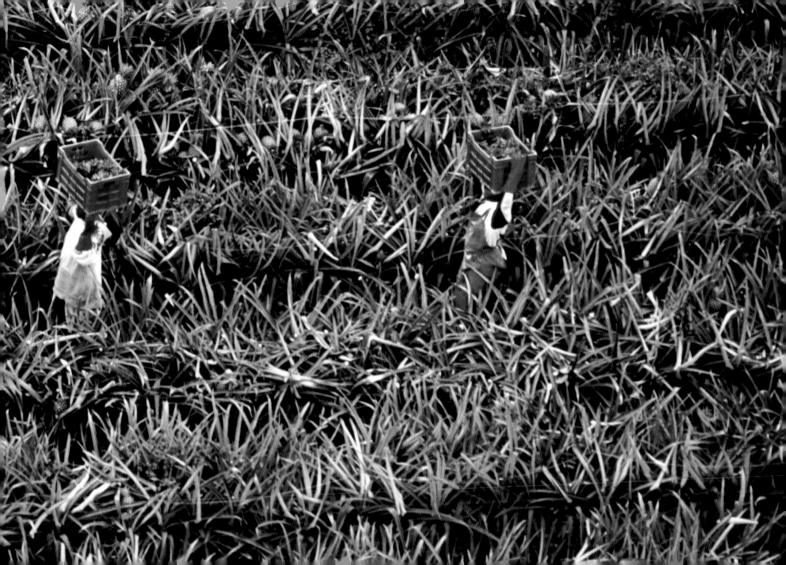

518
This hut in Boundiali, Ivory Coast, projects its living space into the outdoors, inside a courtyard.

519
The population of Lobi in the Bouna region, Ivory Coast, builds earthen rectangular houses, with their typical terraces.

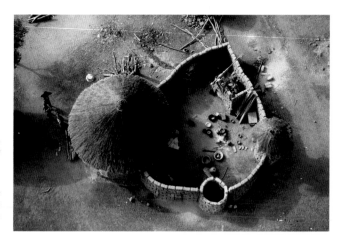

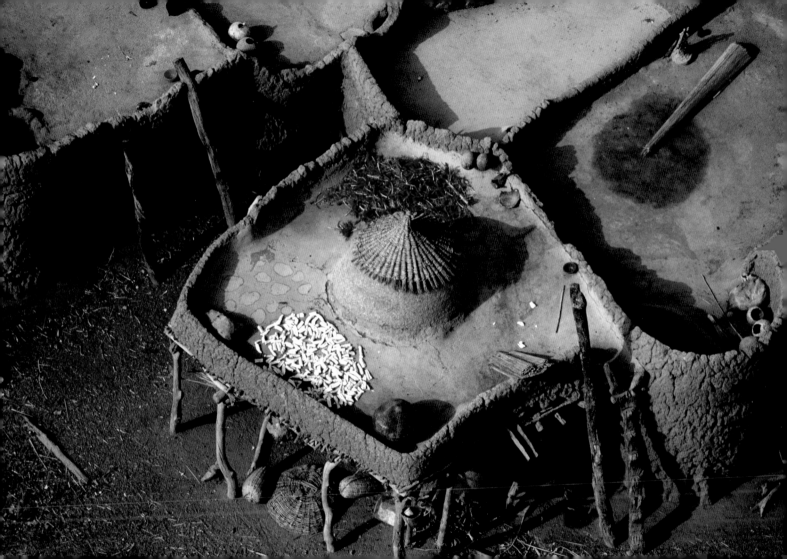

521
The famous masks guard over the harmony in the Baule villages, like this one in Me-kro, Ivory Coast.

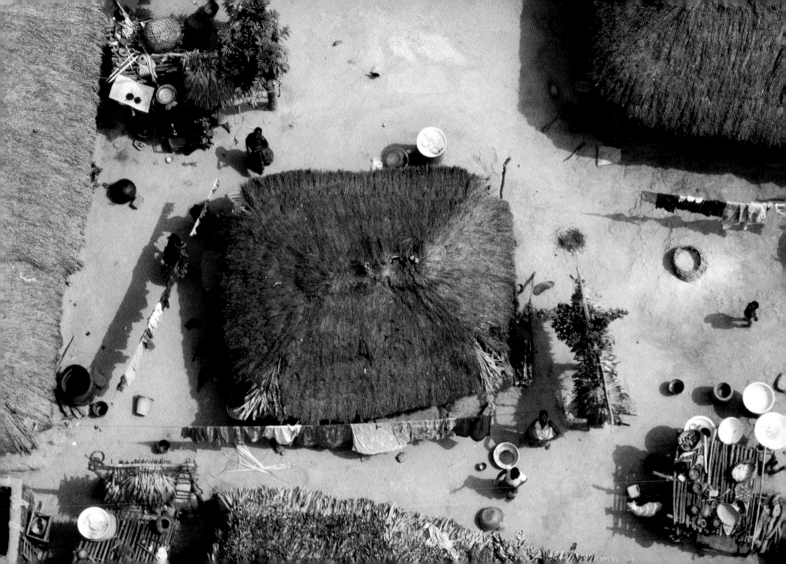

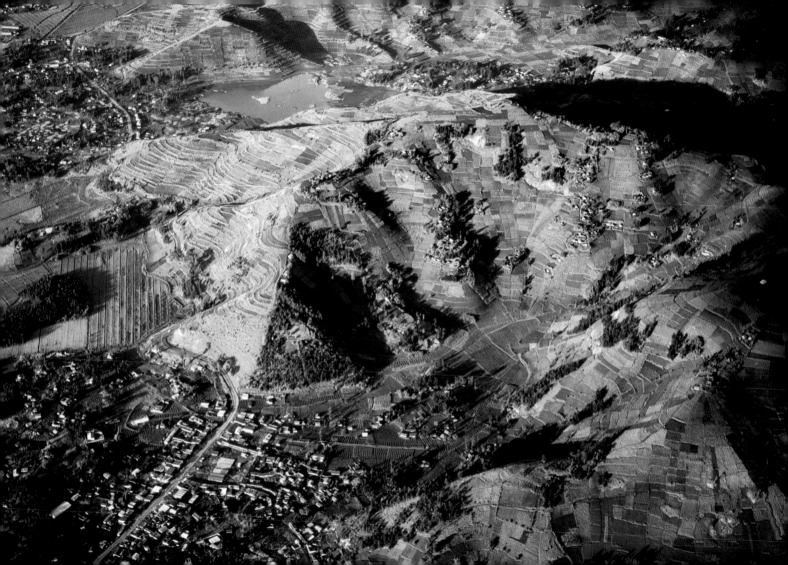

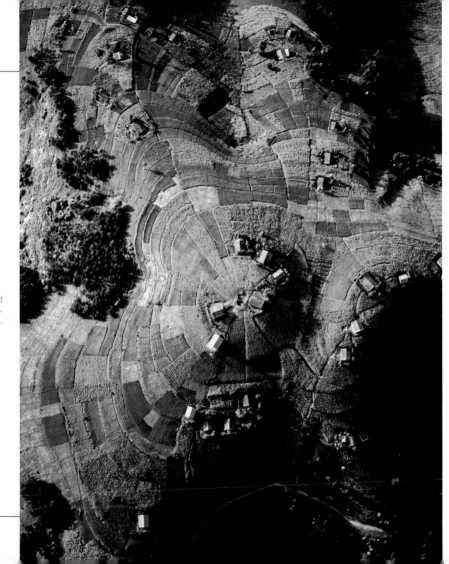

522 and 523
A meticulous network of cultivated fields covers the slopes of the Virunga Mountains, one of the most densely populated areas of Rwanda.

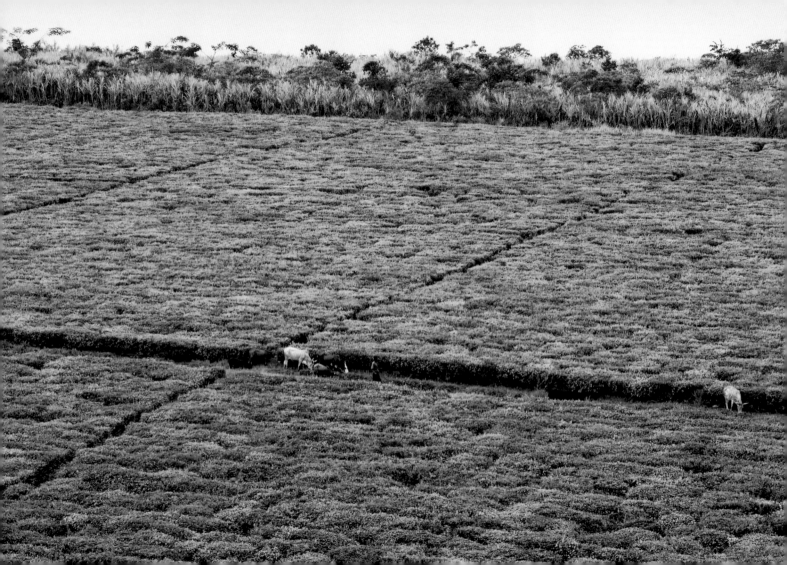

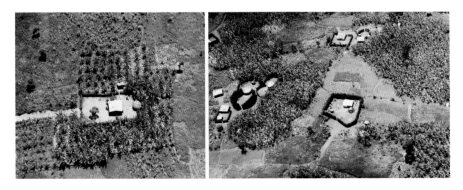

524
Tea cultivation, principally destined for exportation, represents an important income of precious currency for Rwanda.

525
A great part of the territory in Rwanda is subdivided into small sections where subsistence agriculture is practiced.

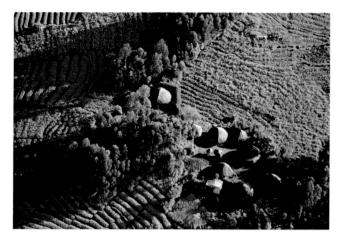

526
The highlands of eastern Congo, in the Goma region, offer a relatively healthy climate and good land on which to cultivate.

527
The villages situated along the slopes of the Virunga mountain chain, in eastern Congo, are generally modest in size.

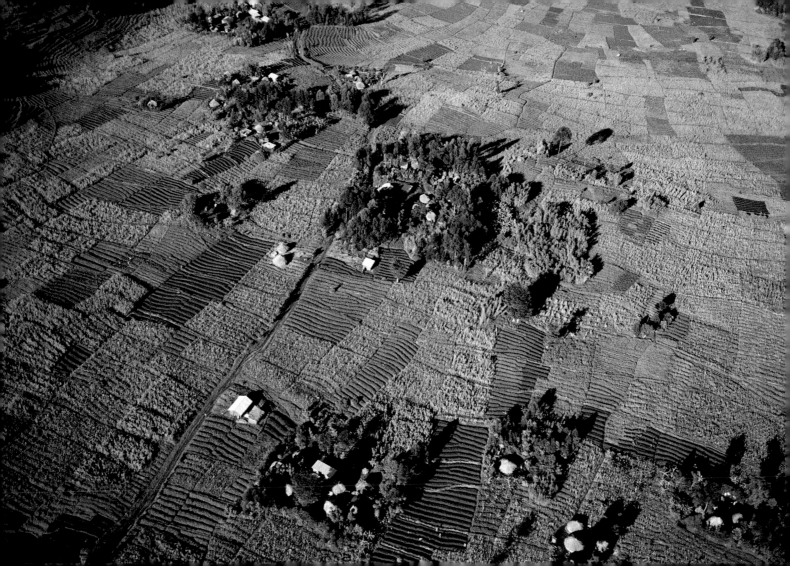

528-529
A thorny hedge in the Omo Valley, Ethiopia, protects the Nyangatom settlements from wild animals and attacks from neighboring enemies.

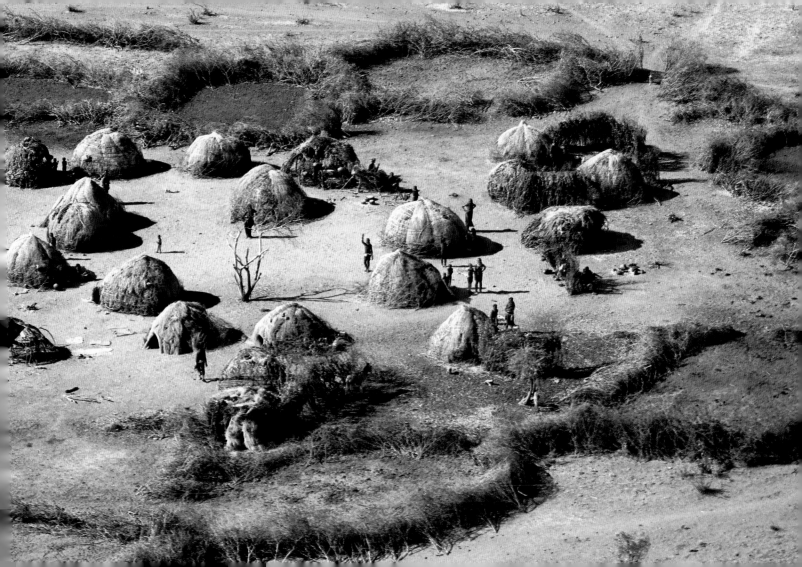

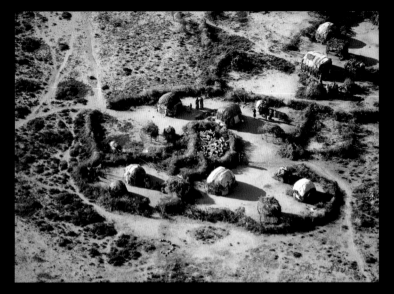

530
After a day at pasture, at sunset, the shepherds of Somalia fence in
their goats in a well-protected area at the center of the village.

531
In the deserts of Somalia, lacking dependable communication routes,
the dromedary is still the most convenient means of transport.

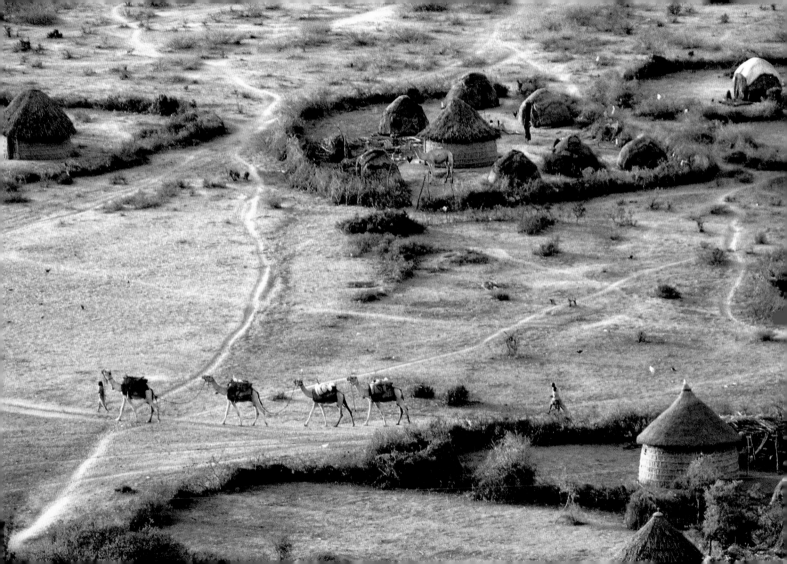

532
The goats, capable of taking full advantage of the scarce availability of vegetation in the desert, are precious animals for the economy of the shepherds in Somalia.

533
In the Somalia deserts, the position of the settlements doesn't depend as much on the presence of water as on the possibility of pasture for the animals.

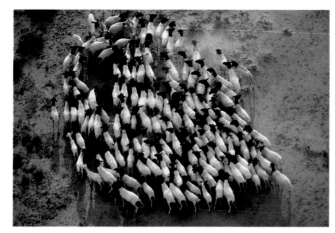

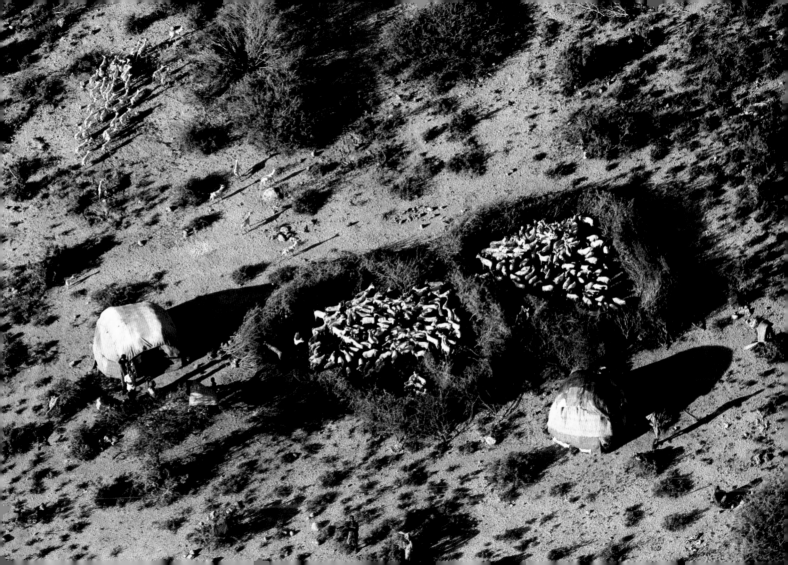

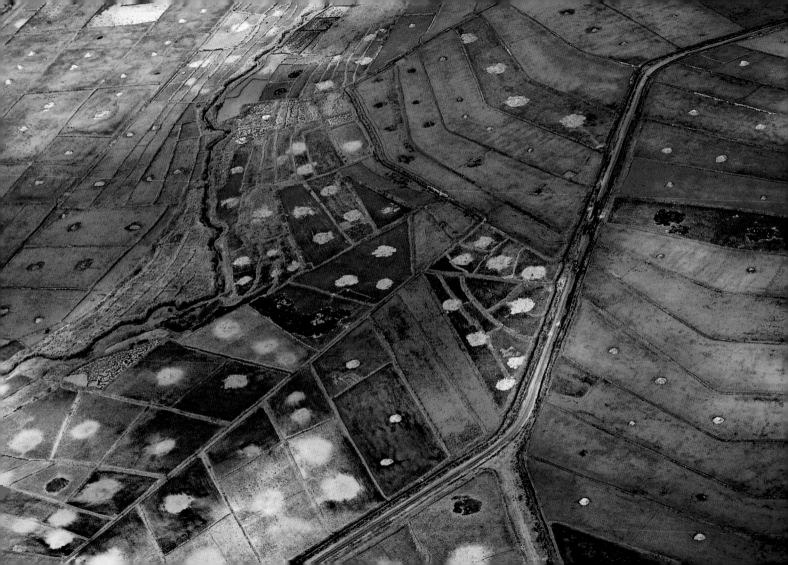

534 and 535
The great plots of land cultivated with modern methods for grains guarantee a good level of self-sufficiency to Kenya's population.

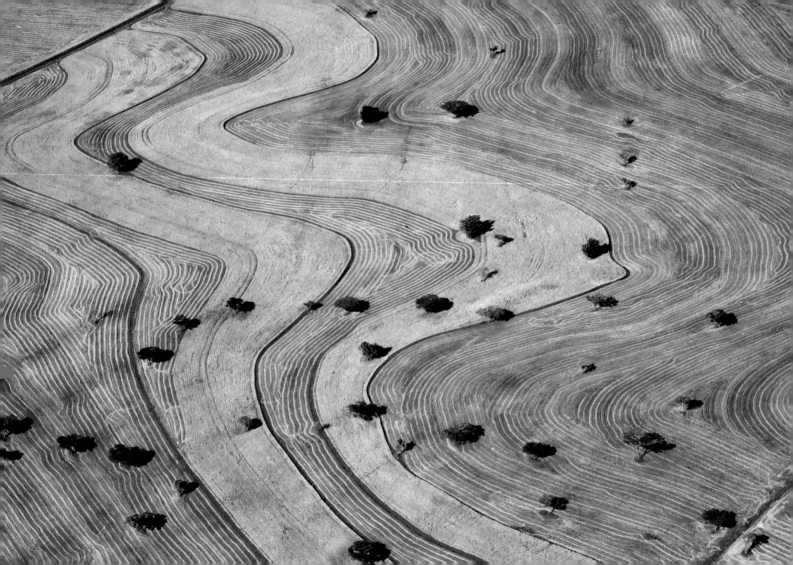

FLYING HIGH AFRICA

536
This image shows the plains in Kenya, destinated to the cultivation of cereals.

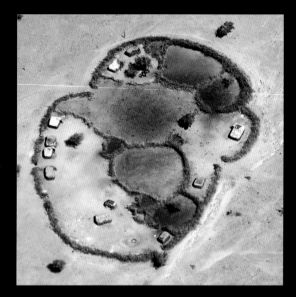

538 and 539
The Masai settlements, like this one photographed in northern Tanzania, are protected by a thorny hedge as thick as ten feet.

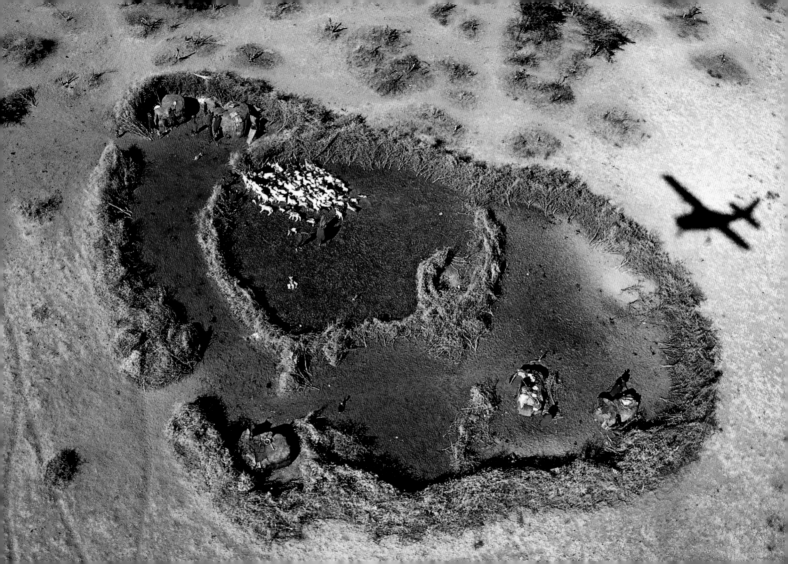

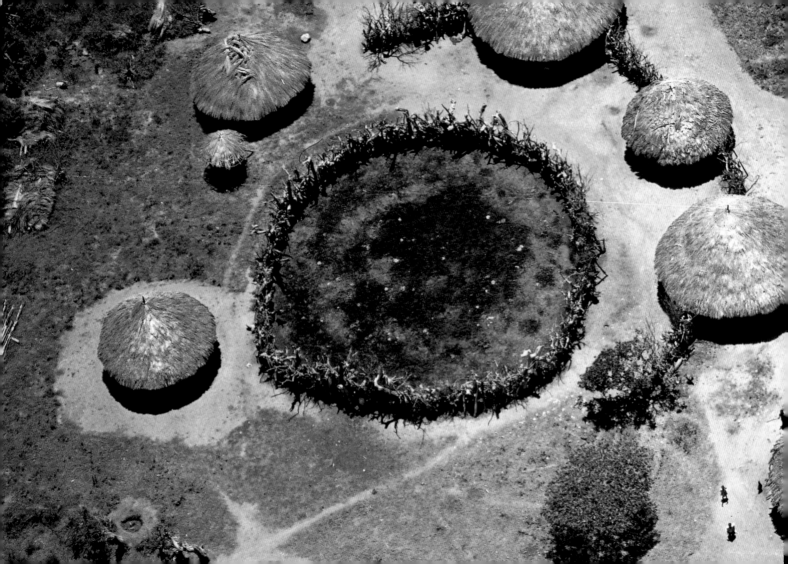

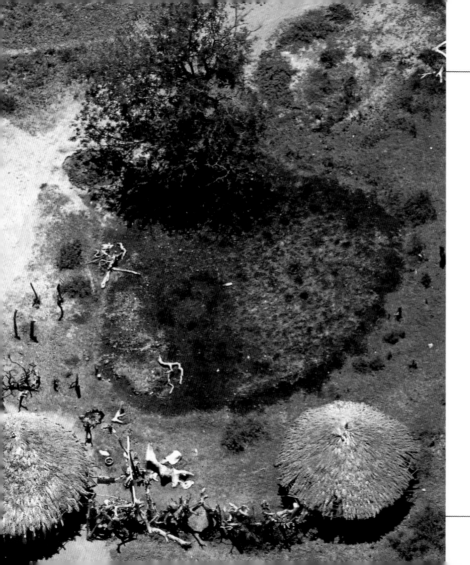

540-541

This village, on the border of Se-
rengeti National Park, in Tanzania,
represents the structure of the
settlements of the Maasai popu-
lation, constituted by huts dispo-
sed in a circle around the fence,
in which the livestock is kept.

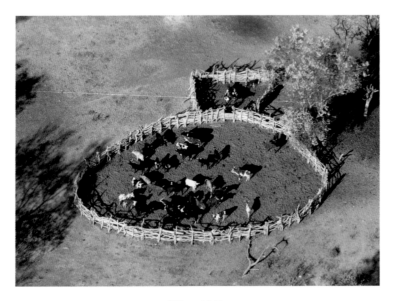

542 and 543
In Botswana, the inhabitants of the villages around the internal delta of
the Okawango River, a very arid area compared to that surrounding
the last part of the river, depend primarily on sheep-farming for their
sustenance.

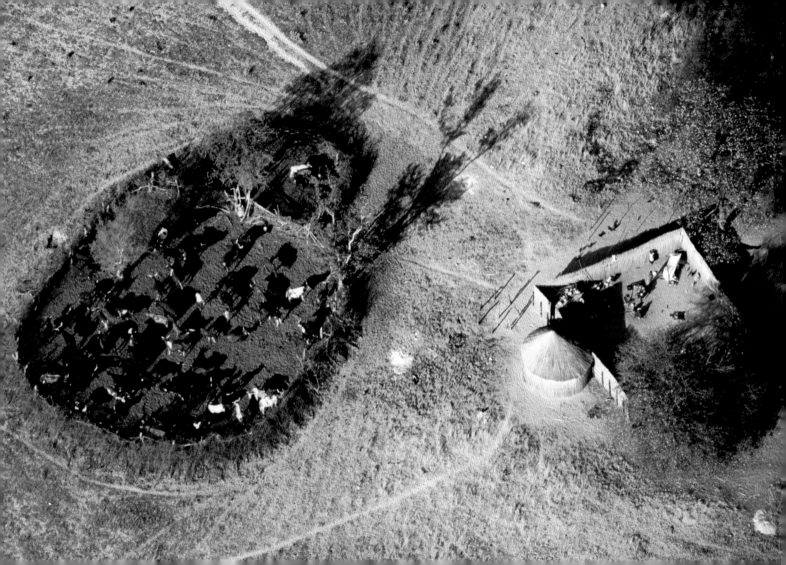

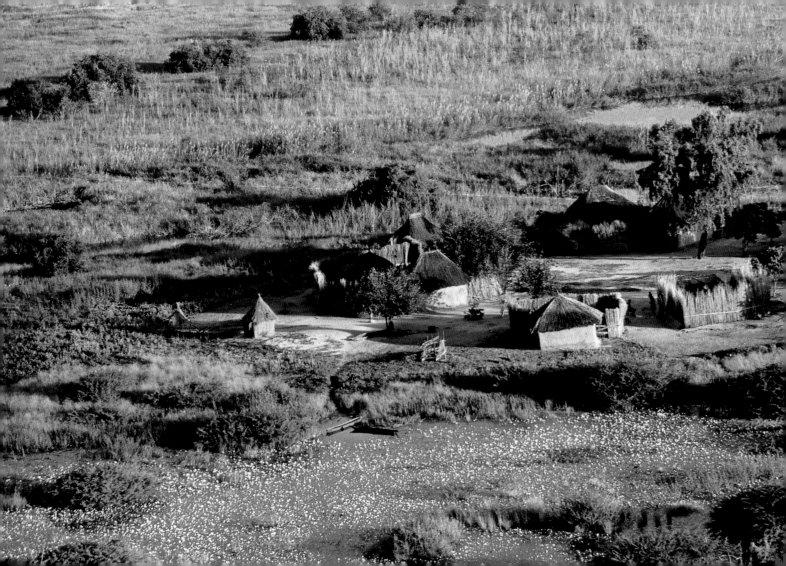

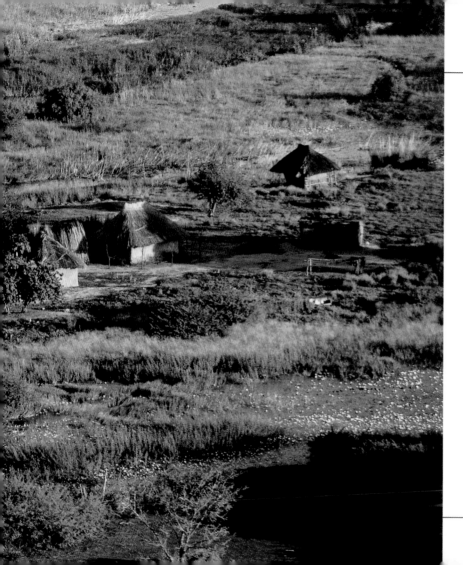

544-545
A small village stands on a piece of land emerging from the marshes formed by the course of the Zambesi River, in the region of Caprivi, in Namibia. In the settlements of this area, family descendence and personal status establish the various levels of social hierarchy.

546 and 547
The South African wine production, based in the western province of the Cape, is appreciated worldwide for its quality.

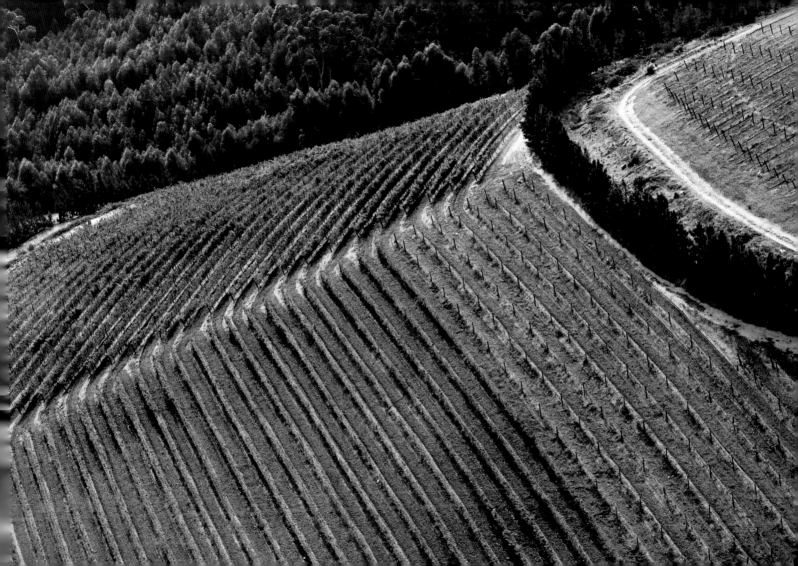

548-549
The grape vine, introduced into South Africa at the end of the 1600s, has been cultivated successfully in the Stellenbosch zone.

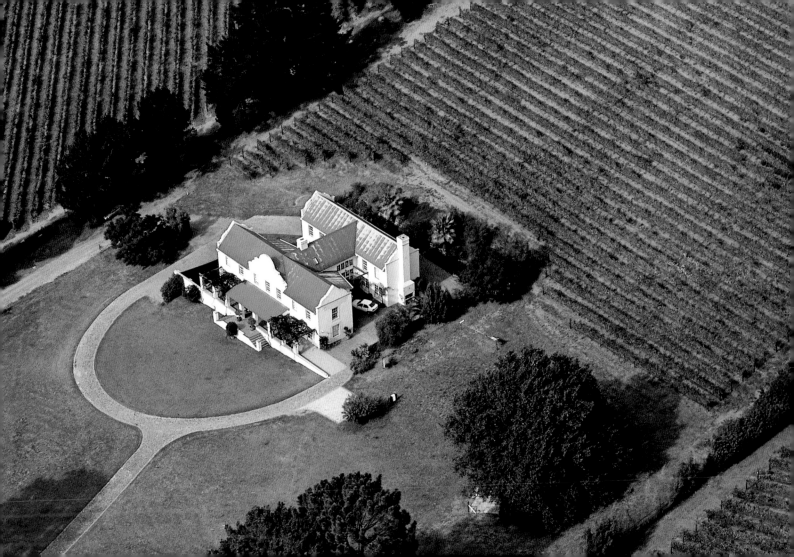

550 and 551

These cultivations, photographed near Blyde River Canyon, reveal the high level of efficiency attained in South African agriculture.

552-553

Dried fruit produced in the plains of Calitzdorp, in the province of South Cape, is considered to be among the best in South Africa.

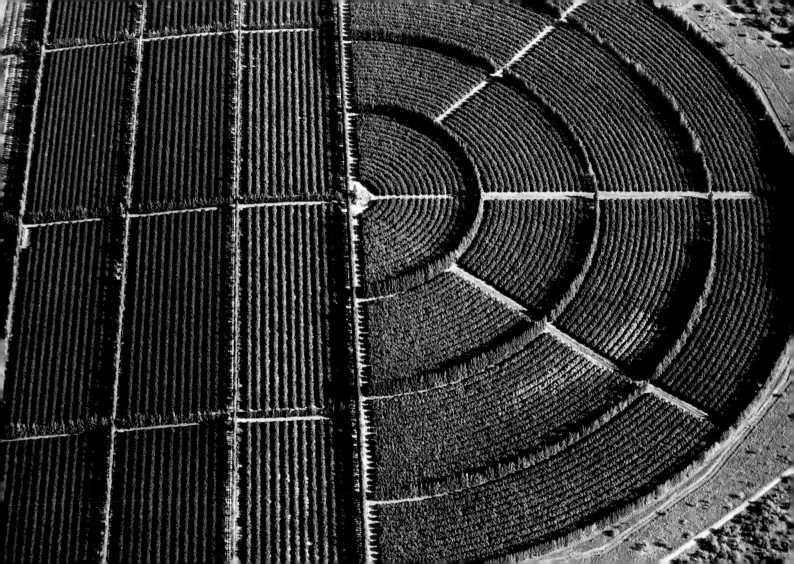

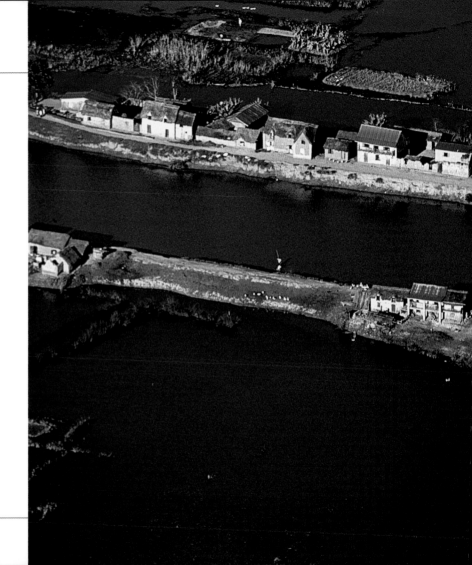

554-555
Rows of houses mark the borders between a course of water and flooded rice fields in the Antananarivo region, in Madagascar.

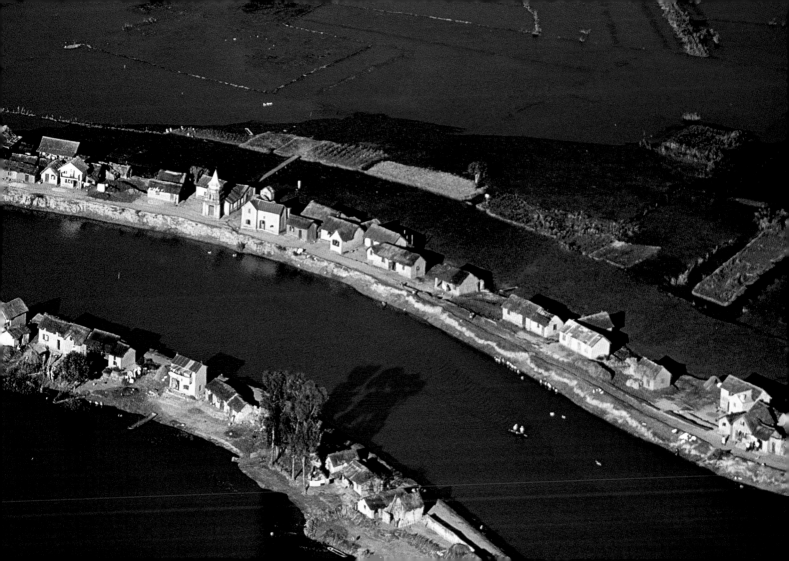

556
In Madagascar, the terraced land destined to the cultivation of rice can be seen between the Ambositra region and Antananarivo.

557
Lush fields envelops the slopes of a volcano situated west of Lake Itsay in Madagascar.

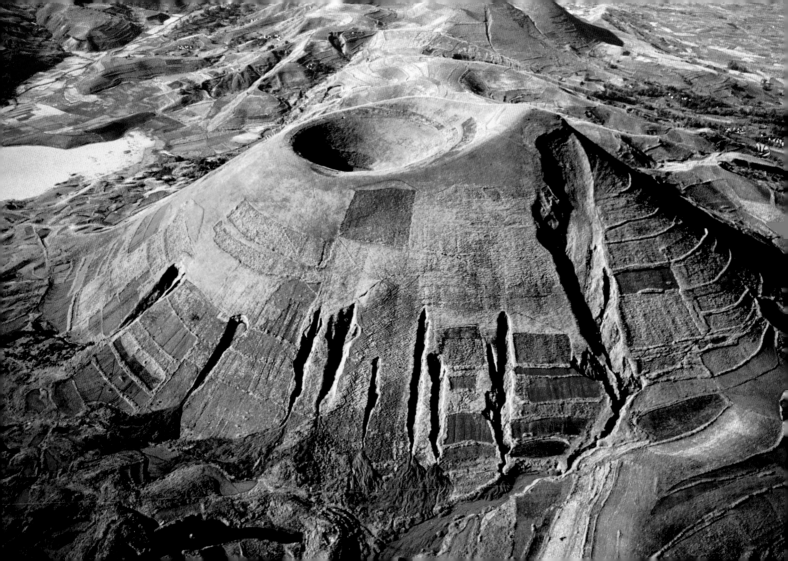

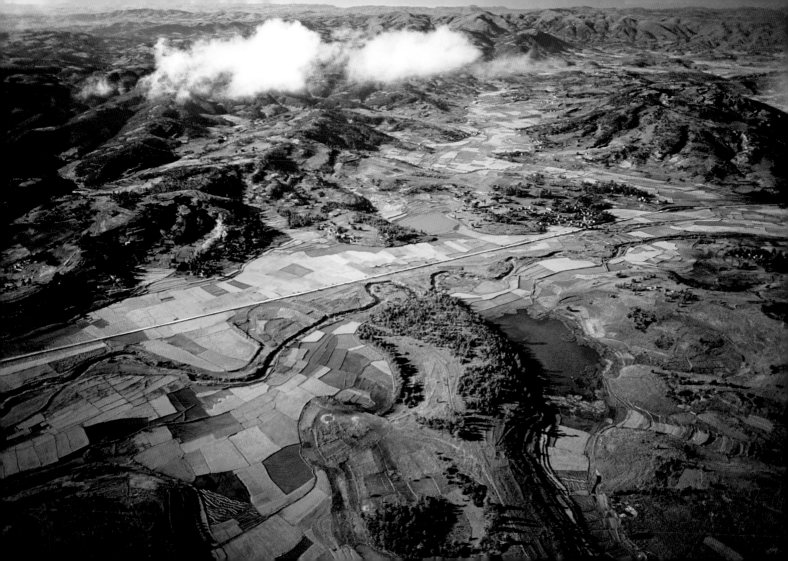

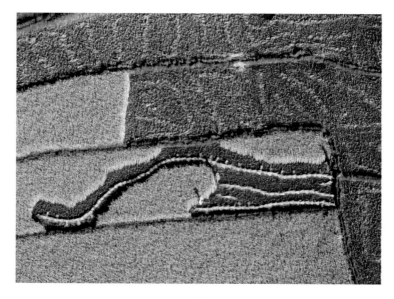

558
The pleasant highlands in the Antananarivo region are intensely culti-
vated with rice.

559
Rice cultivation in Madagascar dates back to the XVI century and was
probably introduced by colonies from the Indonesian islands.

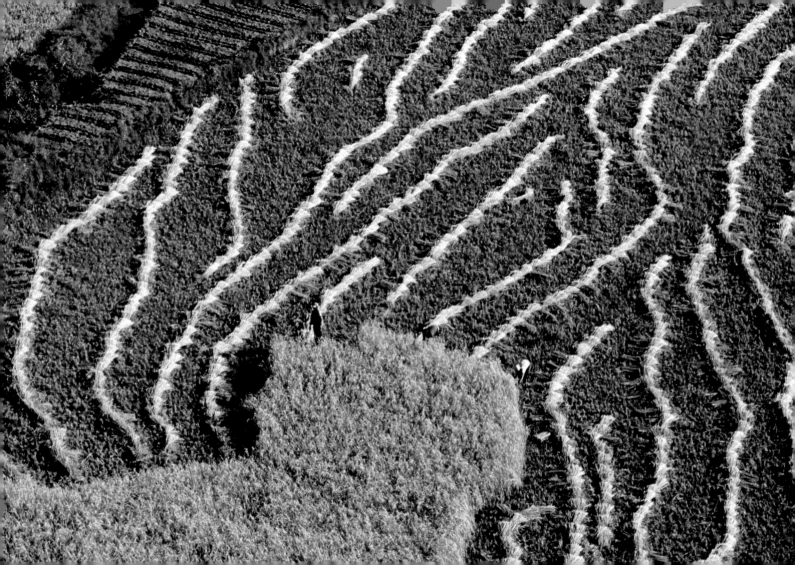

560
Only a small part of the Madagascar territory is adapted for agriculture, usually prac-
ticed with primitive instruments of scarce effect.

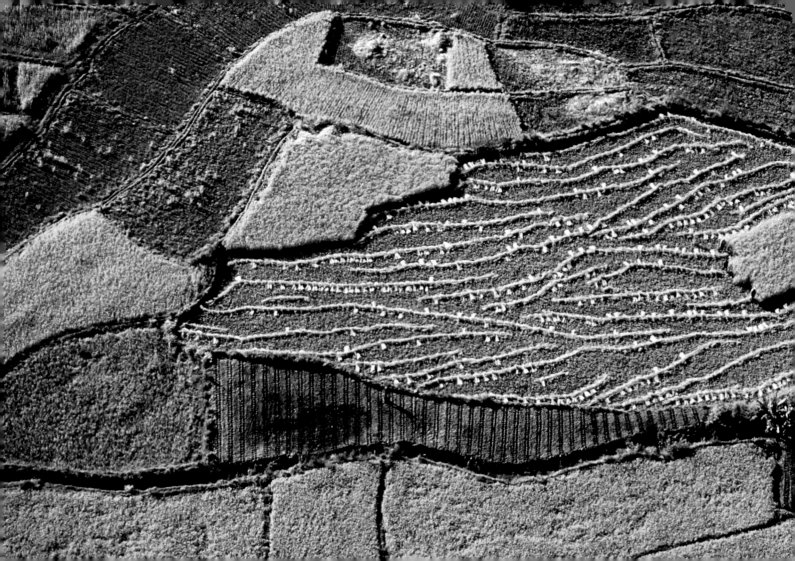

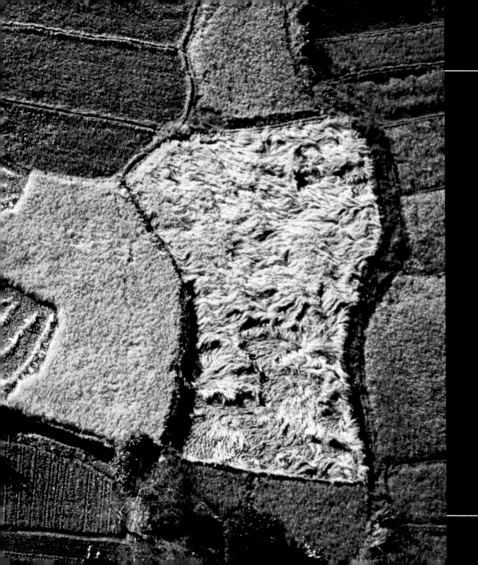

562-563
Madagascar's agriculture is or-
ganized in small family run busi-
nesses whose primary goal is
self-sufficiency.

564-565
The terraces carved into the si-
des of the hills permit the people
of Betsilleo, in central Madaga-
scar, an efficient and constant ir-
rigation in the fields.

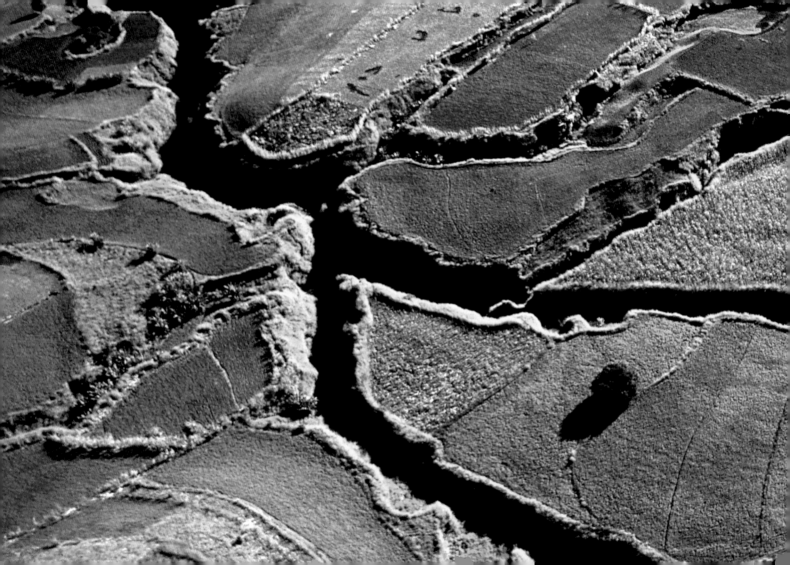

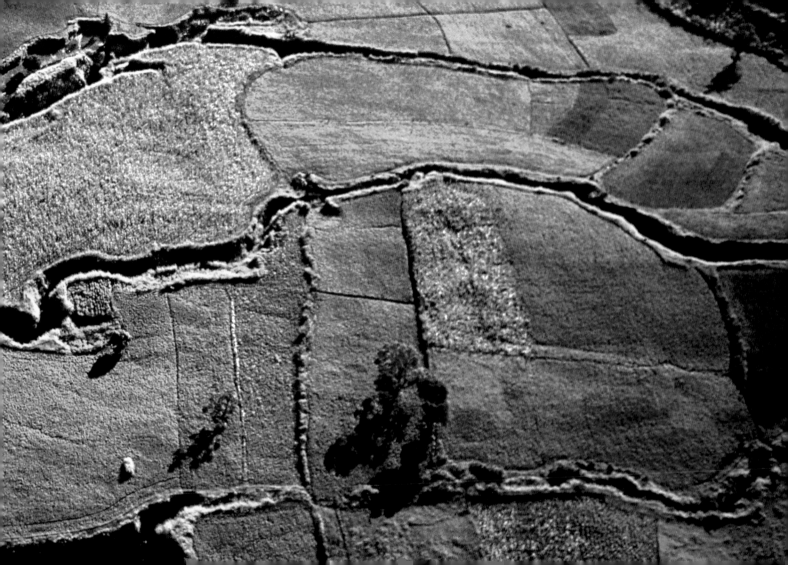

THE SIGNS
OF HISTORY

FLYING HIGH

567

Tunisi graneries (left) and the Dakka temple, in Egypt (right).

568

The Giza plain with the Kafre and Khufu pyramids.

"Africa is not a historical part of the world; it offers no movement or development, no historical evolution of its own," signed Georg Friedrich Hegel, in *The Philosophy of History*, 1830. According to Hegel, Egypt did not belong to Africa. It was instead part of the Asian and European civilizations. This theory of Africa lacking in a history has had many followers, even up to recent times: legends die hard.

Even the White Maid stone painting, found in Namibia's Brandburg massif, was attributed to migrants from Crete. Great Zimbabwe was considered the ruins of an abandoned Phoenician city and Egypt, the fruit of oriental knowledge and skill. Black Africans did not exist, or were thought to live a sort of timeless barbaric existence. Reality is slightly different. The example of Egypt is emblematic: the supporters of the idea of an Africa with no history felt authorized to affirm that its inhabitants were non-Africans and, above all, not black (much like the Berbers and Ethiopians).

Actually, we now know that the origin of the Egyptian civilization has its roots in the Sahara. The phase of grave aridity struck the region starting in 4000 BC, inducing the population to migrate towards zones more abundant in water. Groups originating from continental Africa, mostly with dark skin, primarily formed this population of animal breeders and farmers.

The Nile Valley became the focal point of a gradual but massive migration. Even though

572-573

Fortified villages along oued Rheris, in southern Morocco, were once crucial points in the trans-Saharan commerce with black Africa.

The Signs of History

there was contact with foreign countries and raids from Mesopotamia, the "Egyptian boom" was essentially an autochthonous event. Ancient Egypt was no doubt a gift of the Nile, but also of the Sahara.

Traces of its millenary splendor adorn its banks from the second cataract to its delta. Here are found the temples of Abu Simbel, miraculously saved from the waters of Lake Nasser: embelished with colossal statues, over 65 feet high, they celebrate the glory of Ramses II and of the god Amon.

The island of File has been submerged for over ten years, but not the temple of Isi, transferred, piece by piece, to the rocky coast of Agilkia with an epic restoration operation organized by the United Nations in 1972.

Aswan, the ancient Siene, is near File, exactly on the tropic of Cancer. The famous nilometer used to measure the level of water in the Nile and anticipate the high tide, is still visible on the south side of Elephantine Island. To the north rises Edfu, ancient site of the cult dedicated to Horus, the Falcon God: the hieroglyphics carved onto its walls are a summary of Egyptian religion. On the opposite bank of the river is Kom Ombo, erected in honor of Sobek and Haroeri, gods resembling a crocodile and a falcon, respectively.

Karnak and Luxor: grand piers adorned with bas-relief, obelisks, columns, sanctuaries and streets lined with interminable rows of sphinxes are all that is left of the famous city of Thebes, sacred to Amun. Thebes also hosts the Valley of the Queens and the Valley of the Kings, where Tutankhamun's tomb was discovered.

Proceeding towards the delta of the Nile, the wonders increase with the temples of Dendera and Abido and the pyramids of Saqqara and Menfi, capital of the Ancient Domain. Finally, there is Giza, with the Sphinx and the massive pyramids of Khufu, Kafre and Menkaure, the

The Signs of History

largest edifices ever built by man. Compared to the grandeur of Egyptian civilization, everything else is subordinate. However, around 750 BC, the rulers of Kush, the so-called Black Pharos of Nubia, took control for almost a century, dominating the middle and low courses of the Nile. At Meroe their tombs can be found: pointed stone pyramids, towering 50 feet high over the flat Sudan desert. The Kushite rulers also erected beautiful palaces and temples dedicated to their bizarre gods with a man's body and lion's head. Contemporarily at Kush, in the inaccessible mountains to the east, in Ethiopia, a new civilization with original characteristics was coming of age. At Axum, great stone steles and an intricate catacomb testify to the existence of an organized state that based its wealth on commerce with Arabia.

The churches of Lalibela, carved directly into the rock, and the castles of Gondar demonstrate the historical continuity of the Ethiopian Empire and the vitality of the purely African culture. This period, which corresponds to the West's medieval era, was a fecund period in Africa's history. From one end to the other, dynasties and empires bloomed, extending their influence in vast territories: Ghana, Mali and Songhai on the Niger's midcourse; Kanem-Bornu in Ciad's lake region; Benin in what is now Nigeria; and the Swahili civilization along the coast of the Indian Ocean. This illustrious past has left us with magnificent mosques in clay, coral cities and enigmatic votive masks in bronze and gold.

The ruins of the Great Zimbabwe, legendary capital of the Momnomotapa Empire, sanction the true dimension of Africa's history. The enormous stone fences, conical towers and sacred platforms scattered throughout the silent undergrowth are milestones of a long journey: one that began many thousands of years ago, when men were gods.

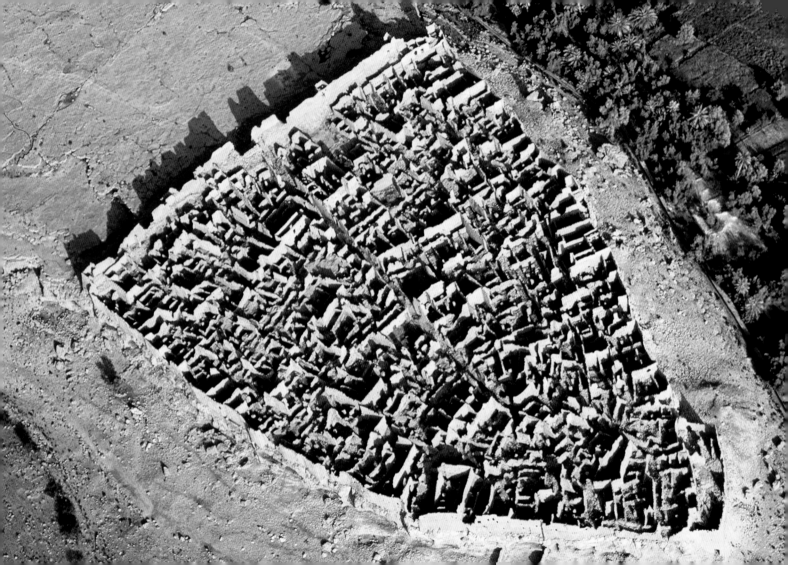

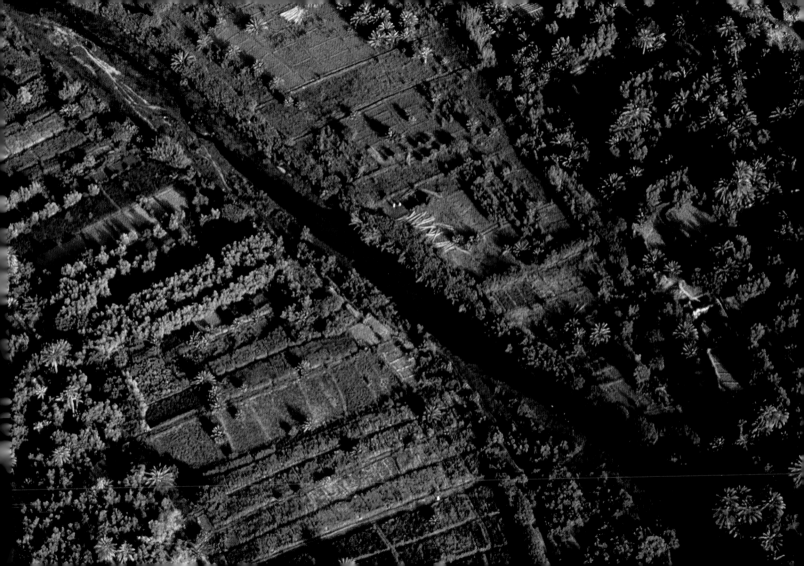

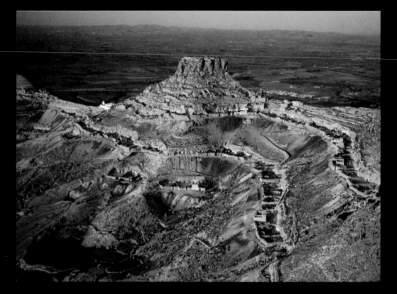

574
The villages in the region between Mattata and Tataouine, in south-
ern Tunisia, are often situated on platforms carved into the side of the
mountain.

575
The collective granaries *(ksar)* once used by the berber populations
of southern Tunisia resemble fortresses.

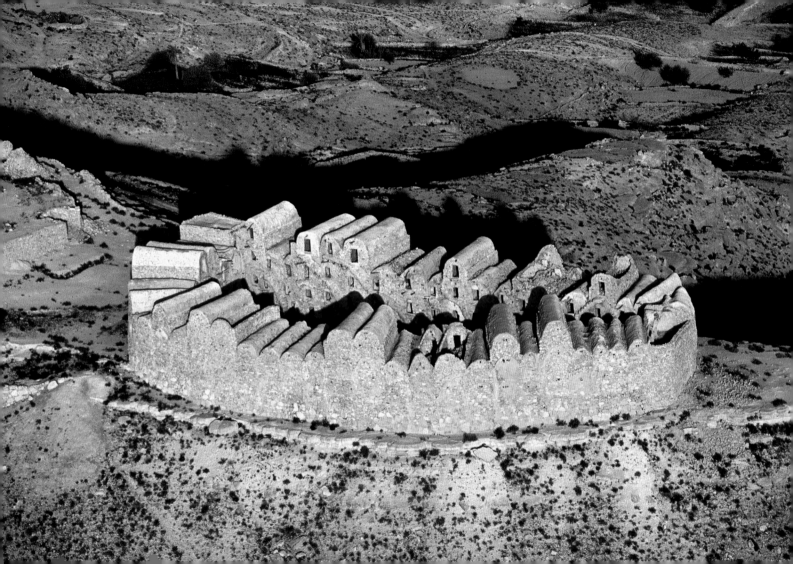

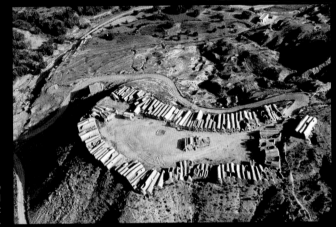

576 and 577
Southern Tunisia's collective granaries are usually placed around a central courtyard that also served for social gatherings.

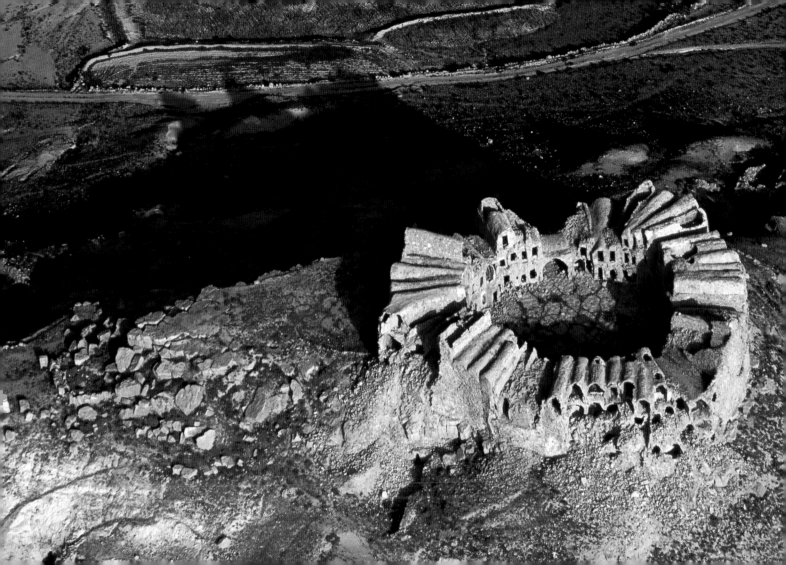

579

The roman amphitheater at El-Jem, in Tunisia, is one of the biggest in the world and could accomodate up to 30,000 spectators.

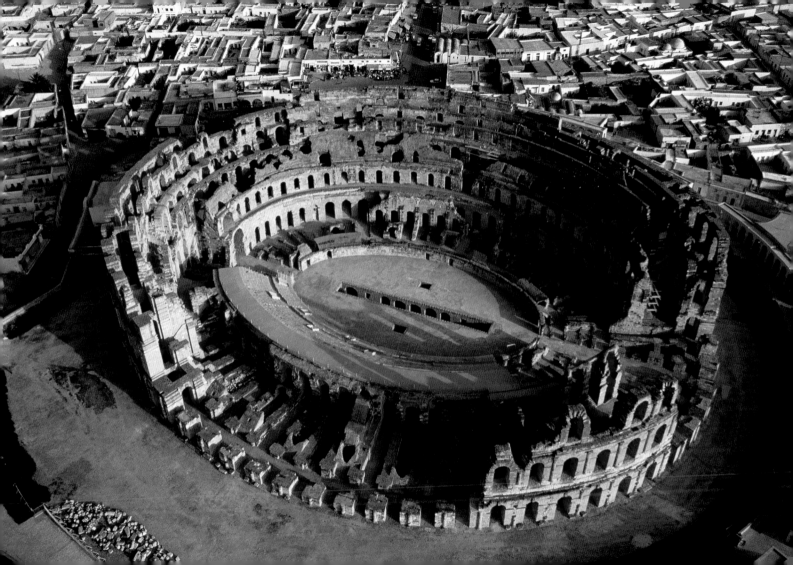

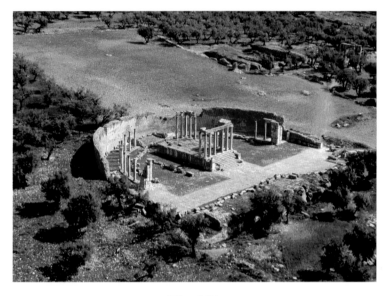

580 and 581
The ruins of the roman city Dougga, in Tunisia, is one of the most important archeological sites in northern Africa.

582-583
In Tunisia, acquaducts and ruins of ancient cities testify to the intense roman colonization that followed the destruction of Carthage.

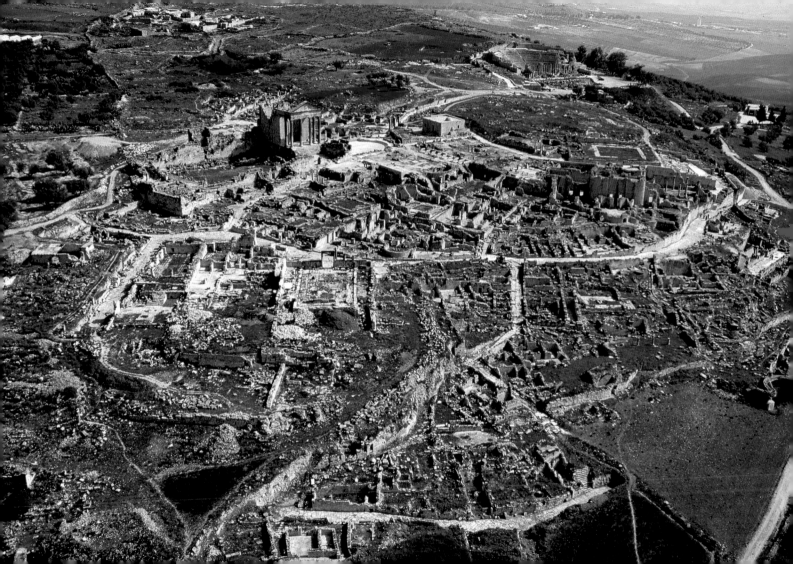

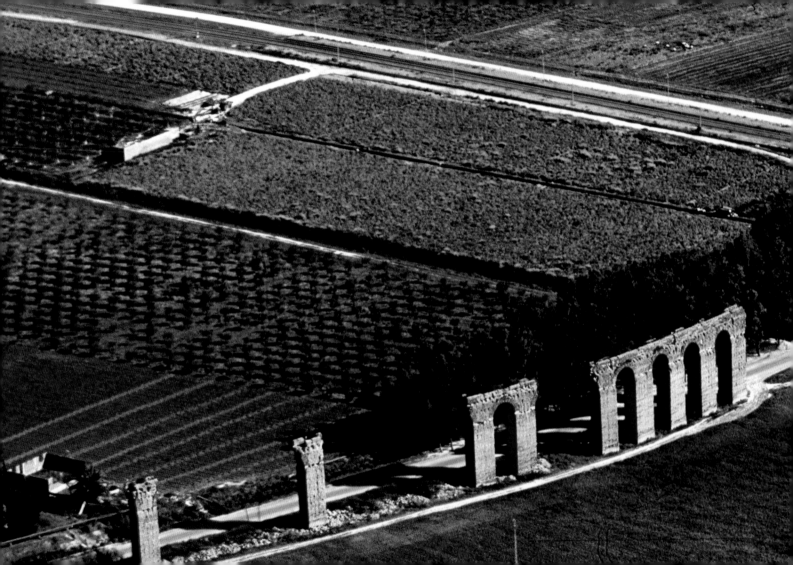

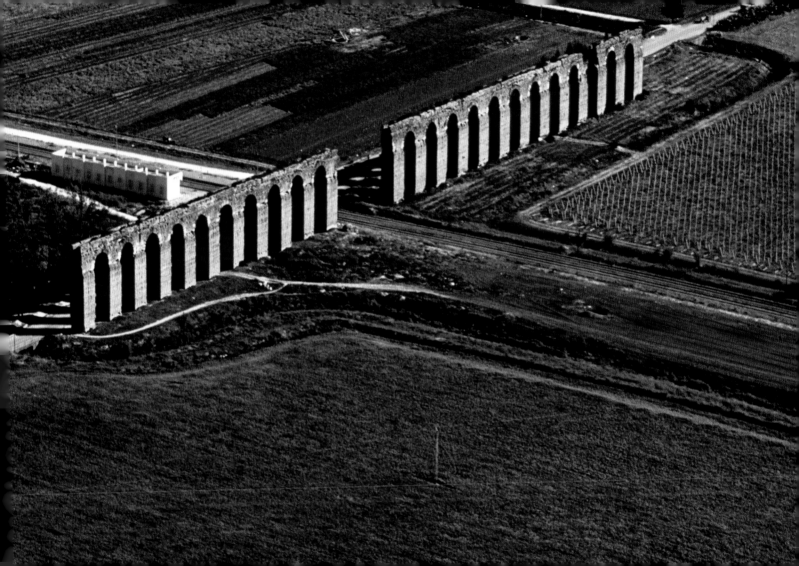

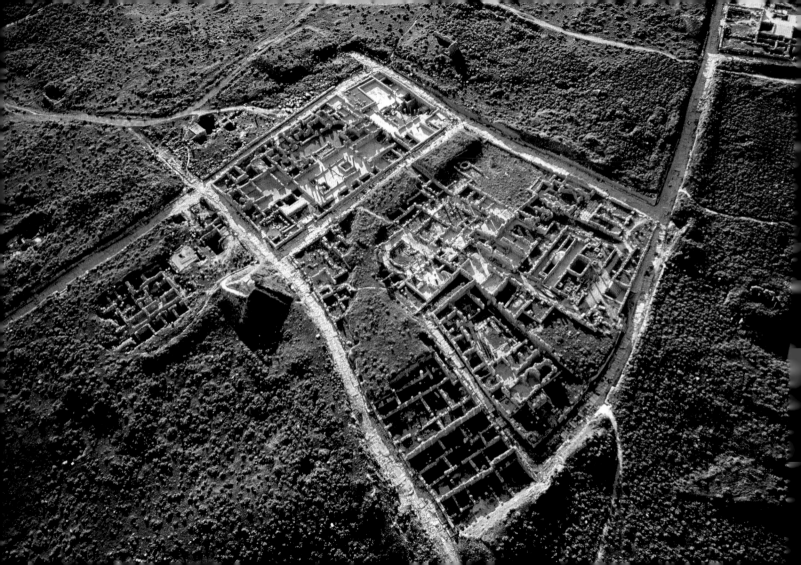

FLYING HIGH AFRICA

584
Imponent villas and hypogeum habitations, decorated with splendid mosaics, characterize the roman city of Bulla Regia, in Tunisia.

FLYING HIGH AFRICA

587
The roman city, Leptis Magna, on the Mediterranean coast of Libya, at the height of its splendor, hosted 80,000 inhabitants.

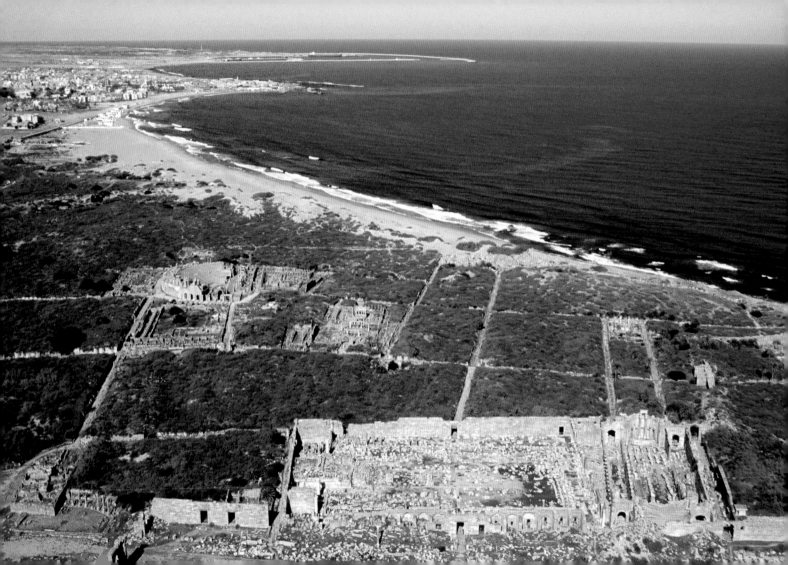

588-589
The roman city Sabratha, in Libya, was an important commercial center connected to the network of carovan traffic that started at the Ghadames oasis.

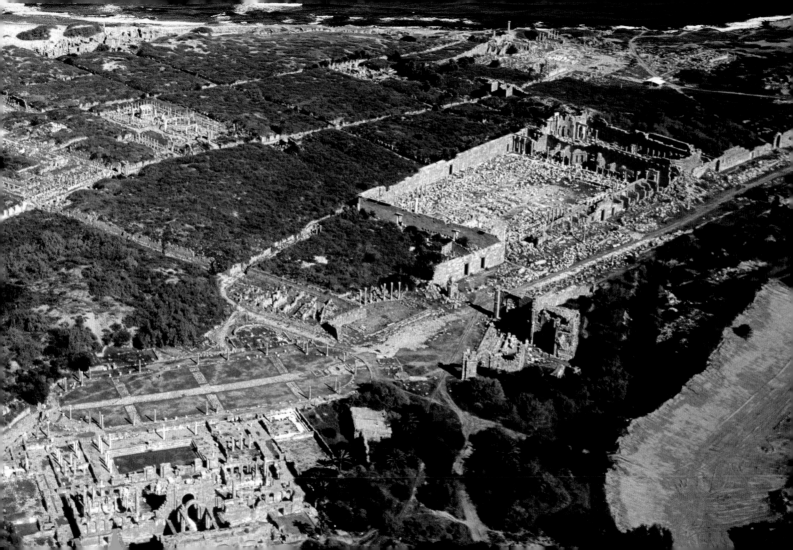

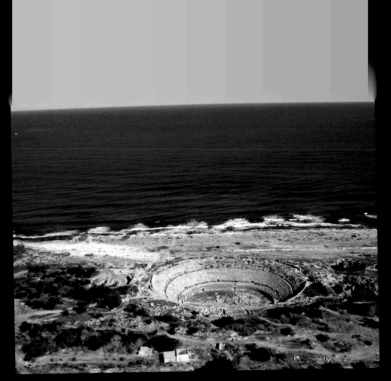

590

A network of underground passageways extended under the pavement and on the sides of the great elliptical arena of the Roman amphitheater in Sabratha, Libya.

591

The roman theater, dominated by a three-storey stage, is the most spectacular and well conserved monument in Sabratha, Libya.

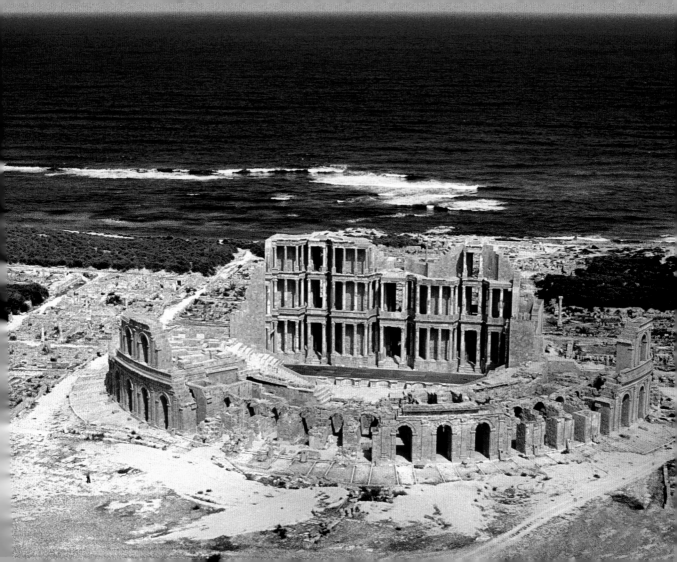

592-593

ˡounded on the coast, as a
ᵖhoenician post of commerce,
ᵇabratha successively became
ˑart of the numidic reign of Massi-
ˑssa, before becoming Roman-
ᵉd and reconstructed between
ˑhe II and III centuries B.C.

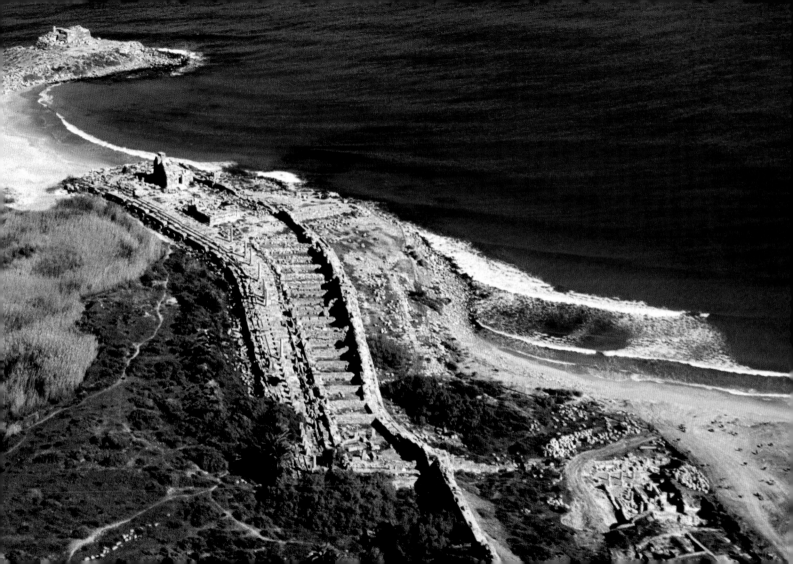

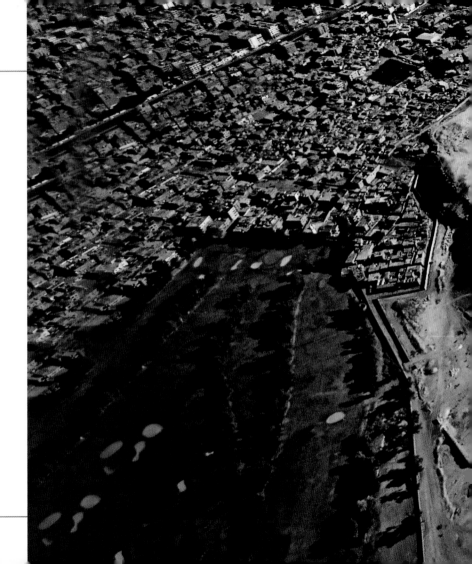

594-595

The Giza pyramids (from the left Khufu, Kafre and Menkaure) were surrounded by a vast necropolis that consisted of hundreds of tombs of the nobles and members of the pharaoh's family.

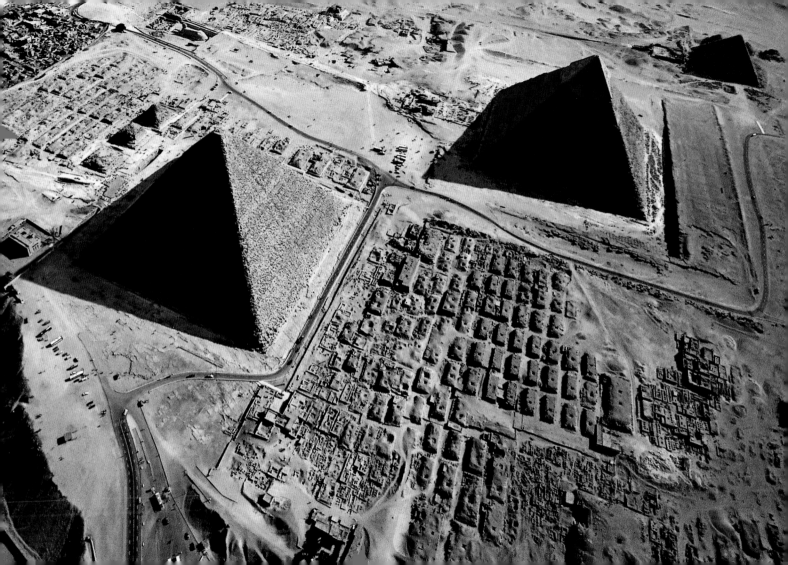

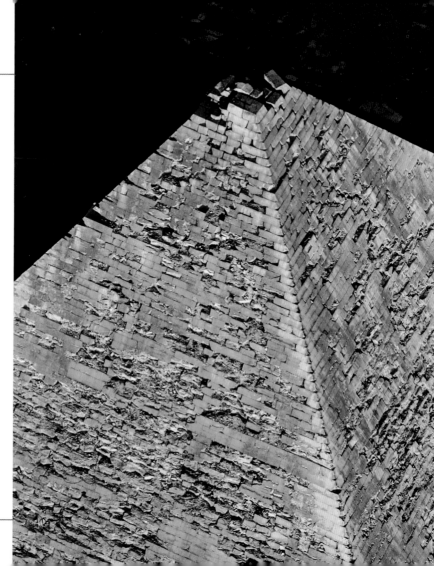

596
The pyramids of Kafre in Giza, Egypt, represent one of the rare cases in which part of the original covering of the pyramid, usually made with precious limestone, is conserved.

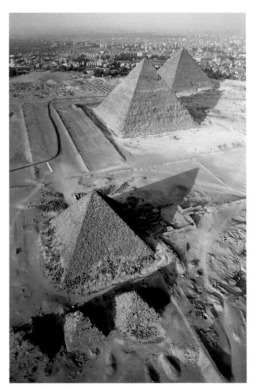

597
The mastodontic pyramids of Giza, in Egypt, were not constructed by slaves, as is comonly believed, but by regularly paid laborers.

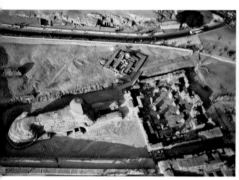
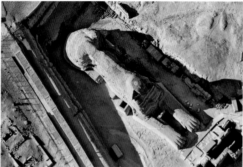

598
The colossal Sphinx, constructed under Kafre's reign circa 2500 B.C., is one of ancient Egypt's biggest stautues.

599
Carved from an enormous block of limestone and almost 200 feet long, the Sphinx is the enigmatic guardian of the Giza necropolis, in Egypt.

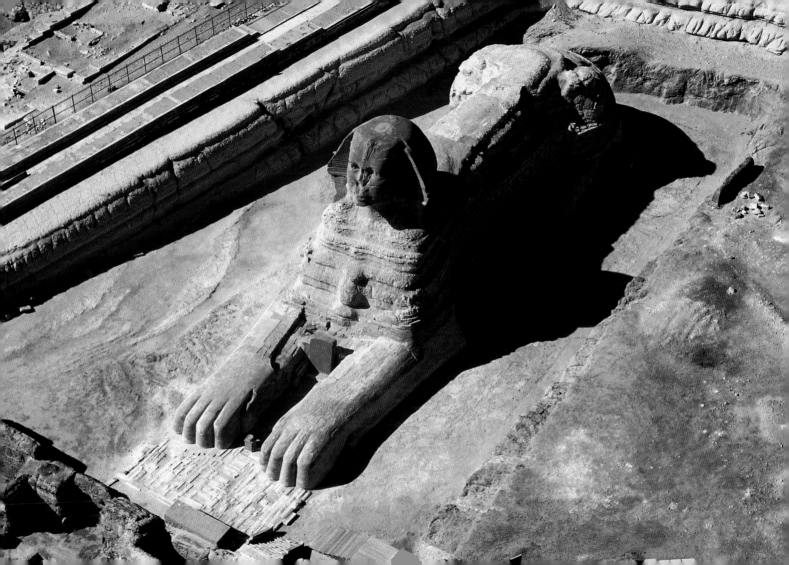

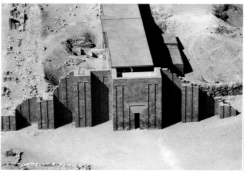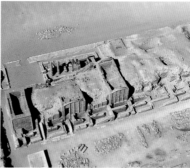

600

The fence surrounding the funerary complex of Djoser in Saqqara, Egypt, had only one entrance (left), which opened onto two chapels, whose perimetric walls still remain (right).

601

The funerary complex of Djoser, with graded pyramids, is the grandest monument of the Saqqara necropolis in Egypt.

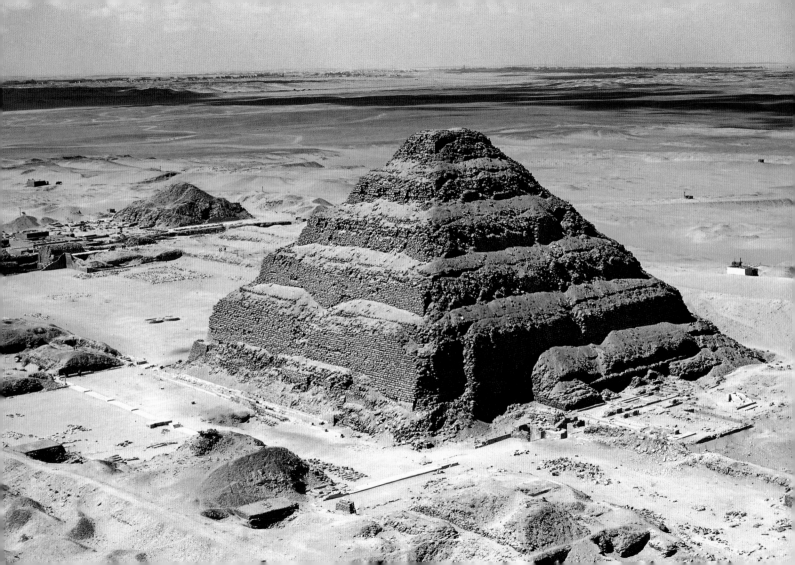

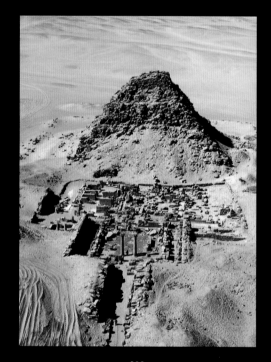

602
The Sahure pyramid at Abu Sir is preceeded by the funerary temple.

603
The Abu Sir pyramids, at Saqqara, in Egypt, were built by the pharoahs of the 5th Dynasty.

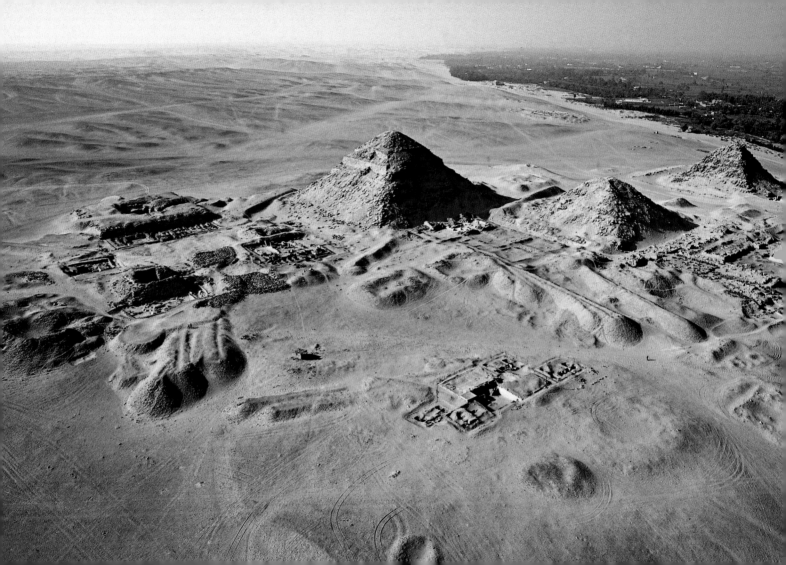

604 left
The construction of the Medium pyramid, in Egypt, is attributed to Huni, last king of the 3rd Dynasty.

604 right
The so-called "red pyramid" of Dashsur, in Egypt, was the first example of a geometrically perfect pyramid.

605
A great part of the covering of the Bent Pyramid in Dashur, Egypt, has survived until today. Only the corners and lower part of the building have been damaged.

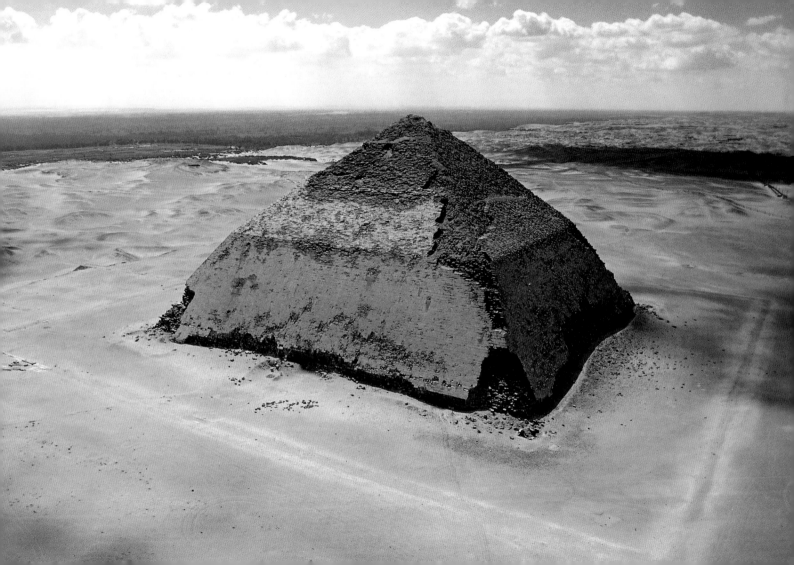

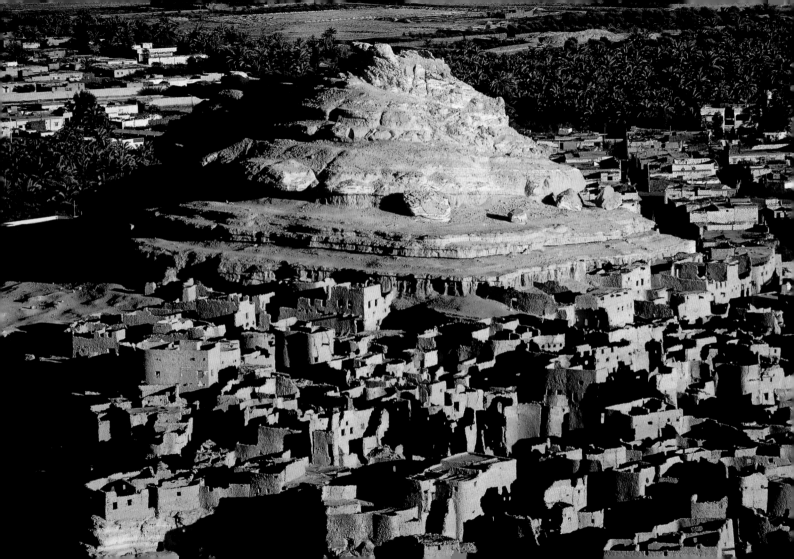

606
The ruins of the ancient city Siwa, in Egypt, are scattered with numerous tapered towers.

607
Numerous palms in the Siwa oasis surround the ruins of a temple dedicated to the famous oracle Amun.

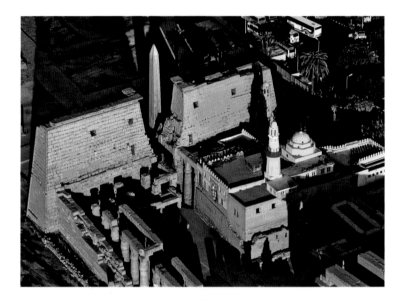

608
The Luxor temple, ancient Thebes in Egypt, is a great example of religious architecture. Inside the temple's first inner courtyard is the Abu al-Haggag mosque.

609
The Luxor temple, in Egypt, rises majestically along the shore of the Nile, surrounded by the crowded, modern city.

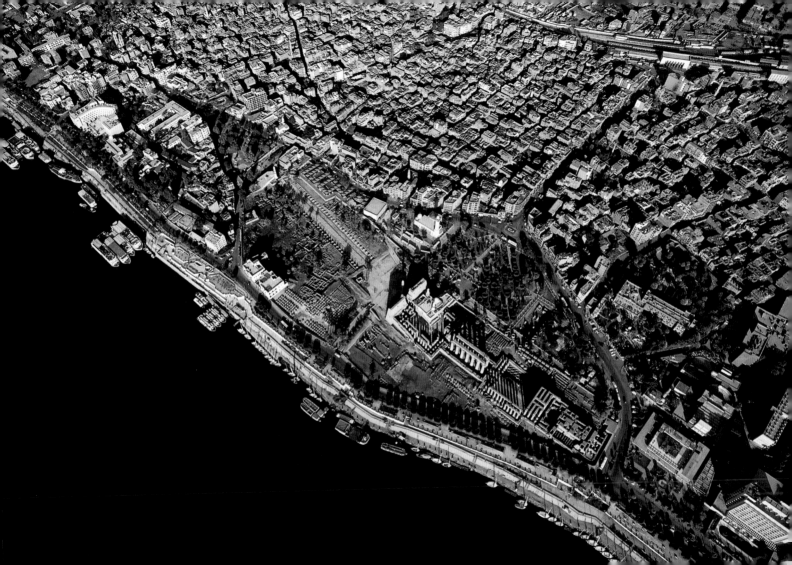

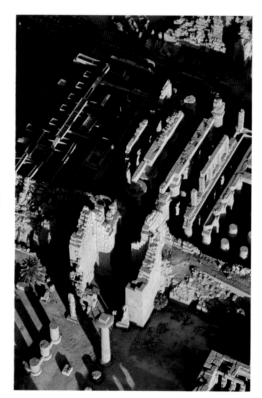

610

Enormous columns, representing the primordial swamp, characterize the structure of the hypostyle hall in the Karnak temple, at Luxor, Egypt.

611

The Amun-Ra temple, at Karnak, extends over a surface of 3,229,200 square feet near the city of Luxor, in Egypt.

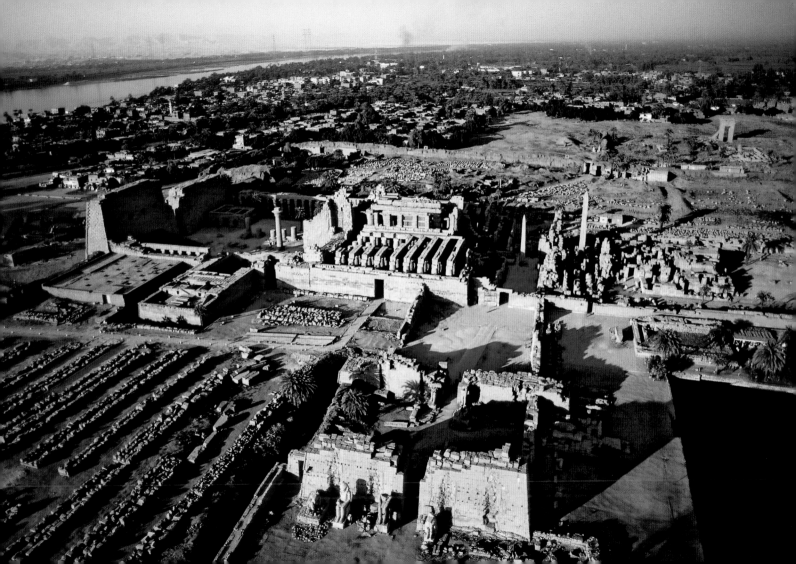

612 and 613
The temple of queen Hatshepsut, constructed on descending terraces, is the most sublime example of funerary architecture in western Thebes, Egypt.

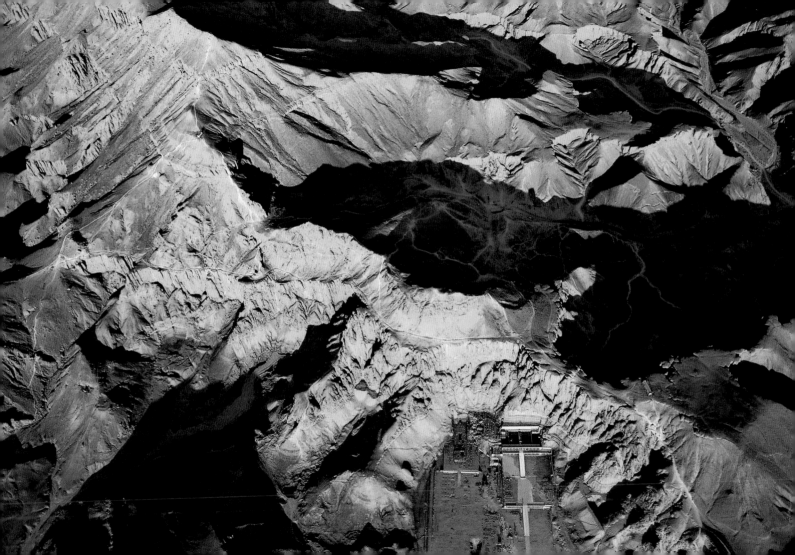

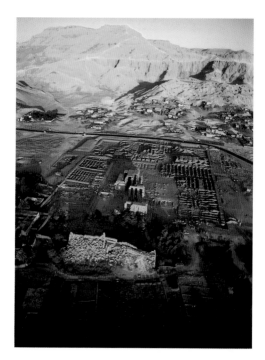

614 and 615
On the western shore of the Nile at Luxor, Egypt, stands
Ramesseum, Ramesses II's funerary temple (left) and the tem-
ple of Sethi I (right).

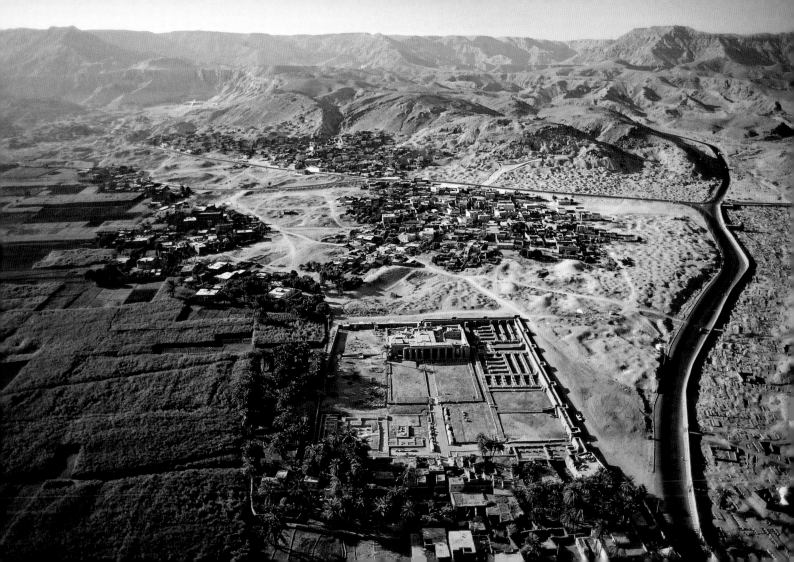

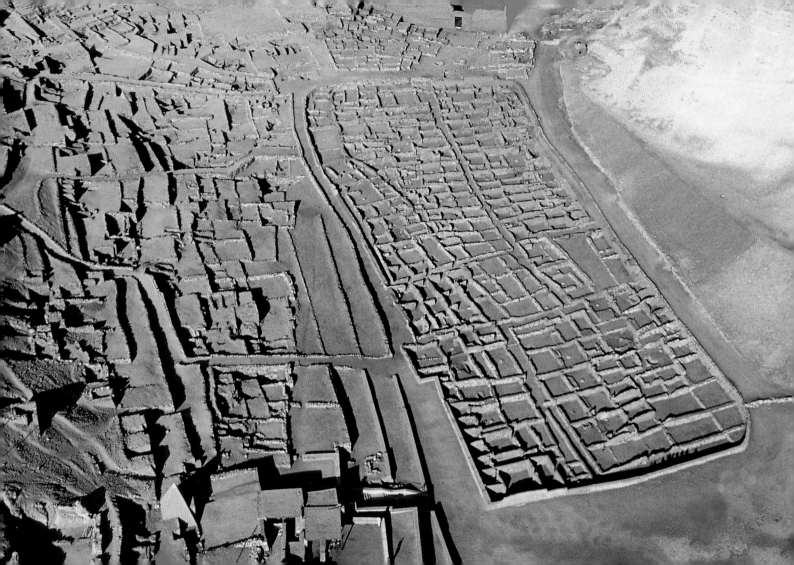

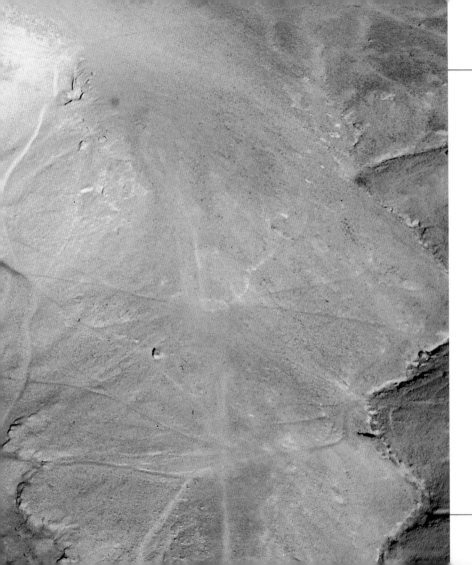

616-617
The Deir al-Medina village, home to the laborers dedicated to the construction of the royal palace, was the only inhabited place in western Thebes, Egypt.

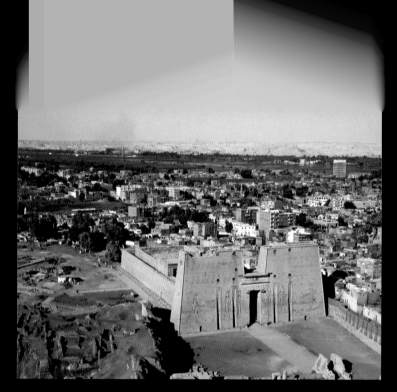

618

The pylon of the Edfu temple faces south, contrary to most Egyptian temples, which face the east-west axis.

619

The temple of Dandara, constructed in the first century B.C., was dedicated to the godess Hathor and is one of the best conserved sacred constructions of Ancient Egypt.

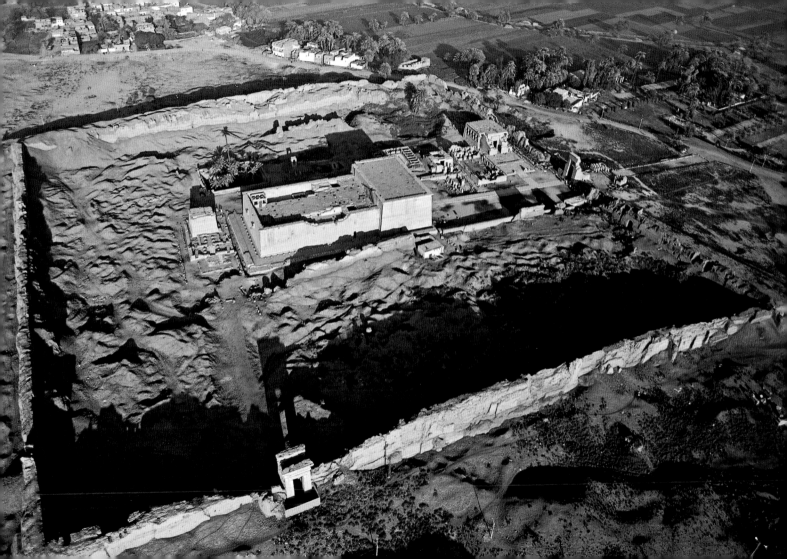

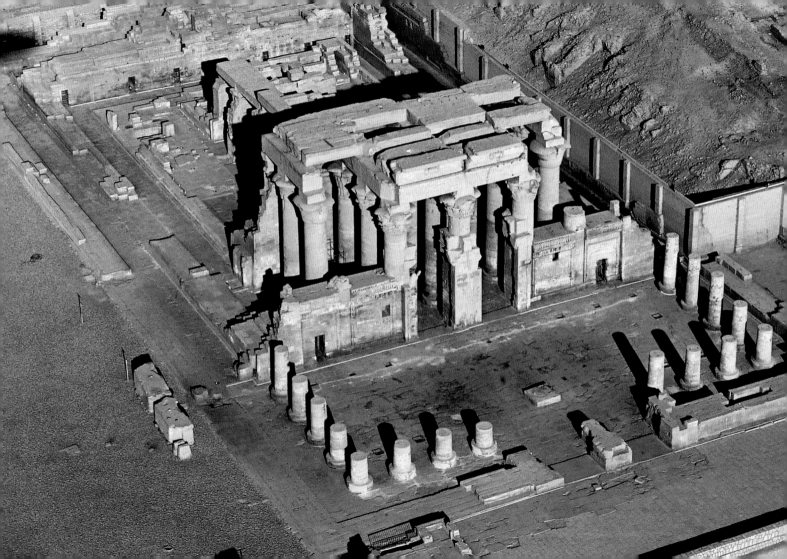

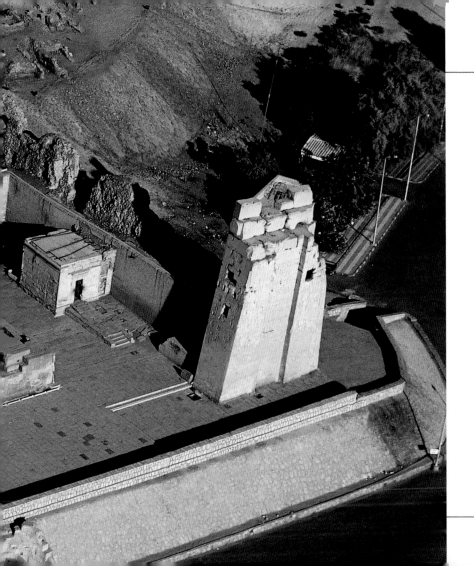

620-621
The Ptolemaic temple of Kom Ombo in Egypt was dedicated to two distinct divinities, Sobek and Haroeris, both objects of a popular cult.

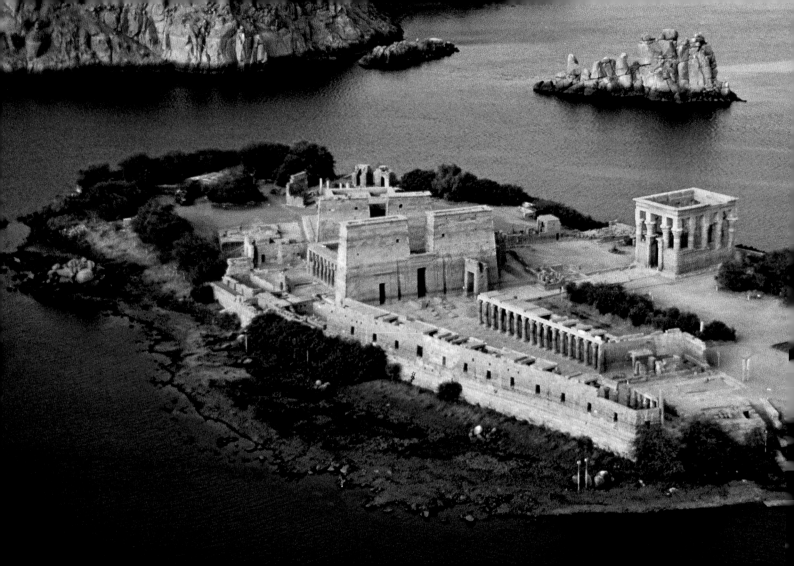

622-623
The impressive pylon of Isis' ptolemaic temple and the elegant outline of the Trajan courtyard, dominate the ruins of File, at Aswan, Egypt.

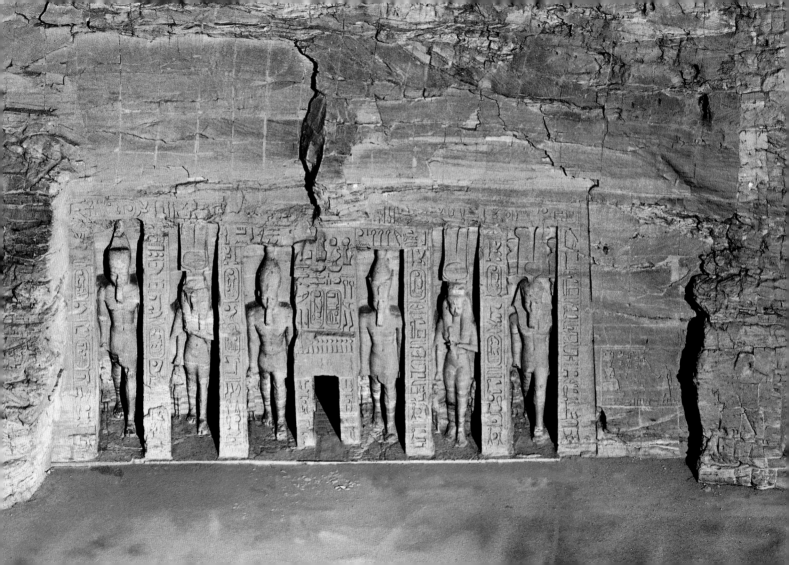

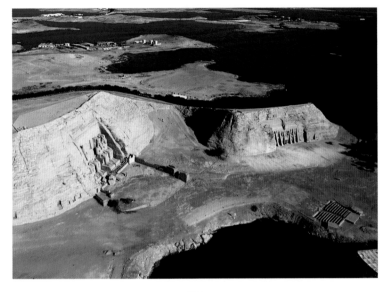

624

In the small Abu Simbel temple, in Egypt, the identification of queen Nefertari with the godess Hathor legitimizes the royal lineage.

625

The temples of Abu Simbel, in Egypt, were saved from the waters of Lake Nasser through a titanic operation of recovery that lasted four years.

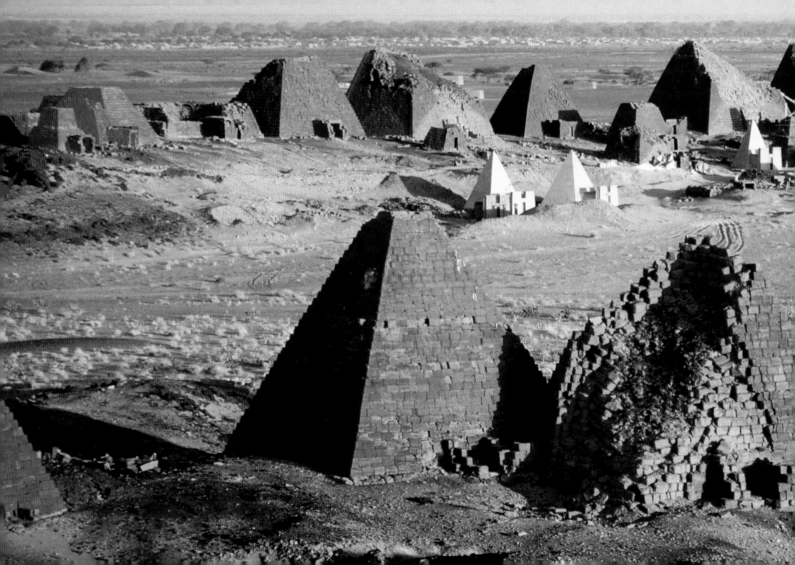

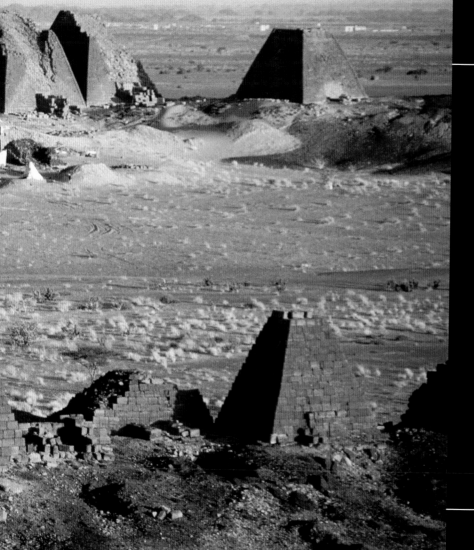

626-627
The sharp outlines of the pyramids of Meroe, second capital of the Kush Empire, rise over the desolate Saharan landscape in northern Sudan.

628

The suggestive remains of the Palace of David are part of the Imperial city of Gondar, one of the biggest monumental complexes in Ethiopia.

629

Four round corner towers characterize the castle of the Emperor Fasildas in Gondar, Ethiopia, constructed in the mid 1600s.

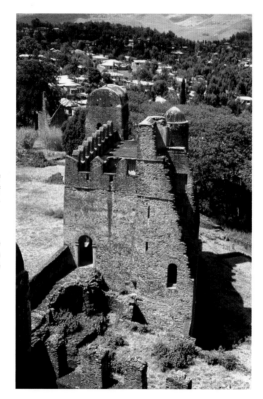

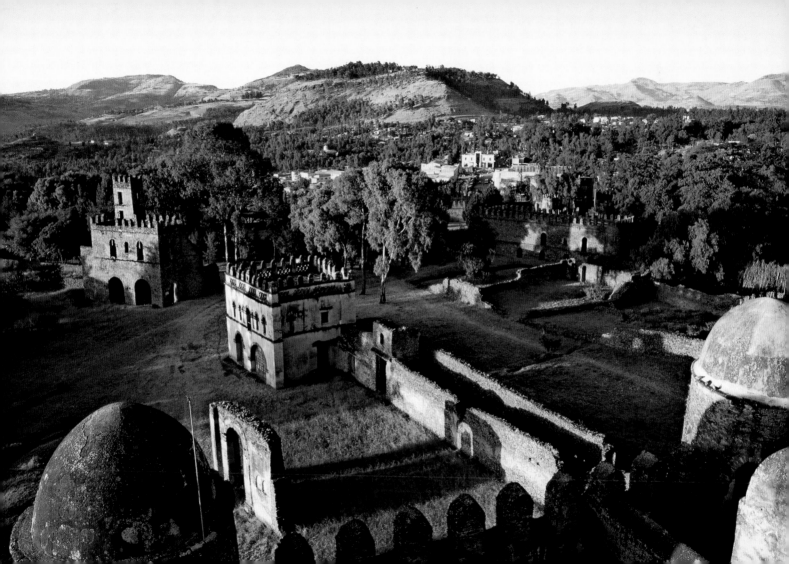

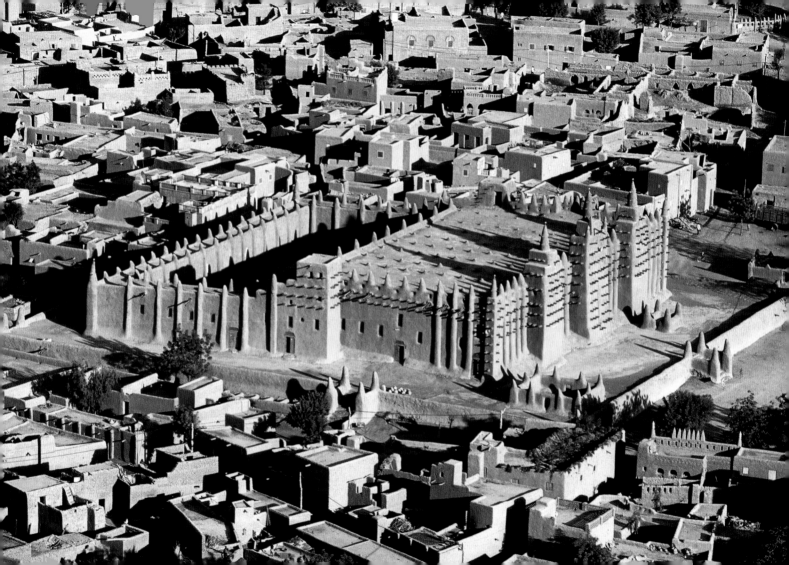

630
The Great Mosque at Djenné, in Mali, is the biggest clay construction in the world. With its tower and embattled walls, it is the symbol of the city and of "black Islam."

Paolo Novaresio, was born in Turin in 1954 and graduated with a degree in Contemporary History. A traveler, historian and writer, he has always worked in the field of exploration methods. By car, on foot and using local transportation, he has covered numerous itineraries in the lesser known areas of Africa, from the Sahara Desert to the Congo Basin, as well as East and South Africa. Novaresio has sailed the Nile and Aruwimi, and crossed Lake Tanganyika. On foot, he has also explored vast regions of the Sahara and the Suguta Valley in Kenya. Following a long journey across the Dark Continent between 1981 to 1983, he stayed in Kenya for over a year, studying the culture and transhumance routes of the Samburu and Turkana nomads. He has recently concentrated his research in Kenya, Botswana, Namibia and South Africa. Novaresio also oversees the logistical preparation of trips and scientific expedition, and has contributed articles on African history and civilization to numerous newspapers and magazines. He published *Men towards the unknown* (1997), *Sahara* (2003) and *Vanishing Africa* (2004) with White Star.

Index

Index

Index

Index

Index

Index

Photo Credits

Photo Credits

640

Along the eastern coast of the island of Zanzibar, facing the Indian Ocean off the coast of Tanzania, a fishermen's boat is grounded among the shiny puddles left by the low tide

FLYING HIGH AFRICA

FLYING HIGH